Keds

Look for HOOKLESS on the pull

Pavillon de l'Élégance

Levi's

THE ONE AND ONLY wonderbra

the gap

FIORUCCI

MW00532919

★ EXTRA ★

THE DAILY TRIBUNE

FINAL MARKETS
SPECIAL
SPORTS REVIEW

NATION'S HEADLINE DAILY

PAGE 1

BEAUTY DISAPPEARS !
MYSTERY FIGURE HIDES

JIM HEIMANN · ALISON A. NIEDER

20TH CENTURY

Fashion

TASCHEN

Bibliotheca Universalis

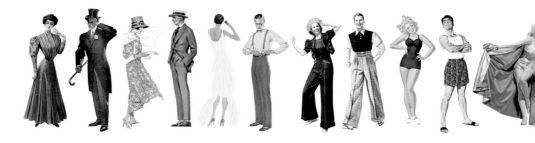

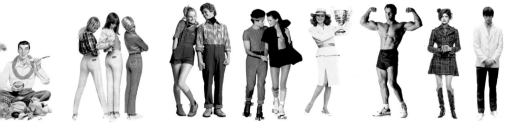

"CLOTHES MAKE THE
MAN. NAKED PEOPLE
HAVE LITTLE OR NO
INFLUENCE ON SOCIETY."
–MARK TWAIN

„KLEIDER MACHEN
LEUTE. NACKTE
HABEN WENIG
ODER GAR KEINEN
EINFLUSS AUF DIE
GESELLSCHAFT."
–MARK TWAIN

INT ROD

« L'HABIT FAIT L'HOMME.
LES GENS NUS ONT PEU OU
PAS D'INFLUENCE SUR LA
SOCIÉTÉ. »
– MARK TWAIN

UCTION

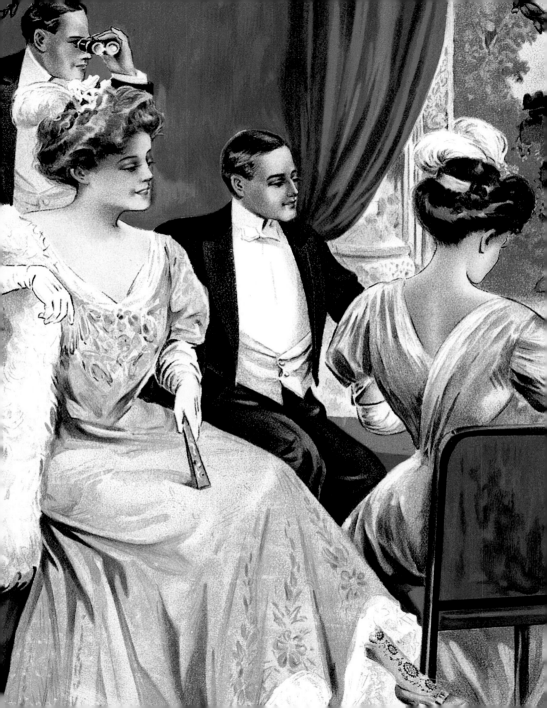

FASHION FORWARD

The birth of couture coincides with the invention of the sewing machine and the beginning of the industrial age. Mechanization and automation were creating mass-produced clothing for a burgeoning middle class.

IN SEPTEMBER 1947, THE OCEAN LINER QUEEN ELIZABETH DOCKED IN NEW YORK HARBOR WITH A PASSENGER LIST THAT INCLUDED CHRISTIAN DIOR AND SALVATORE FERRAGAMO, both en route to Dallas, Texas, to receive the Neiman Marcus fashion awards. Six months before, Dior had released his first solo collection. Dubbed the "New Look" by *Harper's Bazaar* editor Carmel Snow, Dior's silhouette was a radical departure from the austere, masculine wartime styles of the decade's early years.

"We want to forget all about the war," Dior told a *New York Times* reporter on the dock that day. After being told that some American women did not like his new silhouette, with its long, full skirts and hourglass shape, Dior replied, "Once they have seen it, they are convinced. From the male point of view, long skirts are much more feminine." Despite the *Times* reporter's questions on that autumn day in 1947, Dior's redefinition of the female form was already evident.

In reviving the feminine silhouette, Dior also revived the French fashion industry, which had suffered considerably during World War II. Designers like Mainbocher left for America, and others, like Coco Chanel, simply shut their doors. During the war, fabric and metal trim was in short supply in many European countries due to strict rationing. In America the shortages were less severe, but they still brought an end to such high-yardage styles as long skirts, bias cuts, and shawl collars.

The "New Look" was not just a reaction to an earlier silhouette and the end of the deprivations of war—it was also the result of a very fortuitous partnership. Dior, who had worked with couturiers

Robert Piguet and Lucien Lelong before the war, struck out on his own with the backing of his business partner, French cotton millionaire Marcel Boussac.

The partnership and the resulting collection echoed the 19th-century collaboration between Charles Frederick Worth, the first couturier, and French empress Eugénie Bonaparte, who together popularized numerous trends, including the voluminous hoopskirt. Replacing layers of bulky petticoats, the hoopskirt, or crinoline, provided a large canvas for Worth's ideas and for the conspicuous consumption of Napoléon III's court. But it also bolstered the French textile industry. The exaggerated silhouette used upwards of ten yards of fabric at the hem, helping to turn the fortunes of struggling silk weavers in Lyon.

The collaboration also marked the beginning of the partnership between designers and members of high society, an association that escalated in the 20th century as photography became more prevalent and society coverage found a home in newspapers and magazines. Decades before icons like Grace Kelly, Jacqueline Kennedy, and Princess Diana, American Wallis Simpson became an international obsession after her marriage to the former King of England, Edward VIII. Later known as the Duke of Windsor, Edward was also a trendsetter, eschewing formal dress for business suits and adopting casual, sportswear-like plus fours and V-neck sweaters for everyday attire. In the 1930s, American debutantes began embracing their roles as style leaders and started working with designers to make sure they were spotted wearing the latest styles when they were out on the town. The fashion magazines joined in, using society women as models in fashion spreads and editorial features.

At the same time, consumers were taking their fashion cues from the stars of the silver screen, mimicking looks seen in films or in the pages of fan magazines and gossip columns. Recognizing the influence of celebrities, some advertisers signed them on to endorse their products and appear in their ads. One of the first companies to recognize the potential of a celebrity spokesperson was Portland, Oregon-based swim label Jantzen, whose models ranged from Olympic champions Johnny Weissmuller and Duke Kahanamoku to actors Loretta Young, Joan Blondell, Ginger Rogers, and Dick Powell.

As the century progressed, celebrities eclipsed high society as the driving force for fashion trends. And by the 1950s, models began coming to the fore, achieving celebrity in their own right.

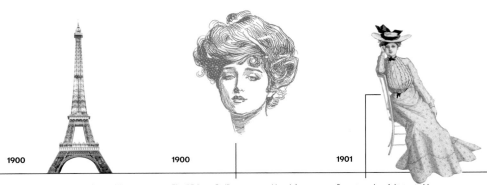

1900

Victorian styles decline with rise of Art Nouveau at Universal Expo, Paris

Blüte des Jugendstils auf der Pariser Weltausstellung, Ende der Mode viktorianischen Stils

Fin de l'ère victorienne, l'Art Nouveau est à son apogée lors de l'Exposition Universelle de Paris

1900

The "Gibson Girl" appears weekly in *Life* magazine

Charles Dana Gibsons „Gibson Girl" erscheint allwöchentlich in der Zeitschrift *Life*

La « Gibson Girl » de Charles Dana Gibson apparaît chaque semaine dans le magazine *Life*

1901

Booming sales of shirtwaist blouse

Der Verkauf von Hemdblusen boomt

Les ventes de corsages explosent

Dorian Leigh, Suzy Parker, Jean Shrimpton, Twiggy, Brooke Shields, Cheryl Tiegs, Christie Brinkley, Iman, Cindy Crawford, Kate Moss—they all personified the look of their eras, and their activities, opinions, and love lives became as closely watched as any debutante or Hollywood starlet.

The advent of the so-called supermodel put the spotlight on the relationship between designer and muse. But that symbiotic relationship stretches back to Empress Eugénie and Worth, the British designer acknowledged to be the first couturier.

BORN IN 1826, IN BOURNE, LINCOLNSHIRE, ENGLAND, CHARLES FREDERICK WORTH WORKED AS A FABRIC SALESMAN FROM AN EARLY AGE, first in England and later in Paris. By 1858, he'd established the House of Worth on Paris's rue de la Paix. Before Worth, wealthy women's clothing was designed by female dressmakers, designing with considerable input from their clientele. Only menswear was designed by male tailors. The birth of couture coincides with the invention of the sewing machine and the beginning of the industrial age. Mechanization and automation were creating mass-produced clothing for a burgeoning middle class. In America, catalog merchants like Montgomery Ward and Sears, Roebuck and Co. began delivering everyday products—as well as the latest fashions—to America's most remote regions. Meanwhile, European designers had already taken steps to preserve the art of handcraftsmanship, and, in 1868, the French government stepped in, forming the Chambre Syndicale de la Haute Couture in Paris, a trade organization strictly regulated by the French Department of Industry.

Like Dior, many of the Chambre Syndicale's members can be credited with revolutionary designs that significantly altered the look of fashion of the day. In America, those who could afford to travel to Europe to buy couture, did. Others purchased "licensed" reproductions of couture pieces from upscale department stores. And within a few seasons, details culled from couture collections were adapted for lesser-priced lines, reaching far wider audiences. Thus, Chanel's wool jersey pieces with details borrowed from menswear have become synonymous with the look of the modern 1920s woman. Elsa Schiaparelli's highly tailored looks and strong, padded shoulders became a mainstay of the 1930s and 1940s. Cristobal Balenciaga's architectural designs provided a counterbalance to

1905

1907

1908

Illustrator J. C. Leyendecker creates Arrow Collar Man campaign

Der Illustrator J. C. Leyendecker entwirft die Kampagne Arrow Collar Man

L'illustrateur J. C. Leyendecker crée la campagne Arrow Collar Man

Annette Kellerman wears one-piece bathing suit leading to athletic styles

Annette Kellermans Auftritt im einteiligen Badeanzug: Beginn sportlich-athletischer Trends

La nageuse Annette Kellerman en maillot de bain une pièce lance la mode du sportswear

Ford's open Model T brings cars—and motor robes—to masses

Fords offenes Modell T macht Autos – und Autofahrer-Garderobe – zum Massenartikel

La Model T décapotable de Ford démocratise la voiture et les vêtements automobiles

Dior's structured glamour. And Pierre Cardin's modern designs, with their emphasis on clean, graphic shapes, ushered in the space-age styles of the 1960s.

But the person credited with the first fashion shift of the 20th century is Paul Poiret, a French designer who left the House of Worth with a concept for Oriental-inspired fashion designed for a completely new body type. The Victorian aesthetic locked the ideal woman in a rigid corset that lifted her bust while constricting her waist to tiny proportions. Poiret had another idea about beauty. Using his wife, Denise, as his muse and model, the designer began with a slender, athletic body, which he then draped in column-like dresses and kimono-style robes that gave the wearer the appearance of being wrapped in a luxurious cocoon. His designs were exotic and radical, and they helped to transform the body's silhouette.

Madeleine Vionnet's bias-cut gowns evoked the image of blonde bombshell Jean Harlow and the escapist glamour depicted in Hollywood films of the early 1930s. But the glamour reflected on the screen belied the harsh reality of the Great Depression. Women's magazines still ran fashion spreads showing the latest styles, but many also published tips for altering and updating existing pieces from one's wardrobe.

The look of fashion advertising also changed in the 1930s, as magazines and advertisers relied less on well-known illustrators to attract attention and underscore the quality of the product and more on photography and less costly in-house artists. The shift marked an end to a rich history of ads using such name artists as J.C. Leyendecker, whose artwork for Arrow shirts and Interwoven socks conveyed sophistication and panache; the Art Nouveau–style illustrations of Maxfield Parrish; the pinup girls drawn by Coles Phillips for Holeproof Hosiery; or George Petty, whose long-limbed Petty Girl was first featured as the Jantzen Diving Girl logo.

And while magazines and advertisers were downsizing, cash-strapped American consumers were looking for economical alternatives, as well. Considered the progenitor of what came to be known as the American Look, Claire McCardell designed everything from everyday apparel to outerwear, skiwear, and wedding dresses. From the 1930s through the 1950s, McCardell's mix-and-match separates became a mainstay of women's wardrobes. Denim, calico, and madras

1911

1911

1912

Jantzen and Bentz Knitting Mills begin making knitted swimsuits

Jantzen and Bentz Knitting Mills beginnen mit der Produktion gestrickter Badeanzüge

Jantzen et Bentz Knitting Mills commencent à produire des maillots de bain en tricot

Triangle Shirtwaist Factory fire leads to labor reform in New York City

Feuer in der Triangle Shirtwaist Factory in New York führt zu großen Reformen für die Arbeiter

L'incendie de la Triangle Shirtwaist Factory à New York entraîne une réforme du travail

Brown Shoe Company goes public

Die Brown Shoe Company geht an die Börse

La société Brown Shoe Company est introduite en bourse

plaid became signature fabrics for the designer, who also favored such details as topstitching, hoods, spaghetti ties, and patch pockets, as well as leotards and pedal pushers.

While McCardell was designing in New York, California's West Coast casual style was beginning to influence trends in sportswear. Costume designer Bonnie Cashin was "discovered" by Carmel Snow to head design for women's suit maker Adler & Adler. In her 40-year career, Cashin designed everything from Adler & Adler's suits and coats to costumes for the 1944 film *Laura* and accessories for Coach and Hermès.

The West Coast was also home to the swimwear industry, where brands like Jantzen, Catalina, and Cole of California thrived. Evolving from heavy woolen knits, swimwear's foundation was rocked by the invention of the bikini in 1946. The daring new style had a starring role throughout the 1950s and 1960s in popular beach- and surf-themed movies, which helped drive swim trends beyond their seaside roots.

DESPITE THE RAPID AND UNIVERSAL SUCCESS OF DIOR'S "NEW LOOK", HIS TENURE COINCIDED WITH OTHERS, LIKE CARDIN AND BALENCIAGA, whose ideas of beauty helped pave the way for the space-age styles of the 1960s. One of the first proponents of ultramodern design was André Courrèges, who created deceptively simple pieces in stark colors that looked more stamped in hard plastic than cut from fabric. His short hemlines and white go-go boots were both iconic to the decade and inspirational to a generation of designers. Courrèges's Los Angeles-based contemporary Rudi Gernreich also hewed to the modernist approach, but his design philosophy was even more conceptual. Remembered best for his topless "monokini" swimsuit, Gernreich also created the soft bralette, which complemented his whimsical designs. Using his favorite model, Peggy Moffitt, as his muse, Gernreich helped craft the mod look, and Moffitt's husband, photographer William Claxton, helped preserve it. While Courrèges and Gernreich were raising hemlines to new heights, British designer Mary Quant and her Chelsea Look took the mini to the masses.

In the late 1960s, former Dior designer Yves Saint Laurent struck out on his own, creating a label that at once defined trends and defied convention. Saint Laurent's creations were quickly adopted into mainstream fashion. From the classic men's tuxedo—known as Le Smoking—to fashions

1913

1913

1914

Influence of Orientalism seen in Poiret designs and beyond

Orientalische Einflüsse sind unter anderem in Poirets Kreationen sichtbar

L'Orientalisme influence les créations de Poiret et d'autres couturiers

Grecian hairstyles conform more to natural shape of the head

Frisuren im griechischen Stil folgen stärker der natürlichen Kopfform

Les coiffures à la grecque épousent mieux la forme naturelle de la tête

Mack Sennett's "Bathing Beauties" debut in Keystone comedies

Mack Sennetts „Bathing Beauties" geben ihr Debut in den Keystone-Komödien

« Les jolies baigneuses » de Mack Sennett font leurs débuts dans les comédies Keystone

inspired by Russian, Gypsy, and African garments, his influence can be clearly seen in the street trends of the 1960s and 1970s.

The 1970s also saw blue jeans evolve from the uniform of the working man, counterculture, and kids to a legitimate fashion essential. Denim's dominance—and the importance of branding—continued throughout the century, as labels like Levi's, Lee, and Wrangler saw new competition from designer brands like Jordache, Calvin Klein, Guess, and Diesel. To move denim from its utilitarian past to its fashionable future required new cuts, new washes, and a new marketing message. Klein, one of the first designers to recognize that fact, put his brand and Brooke Shields on the fashion map with his landmark 1980 ad, shot by photographer Richard Avedon, that featured the 15-year-old Shields declaring that nothing came between her and her Calvins.

THROUGHOUT THE 1980S, LUXURY FASHION BRANDS–NOTABLY CALVIN KLEIN–WORKED WITH AN EVER-EXPANDING ROSTER OF FASHION PHOTOGRAPHERS, including Steven Meisel, Patrick Demarchelier, Mario Testino, and Helmut Newton. Following the success of the Brooke Shields ad, Klein continued to use controversial imagery to market his underwear and jeans. Photographer Bruce Weber created many of his memorable campaigns featuring chiseled male models in various stages of undress, and Herb Ritts, whose 1992 Calvin Klein ad featuring a young white rapper named Marky Mark (aka Mark Wahlberg) in his underwear, shocked tourists and locals when it appeared as a giant billboard looming over New York's Times Square.

Similarly, jeans maker Guess updated the pinup for the modern era with a mix of supermodels (Claudia Schiffer and Naomi Campbell were both Guess girls) and celebrity (Anna Nicole Smith, who got her start as a Guess girl).

The silhouette shifted again in the 1980s. As more women entered the workforce and began achieving positions of power, designers like Giorgio Armani, Donna Karan, and Claude Montana responded with strong-shouldered, tailored fashions. There was an avant-garde wave of design coming from Japan, led by Comme des Garçons designer Rei Kawakubo. Meanwhile, music-inspired fashions from punk to pop to new wave were broadcast into people's homes through the new MTV cable channel.

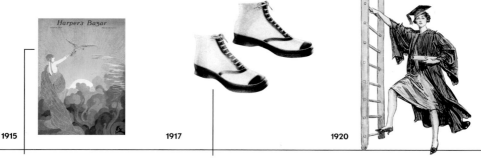

1915

1917

1920

Artist and costumer Erté lands *Harper's Bazaar* cover contract

Der Künstler und Kostümbildner Erté schließt mit *Harper's Bazaar* einen Cover-Vertrag ab

Contrat entre Erté et *Harper's Bazaar* pour créer toutes les couvertures du magazine

Demand increases for athletic shoes

Steigende Nachfrage nach Sportschuhen

La demande en chaussures de sport augmente

American women gain right to vote in national elections

Amerikanische Frauen erringen auf nationaler Ebene das Wahlrecht

Les Américaines obtiennent le droit de vote aux élections nationales

In the 1990s, street- and music-inspired fashion took center stage with grunge-inspired anti-fashion and oversize urban streetwear. Several New York designers — including Anna Sui, Christian Francis Roth, and Marc Jacobs, then designing for Perry Ellis — attempted to incorporate grunge trends into their collections, all with mixed results. But by the end of the decade, the look changed again, with new designers Miuccia Prada and Gucci's Tom Ford offering divergent takes on new luxury: Prada highlighted minimalist sophistication, while Ford's look was sexy and indulgent. Early on, both designers showed a keen understanding of branding and the potential of using accessories to reach a wider audience — the consumer who couldn't afford a Gucci or Prada ensemble might be able to project the glamour of the label by buying Gucci sunglasses or a Prada backpack. Other high-end and haute-couture labels joined in with their own luxury accessories, and soon brands were vying for their latest clutch, tote, or "baguette" to be declared the "it" bag of the season.

As the decade and the millennium came to a close, fashion companies vied for ways to set their brands apart. For some, that meant injecting a little shock value into their marketing. Benetton became the subject of controversy when the Italian brand addressed the AIDS crisis, racism, and ethnic violence in its ads. And Diesel, ever the provocateur, scandalized the editors at *Mother Jones* magazine with a 1998 ad that featured bound and submerged men and women, with the tag line, "At least you'll leave a beautiful corpse."

Meanwhile, the House of Dior — now owned by French conglomerate Moët Hennessey Louis Vuitton — made its own shocking announcement, naming John Galliano as head of design. He wasted no time in putting his iconoclast imprint on the label, drawing inspiration from a romantic mélange that included the English countryside, pinup girls, Maasai beadwork, Casanova, and the homeless. Still, the enfant terrible has been credited with instilling in the House of Dior — and the art of haute couture — a newfound sense of fun and youthful artistry. Indeed, *The New York Times*, in reviewing Galliano's first collection for Dior, wrote, "Mr. Galliano's show was a credit to himself, to Mr. Dior, whose name is on the door, and to the future of the art, which is always in question."

1920

Society Brand Clothing begins air-shipping orders

Society Brand Clothing beginnt mit Belieferung auf dem Luftweg an schwer erreichbaren Orten

Society Brand Clothing livre par avion les communautés non desservies par le train

1922

Cloche hat with narrow brim popular for women with shorter hairstyles

Glockenhut mit schmaler Krempe beliebt bei Frauen mit Kurzhaarfrisur

Les femmes aux cheveux courts adoptent le chapeau cloche à bord étroit

1926

Movies add sound

Aufkommen des Tonfilms

Début du cinéma parlant

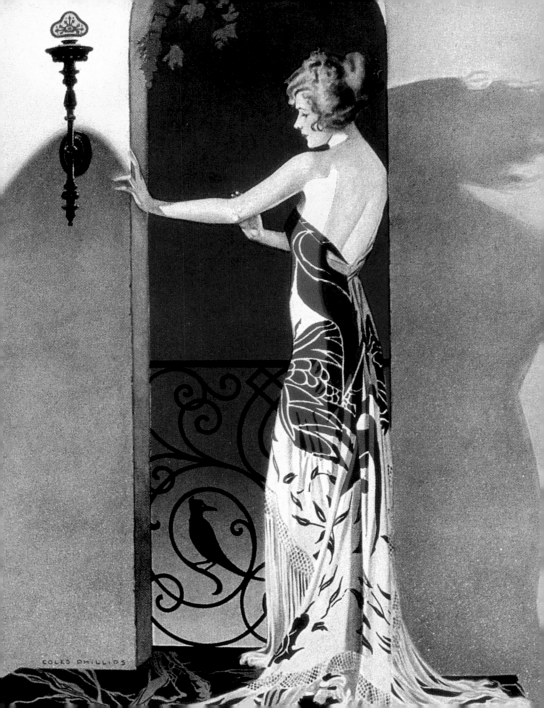

MODE IM ZEITRAFFER

Die Geburtsstunde der Couture fällt mit der Erfindung der Nähmaschine und dem Beginn des Industriezeitalters zusammen. Mechanisierung und Automation brachten Kleidung als Massenware für die aufstrebende Mittelschicht auf den Markt.

IM SEPTEMBER 1947 DOCKTE DIE QUEEN ELIZABETH MIT CHRISTIAN DIOR UND SALVATORE FERRAGAMO AUF DER PASSAGIERLISTE IM HAFEN VON NEW YORK AN. Die beiden waren auf dem Weg nach Dallas, Texas, um die Neiman Marcus Fashion Awards entgegenzunehmen. Sechs Monate zuvor hatte Dior seine revolutionäre erste Solo-Kollektion vorgestellt. Die Herausgeberin von *Harper's Bazaar,* Carmel Snow, taufte Diors neue Silhouette, die sich so radikal von den nüchternen, maskulinen Trends der Kriegsjahre zu Beginn des Jahrzehnts unterschied, „The New Look".

„Wir wollen alles, was mit dem Krieg zusammenhängt, vergessen", erklärte Dior an jenem Tag noch am Kai einem Reporter der *New York Times.* Nachdem man ihm mitgeteilt hatte, dass manche Amerikanerinnen seine neue Silhouette mit den langen, weiten Röcken und der Sanduhr-Figur nicht goutierten, erwiderte Dior: „Sobald sie es gesehen haben, werden sie überzeugt sein. Vom männlichen Standpunkt aus gilt, dass lange Röcke sehr viel weiblicher wirken." Trotz der Fragen des *Times*-Reporters an jenem Herbsttag 1947 war Diors Neubestimmung der weiblichen Figur bereits offensichtlich.

Mit der Wiederbelebung der femininen Silhouette gab Dior auch der französischen Modeindustrie neuen Auftrieb, die während des Zweiten Weltkriegs beträchtlich gelitten hatte. Designer wie Mainbocher waren damals nach Amerika ausgewandert, andere wie Coco Chanel hatten ihre Läden einfach dicht gemacht. Während des Krieges waren Stoff und Zubehör aufgrund der strikten Rationierungsmaßnahmen in vielen europäischen Ländern Mangelware. In den USA war die Verknappung

weniger schlimm, bedeutete aber dennoch das Ende meterverschlingender Trends wie lange Röcke, Schrägschnitt und Schalkragen.

Der New Look war nicht nur eine Reaktion auf frühere Silhouetten und das Ende des kriegsbedingten Mangels – er war auch das Ergebnis einer ganz zufälligen Verbindung. Dior, der vor dem Krieg mit den Couturiers Robert Piguet und Lucien Lelong gearbeitet hatte, wurde mit Unterstützung seines Geschäftspartners, des französischen Baumwollmillionärs Marcel Boussac, selbst kreativ.

Die Partnerschaft und die daraus resultierende Kollektion erscheint wie eine Wiederholung der Kooperation zwischen dem ersten Couturier Charles Frederick Worth und der französischen Kaiserin Eugénie Bonaparte im 19. Jahrhundert; die beiden sorgten für die Verbreitung zahlreicher Moden, darunter der voluminöse Reifrock. Der Reifrock, auch Krinoline genannt, machte die vielen Schichten bauschiger Unterröcke überflüssig und sorgte für den richtigen Hintergrund zu Worths Ideen und dem aufwändigen Lebensstil am Hof von Napoléon III. Das Ganze förderte zugleich die französische Textilindustrie. Für die auffällige Silhouette wurden am Saum mindestens zehn Laufmeter Stoff benötigt, was den darbenden Seidenwebern in Lyon sehr zupass kam.

Diese Kooperation markierte aber auch den Beginn der Partnerschaften zwischen Designern und bedeutenden Mitgliedern der Gesellschaft; wobei diese Zweckbeziehung erst im 20. Jahrhundert ihren Höhepunkt erreichte, als die Fotografie immer mehr Verbreitung fand und Gesellschaftsreportagen zum festen Bestandteil von Zeitungen und Magazinen wurden. Jahrzehnte vor Ikonen wie Grace Kelly, Jacqueline Kennedy und Lady Diana gab es einen internationalen Hype um die Amerikanerin Wallis Simpson, nachdem diese den ehemaligen König von England, Edward VIII., geheiratet hatte. Der fortan nur noch als Herzog von Windsor betitelte Edward war ebenfalls ein Trendsetter, der formelle Kleidung als Business-Outfit mied und lässige Sportswear mit Knickerbocker und V-Ausschnitt-Pullover als Alltagsgarderobe salonfähig machte. In den 1930er Jahren begannen amerikanische Debütantinnen ihre stilbildenden Rollen anzunehmen und die Dienste von Designern in Anspruch zu nehmen, um sicherzugehen, dass man sie in den neuesten Trends sah, wenn sie sich ins Licht der Öffentlichkeit begaben. Die Modezeitschriften griffen das auf und begannen, Damen der Gesellschaft als Models in Modebeilagen und redaktionellen Beiträgen zu präsentieren.

1928

Gordon introduces proportioned stockings

Gordon bringt proportionierte Strümpfe auf den Markt

Gordon lance les bas dits « proportionnés »

1928

Zipper trademarked by Talon

Talon lässt sich den Reißverschluss patentieren

La société Talon fait breveter la fermeture à zip

1932

Athlete turned actor Johnny Weissmuller inspires broad-shouldered cuts

Der Sportler Johnny Weissmüller wird Schauspieler, inspiriert zu schulterbetonten Schnitten

L'athlète Johnny Weissmueller devient acteur et inspire la mode du costume à épaules larges

Gleichzeitig holten sich die Konsumenten Modetipps bei den Leinwandstars und ahmten Outfits nach, die sie in Filmen, Fanzeitschriften und Klatschkolumnen gesehen hatten. Nachdem sie den Einfluss der Prominenten erkannt hatten, nahmen einige Werbekunden diese unter Vertrag, damit sie Produkte empfahlen und in Annoncen auftraten. Eine der ersten Firmen, die das Potenzial eines berühmten Fürsprechers erkannten, war die Bademodenmarke Jantzen mit Sitz in Portland, Oregon; zu ihren Modellen zählten die Olympiasieger Johnny Weissmueller und Duke Kahanamoku, aber auch Schauspieler wie Loretta Young, Joan Blondell, Ginger Rogers und Dick Powell.

Im weiteren Verlauf des Jahrhunderts verdrängten Prominente die Angehörigen der besseren Gesellschaft als Vorreiter für modische Trends. Etwa ab den 1950er Jahren rückten schließlich die Models selbst in den Vordergrund und besaßen fortan ebenfalls den Status von Berühmtheiten. Dorian Leigh, Suzy Parker, Jean Shrimpton, Twiggy, Brooke Shields, Cheryl Tiegs, Christie Brinkley, Iman, Cindy Crawford und Kate Moss – sie alle personifizierten den Look ihrer jeweiligen Ära, während ihre Aktivitäten, Ansichten und Liebschaften so aufmerksam verfolgt und dokumentiert wurden wie bis dato bei Debütantinnen oder Hollywood-Sternchen.

Das Aufkommen sogenannter Topmodels brachte die Beziehung zwischen Designer und Muse ins Rampenlicht. Doch auch diese Symbiose lässt sich schon Kaiserin Eugénie und dem britischen Modeschöpfer Worth, der als erster Couturier gilt, attestieren.

DER 1826 IN BOURNE, LINCOLNSHIRE, ENGLAND GEBORENE CHARLES FREDERICK WORTH ARBEITETE SCHON IN JUNGEN JAHREN ALS TEXTILKAUFMANN, ZUNÄCHST IN ENGLAND, SPÄTER IN PARIS. 1858 eröffnete er in der Pariser Rue de la Paix sein House of Worth. Vor ihm war die Garderobe betuchter Damen von Schneiderinnen und maßgeblich nach den Wünschen der Klientel entworfen worden. Schneider waren damals nur für Herrenmode zuständig. Die Geburtsstunde der Couture fällt mit der Erfindung der Nähmaschine und dem Beginn des Industriezeitalters zusammen. Mechanisierung und Automation brachten Kleidung als Massenware für die aufstrebende Mittelschicht auf den Markt. In Amerika begannen Versandhändler wie Montgomery Ward und Sears, Roebuck and Co. Alltagsprodukte – wie auch die neuesten modischen Errungenschaften – in die ent-

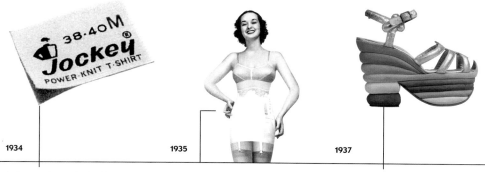

1934	1935	1937
Jockey manufactures first brief underwear for men	Warner Brothers Corset Co. introduces standard A, B, C, and D bra sizes	Salvatore Ferragamo opens shop in Florence, Italy; patents cork wedge heel
Jockey produziert die erste kurze Unterwäsche für Herren	Warner Brothers Corset Co. führt die Standardgrößen A, B, C und D für Büstenhalter ein	Salvatore Ferragamo eröffnet sein Geschäft in Florenz, patentiert sich den Keilabsatz aus Kork
Jockey fabrique le premier slip pour homme	Warner Brothers Corset Co. lance les tailles de bonnets de soutien-gorge A, B, C et D	Salvatore Ferragamo ouvre une boutique à Florence ; brevetage du talon compensé en liège

legensten Regionen des Landes zu liefern. Inzwischen hatten europäische Modeschöpfer bereits Maßnahmen ergriffen, um die Kunst ihres Handwerks zu schützen. Schon 1868 war die französische Regierung auf den Plan getreten und hatte in Paris das Chambre Syndicale de la Haute Couture gegründet, einen vom französischen Industrieministerium streng regulierten Händlerverband.

Wie Dior zeichneten auch viele andere Mitglieder des Chambre Syndicale für revolutionäre Kreationen verantwortlich, die das Bild der Mode in der jeweiligen Zeit maßgeblich bestimmten. Wer es sich leisten konnte, reiste aus den USA nach Europa, um dort Haute Couture zu erstehen. Andere kauften „lizensierte" Reproduktionen von Couture-Modellen in gehobenen Warenhäusern. Innerhalb weniger Saisonen wurden ausgewählte Details aus Couture-Kollektionen in günstigere Linien übernommen und erreichten so ein weit größeres Publikum. Auf diese Weise wurden etwa Chanels Kostüme aus Wolljersey mit aus der Herrenmode entlehnten Details zum Synonym des modischen Erscheinungsbilds der modernen Frau in den 1920er Jahren. Elsa Schiaparellis anspruchsvoll geschneiderte Outfits und die betonten, gepolsterten Schultern wurden zum Hauptmerkmal der 1930er und 1940er. Cristobal Balenciagas geometrische Entwürfe lieferten ein Gegengewicht zu Diors wohlgesetztem Glamour. Pierre Cardins moderne Kreationen mit ihren betont klaren, grafischen Silhouetten leiteten die spacigen Trends der 1960er ein.

Die erste große modische Veränderung des 20. Jahrhunderts muss man jedoch Paul Poiret zugute halten. Der französische Modeschöpfer verließ das House of Worth mit einem Konzept für orientalisch-inspirierte Mode, die er für einen ganz neuen Körpertyp entworfen hatte. Während die viktorianische Ästhetik die Idealfrau in ein starres Korsett gezwängt hatte, das ihre Büste hob und ihre Taille möglichst eng zusammenschnürte, hing Poiret einem ganz anderen Schönheitsideal an. Mit seiner Frau Denise als Muse und Modell ging er von einem schlanken, athletischen Körper aus, den er sodann in säulenförmige Kleider und kimonoartige Roben kleidete, die ihre Trägerin wie in einen kostbaren Kokon gehüllt erscheinen ließen. Seine Kreationen waren so exotisch wie radikal und trugen dazu bei, die weibliche Silhouette grundlegend zu verändern.

Madeleine Vionnets schräg geschnittene Abendkleider wecken Erinnerungen an das blonde Gift Jean Harlow und den irrealen Glamour der Hollywoodfilme der frühen Dreißigerjahre. Dabei strafte der Leinwandglanz die harte Realität der Großen Depression Lügen. Damals gab es in Frauenzeitschrif-

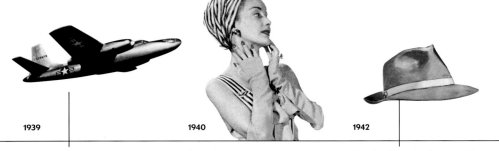

1939

World War II begins

Der 2. Weltkrieg beginnt

Début de la Seconde Guerre mondiale

1940

Turbans become popular accessory

Turbane werden zum gefragten Accessoire

Les turbans deviennent un accessoire très tendance

1942

Humphrey Bogart dons de rigueur fedora in *Casablanca*

Humphrey Bogart trägt in *Casablanca* den unerlässlichen weichen Filzhut

Humphrey Bogart porte le fedora de rigueur dans *Casablanca*

ten zwar immer noch Modebeilagen, die die neuesten Trends präsentierten, viele veröffentlichten aber auch Tipps zum Ändern und Auffrischen bereits vorhandener Teile der eigenen Garderobe.

Das Erscheinungsbild der Modewerbung änderte sich in den 1930ern ebenfalls, denn Zeitschriften wie Werbemacher setzten nicht mehr so stark auf bekannte Illustratoren, um Aufmerksamkeit zu erregen und die Produktqualität zu betonen, sondern stärker auf Fotografie und weniger kostspielige hauseigene Künstler. Der Wandel bedeutete das Ende der Werbeanzeigen von Künstlern wie J. C. Leyendecker, dessen Illustrationen für die Hemdenmarke Arrow und den Sockenhersteller Interwoven Raffinesse und Flair ausstrahlten, der Jugendstil-Illustrationen von Maxfield Parrish, der von Coles Phillips für Holeproof Hosiery gezeichneten Pin-up-Girls oder des Petty Girls von George Petty, das zunächst als Diving-Girl-Logo für Jantzen fungierte.

Und während Zeitschriften und Werbeleute den Gürtel enger schnallten, sahen sich die amerikanischen Konsumenten, die knapp bei Kasse waren, ebenfalls nach kostengünstigen Alternativen um. Als Vorreiterin des späteren American Look entwarf Claire McCardell schlichtweg alles – von Alltagskleidung bis zu Skianzügen, von Unterwäsche bis zu Brautmoden. Von den 1930ern bis in die 1950er waren McCardells perfekt kombinierbare Einzelteile ein Hauptbestandteil der Damenmode. Denim, Kattun und Schottenkaro waren die Lieblingsstoffe der Designerin, die außerdem eine Vorliebe für Details wie Abnäher, Kapuzen und aufgesetzte Taschen, aber auch für Trikots und Caprihosen hatte.

Während McCardell in New York designte, begann der lässige Stil der kalifornischen Westküste die Trends der Sportmode zu beeinflussen. Bonnie Cashin war eine Kostümbildnerin, die Carmel Snow für den Damenkostüm-Hersteller Adler & Adler „entdeckte". In ihrer 40-jährigen Karriere entwarf auch Cashin praktisch alles, von Kostümen und Mänteln bis zur Ausstattung des Films *Laura* von 1944 oder Accessoires für Coach und Hermès.

Die Westküste war die Heimat der Bademodenindustrie, wo Marken wie Jantzen, Catalina und Cole of California florierten. Nachdem man ursprünglich mit dickem wollenen Strickstoff begonnen hatte, kam die Erfindung des Bikinis 1946 einem Erdbeben gleich. Diese gewagte neue Mode spielte eine Hauptrolle in den beliebten Strand- und Surferfilmen der 1950er und 1960er, die Bademodentrends auch über den Strand hinaus förderten.

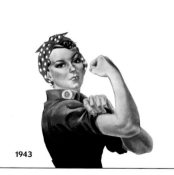

1943

1946

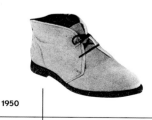

1950

Rosie the Riveter, WWII-era symbol of female workforce

Rosie the Riveter, Symbol im 2. Weltkrieg für Amerikanerinnen aus der Rüstungsindustrie

Rosie la Riveteuse, symbole des ouvrières américaines pendant la Seconde Guerre mondiale

Engineer Louis Réard scandalizes Paris with G-string bikini bathing suit

Der Ingenieur Louis Réard sorgt mit dem G-String-Bikini für einen Skandal in Paris

L'ingénieur Louis Réard scandalise Paris avec son bikini

Men's desert boot introduced; counterculture favorite by 1960s

Der Desert Boot erscheint, wird in den 60ern zum Lieblingsschuh der Protestbewegung

Lancement du modèle Desert Boot, un emblème de la contre-culture des années 1960

TROTZ DES RASCHEN UND WELTWEITEN ERFOLGS VON DIORS NEW LOOK FIEL SEINE ZEIT MIT DEM ERFOLG ANDERER WIE CARDIN UND BALENCIAGA ZUSAMMEN, deren Schönheitsideale dazu beitrugen, den Weg für die spacigen Trends der 1960er zu bereiten. Einer der ersten Verfechter ultramodernen Designs war André Courrèges, der scheinbar simple Kleidungsstücke in kräftigen Farben kreierte, die wie aus Hartplastik gestanzt wirkten. Seine kurzen Säume und weißen Go-go-Stiefel avancierten zu Ikonen jenes Jahrzehnts wie auch zur Inspirationsquelle einer ganzen Generation von Designern. Courrèges' in Los Angeles arbeitender Zeitgenosse Rudi Gernreich war zwar auch ein Vertreter des modernistischen Ansatzes, doch war seine Design-Philosophie noch konzeptioneller. Am bekanntesten ist er für seinen Oben-ohne-Badeanzug namens Monokini. Gernreich entwarf aber auch die weiche Bralette, die seine skurrilen Entwürfe perfekt ergänzte. Unter Mitwirkung seines Lieblingsmodels Peggy Moffitt als Muse trug Gernreich zur Erfindung des Mod-Looks bei, den Moffitts Ehemann, der Fotograf William Claxton, für die Nachwelt dokumentierte. Während Courrèges und Gernreich die Säume zu neuen Höhen steigen ließen, machte die britische Designerin Mary Quant mit ihrem Chelsea Look den Minirock zu einem Massenphänomen.

In den späten Sechzigern wagte der vormalige Dior-Designer Yves Saint Laurent den Schritt in die Selbstständigkeit und gründete ein Label, das Trends setzte und mit Konventionen brach. Saint Laurents Kreationen wurden schnell für die Mainstream-Mode adaptiert. Angefangen beim klassischen Smoking für den Herrn bis hin zu Trends, die von russischer, afrikanischer und Zigeuner-Kleidung inspiriert waren, lässt sich Saint Laurents Einfluss auf die Mode für die breite Masse in den 1960ern und 1970ern deutlich ablesen.

In den Siebzigern entwickelte sich auch die Bluejeans von der Uniform des amerikanischen Arbeiters, vom Symbol der Gegenkultur zu einem vollwertigen modischen Basic. Die Dominanz von Denim – und die wichtige Rolle der jeweiligen Marken – sollte das gesamte Jahrhundert hindurch andauern, während altehrwürdige Marken wie Levi's, Lee und Wrangler sich neuer Konkurrenz in Gestalt von Designerlabels wie Jordache, Calvin Klein, Guess und Diesel gegenüber sahen. Um sich von der funktionalen Vergangenheit zu lösen, benötigte man neue Schnitte, Waschverfahren und eine neue Marketing-Message für den Jeansstoff. Klein erkannte diese Tatsache als einer der ersten

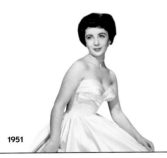

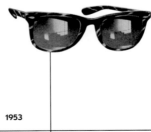

1951

Elizabeth Taylor changes prom dress history

Elizabeth Taylors schulterfreies Abendkleid avanciert zum meistkopierten Ballkleid

La robe bustier d'Elizabeth Taylor devient la robe de bal de promo la plus copiée de l'histoire

1953

Ray-Ban Wayfarers will become best-selling sunglasses of all time

Ray-Ban lässt sich die Wayfarers patentieren; die meistverkaufte Sonnenbrille aller Zeiten

Ray-Ban fait breveter les Wayfarers, les lunettes de soleil les plus vendues de l'histoire

1954

TV sales surpass radio

Werbeumsätze im Fernsehen übertreffen die des Radios

Les ventes de téléviseurs dépassent celles des radios

Designer und platzierte in seiner legendären Anzeige seine Marke zusammen mit Brooke Shields auf der modischen Landkarte. Das Foto von Richard Avedon zeigt die 15-jährige, die erklärt, ihr käme nichts zwischen sie und ihre Calvins.

IM LAUFE DER 1980ER ARBEITETEN LUXUSLABELS – ALLEN VORAN CALVIN KLEIN – MIT EINER STÄNDIG WACHSENDEN SCHAR VON MODEFOTOGRAFEN, darunter Steven Meisel, Patrick Demarchelier, Mario Testino und Helmut Newton. Nach dem Erfolg der Brooke-Shields-Anzeige setzte Klein die Verwendung kontroverser Bilder fort, um seine Dessous und Jeans zu bewerben. Der Fotograf Bruce Weber schuf viele der Calvin-Klein-Anzeigen, die Männermodels beim Ausziehen zeigten. Herb Ritts Anzeige von 1992 präsentierte einen jungen weißen Rapper namens Marky Mark (alias Mark Wahlberg) in Unterwäsche, der auf einem Riesenplakat am New Yorker Times Square die Passanten schockte.

Auf ähnliche Weise aktualisierte der Jeanshersteller Guess die Idee des Pin-ups, und zwar mit einer Mischung aus Supermodels (sowohl Claudia Schiffer als auch Naomi Campbell waren Guess-Girls) und anderen Prominenten (so begann etwa Anna Nicole Smith ihre Karriere als Guess-Girl).

Die 1980er brachten mal wieder eine neue Silhouette in die Mode. Nachdem immer mehr Frauen auf den Arbeitsmarkt drängten und zunehmend begannen einflussreiche Positionen zu erklimmen, reagierten Designer wie Giorgio Armani, Donna Karan und Claude Montana mit betonten Schultern und maßgeschneiderter Mode darauf. Aus Japan kam eine avantgardistisch geprägte Design-Welle, angeführt von Comme des Garçons' Designerin Rei Kawakubo. Inzwischen erreichten von der Musik inspirierte Modeströmungen – von Punk über Pop bis hin zu New Wave – über den neuen Kabelkanal MTV die Menschen in ihre eigenen Wohnzimmer.

In den 1990ern stand vom Alltag und der Musik inspirierte Mode ebenso im Mittelpunkt wie die grungeartige Anti-Mode und bewusst überschnittene urbane Streetwear. Einige New Yorker Designer – darunter Anna Sui, Christian Francis Roth und Marc Jacobs, der damals für Perry Ellis entwarf – versuchten mit gemischtem Erfolg Grunge-Trends in ihre Kollektionen zu integrieren. Zum Ende des Jahrzehnts änderte sich der Look abermals, als neue Designer wie Miuccia Prada und Tom Ford

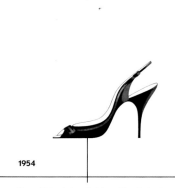

1954

Roger Vivier designs first shoe with spike heel for House of Dior

Roger Vivier entwirft den ersten Schuh mit Pfennigabsatz für das Haus Dior

Roger Vivier conçoit les premières chaussures à talons aiguilles pour la maison Dior

1956

Brigitte Bardot's appearance in *And God Created Woman* popularizes bikini

Brigitte Bardots Darstellung in *Und ewig lockt das Weib* macht den Bikini populär

Brigitte Bardot démocratise le bikini dans *Et Dieu créa la femme*

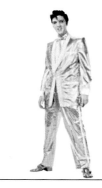

1959

Nudie's Rodeo Tailors make Elvis Presley $10,000 custom gold lamé tuxedo

Nudie's Rodeo Tailors kreiert Elvis Presleys 10.000 $ teuren Maß-Smoking aus Goldlamé

Pour Elvis Presley, Nudie's Rodeo Tailors crée un smoking lamé or d'une valeur de 10 000 $

von Gucci divergierende Interpretationen des neuen Luxus offerierten: Pradas betont minimalistische Raffinesse und Fords sexy Überfluss. Von Anfang an bewiesen beide Designer kluges Markenverständnis und erkannten das Potenzial von Accessoires, um ein breiteres Publikum zu erreichen – wer sich kein komplettes Outfit von Gucci oder Prada leisten konnte, der wollte vielleicht mit einer Gucci-Sonnenbrille oder einem Prada-Rucksack etwas vom Glamour dieser Labels auf sich projizieren. Andere Nobel- und Haute-Couture-Labels sprangen mit eigenen Luxus-Accessoires auf denselben Zug auf. Und bald wetteiferten die Marken darum, dass ihre neuesten Clutch-, Tote- oder Baguette-Modelle zur „It"-Bag der Saison würden.

Als Jahrzehnt und Jahrtausend sich dem Ende zuneigten, rangen die Modefirmen darum, ihre Marken voneinander abzugrenzen. Einige taten dies, indem sie ihre Marketingkampagnen mit einer gewissen Schockwirkung versahen. So geriet etwa Benetton in die Kontroverse, weil die italienische Marke in ihren Anzeigen AIDS, Rassismus und Gewalt gegen Minderheiten thematisierte. Als Provokateur schlechthin sorgte Diesel 1998 für einen Skandal in der Redaktion der Zeitschrift *Mother Jones*, und zwar mit einer Anzeige, die gefesselte Männer und Frauen unter Wasser zeigte, versehen mit dem Slogan „At least you'll leave a beautiful corpse".

Etwa zur gleichen Zeit gab das Haus Dior – inzwischen im Besitz des französischen Marken-Konglomerats Moët Hennessey/Louis Vuitton – die schockierende Nachricht bekannt, John Galliano als Chefdesigner ernannt zu haben. Dieser vergeudete keine Zeit, sondern drückte dem Hause Dior seinen ikonoklastischen Stempel auf; dabei bezog er seine Inspiration aus einer romantischen Melange von englischem Landleben, Pin-up-Girls, Massai-Perlen, Casanova und Obdachlosen-Chic. Dennoch attestierte man dem Enfant terrible, dem Hause Dior – und der Kunst der Haute Couture an sich – einen neuen Sinn für Spaß und jugendliche Kunstfertigkeit zurückgegeben zu haben. In einer Kritik der ersten Galliano-Kollektion für Dior schrieb die *New York Times*, „Mr. Gallianos Show habe ihm selbst, Mr. Dior, dessen Name an der Tür steht, ebenso zur Ehre gereicht wie der Zukunft seiner Kunst, die schließlich stets zur Disposition stünde".

▶ Jantzen Skiwear, 1947
▶▶ Wool Bureau/Dalton of America, 1964

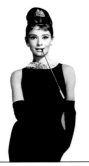

1963

1964

1966

Audrey Hepburn dons trendsetting little black dress in *Breakfast at Tiffany's*

Audrey Hepburn trägt in *Frühstück bei Tiffany* ein kleines Schwarzes, das einen Trend begründet

Audrey Hepburn lance la mode de la petite robe noire dans *Diamants sur canapé*

Beatles arrival in America starts skinny-tie trend

Die Ankunft der Beatles in Amerika bereitet der schmalen Krawatte den Weg

La venue des Beatles aux États-Unis déclenche la mode des cravates fines

Miniskirt goes mainstream

Der Minirock wird zum Massentrend

La minijupe se démocratise

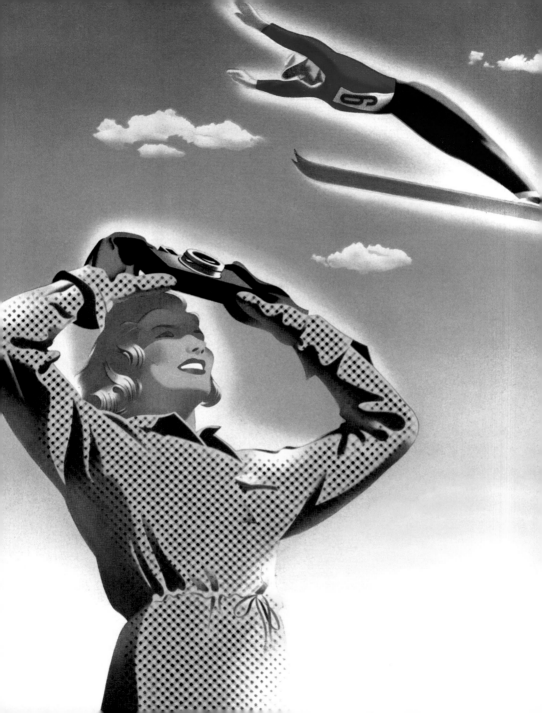

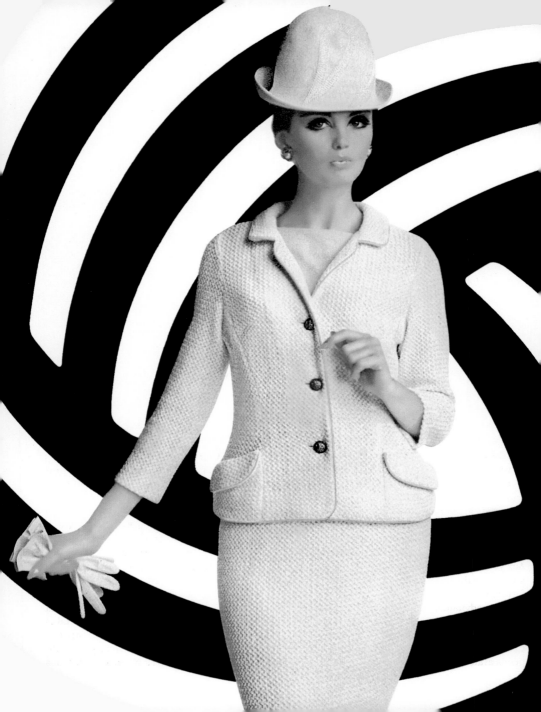

EN AVANT LA MODE !

La naissance de la haute couture coïncida avec l'invention de la machine à coudre et les débuts de l'ère industrielle. La mécanisation et l'automatisation permirent de produire des vêtements en masse pour la classe moyenne émergente.

QUAND LE PAQUEBOT QUEEN ELIZABETH JETA L'ANCRE À NEW YORK EN SEPTEMBRE 1947, IL COMPTAIT PARMI SES PASSAGERS CHRISTIAN DIOR ET SALVATORE FERRAGAMO, tous deux en route vers Dallas, Texas, pour recevoir leurs prix Neiman Marcus. Six mois plus tôt, Dior avait provoqué une petite révolution en lançant sa première collection à son nom. Etiquetée de «New Look» par la rédactrice en chef d'*Harper's Bazaar* Carmel Snow, la silhouette Dior représentait un changement radical par rapport aux modèles austères et masculins des années de guerre.

«Nous voulons tout oublier de la guerre», expliqua Dior à un reporter du *New York Times* présent sur le port ce jour-là. Après s'être entendu dire que certaines Américaines n'aimaient pas sa nouvelle silhouette en forme de sablier et ses longues jupes amples, Dior répondit : «L'essayer, c'est l'adopter. Aux yeux d'un homme, les jupes longues sont beaucoup plus féminines.» Malgré les questions du journaliste du *Times* en ce jour d'automne 1947, il semblait évident que Dior avait déjà redessiné les formes féminines.

En redynamisant la silhouette féminine, Dior insuffla aussi une nouvelle vie à l'industrie de la mode française qui avait considérablement souffert pendant la Seconde Guerre mondiale. Certains couturiers, comme Mainbocher, s'étaient exilés aux États-Unis, tandis que d'autres, notamment Coco Chanel, avaient tout simplement fermé boutique. Tout au long de la guerre, de nombreux pays européens avaient été confrontés à une pénurie de tissu et d'articles de mercerie en raison de politiques

de rationnement très rigoureuses. Bien que la pénurie fût moins sévère outre-Atlantique, on avait également interrompu la production des vêtements nécessitant beaucoup de tissu, comme les jupes longues, les coupes en biais et les cols châles.

Le New Look n'était pas qu'une réaction à la silhouette précédente et à la fin des privations de la guerre : il fut aussi le fruit d'un partenariat absolument improbable. Dior, qui avait travaillé avec des couturiers tels Robert Piguet et Lucien Lelong avant la guerre, finit par lancer sa propre maison grâce au soutien financier de son associé Marcel Boussac, un millionnaire français du coton.

Ce partenariat et la collection à laquelle il donna lieu rappelaient la collaboration entre Charles Frederick Worth, le tout premier couturier, et l'impératrice française Eugénie Bonaparte, qui avaient tous deux lancé de nombreuses tendances au 19ème siècle, notamment celle de la volumineuse jupe à cerceaux, ou crinoline. En remplaçant les nombreuses et inconfortables couches de jupons, la crinoline offrait plus de place aux idées de Worth et à la consommation ostentatoire qu'en faisait la cour de Napoléon III. Cependant, la crinoline avait aussi soutenu l'industrie française du textile. Nécessitant plus de neuf mètres de tissu à l'ourlet, cette silhouette démesurée avait relancé les soieries de Lyon alors menacées de banqueroute.

Cette collaboration marqua aussi le début des partenariats entre couturiers et membres de la haute société, une forme d'association qui prit tout son essor au 20ème siècle quand la photographie devint omniprésente et que la jet-set se retrouva dans les journaux et les magazines. Bien longtemps avant des icônes comme Grace Kelly, Jacqueline Kennedy et Lady Diana, le monde entier avait les yeux braqués sur l'Américaine Wallis Simpson, qui venait d'épouser l'ex-roi d'Angleterre, Édouard VIII. Plus tard connu sous le nom de duc de Windsor, Édouard lança de nombreuses tendances. Délaissant les tenues officielles au profit des costumes, il adopta le sportswear décontracté au quotidien sous la forme de culottes de golf et de pulls à col V. Pendant les années 30, les débutantes américaines commencèrent à assumer leur rôle de figures de mode et collaborèrent avec les couturiers pour être sûres d'être vues dans leurs modèles les plus récents lors de leurs sorties en ville. Les magazines de mode suivirent le pas, transformant les femmes de la haute société en mannequins dans leurs photos de mode et leurs éditoriaux.

1966

1967

1971

Mary Quant's "Chelsea Look" is British invasion of fashion world

Mary Quants „Chelsea Look" ist die britische Invasion in die Modewelt

Le « Chelsea Look » de Mary Quant traduit l'invasion de la mode par les Britanniques

Summer of Love

Summer of Love

Les Américains vivent leur « Summer of Love »

Disco era inspires oversize butterfly collars for men

Die Disco-Ära ist Inspiration für die überdimensionalen Schmetterlingskrägen für Herren

L'ère du disco inspire la mode du col pelle à tarte chez les hommes

À la même époque, les femmes s'inspirèrent des stars du grand écran en reproduisant les tenues repérées dans les films ou dans les pages des magazines de fans et les chroniques mondaines. Conscients de l'influence exercée par les célébrités, certains annonceurs leur firent signer des contrats pour promouvoir leurs produits et apparaître dans leurs publicités. L'une des premières marques à avoir exploité le potentiel d'un interprète célèbre fut le fabricant de maillots de bain Jantzen, basé à Portland dans l'Oregon, qui compta parmi ses égéries les champions olympiques Johnny Weissmuller et Duke Kahanamoku, mais aussi les actrices Loretta Young, Joan Blondell, Ginger Rogers et le comédien Dick Powell.

Au fil du siècle, les célébrités prirent la place de la haute société pour lancer les tendances. À partir des années 50, les mannequins commencèrent à occuper le devant de la scène et devinrent des stars à part entière. Dorian Leigh, Suzy Parker, Jean Shrimpton, Twiggy, Brooke Shields, Cheryl Tiegs, Christie Brinkley, Iman, Cindy Crawford et Kate Moss : elles ont toutes incarné le look de leurs époques respectives. Leurs activités, opinions et vies sentimentales ont été scrutées et documentées comme celles de n'importe quelle débutante ou starlette hollywoodienne.

L'arrivée de celles qu'on appelle les top-modèles vit renaître la relation entre le créateur et sa muse, un rapport symbiotique qui remontait déjà à l'époque de l'Impératrice Eugénie et de Worth, le styliste anglais reconnu comme le premier grand couturier de l'histoire.

NÉ EN 1826 À BOURNE DANS LE LINCOLNSHIRE, L'ANGLAIS CHARLES FREDERICK WORTH COMMENÇA À TRAVAILLER TRÈS TÔT COMME VENDEUR DE TISSU, D'ABORD EN ANGLETERRE PUIS À PARIS. En 1858, il ouvrit la maison Worth rue de la Paix à Paris. Avant Worth, les femmes riches commandaient leurs vêtements à des couturières qui suivaient leurs ordres à la lettre. Seule la mode pour homme était conçue par des tailleurs. La naissance de la haute couture coïncida avec l'invention de la machine à coudre et les débuts de l'ère industrielle. La mécanisation et l'automatisation permirent de produire des vêtements en masse pour la classe moyenne émergente. Aux États-Unis, les vendeurs par correspondance, comme Montgomery Ward et Sears, Roebuck and Co., se mirent à commercialiser des produits d'usage quotidien – dont les derniers vêtements à la mode – dans les

 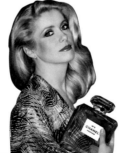

1972

L'eggs, first pantyhose brand sold, introduces Sheer Energy

L'eggs, die erste verkaufte Strumpfhosenmarke, bringt das Modell Sheer Energy heraus

L'eggs, première marque de collants lance son modèle Sheer Energy

1972

Catherine Deneuve lends face to Chanel No. 5 throughout the 1970s

Catherine Deneuve ist in den 70ern das Gesicht zu Chanel No 5

Catherine Deneuve prête son visage à Chanel Nº 5 tout au long des années 70

1976

Italian boutique Fiorucci opens in New York, becoming "daytime Studio 54"

Die in New York eröffnete italienische Boutique Fiorucci wird zum „Studio 54 für tagsüber"

La boutique italienne Fiorucci ouvre à New York et devient le « Studio 54 » de jour

régions les plus reculées du pays. Pendant ce temps, les couturiers européens avaient déjà pris des mesures pour préserver l'artisanat fait main et, en 1868, le gouvernement français s'engagea en fondant la Chambre Syndicale de la Haute Couture de Paris, une organisation strictement réglementée par le Ministère de l'Industrie.

Comme Dior, de nombreux membres de la Chambre Syndicale inventèrent des créations révolutionnaires qui influencèrent considérablement le look de l'époque. Les Américaines les plus fortunées se rendaient en Europe pour acheter des pièces de haute couture, les autres se contentant de leurs reproductions fabriquées « sous licence » et vendues dans les grands magasins de luxe. En l'espace de quelques saisons, les détails repérés dans les collections de haute couture furent repris dans des gammes plus accessibles destinées à une clientèle beaucoup plus large. Voilà comment les tailleurs Chanel en jersey de laine et leurs détails empruntés à la mode masculine devinrent synonymes du look de la femme moderne des années 20. Les tailleurs très structurés d'Elsa Schiaparelli et leurs épaules carrées avec épaulettes s'imposèrent comme le pilier de la mode des années 30 et 40. Les créations architecturales de Cristobal Balenciaga apportèrent un contrepoint au glamour étudié de Dior. Les tenues modernes de Pierre Cardin, qui mettaient l'accent sur les formes pures et graphiques, lancèrent la mode des tenues « space age » dans les années 60.

C'EST TOUTEFOIS À PAUL POIRET QUE L'ON DOIT LA PREMIÈRE RÉVOLUTION DE LA MODE AU 20ÈME SIÈCLE. Ce couturier français avait quitté la maison Worth avec un concept de mode d'inspiration orientale pour une toute nouvelle silhouette. L'esthétique victorienne avait verrouillé l'idéal féminin dans un corset rigide qui rehaussait la poitrine tout en réduisant le tour de taille à des proportions minuscules. Poiret avait une autre idée de la beauté. Avec son épouse Denise comme muse et mannequin, le couturier travailla sur un corps athlétique plus élancé qu'il drapait dans des robes-colonnes et des manteaux kimonos donnant l'impression que la femme était enveloppée dans un cocon. Exotiques et radicales, ses créations transformèrent la silhouette du corps féminin.

Les robes taillées en biais de Madeleine Vionnet évoquent aujourd'hui l'image de la sulfureuse blonde Jean Harlow et le glamour dépeint par Hollywood au début des années 30 pour faire oublier la

1976

Farrah Fawcett in *Charlie's Angels*, inspires feathered-hair look

Mit *Drei Engel für Charlie* macht Farrah Fawcett den Löwenmähnen-Look populär

Dans *Drôles de dames*, Farrah Fawcett lance la mode du brushing « à la lionne »

1977

Studio 54 opens in New York, soon becoming the epicenter of disco chic

In New York öffnet das Studio 54 und avanciert bald zum Epizentrum des Disco-Chic

Ouverture du Studio 54 à New York, qui devient rapidement l'épicentre du disco chic

1977

Men's leisure-suit trend reaches height of popularity

Der Trend zum Freizeitanzug für Männer erreicht seinen Höhepunkt

Le costume disco pour homme atteint des sommets de popularité

dure réalité de la Grande Dépression. Les magazines féminins publiaient encore des pages de mode sur les dernières tendances, mais la plupart d'entre eux proposaient des conseils pour modifier et remettre au goût du jour les vêtements de votre garde-robe.

La publicité de la mode changea de look dans les années 30 : pour attirer l'attention et mettre en avant la qualité des produits, les magazines et les annonceurs comptaient plus sur la photographie et leurs dessinateurs maison moins onéreux que sur les illustrateurs célèbres. Cette transition marqua la fin d'un patrimoine de publicités faisant appel à des artistes aussi connus que J. C. Leyendecker, dont le travail pour les chemises Arrow et les chaussettes Interwoven véhiculait sophistication et panache, Maxfield Parrish et ses illustrations Art Nouveau, Coles Phillips et les pin-up qu'il dessinait pour Holeproof Hosiery, ou George Petty, dont la femme aux longues jambes avait fait sa première apparition en tant que plongeuse du logo Jantzen.

Alors que les magazines et les annonceurs licenciaient à tour de bras, les Américains à court d'argent recherchaient des alternatives de consommation. Considérée comme la mère de ce qui allait devenir le « look américain », Claire McCardell conçut toutes sortes de modèles, des tenues de tous les jours aux vêtements de ski et de plein air en passant par les robes de mariée. Des années 30 à la fin des années 50, ses ensembles coordonnés s'imposèrent dans la plupart des garde-robes féminines. Le denim, le calicot et les carreaux madras devinrent ses tissus signature, la styliste privilégiant également les détails comme les surpiqûres, les capuches, les bretelles spaghettis et les poches plaquées, mais aussi les collants de danse et les corsaires.

Pendant que Claire McCardell s'activait à New York, le style décontracté de la côte ouest californienne commença à influencer les tendances du sportswear. Carmel Snow de *Harper's Bazaar* « découvrit » la costumière Bonnie Cashin, destinée à devenir directrice de la création chez le fabricant de tailleurs Adler & Adler. En quarante ans de carrière, Bonnie Cashin a tout fait, des tailleurs et manteaux d'Adler & Adler aux costumes du film *Laura* (1944) en passant par des accessoires pour Coach et Hermès.

La côte ouest, également berceau de l'industrie des vêtements de plage, vit prospérer des marques comme Jantzen, Catalina et Cole of California. Abandonnant les maillots en laine trop

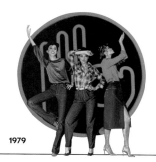

1978

Miuccia Prada takes helm at Prada

Miuccia Prada übernimmt die Leitung von Prada

Miuccia Prada reprend la direction de Prada

1978

Banana Republic debuts khakis and other safari-inspired wear

Banana Republic startet mit Khakis und anderer vom Safaristil inspirierter Kleidung

Banana Republic lance les pantalons de treillis et autres vêtements d'inspiration safari

1979

Sasson launches "Oo la la!" campaign

Sasson startet die Kampagne „Oo la la!"

Sasson lance sa campagne « Oo la la! »

lourds, la structure du maillot de bain fut révolutionnée par l'invention du bikini en 1946. Dans les années 50 et 60, cette nouveauté audacieuse joua un rôle de premier plan dans les films à succès sur les thèmes de la plage et du surf qui contribuèrent à exporter les tendances de la mode nautique bien au-delà du littoral.

MALGRÉ LE SUCCÈS RAPIDE ET UNIVERSEL DU NEW LOOK DE DIOR, SON RÈGNE COÏNCIDA AVEC CELUI D'AUTRES COUTURIERS TELS CARDIN ET BALENCIAGA, dont la vision de la beauté permit l'avènement de la mode « space age » dans les années 60. Pionnier de cet ultramodernisme, André Courrèges créa des vêtements faussement simples aux couleurs soutenues qui avaient l'air taillés dans du plastique rigide et non dans du tissu. Ses jupes courtes et ses bottes blanches à talons plats furent à la fois l'emblème de la décennie et une source d'inspiration pour toute une génération de créateurs. Rudi Gernreich, contemporain de Courrèges vivant à Los Angeles, adopta aussi l'approche moderniste, mais avec une philosophie créative encore plus conceptuelle. Surtout connu pour son monokini « topless », Gernreich inventa également la brassière souple pour compléter ses créations farfelues. Avec sa muse et mannequin préférée Peggy Moffitt, Gernreich participa à l'élaboration du look Mod, tandis que le mari de Peggy, le photographe William Claxton, l'aida à l'immortaliser. Pendant que Courrèges et Gernreich hissaient l'ourlet des robes vers de nouveaux sommets, la styliste anglaise Mary Quant et son « Chelsea Look » firent descendre la minijupe dans la rue.

À la fin des années 60, Yves Saint Laurent, ex-styliste de Dior, lança une griffe qui remettait en question les conventions tout en définissant les tendances. Les créations de Saint Laurent furent rapidement reprises par la mode grand public. Du smoking classique pour homme, appelé « Le Smoking », aux pièces inspirées des vêtements russes, tsiganes et africains, Saint Laurent influença clairement la mode de la rue des années 60 et 70.

Les années 70 virent aussi évoluer le jean – jusqu'alors réservé aux ouvriers, à la contre-culture et aux ados – au rang de véritable basique de mode. La domination du denim, et l'importance du branding, se poursuivit tout au long du siècle, de vénérables marques comme Levi's, Lee et Wrangler entrant en concurrence avec des griffes de créateurs telles que Jordache, Calvin Klein, Guess et

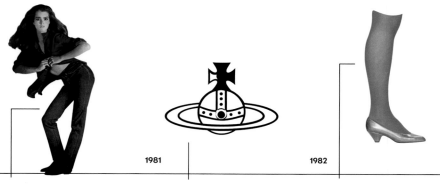

1980

Brooke Shields appears in Calvin Klein jeans campaign

Brooke Shields posiert für die Jeans-Kampagne von Calvin Klein

Brooke Shields pose pour la campagne publicitaire des jeans Calvin Klein

1981

Vivienne Westwood launches her first eponymous collection in London

Vivienne Westwood bringt in London ihre erste, nach ihr benannte Kollektion heraus

Vivienne Westwood lance sa première collection éponyme à Londres

1982

Frank Zappa and teen daughter Moon Unit immortalize "Valley Girls"

Frank Zappa und seine 14-jährige Tochter Moon Unit machen „Valley Girls" unsterblich

Frank Zappa et sa fille de 14 ans Moon Unit immortalisent « Valley Girls »

Diesel. Pour faire oublier le passé utilitaire du denim et le faire entrer dans la mode du futur, il fallait de nouvelles coupes, de nouveaux délavages et un nouveau message marketing. Calvin Klein fut l'un des premiers à en prendre conscience. Il fit la réputation de sa marque, et celle de Brooke Shields au passage, grâce à son inoubliable visuel publicitaire de 1980 photographié par Richard Avedon, sur lequel la jeune mannequin de quinze ans déclarait qu'il n'y aurait jamais rien entre elle et son Calvin.

TOUT AU LONG DES ANNÉES 80, LES GRIFFES DE LUXE – EN PARTICULIER CALVIN KLEIN – TRA- VAILLÈRENT AVEC UN NOMBRE DE PHOTOGRAPHES SANS CESSE CROISSANT, notamment Ste- ven Meisel, Patrick Demarchelier, Mario Testino et Helmut Newton. Face au succès de son affiche avec Brooke Shields, Calvin Klein continua de recourir aux images controversées pour vendre ses sous-vête- ments et ses jeans. Le photographe Bruce Weber signa un grand nombre de pubs mémorables pour Cal- vin Klein qui présentaient des hommes aux corps sculptés plus ou moins dévêtus, tandis qu'Herb Ritts, toujours pour Calvin Klein en 1992, mit en scène un jeune rappeur blanc en slip nommé Marky Mark (alias Mark Wahlberg) dans une affiche géante qui, une fois placardée au-dessus de Times Square, cho- qua les touristes et les New-Yorkais.

De même, le spécialiste du jean Guess modernisa la pin-up d'autrefois grâce à un mélange de top-modèles (Claudia Schiffer et Naomi Campbell furent toutes deux des Guess girls) et de célébrités (Anna Nicole Smith, qui doit sa renommée à Guess).

La silhouette changea à nouveau dans les années 80. Alors que plus de femmes entraient dans le monde du travail et commençaient à occuper des postes à responsabilités, des créateurs tels Giorgio Armani, Donna Karan et Claude Montana leur proposèrent des tailleurs aux épaules très marquées. Menée par la styliste Rei Kawakubo de Comme des Garçons, une vague avant-gardiste déferla aussi sur le Japon. Au même moment, la nouvelle chaîne câblée MTV popularisait les tendances inspirées par la scène musicale, du punk à la pop en passant par la new wave.

Dans les années 90, les looks de la rue et les fans de musique occupèrent une place centrale grâce au mouvement anti-mode du grunge et aux vêtements surdimensionnés du streetwear urbain. Plusieurs créateurs de New York – Anna Sui, Christian Francis Roth et Marc Jacobs, qui travaillait

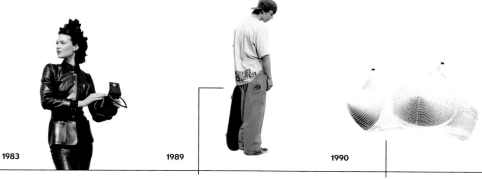

1983

1989

1990

Karl Lagerfeld revives Chanel brand with racy new edge

Karl Lagerfeld sorgt mit gewagten Innovatio- nen für die Wiederbelebung der Marke Chanel

Karl Lagerfeld fait revivre la marque Chanel grâce à un nouveau style racé

Japanese trend inspires oversize streetwear

Einem japanischen Trend folgend ändert sich die Alltagsmode von figurnah zu oversized

Le streetwear adopte des modèles surdimen- sionnés, une tendance venue du Japon

Madonna brings back the bullet bra, or cone bra, on her Blonde Ambition tour

Madonna bringt auf ihrer Blonde-Ambition- Tour den Spitz-BH wieder ins Bewusstsein

Madonna remet à la mode le soutien-gorge « à obus » lors de sa tournée Blonde Ambition

alors pour Perry Ellis – tentèrent d'intégrer les tendances grunge dans leurs collections, mais avec des résultats mitigés. Vers la fin du siècle, le look changea encore une fois avec l'arrivée des stylistes Miuccia Prada et Tom Ford (chez Gucci) qui proposèrent des visions divergentes du nouveau luxe : Prada mit l'accent sur la sophistication minimaliste, tandis que Tom Ford inventa un look sexy et décadent. Ces deux créateurs comprirent très rapidement les stratégies de branding et exploitèrent tout le potentiel des accessoires pour toucher un plus large public : le consommateur qui n'avait pas les moyens de s'offrir un ensemble Gucci ou Prada pouvait s'approprier le glamour de la marque en achetant des lunettes de soleil Gucci ou un sac à dos Prada. Les autres marques de luxe ou de haute couture rejoignirent le mouvement en lançant leurs propres accessoires, rêvant toutes de voir leur dernier modèle de sac à main, de cabas ou de pochette être déclaré « it bag » de la saison.

À l'approche du troisième millénaire, les griffes de mode rivalisèrent d'inventivité pour se distinguer. Pour certaines, cela revenait à injecter un peu de provocation dans leur communication marketing. Benetton suscita la controverse quand la marque italienne aborda les problèmes du sida, du racisme et des violences ethniques dans ses publicités. En 1998, l'éternel provocateur Diesel scandalisa les journalistes du magazine *Mother Jones* avec une publicité présentant des hommes et des femmes sous l'eau enchaînés à des parpaings, assortie du slogan : « Au moins, vous ferez un beau cadavre ».

À la même époque, la maison Dior – désormais propriété du groupe français LVMH – décida aussi de choquer en nommant John Galliano à la direction de la respectable marque. Ce dernier ne perdit pas de temps pour imprimer sa patte iconoclaste aux collections Dior, puisant son inspiration dans un cocktail romantique de campagne anglaise, de pin-up, de perles massaï, de Casanova et de SDF.

On reconnaît à l'enfant terrible l'exploit d'avoir insufflé un nouveau sens de l'humour et une créativité débordante de jeunesse à la maison Dior, mais aussi à l'art de la haute couture en soi. En effet, dans sa critique de la première collection de Galliano pour Dior, *The New York Times* écrivait : « Le défilé de M. Galliano est tout à son honneur, à celui de M. Dior, dont le nom est écrit sur la porte, et à l'avenir de l'art, sans cesse remis en question. »

▶ Guess Lingerie, 1992

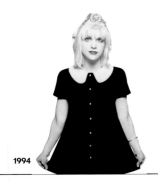

1994

1994

1998

Courtney Love brings back baby-doll dress

Courtney Love bringt das Babydoll-Kleid wieder in Mode

Courtney Love remet les robes babydoll à la mode

Tommy Hilfiger gets boost from Snoop Dogg appearance on *Saturday Night Live*

Tommy Hilfiger profitiert von Snoop Doggs Auftritt bei *Saturday Night Live*

Snoop Dogg porte des vêtements Tommy Hilfinger au *Saturday Night Live*

Manolo Blahnik shoes star in *Sex and the City* television series

Schuhe von Manolo Blahnik genießen in der Fernsehserie *Sex and the City* Kultcharakter

Les chaussures Manolo Blahnik jouent un rôle de premier plan dans la série *Sex & the City*

GEORGES MARCIANO

"THE NOVELTIES OF ONE GENERATION
ARE ONLY THE RESUSCITATED FASHIONS
OF THE GENERATION BEFORE LAST."
– GEORGE BERNARD SHAW

„DIE NEUHEITEN EINER
GENERATION SIND NICHTS
WEITER ALS DIE WIEDER-
BELEBTEN MODEN DER
VORLETZTEN."
– GEORGE BERNARD SHAW

1900

« LES NOUVEAUTÉS D'UNE GÉNÉRATION
NE SONT QUE LES MODES RESSUSCITÉES
DE LA GÉNÉRATION PRÉCÉDENTE. »
– GEORGE BERNARD SHAW

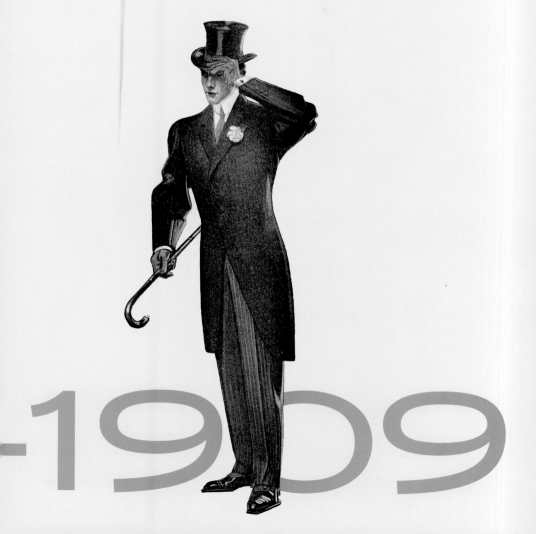

-1909

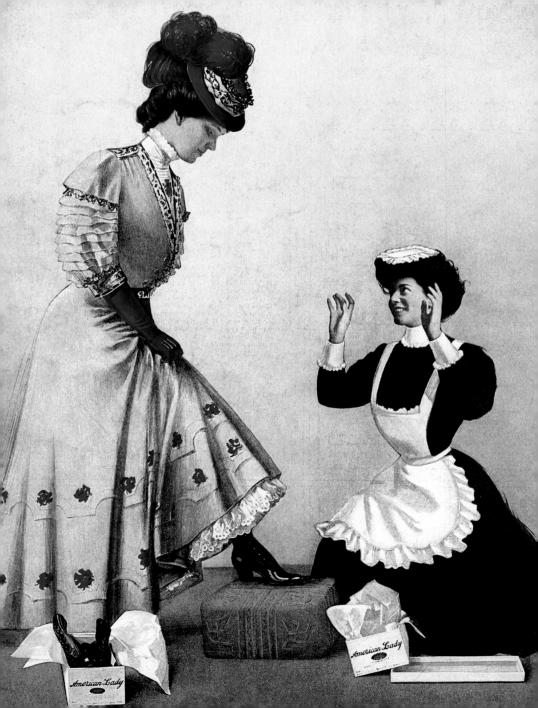

A BELLE-ÉPOQUE BREAK WITH THE PAST

Dressed in the styles of the day, the Gibson Girl wore long skirts and shirtwaist tops over a tightly corseted figure… By mid-decade, the Sears, Roebuck and Co. catalog was advertising 150 styles of shirtwaist.

THE FIRST DECADE OF THE NEW CENTURY WAS FILLED WITH HOPE, ANTICIPATION, AND INNOVATION. The effects of the Industrial Revolution spreading across Europe and North America had radically shifted Western society from an agrarian culture to a modern, urban one. With it came the new middle class—filled with upwardly mobile businessmen and their families, ready to consume the goods the marketplace could now deliver.

It would be a decade of firsts. The Exposition Universelle in Paris in 1900 publicized talking movies, diesel engines, and telescopes, but it also gave visitors a glimpse of Art Nouveau, whose sensuous, rounded shapes and curving lines were a dramatic departure from the Victorian emphasis on minute details and exaggerated adornment. The Wright brothers first took flight in Kitty Hawk, North Carolina, in 1903. That same year, the first movie—*The Great Train Robbery*, which had a running time of 12 minutes—debuted in America. Within five years, 10,000 stores had been converted to nickelodeons, and the modern film age had begun.

Before the widespread adoption of the camera (soon to take off with Kodak's inexpensive and easy-to-use Brownie model) the turn-of-the-century ideal of beauty was propagated by the illustrators of the day. Chief among them was Charles Dana Gibson, who popularized his version of the ideal woman—shapely, with large eyes, delicate features, and a pile of luxurious, dark hair. The "Gibson Girl" became so popular that, in 1900, *Life* magazine began running a serial cartoon

featuring her daily adventures. Dressed in the styles of the day, the Gibson Girl wore long skirts and shirtwaist tops over a tightly corseted figure. A wide-brimmed hat — sometimes trimmed in exotic bird feathers — was perched atop her upswept hair. The look was so pervasive that, by mid-decade, the Sears, Roebuck and Co. catalog was advertising 150 styles of shirtwaist. The prodigious use of feathers — from exotic ostriches and egrets to more commonplace skylarks, pigeons, and wrens — led to the formation of the National Audobon Society, which protested the slaughter of birds for the sake of fashion.

Men wore the slim-suited look, often topped with a bowler in the daytime, sticking to formal attire for evening. Chicago suitmaker Hart Schaffner & Marx began introducing suits in "basic body" types. Menswear's looks were rapidly heading for the mass market.

Womenswear, on the other hand, was heading for revolutionary changes, due, in large part, to Paul Poiret, a former protégé of Paris couturier Charles Frederick Worth. Poiret opened his Paris salon in 1903 with a new vision for women's apparel. Inspired by Orientalism, Poiret's designs were truly radical. Kimono-style opera coats, turbans, harem pants, and, perhaps most shocking of all, the appearance of an uncorseted shape. Still considered avant-garde in most circles, it would be another ten years until the corset began to fall from popularity. In fact, due to concerns that the tight-lacing models popularized in the mid-1800s could be harmful, the "S-bend" or "health" corset — which thrust the torso forward and hips back, therefore putting less pressure on the abdomen — was introduced in 1900, only to be replaced by the long-line corset. The girdle would soon follow.

◀◀ American Lady Shoes, 1906 ▶ Redfern Corsets, 1909

1900

1900

1900

Upswept pompadour hairstyles achieved with false hair

Hochgebürstete Pompadour-Frisuren erzielte man mit Haarteilen und Gestellen

Les coiffures à la Pompadour incluent de faux cheveux et une armature de « transformation »

First patented in 1868, union suit still most popular form of underwear for men

Der 1868 patentierte Union Suit bleibt die beliebteste Herrenunterwäsche

Brevetée en 1868, la combinaison longue reste le sous-vêtement le plus porté par les hommes

Straw boater hats, formerly worn by British Navy, become popular summer headwear

Strohmatrosenhüte, von britischer Marine getragen, werden zur beliebten Kopfbedeckung

Jusqu'alors réservé à la British Navy, le canotier devient le chapeau d'été à la mode

Redfern
Whalebone
Corsets

$3.⁰⁰ to $15.⁰⁰ per pair

The Standard of Corset Fashion

The Foundation of a Perfect-Fitting Gown

*Security Rubber Button Hose Supporters
Attached to all
Redfern Whalebone Corsets*

Sold at all High-Class Shops

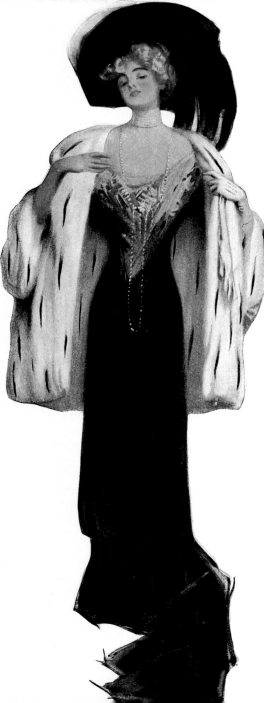

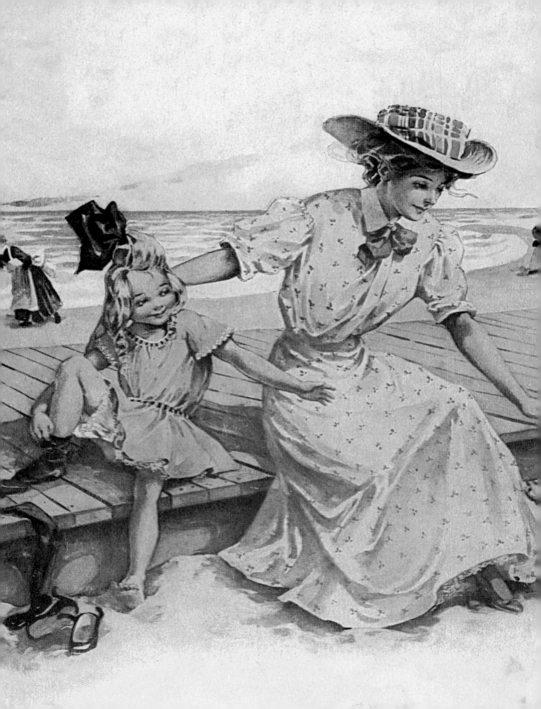

DIE BELLE ÉPOQUE BRICHT MIT VERGANGENEM

Nach der aktuellen Mode gekleidet trug das Gibson Girl lange Röcke und Hemdblusenoberteile an ihrem von einem Korsett stramm geschnürten Körper… Dieser Look war ein so durchschlagender Erfolg, dass der Katalog von Sears, Roebuck and Co. um die Mitte des Jahrzehnts sage und schreibe 150 Varianten von Hemdblusen anbot.

DIE ERSTE DEKADE DES NEUEN JAHRHUNDERTS WAR EINE ZEIT DER HOFFNUNG, ERWARTUNG UND ERNEUERUNG. Die Auswirkungen der Industriellen Revolution, die in ganz Europa und Nordamerika spürbar waren, hatten aus der bis dato landwirtschaftlich geprägten westlichen Gesellschaft auf radikale Art eine modern-urbane gemacht. Im Zuge dieser Entwicklung entstand auch eine neue Mittelschicht – aufstrebende Geschäftsleute und deren Familien, die nur zu bereit waren, all die Waren zu konsumieren, die der Markt plötzlich zu bieten hatte.

Es sollte ein Jahrzehnt der „Ersten" werden. So wurden 1900 auf der Weltausstellung in Paris der Öffentlichkeit erstmals Tonfilme, Dieselmotoren und das größte Linsenfernrohr vorgestellt, zugleich bekamen die Besucher aber auch einen Eindruck vom Jugendstil, der sich mit seinen sinnlichen runden Formen und geschwungenen Linien auf geradezu dramatische Weise von der viktorianischen Vorliebe für winzigste Details und übertriebenes Dekor unterschied. 1903 unternahmen die Gebrüder Wright in Kitty Hawk, North Carolina, ihren ersten Flug. Im selben Jahr hatte der erste Kinofilm – *The Great Train Robbery*, mit einer Länge von 12 Minuten – sein Amerikadebüt. Innerhalb von fünf Jahren wurden 10.000 Geschäfte zu Nickelodeons (Vorläufern der späteren Kinos) umgebaut; damit hatte das moderne Kinozeitalter begonnen.

Vor dem verbreiteten Einsatz von Fotoapparaten (der mit Kodaks preiswertem und leicht zu bedienendem Brownie seinen Anfang nehmen sollte) wurde das Schönheitsideal der Jahrhundert-

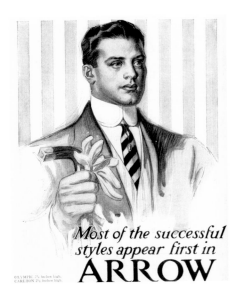

Most of the successful
styles appear first in
ARROW

OLYMPIC 2¼ inches high.
CARLTON 2¼ inches high.

◄◄ Colgate's Talc Powder, 1908 Arrow Collars, 1909

wende von den Illustratoren der Tagespresse verbreitet. Der wichtigste unter ihnen war Charles Dana Gibson, der sein Idealbild einer Frau – wohlgeformt, mit großen Augen, feinen Zügen und einer prachtvollen dunklen Haarflut – popularisierte. Das „Gibson Girl" war schließlich so berühmt, dass die Zeitschrift *Life* ihr für ihre Alltagsabenteuer eine eigene Cartoon-Serie zubilligte. Nach der aktuellen Mode gekleidet trug das Gibson Girl lange Röcke und Hemdblusenoberteile an ihrem von einem Korsett stramm geschnürten Körper. Ein breitkrempiger Hut – manchmal mit exotischen Vogelfedern geschmückt – thronte auf ihrer Hochsteckfrisur. Dieser Look war ein so durchschlagender Erfolg, dass der Katalog von Sears, Roebuck and Co. um die Mitte des Jahrzehnts sage und schreibe 150 Varianten von Hemdblusen anbot. Die maßlose Verwendung von Federn – angefangen bei exotischen Straußen- und Reihern- bis hin zu gewöhnlicheren wie Lerchen-, Tauben- und Zaunkönigfedern – führte zur Gründung der National Audobon Society, die sich gegen die Tötung von Vögeln zu Modezwecken engagierte.

Die Herren trugen tagsüber schmale Anzüge, oft mit einem Filzhut und hielten sich abends nach wie vor an die traditionellen Kleidervorschriften. Der Anzughersteller Hart Schaffner & Marx aus Chi-

1900

1901

1901

S-bend health corset defines the Edwardian hourglass silhouette

Das s-förmige Gesundheitskorsett erzeugt die edwardianische Sanduhr-Silhouette

Le corset en « S » définit la silhouette en sablier de la Belle Époque

Height of womens' heels lowers to under three inches; Louis XIV heel popular

Die Absatzhöhe für Damen sinkt unter 7,5 Zentimeter; Louis-XIV-Absatz ist gefragt

La hauteur des talons descend sous la barre des 7,5 cm ; mode du talon Louis XIV

Troy, NY, becomes known as "Collar City"

Troy im Bundesstaat New York sichert sich den Spitznamen „Collar City"

Troy dans l'État de New York, avec plus de 25 fabricants de cols, devient « Collar City »

cago brachte als erster Anzüge für unterschiedliche „Körpertypen" auf den Markt. Überhaupt strebten die Trends der Herrenmode rasch nach dem Massenmarkt.

Die Damenmode hatte dagegen revolutionäre Veränderungen im Sinn, was sie größtenteils Paul Poiret, dem ehemaligen Schützling des Pariser Couturiers Charles Worth, verdankte. 1903 eröffnete Poiret seinen Pariser Salon mit einer neuen Vision für die Damenbekleidung. Seine orientalisch inspirierten Kreationen waren geradezu radikal. Opernmäntel im Kimonostil, Turbane, Pluderhosen und das vielleicht Schockierendste überhaupt: eine weibliche Silhouette ohne Korsett. Das galt in den meisten Kreisen lange als avantgardistisch, und es sollte noch weitere zehn Jahre dauern, bis die Popularität des Korsetts nachließ. Man führte im Jahr 1900, nachdem gesundheitliche Bedenken gegen die seit Mitte des 19. Jahrhunderts beliebten eng geschnürten Modelle aufgekommen waren, sogar noch ein „s-förmiges" oder „Gesundheits"-Korsett ein, das den Brustkorb

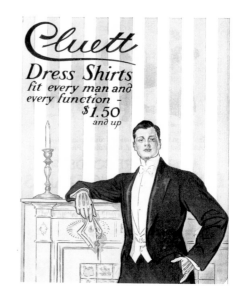

Cluett Shirts, 1909

nach vorn und die Hüften nach hinten drückte und dadurch den Druck auf den Bauch verringerte. Darauf folgte ein längeres Modell und schließlich bald der Hüfthalter.

1903

First World Series played: Boston Americans 5, Pittsburgh Pirates 3

Die ersten World Series werden gespielt: Boston Americans 5, Pittsburgh Pirates 3

Première World Series de baseball: Boston Americans 5, Pittsburgh Pirates 3

1903

Couturier Paul Poiret opens salon in Paris

Couturier Paul Poiret eröffnet seinen Pariser Modesalon

Le couturier Paul Poiret ouvre un salon à Paris

1904

Brown Shoe adopts Buster Brown name and character at St. Louis World's Fair

Brown Shoe setzt bei der Weltausstellung in St. Louis auf den Namen und die Figur Buster Brown

La société Brown Shoe associe le nom et le personnage de Buster Brown à son entreprise

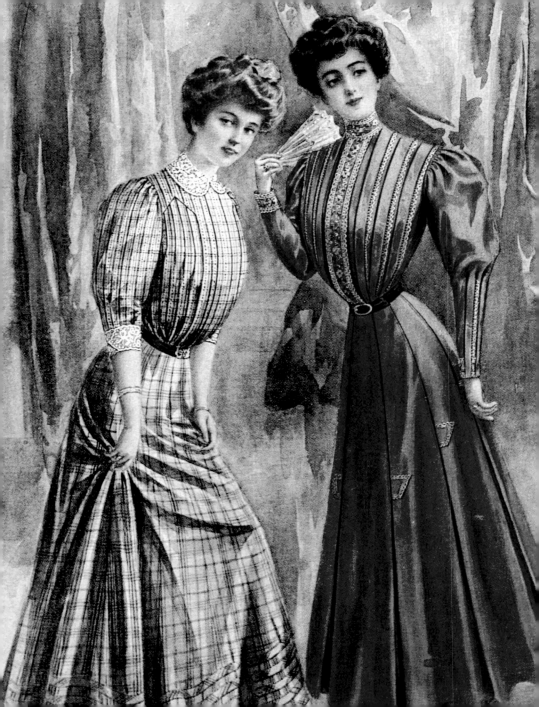

LA BELLE ÉPOQUE : RUPTURE AVEC LE PASSÉ

Toujours à la pointe de la mode, la Gibson Girl porte de longues jupes et des corsages sur une silhouette fermement corsetée… Ce look se répand si vite que, vers 1905, le catalogue Sears, Roebuck and Co. fait la promotion de 150 modèles de corsages.

LA PREMIÈRE DÉCENNIE DU NOUVEAU SIÈCLE EST UNE PÉRIODE PLEINE D'ESPOIRS, D'ATTENTES ET D'INNOVATIONS. À travers toute l'Europe et l'Amérique du Nord, les effets de la révolution industrielle transforment radicalement la société occidentale, la culture rurale cédant du terrain à la culture urbaine moderne. Ils provoquent l'émergence de la nouvelle classe moyenne – composée d'hommes d'affaires ambitieux et de leurs familles – prête à consommer les produits que le marché est désormais en mesure de lui proposer.

Ce devait être la décennie des premières. En 1900, l'Exposition Universelle de Paris présente les films parlants, les moteurs diesel et les télescopes, mais permet aussi aux visiteurs de découvrir l'Art Nouveau, dont les formes rondes voluptueuses et les lignes arrondies tranchent de façon spectaculaire avec l'insistance victorienne sur les petits détails et l'ornementation chargée. En 1903, les frères Wright effectuent leur premier vol en avion à Kitty Hawk, Caroline du Nord. La même année, *Le Vol du grand rapide* – le tout premier film de cinéma, d'une durée de 12 minutes seulement – sort sur les écrans américains. En l'espace de cinq ans, 10 000 boutiques se reconvertissent en salles de projection, annonçant les débuts de l'ère cinématographique moderne.

Bien avant la démocratisation de l'appareil photo (qui devait connaître un essor rapide grâce au modèle Brownie, pratique et bon marché, de Kodak), ce sont les illustrateurs qui véhiculent l'idéal de beauté en ce début de siècle. Parmi les plus éminents, Charles Dana Gibson popularise sa

propre version de la femme idéale : bien faite, avec de grands yeux, des traits fins et une épaisse et luxueuse crinière brune. La « Gibson Girl » remporte un tel succès qu'en 1900 le magazine *Life* lance un feuilleton en bande dessinée racontant ses aventures quotidiennes. Toujours à la pointe de la mode, la Gibson Girl porte de longues jupes et des corsages sur une silhouette fermement corsetée. Ses cheveux remontés sont coiffés d'un chapeau à larges bords, parfois décoré de plumes d'oiseaux exotiques. Ce look se répand si vite que, vers 1905, le catalogue Sears, Roebuck and Co. fait la promotion de 150 modèles de corsages. L'utilisation prodigue des plumes – d'autruches et d'aigrettes exotiques aux espèces plus courantes comme l'alouette, le pigeon et le roitelet – mène à la fondation de la National Audobon Society, une association qui proteste contre le massacre des oiseaux au profit de la mode.

Les hommes portent des costumes près du corps, souvent avec un chapeau melon la journée, s'en tenant aux habits classiques pour le soir. Hart Schaffner & Marx, un tailleur de Chicago, commence à proposer des modèles de costumes « standard ». La mode pour homme s'oriente rapidement vers le marché de masse.

À l'opposé, la mode pour femme s'apprête à connaître des changements révolutionnaires principalement dus à Paul Poiret, un ancien protégé du couturier parisien Charles Worth. Fort d'une nouvelle vision de la mode féminine, Poiret ouvre son salon à Paris en 1903. Inspirées par l'orientalisme, ses créations sont vraiment radicales : manteaux de soirée en forme de kimono, turbans, pantalons de harem et – sans doute le plus grand choc – l'introduction d'une silhouette sans corset. Poiret étant encore considéré comme un avant-gardiste dans la plupart des milieux, il faudra attendre dix ans de plus pour que le corset commence à perdre en popularité. En raison des inquiétudes suscitées par les modèles à laçage très serré qui étaient en vogue au milieu du 19ᵉᵐᵉ siècle, le corset « en S » – qui projette le torse vers l'avant et les hanches vers l'arrière en exerçant donc moins de pression sur l'abdomen – avait été lancé en 1900, avant d'être remplacé par le corset long. La gaine n'allait pas tarder à suivre.

◄◄ Butterick Patterns, 1906 ► Cluett Shirts, 1904

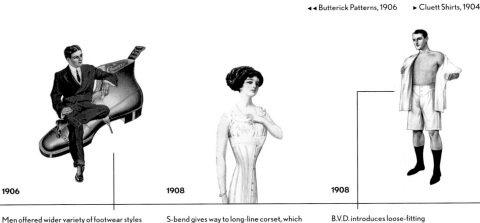

1906

1908

1908

Men offered wider variety of footwear styles

Das Angebot der Schuhmodelle für den Herrn vergrößert sich

Les hommes disposent d'un plus grand choix de chaussures

S-bend gives way to long-line corset, which slims hips as well as waist

Das S-Korsett wird von einem länger geschnittenen Modell verdrängt

Le corset en S est remplacé par le corset long qui affine les hanches et la taille

B.V.D. introduces loose-fitting underwear for men

B.V.D. führt locker sitzende Herrenunterwäsche ein

B.V.D. commercialise des sous-vêtements amples pour homme

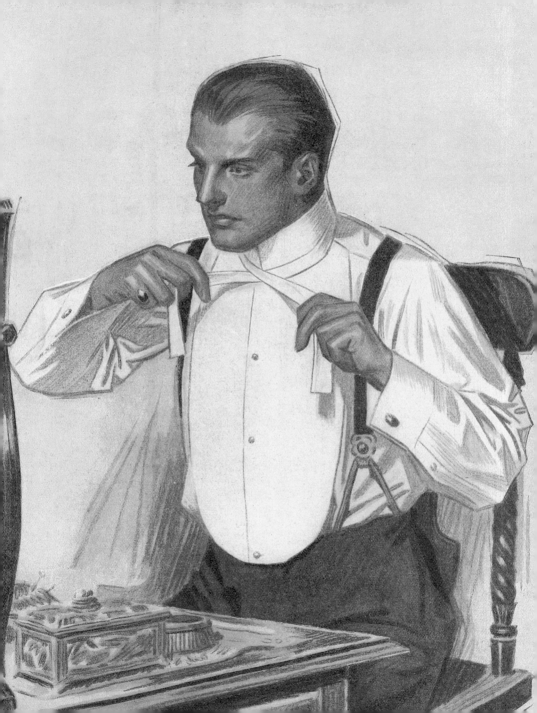

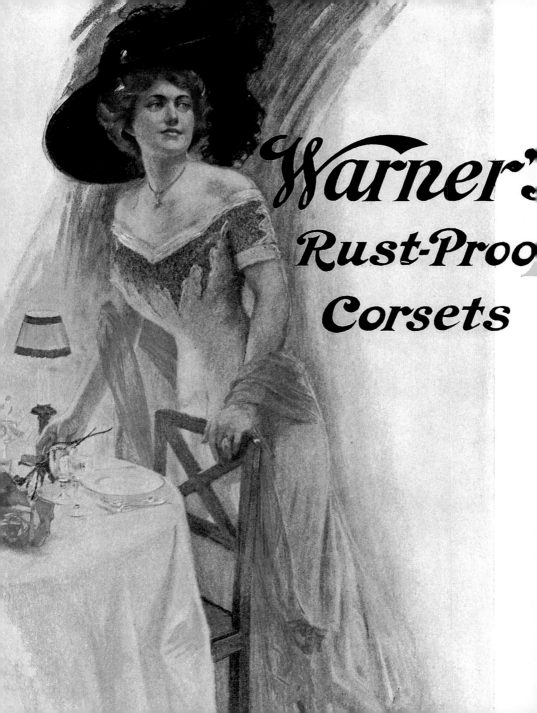

Warner's
Rust-Proof
Corsets

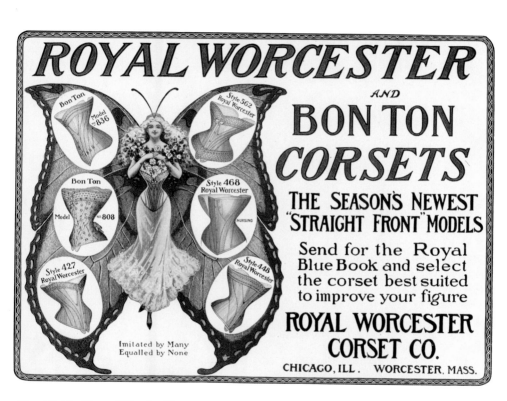

◄ Warner's Rust-Proof Corsets, 1909 Royal Worcester Corsets, 1902

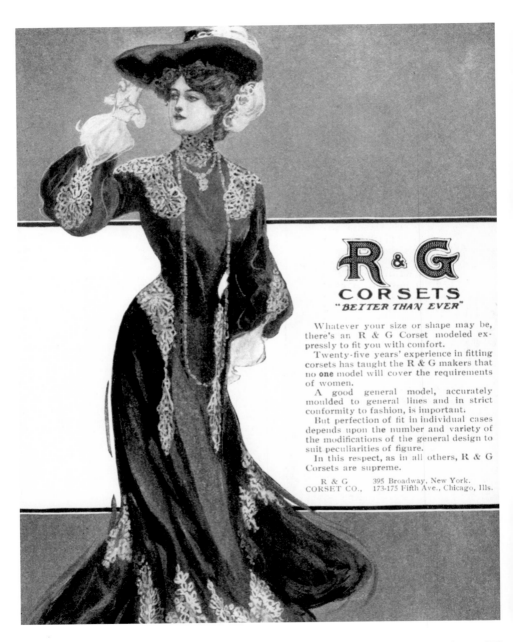

R & G
CORSETS
"BETTER THAN EVER"

Whatever your size or shape may be, there's an R & G Corset modeled expressly to fit you with comfort.

Twenty-five years' experience in fitting corsets has taught the R & G makers that no **one** model will cover the requirements of women.

A good general model, accurately moulded to general lines and in strict conformity to fashion, is important.

But perfection of fit in individual cases depends upon the number and variety of the modifications of the general design to suit peculiarities of figure.

In this respect, as in all others, R & G Corsets are supreme.

R & G CORSET CO., 395 Broadway, New York. 173-175 Fifth Ave., Chicago, Ills.

R & G Corsets, 1904 ▶ Kuppenheimer Menswear, 1907

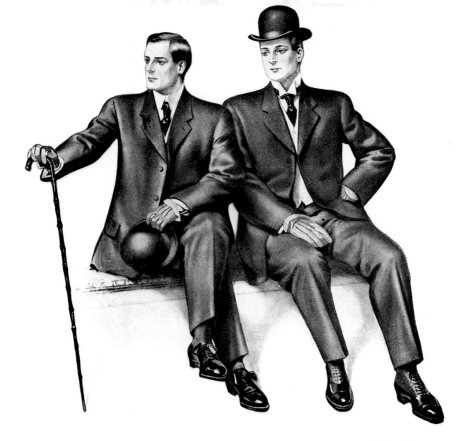

❡ The constant advance in culture and good taste is but another argument for the wearing of Kuppenheimer Clothes. ❡ You'll find exclusive fabrics and styles in our garments—effects which have always placed Kuppenheimer suits and overcoats beyond the commonplace.

In almost every community where there is a good clothier—a particular merchant —there is a representative of The House of Kuppenheimer who has a complete array of the authoritative styles for Fall and Winter. We'll gladly send you a book of authentic fashions, "Styles for Men," merely for the asking.

THE HOUSE OF KUPPENHEIMER
CHICAGO NEW YORK BOSTON

THE reasons for buying Hart Schaffner & Marx clothes are the same for full dress and Tuxedo as for business suits and overcoats. Correct style, exact tailoring, rigid honesty in all-wool fabrics, perfect fit.

For six cents we'll send our new Style Book; very artistic cover; a new subject, powerfully treated, in rich colors. The book shows many clothing styles

H a r t S c h a f f n e r & M a r x
Good Clothes Makers

CHICAGO BOSTON NEW YORK

Hart Schaffner & Marx Menswear, 1909

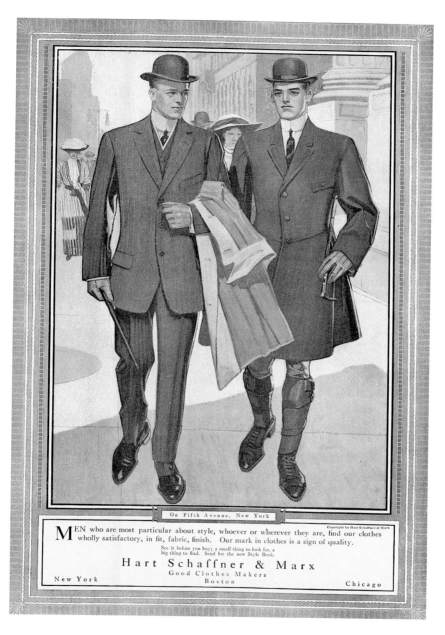

On Fifth Avenue, New York

Copyright by Hart Schaffner & Marx

MEN who are most particular about style, whoever or wherever they are, find our clothes wholly satisfactory, in fit, fabric, finish. Our mark in clothes is a sign of quality.

See it before you buy; a small thing to look for, a big thing to find. Send for the new Style Book.

Hart Schaffner & Marx
Good Clothes Makers

New York

Boston

Chicago

Hart Schaffner & Marx Menswear, 1909

THE important thing with us is to make clothes as good as we know how; and to know how. We learn every day; our full-dress clothes are the latest and highest expressions of our skill.

Send six cents for the Spring Style Book; handsome poster cover with many styles illustrated.

Hart Schaffner & Marx
Good Clothes Makers

Hart Schaffner & Marx Menswear, 1908

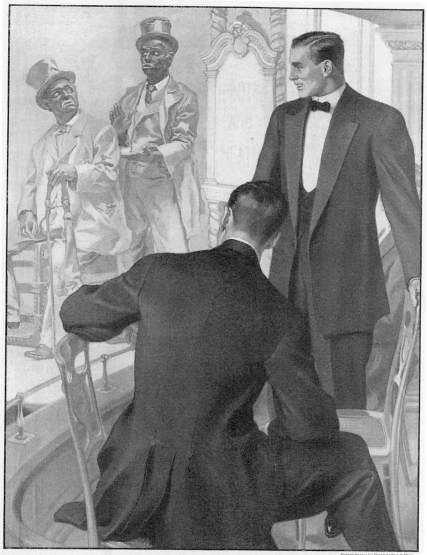

Copyright 1909 by Hart Schaffner & Marx

CRITICAL dressers will find nothing to criticise in the evening and dinner clothes we make; in richness of fabrics; silk linings; perfection of style and finish; fit; they are right.

When you buy dress clothes look for our mark; it's a big thing to find. Send six cents for the Style Book.

Hart Schaffner & Marx Menswear, 1908

Mallory Hats, 1907

Named for William Bowler, a 19th-century London hat manufacturer, the bowler hat – also called the derby or the coke—continued to be in vogue in the early years of the 20th century.

Der nach William Bowler, einem Londoner Hutmacher aus dem 19. Jahrhundert, benannte Bowler – in England auch Coke, im deutschen Sprachraum Melone oder Koks genannt – war bis zu Beginn des 20. Jahrhunderts in Mode.

Nommé d'après William Bowler, un chapelier londonien du 19ème siècle, le « bowler », chapeau melon en français, était encore à la mode au début du 20ème siècle.

▶ Fred Kauffmann Tailor, 1903

▶▶ Cluett Shirts, 1909

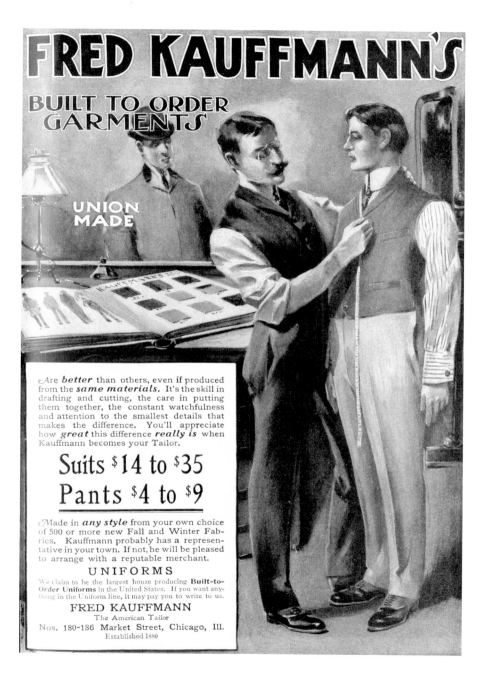

FRED KAUFFMANN'S

BUILT TO ORDER GARMENTS

UNION MADE

*Are **better** than others, even if produced from the **same materials.** It's the skill in drafting and cutting, the care in putting them together, the constant watchfulness and attention to the smallest details that makes the difference. You'll appreciate how **great** this difference **really is** when Kauffmann becomes your Tailor.

Suits $14 to $35
Pants $4 to $9

*Made in **any style** from your own choice of 500 or more new Fall and Winter Fabrics. Kauffmann probably has a representative in your town. If not, he will be pleased to arrange with a reputable merchant.

UNIFORMS

We claim to be the largest house producing **Built=to= Order Uniforms** in the United States. If you want anything in the Uniform line, it may pay you to write to us.

FRED KAUFFMANN
The American Tailor
Nos. 180-186 Market Street, Chicago, Ill.
Established 1880

A

to app

best v

eveni

bulgi

bosom

most

efforts

get a

Donches

a Cluett Dress Shirt that h
trouser band instead of bulg

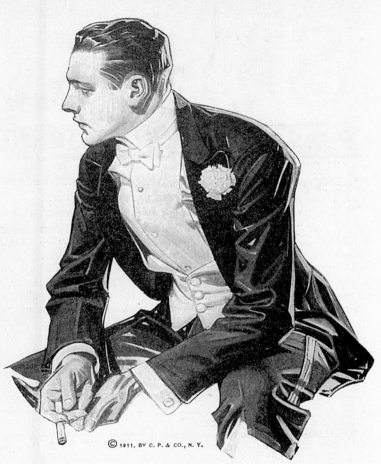

AN likes
his very
he is in
ress. A
creased
spoil his
staking
void it—

?r Dress Shirt

bosom that slides over the
ut of the waistcoat. *$2 to $3*

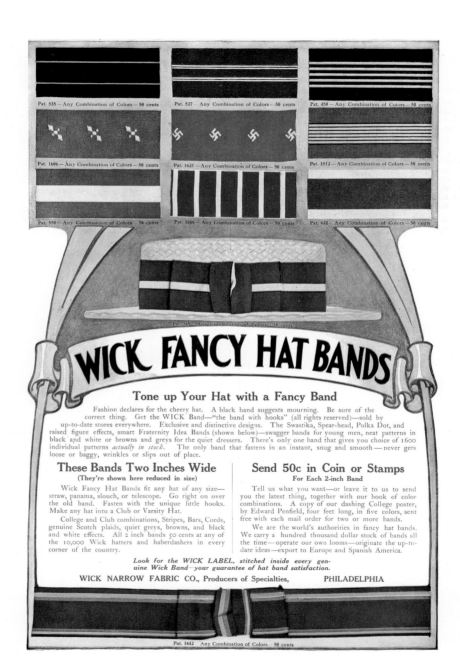

Pat. 535—Any Combination of Colors—50 cents

Pat. 527—Any Combination of Colors—50 cents

Pat. 450—Any Combination of Colors—50 cents

Pat. 1606—Any Combination of Colors—50 cents

Pat. 1621—Any Combination of Colors—50 cents

Pat. 1512—Any Combination of Colors—50 cents

Pat. 850—Any Combination of Colors—50 cents

Pat. 1666—Any Combination of Colors—50 cents

Pat. 622—Any Combination of Colors—50 cents

Pat. 559—Any Combination of Colors—50 cents

WICK FANCY HAT BANDS

Tone up Your Hat with a Fancy Band

Fashion declares for the cheery hat. A black band suggests mourning. Be sure of the correct thing. Get the WICK Band—"the band with hooks" (all rights reserved)—sold by up-to-date stores everywhere. Exclusive and distinctive designs. The Swastika, Spear-head, Polka Dot, and raised figure effects, smart Fraternity Idea Bands (shown below)—swagger bands for young men, neat patterns in black and white or browns and greys for the quiet dressers. There's only one band that gives you choice of 1600 individual patterns *actually in stock*. The only band that fastens in an instant, snug and smooth — never gets loose or baggy, wrinkles or slips out of place.

These Bands Two Inches Wide
(They're shown here reduced in size)

Wick Fancy Hat Bands fit any hat of any size—straw, panama, slouch, or telescope. Go right on over the old band. Fasten with the unique little hooks. Make any hat into a Club or Varsity Hat.

College and Club combinations, Stripes, Bars, Cords, genuine Scotch plaids, quiet greys, browns, and black and white effects. All 2 inch bands 50 cents at any of the 10,000 Wick hatters and haberdashers in every corner of the country.

Send 50c in Coin or Stamps
For Each 2-inch Band

Tell us what you want—or leave it to us to send you the latest thing, together with our book of color combinations. A copy of our dashing College poster, by Edward Penfield, four feet long, in five colors, sent free with each mail order for two or more bands.

We are the world's authorities in fancy hat bands. We carry a hundred thousand dollar stock of bands all the time—operate our own looms—originate the up-to-date ideas—export to Europe and Spanish America.

Look for the WICK LABEL, stitched inside every genuine Wick Band—your guarantee of hat band satisfaction.

WICK NARROW FABRIC CO., Producers of Specialties, PHILADELPHIA

Pat. 1642—Any Combination of Colors—50 cents

◄ Wick Hat Bands, 1908

By 1909, the boater hat's origin as part of the uniform of the British navy was a thing of the past. Queen Victoria popularized the style for children's wear, and, eventually, the hat became a favored summer hat for middle-class gentlemen on both sides of the Atlantic.

Im Jahre 1909 war der Strohhut schon nicht mehr Teil der Uniform britischer Marinesoldaten. Queen Victoria machte ihn als Accessoire der Kindermode wieder beliebt. Und schließlich wurde der Strohhut zur beliebten sommerlichen Kopfbedeckung bei Herren der Mittelschicht zu beiden Seiten des Atlantiks.

En 1909, le canotier n'était plus un élément de l'uniforme de la marine anglaise, la reine Victoria l'ayant mis à la mode pour les enfants. Des deux côtés de l'Atlantique, le canotier finit par devenir le chapeau de prédilection des messieurs de la classe moyenne.

Knapp-Felt Hats, 1908

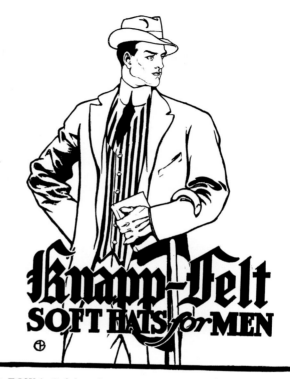

Knapp-Felt SOFT HATS for MEN

NOW is Soft-hat time. A picturesque Knapp-Felt harmonizes with the early fall attire and is an agreeable change from the straw hat—the Knapp-Felt derby comes later.

A variety of appropriate shapes of noticeable elegance of style and superb quality.

Knapp-Felt DeLuxe, Six Dollars. Knapp-Felt, Four Dollars—everywhere.
Write for The Hatman.

THE CROFUT & KNAPP CO., Broadway, cor. Thirteenth Street, New York.

MUNSING UNION SUIT
FOR ALL AGES

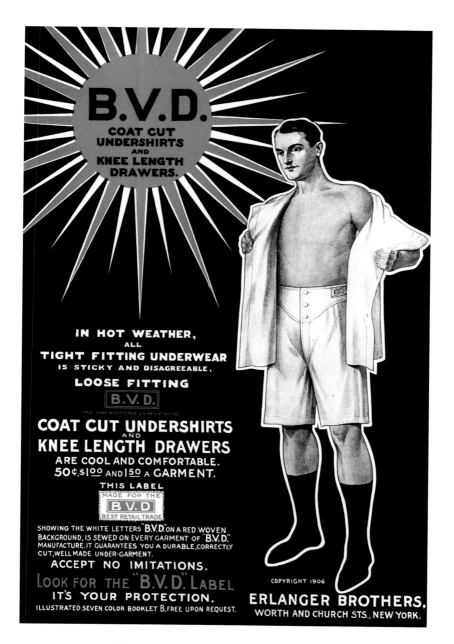

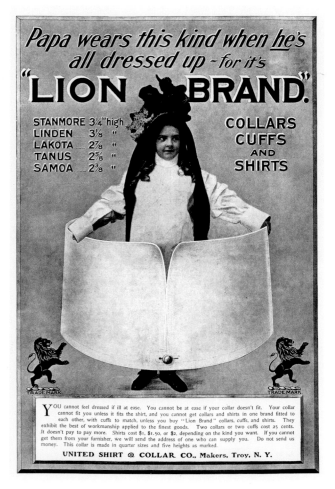

Papa wears this kind when *he's* all dressed up - for it's "LION BRAND."

STANMORE 3¾"high
LINDEN___ 3⅛ "
LAKOTA___ 2⅞ "
TANUS___ 2⅝ "
SAMOA___ 2⅜ "

COLLARS
CUFFS
AND
SHIRTS

YOU cannot feel dressed if ill at ease. You cannot be at ease if your collar doesn't fit. Your collar cannot fit you unless it fits the shirt, and you cannot get collars and shirts in one brand fitted to each other, with cuffs to match, unless you buy "Lion Brand" collars, cuffs, and shirts. They exhibit the best of workmanship applied to the finest goods. Two collars or two cuffs cost 25 cents. It doesn't pay to pay more. Shirts cost $1, $1.50, or $2, depending on the kind you want. If you cannot get them from your furnisher, we will send the address of one who can supply you. Do not send us money. This collar is made in quarter sizes and five heights as marked.

UNITED SHIRT @ COLLAR CO., Makers, Troy, N. Y.

Lion Brand Collars, 1900

Until World War I, men's shirts featured detachable collars that could be removed to be cleaned and heavily starched, separately from the shirt. The style carries into modern dress in formalwear, particularly for White Tie, which features a stiffly starched collar.

Bis zum 1. Weltkrieg hatten Herrenhemden abnehmbare Kragen, die separat gewaschen und steif gestärkt wurden. Bis heute hat man diesen Stil in der Abendkleidung beibehalten, insbesondere zum Frack gehört ein ordentlich gestärkter Kragen.

Jusqu'à la Première Guerre mondiale, les chemises pour homme comportaient des cols amovibles qui pouvaient être détachés pour être lavés et amidonnés séparément de la chemise. Ce style est toujours d'actualité pour les tenues de soirée, surtout les chemises à col rigide amidonné.

▶ R & G Corsets, 1902

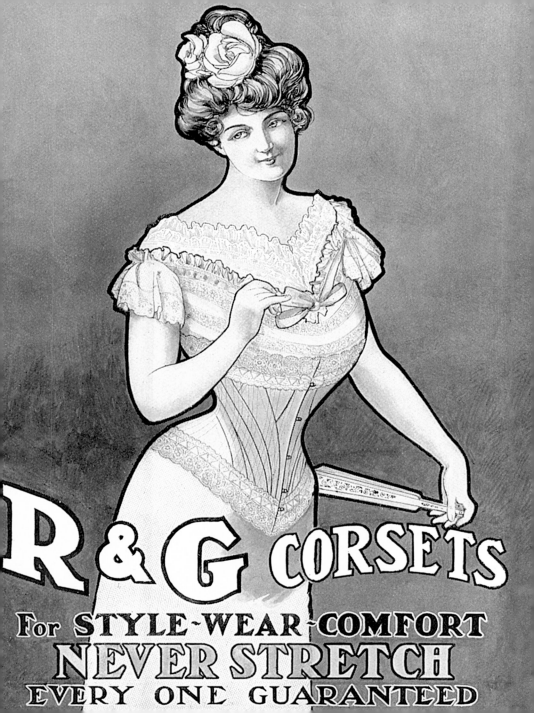

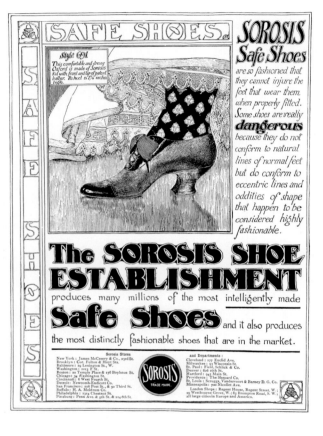

Sorosis Safe Shoes, 1905

Early patent medicine ads employed an alarmist tone and used faux-medical jargon to sell their products. Similarly, this ad warns of the dire—but not very specific—health consequences of being "highly fashionable."

Frühe offenkundig medizinische Inserate schlugen einen alarmierenden Ton an und benutzten einen pseudowissenschaftlichen Jargon, um ihre Produkte zu verkaufen. Auf ähnliche Weise warnt diese Anzeige vor den gefährlichen – aber nicht weiter ausgeführten – gesundheitlichen Folgen extremen Modebewusstseins.

Les premières réclames pour spécialités pharmaceutiques employaient un ton alarmiste et un jargon pseudomédical pour écouler leurs produits. Cette publicité avertit les consommateurs des risques terribles – mais pas vraiment spécifiés – pour la santé quand on est « très à la mode ».

► O' Sullivan's Rubber Heels, 1908

►► Chalmers's "Porosknit" Union Suits, 1909

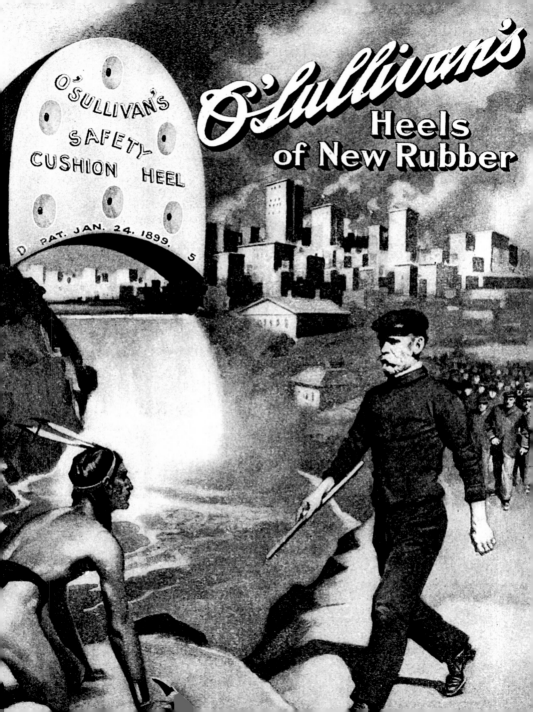

Th

For Men
For Boys

CHALMERS

TRADE MARK

FABRIC PAT. DEC. 12. 1905

"*Porosknit*"

DESIGN PAT. DEC. 19. 1905

REG. U.S. PAT. OFF.

GUARANTEED

Did *You* Ev
Union Suit

The Chalmers "Po
which the elasticity
allows it to "give"
waisted" feeling an

Remember also th
buttons, no cumbers

Chalmers "Porosk
the fabric keeps yo
use of the best (high

Try a suit of elastic,

Men's Mercerized

CHALMER

oof of "Porosknit" Quality

No word could be said—no argument made—regarding the good quality, durability, fit and comfort of genuine "Porosknit" so unanswerable as this: It is absolutely guaranteed. Read the Guarantee Bond.

Try Chalmers "Porosknit." A trial will mean one of two things to you. Either you will find a summer underwear that will thoroughly please you—a source of delight in the years to come—or, if not satisfied, you need be at no loss. With every Chalmers "Porosknit" garment there is a Guarantee Bond (reproduced here).

To you the importance of becoming acquainted with our label is: that you may continue to buy the Chalmers "Porosknit" Underwear if it satisfies you or avoid it if it is not what we claim it to be.

e Crotch?

olved this. The elastic fitting back, in
to run up and down as well as across the back,
turn and bend of the body, and thus prevents "short-

garment that you really enjoy. No gaping between
e ¾ length with covered knee and free ankle.

—for man, for boy. It is hygienic. The texture of
n and evaporation of perspiration. Made possible by
he softness of this yarn saves your skin from irritation.

ealthful "Porosknit" (Union Suit or separate garments).
lk) for $1.00 per garment, or $2.00 per Union Suit.

*Write for Handsome Book
of all Styles*

For MEN	Any Style	For BOYS
50c	Shirts and Drawers per garment	**25c**
For MEN	Union Suits	For BOYS
$1.00	Any Style	**50c**

*Ask
Your
Dealer*

COMPANY 1 Washington Street Amsterdam, N. Y.

"THE BEST COLOR IN THE WHOLE
WORLD IS THE ONE THAT LOOKS
GOOD ON YOU!"
– COCO CHANEL

„DIE SCHÖNSTE
FARBE DER WELT
IST DIE, DIE GUT
AUSSIEHT. UND
ZWAR AN IHNEN!"
– COCO CHANEL

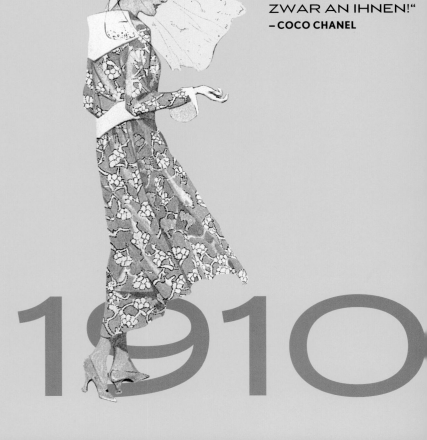

1910

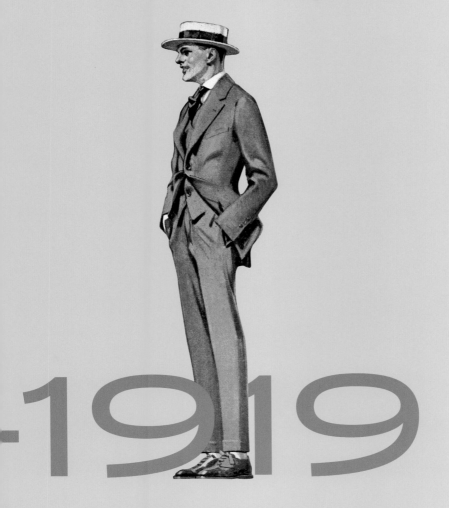

« LA PLUS BELLE COULEUR
DU MONDE, C'EST CELLE QUI
VOUS VA LE MIEUX ! »
– COCO CHANEL

1919

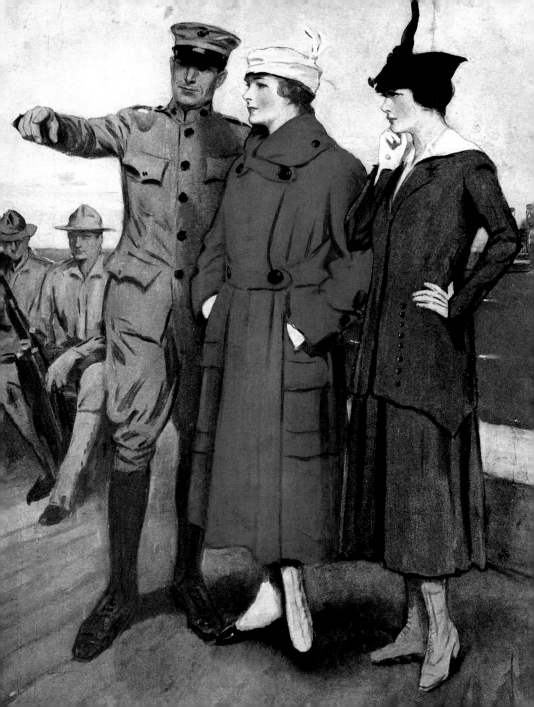

DEFENDING THE
HOME FRONT

*Poiret's influence was still apparent in the 1910s.
His designs sparked a fad for hobble skirts in the
United States, as American dressmakers misin-
terpreted the narrow lines of the designer's look.*

PROMPTED IN PART BY THE MASSIVE IMMIGRATION IN THE PRECEDING DECADE, many
Americans in the 1910s took an isolationist, nativist stance, and nostalgia for small-town living
began to grow. Meanwhile, dissent was brewing abroad; within a few years, Europe—and, soon
after, America—would be thrown into World War I. For many companies, war meant a shift in busi-
ness. Chicago-based men's apparel manufacturer and retailer B. Kuppenheimer & Co. was among
many that began manufacturing uniforms for the U.S. Army. Once the war ended, the president
of another apparel maker and retailer, Society Brand Clothing, looked to the skies—and the
newly decommissioned fighter planes and pilots—to pioneer a new means of distribution for his
products: air delivery.

In the midst of growing international conflict, Gabrielle "Coco" Chanel opened a hat shop in Paris,
followed shortly by dress shops in Deauville and Biarritz, where she began using wool jersey, a fabric
previously used for men's underwear, to create comfortable, chic, modern women's apparel. Chanel's
was a departure from both the corseted Gibson Girl of the first decade and the kimono-clad Poiret
ideal, but Poiret's influence was still apparent in the 1910s. His designs sparked a fad for hobble skirts
in the United States, as American dressmakers misinterpreted the narrow lines of the designer's look.

In 1907, Australian swimming star Annette Kellerman performed the first water ballet at New
York's Hippodrome. Her one-piece bathing suit scandalized a public accustomed to seeing women

dressed in cumbersome swimming-dresses—but it was also trendsetting. Soon new swimming styles were introduced by knitters Jantzen and Bentz Knitting Mills (later renamed Catalina). Indeed, athleticism was on the rise. The Converse Rubber Shoe Company had been founded in 1908, and by the century's second decade, rival U.S. Rubber began mass-marketing its own Keds brand athletic shoes.

Inspired by the New York debut of husband-and-wife ballroom dancers Vernon and Irene Castle, women began bobbing their hair like Irene's while men began wearing theirs slicked back like Vernon's. Both began to learn the pair's signature dances, the Castle Walk and the fox-trot.

Meanwhile, the nascent film industry was leaving New York for the warm climate and cheap land of Southern California, and soon Hollywood was churning out feature-length films, turning its actors into overnight stars and influencing fashion trends around the world. Mack Sennett's Bathing Beauties provided a little cheesecake for Keystone comedies; Gloria Swanson cemented her place as Hollywood's glamour queen; and, with a cascade of blonde ringlets, Mary Pickford, "America's Sweetheart," was the most popular and highest-paid movie star of the decade.

In 1913, the New York Armory Show introduced the United States to Symbolism, Impressionism, Post-Impressionism, Neo-Impressionism, and Cubism. While some were shocked by Marcel Duchamp's *Nude Descending a Staircase* and Henri Matisse's distorted female forms, others were inspired. New York's Wanamaker's department store featured "Cubist-inspired" fashion in its window displays, and *Vogue* magazine began incorporating "Cubist fashion" into its editorials. The Armory Show began traveling around the country, and New York's Gimbel Brothers department store followed with a companion Cubist-fashion exhibition that ran in several major cities around the country.

◄◄ Kenyon Coats and Suits, ca. 1918 ► Niagara Maid Underwear, ca. 1910

Gabrielle Chanel
PARIS

1910	1910	1910
Paul Poiret-inspired hobble skirts become short-lived fad	Gabrielle "Coco" Chanel opens first store in Paris	B. Kuppenheimer & Co. employs nearly 2,000 people in shops in Chicago
Paul Poirets Humpelrock bleibt eine kurzlebige Modeerscheinung	Gabrielle „Coco" Chanel eröffnet ihren ersten Laden in Paris	B. Kuppenheimer & Co. beschäftigt in seinen Läden in Chicago knapp 2000 Leute
Les jupes dites « entravées » de Paul Poiret remportent un bref succès	Gabrielle « Coco » Chanel ouvre sa première boutique à Paris	B. Kuppenheimer & Co. emploie près de 2 000 personnes dans ses points de vente de Chicago

Women to whom
smartness of design
is important as
dainty luxury of fabric
highly prize
"Niagara Maid"
UNDERWEAR
of silk

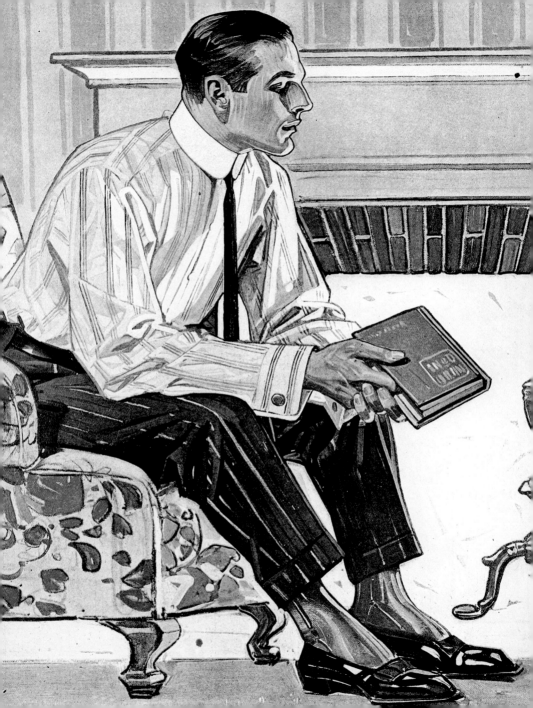

AN DER HEIMATFRONT

*Poirets Einfluss war in der Mode nach 1910
durchaus noch spürbar. Seine Entwürfe lösten
in den USA die Modetorheit Humpelrock aus,
nachdem amerikanische Schneider die schmalen
Schnitte des Designers falsch interpretiert hatten.*

**TEILWEISE BEDINGT DURCH DIE GROSSE EINWANDERUNGSWELLE IM VORANGEGANGE-
NEN JAHRZEHNT,** nahmen viele Amerikaner nach 1910 einen isolationistischen, nativistischen
Standpunkt ein. Eine Nostalgie hinsichtlich des Lebens in der Kleinstadt kam auf. Inzwischen
wuchs die Krisenstimmung im Ausland. Schon wenige Jahre später sollte Europa – und bald dar-
auf auch Amerika – in den Ersten Weltkrieg schlittern. Für viele Unternehmen bedeutete der Krieg
eine geschäftliche Veränderung. So zählte etwa der Herrenbekleidungshersteller und Einzelhändler
B. Kuppenheimer & Co. zu den zahlreichen Firmen, die Uniformen für die U.S. Army erzeugten. Nach
Kriegsende besann sich der Vorsitzende einer anderen Textilkette, Society Brand Clothing, auf die
soeben stillgelegten Kampfflugzeuge und die dazugehörigen Piloten und wurde zum Pionier einer
neuen Vertriebsform seiner Produkte: der Zustellung auf dem Luftweg.

Während sich die internationale Lage bereits wieder gefährlich zuspitzte, eröffnete Gabrielle
„Coco" Chanel ihr Pariser Hutgeschäft, dem bald Modeläden in Deauville und Biarritz folgten; dort
begann sie mit der Verarbeitung von Wolljersey, das bislang nur für Herrenunterwäsche Verwendung
gefunden hatte, zu bequemer, schicker und moderner Damenbekleidung. Chanels Ideal war eine Ab-
kehr sowohl vom korsetttragenden Gibson-Girl des ersten Jahrzehnts wie auch von Poirets Dame
im Kimono. Wobei Poirets Einfluss in der Mode nach 1910 durchaus noch spürbar war. Seine Ent-

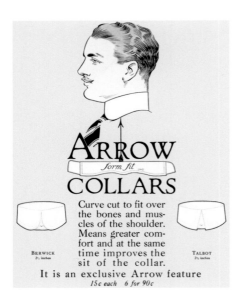

ARROW
form fit
COLLARS

Curve cut to fit over
the bones and mus-
cles of the shoulder.
Means greater com-
fort and at the same
time improves the
sit of the collar.

BERWICK
2½ inches

TALBOT
2½ inches

It is an exclusive Arrow feature
15c each 6 for 90c

◄◄ Cluett Shirts, 1911 Arrow Collars, 1916

würfe lösten in den USA die Modetorheit Humpel-
rock aus, nachdem amerikanische Schneider die
schmalen Schnitte des Designers falsch interpre-
tiert hatten.

1907 brachte der australische Schwimmstar
Annette Kellerman im New Yorker Hippodrome
das erste Wasserballett zur Aufführung. Ihr ein-
teiliger Badeanzug schockte ein Publikum, das
bis dato nur an Frauen in schwerfälligen Bade-
kostümen gewohnt war – und wirkte zugleich als
Trendsetter. Bald wurden neue Bademoden von
der Strickwarenfirma Jantzen and Bentz Knitting
Mills (später umbenannt in Catalina) präsentiert.
Sportlichkeit war zunehmend gefragt. Die Con-
verse Rubber Shoe Company wurde 1908 gegrün-
det; ab den 1920er Jahren trat die Konkurrenz-
firma U.S. Rubber mit der Massenproduktion ihrer
Sportschuhe der Marke Keds auf den Plan.

Nach dem Vorbild des New Yorker Tanz- und
Ehepaares Vernon und Irene Castle begannen
Frauen wie Irene einen Kurzhaar-Bob zu tra-
gen, während die Herren ihr Haar wie Vernon zu-
rückgelten. Beide Geschlechter eigneten sich
außerdem die typischen Tänze des Paares an: den Castle Walk und den Foxtrott.

Inzwischen kehrte die noch im Werden begriffene Filmindustrie New York den Rücken und
strebte nach dem warmen Klima und den billigen Grundstücken Südkaliforniens; schon bald pro-

1910

1912

1914

Lampshade hats reach new heights

Lampenschirm-Hüte erreichen neue Dimen-
sionen

Les chapeaux en forme d'abat-jour atteignent
de nouvelles hauteurs

Millions copy bobbed hair of dancer
Irene Castle

Millionen Frauen kopieren den Bob der Tänze-
rin Irene Castle

Des millions de femmes copient la coupe au bol
de la danseuse Irene Castle

World War I begins

Der Erste Weltkrieg beginnt

Début de la Première Guerre mondiale

duziertte Hollywood am laufenden Band abendfüllende Spielfilme, machte seine Schauspieler über Nacht zu Stars und beeinflusste damit Modetrends in aller Welt.

Mack Sennetts „Bathing Beauties" waren der Augenschmaus bei den Komödien von Keystone; Gloria Swanson sicherte sich ihren Status als Hollywoods Glamourqueen; und mit ihrer blonden Lockenpracht war Mary Pickford „America's Sweetheart" und der beliebteste wie auch bestbezahlte weibliche Kinostar des Jahrzehnts.

1913 machte die New York Armory Show die Vereinigten Staaten erstmals mit Symbolismus, Impressionismus, Post-Impressionismus, Neo-Impressionismus und Kubismus bekannt. Und während einige sich von Marcel Duchamps *Nackter, die eine Treppe hinabsteigt*, und Henri Matisses verzerrten weiblichen Formen schockiert zeigten, fühlten sich andere davon inspiriert. Das New Yorker Kaufhaus Wanamaker's zeigte in seinen Schaufenstern sogar kubistisch-inspirierte Mode, und auch die Zeitschrift *Vogue* begann „kubistische Mode" in ihren redaktionellen Teil zu integrieren.

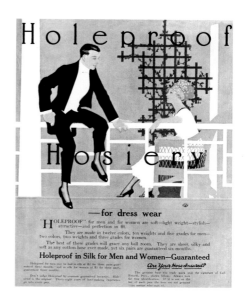

Holeproof Hosiery, 1911

Die Armory Show tourte durchs Land, und das New Yorker Kaufhaus Gimbel Brothers schloss sich ihr mit einer begleitenden Ausstellung zum Thema kubistische Mode an, die in mehreren Großstädten der USA gezeigt wurde.

1914

Coco Chanel popularizes loose-fitting chemise dresses

Coco Chanel macht locker sitzende Hemdblusenkleider populär

Coco Chanel lance la mode des robes-chemises amples

1915

Spectacles with large round frames become fashionable

Brillen mit großen runden Gestellen kommen in Mode

Les lunettes à gros verres ronds deviennent à la mode

1915

Front-laced boots popular for women during World War I

Während des 1. Weltkriegs in Mode: vorne gebundene Schnürstiefel für Damen

Pendant la Première Guerre mondiale, les femmes portent toutes des bottes à lacets

SUR LE FRONT

L'influence de Poiret se fit encore ressentir après 1910. Aux États-Unis, les esquisses des modèles de ce couturier lancent la grande mode des jupes dites « entravées », les couturières américaines interprétant mal les lignes étroites du look Poiret.

EN PARTIE À CAUSE DE L'IMMIGRATION MASSIVE DE LA PRÉCÉDENTE DÉCENNIE, DE NOM-BREUX AMÉRICAINS ADOPTENT PENDANT LES ANNÉES 1910 UNE POSITION ISOLATION-NISTE ET NATALISTE QUI VOIT CROÎTRE LA NOSTALGIE DE LA VIE DE PROVINCE. Pendant ce temps, les tensions s'intensifient à l'étranger ; en quelques années, l'Europe, suivie par les États-Unis, se jette dans la Première Guerre mondiale. Pour de nombreuses entreprises, la guerre implique un changement d'activité. Le fabricant et vendeur de vêtements pour homme B. Kuppenheimer & Co. de Chicago compte parmi ceux qui commencent à manufacturer des uniformes pour l'armée américaine. Après la fin de la guerre, le directeur de Society Brand Clothing, un autre fabricant et détaillant du secteur, tourne son regard vers le ciel – les avions de combat récemment démobilisés – et invente un nouveau moyen de distribution pour ses produits : le transport aérien.

Au milieu des tensions internationales croissantes, Gabrielle «Coco» Chanel ouvre une boutique de chapeaux à Paris, puis des boutiques de vêtements à Deauville et à Biarritz. Elle commence à utiliser le jersey de laine, un tissu autrefois réservé aux sous-vêtements pour homme, pour créer des tenues confortables, chics et modernes à l'intention des femmes. L'idéal Chanel n'a plus rien à voir avec la Gibson Girl corsetée des années 1900 ni avec la femme en kimono de Poiret, bien que l'influence de ce dernier se fasse encore ressentir. Aux États-Unis, les modèles de ce couturier lancent la grande mode des jupes dites «entravées», les couturières américaines interprétant mal les lignes étroites du look Poiret.

En 1907, la star de la natation australienne Annette Kellerman présente le tout premier ballet aquatique à l'Hippodrome de New York. Son maillot une pièce scandalise un public habitué à voir les femmes dans d'encombrantes combinaisons de bain, mais la nageuse réussit néanmoins à lancer la tendance. Rapidement, des fabricants de maille tels Jantzen et Bentz Knitting Mills (rebaptisé plus tard Catalina) proposent de nouveaux modèles de bain, l'athlétisme étant en plein essor. Rejointe vers 1915 par son concurrent U.S. Rubber, la Converse Rubber Shoe Company fondée en 1908 commence à commercialiser ses propres chaussures de sport sous la marque Keds.

Inspirées par les débuts new-yorkais du couple de danseurs Vernon et Irene Castle, les femmes adoptent progressivement la coupe au bol d'Irene et les hommes peignent leurs cheveux vers l'arrière, comme Vernon. Hommes et femmes apprennent les danses emblématiques du duo, le Castle Walk et le fox-trot.

Pendant ce temps, l'industrie cinématographique naissante quitte New York pour le climat chaud et les terrains bon marché de la Californie du Sud. Hollywood ne tarde pas à produire des longs métrages en série, hisse ses acteurs au rang de stars, du jour au lendemain, et influence les tendances de la mode à travers le monde entier. Les jolies baigneuses de Mack Sennett jouent les pin-up dans les comédies produites par Keystone ; Gloria Swanson assoit son statut de reine du glamour hollywoodien ; sous une cascade de boucles blondes, la « petite chérie de l'Amérique » Mary Pickford devient la star de cinéma la plus adulée et la mieux payée de la décennie.

En 1913, le salon artistique Armory Show de New York initie les États-Unis au symbolisme, à l'impressionnisme, au post-impressionnisme, au néo-impressionnisme et au cubisme. Si certains sont choqués par *Nu descendant un escalier* de Marcel Duchamp ou par les formes féminines distordues d'Henri Matisse, d'autres s'en inspirent. Le grand magasin new-yorkais Wanamaker's garnit ses vitrines de vêtements « d'inspiration cubiste » et le magazine *Vogue* commence à intégrer la « mode cubiste » dans sa ligne éditoriale. L'Armory Show part en tournée dans tout le pays, tandis qu'à New York, le grand magasin Gimbel Brothers reprend le flambeau avec une exposition de vêtements cubistes qui visitera plusieurs grandes villes des États-Unis.

◄◄ Naiad Dress Shields, 1912 ► Boston Garter, 1911

1915

1917

1918

Mary Pickford most popular and highest-grossing movie star in Hollywood

Mary Pickford, der beliebteste und bestbe-zahlte Kinostar Hollywoods

Mary Pickford devient la star de cinéma la plus adulée et la mieux payée d'Hollywood

Converse and Keds begin mass-producing athletic shoes

Converse und Keds beginnen mit der Massenproduktion von Sportschuhen

Converse et Keds se lancent dans la production en masse de chaussures de sport

As more Americans begin to drive, related accessories boom

Immer mehr Amerikaner fahren Auto, somit steigen die Verkaufszahlen von Accessoires

De plus en plus d'Américains achètent des voitures et les ventes d'accessoires explosent

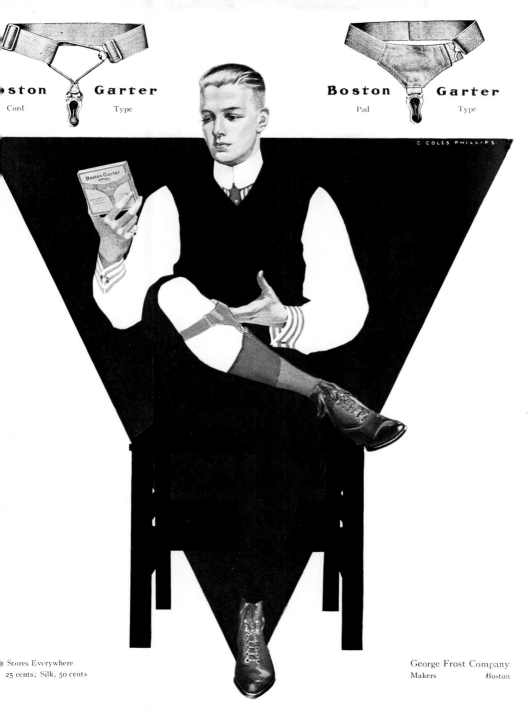

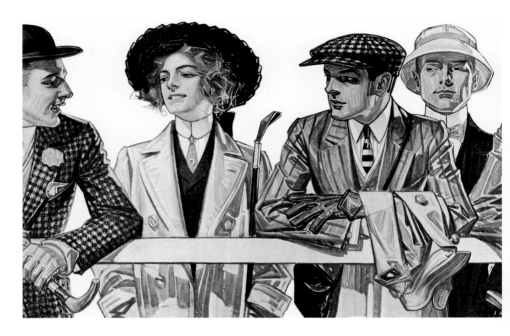

Arrow Collars/Cluett Shirts, 1911

▶ Chase Motor Car Robes, 1917

When Henry Ford introduced the affordable
Model T automobile in 1908, the price was
$850. By 1914, Ford was producing nearly
250,000 Model Ts, and, by 1916, the price had
dropped to $360. With the newfound passion
for driving came accessories—both automotive
and sartorial—to go with the cars.

Als Henry Ford 1908 das erschwingliche
Modell T auf den Markt brachte, kostete es
850 $. 1914 produzierte Ford an die 250.000
Exemplare der Tin Lizzy, im Jahr 1916 war
der Preis auf 360 $ gefallen. Mit der neu
entdeckten Leidenschaft für das Autofahren
kamen passende Accessoires – sowohl für das
Automobil als auch für dessen Insassen – in
den Handel.

Quand Henry Ford lança son abordable Model
T en 1908, son prix était de 850 dollars.
En 1914, Ford produisait près de 250 000
Model T par an, et en 1916, le prix tomba à
360 dollars. La passion de la route entraîna la
création d'accessoires automobiles comme
vestimentaires.

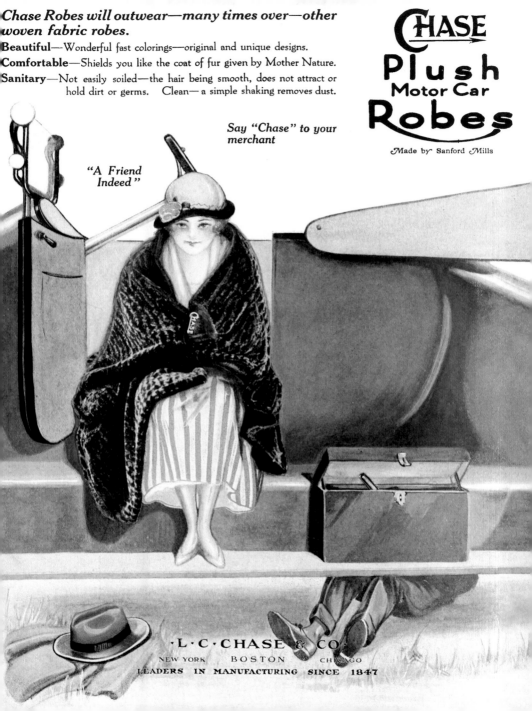

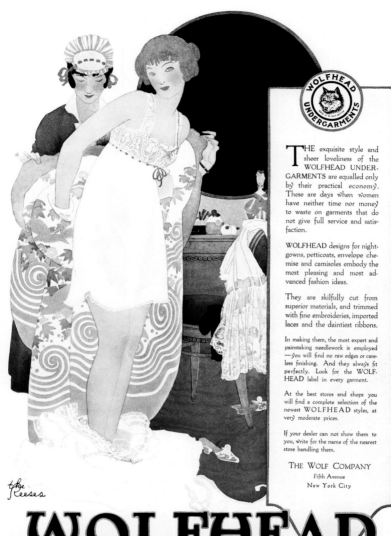

THE exquisite style and
sheer loveliness of the
WOLFHEAD UNDER-
GARMENTS are equalled only
by their practical economy.
These are days when women
have neither time nor money
to waste on garments that do
not give full service and satis-
faction.

WOLFHEAD designs for night-
gowns, petticoats, envelope che-
mise and camisoles embody the
most pleasing and most ad-
vanced fashion ideas.

They are skilfully cut from
superior materials, and trimmed
with fine embroideries, imported
laces and the daintiest ribbons.

In making them, the most expert and
painstaking needlework is employed
—you will find no raw edges or care-
less finishing. And they always fit
perfectly. Look for the WOLF-
HEAD label in every garment.

At the best stores and shops you
will find a complete selection of the
newest WOLFHEAD styles, at
very moderate prices.

If your dealer can not show them to
you, write for the name of the nearest
store handling them.

THE WOLF COMPANY
Fifth Avenue
New York City

WOLFHEAD
Undergarments

Wolfhead Undergarments, 1918

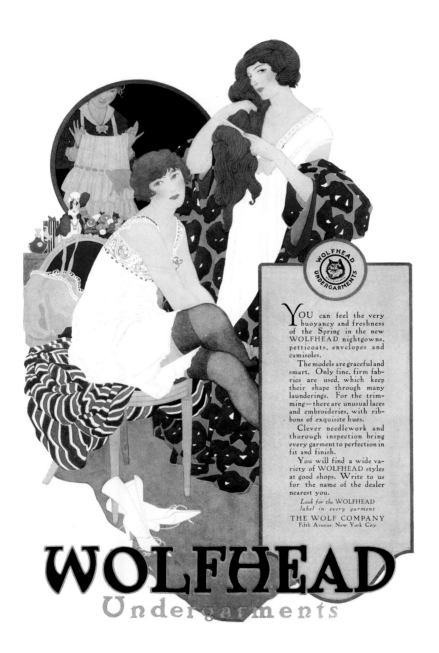

YOU can feel the very buoyancy and freshness of the Spring in the new WOLFHEAD nightgowns, petticoats, envelopes and camisoles.

The models are graceful and smart. Only fine, firm fabrics are used, which keep their shape through many launderings. For the trimming—there are unusual laces and embroideries, with ribbons of exquisite hues.

Clever needlework and thorough inspection bring every garment to perfection in fit and finish.

You will find a wide variety of WOLFHEAD styles at good shops. Write to us for the name of the dealer nearest you.

Look for the WOLFHEAD label in every garment

THE WOLF COMPANY
Fifth Avenue, New York City

WOLFHEAD
Undergarments

Wolfhead Undergarments, 1919

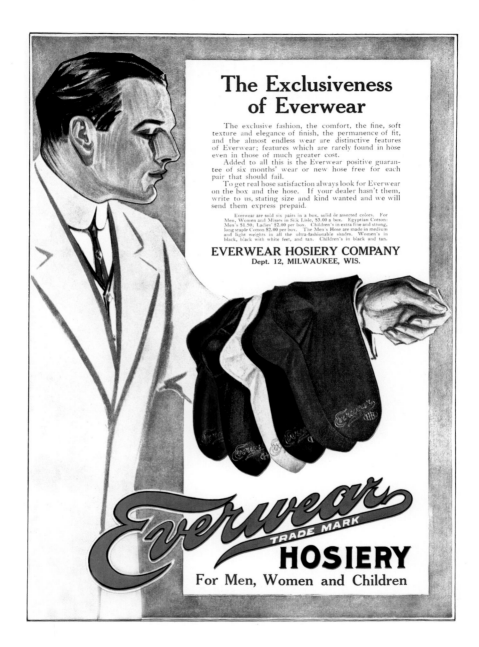

The Exclusiveness of Everwear

The exclusive fashion, the comfort, the fine, soft texture and elegance of finish, the permanence of fit, and the almost endless wear are distinctive features of Everwear; features which are rarely found in hose even in those of much greater cost.

Added to all this is the Everwear positive guarantee of six months' wear or new hose free for each pair that should fail.

To get real hose satisfaction always look for Everwear on the box and the hose. If your dealer hasn't them, write to us, stating size and kind wanted and we will send them express prepaid.

Everwear are sold six pairs in a box, solid or assorted colors. For Men, Women and Misses in Silk Lisle, $3.00 a box. Egyptian Cotton: Men's $1.50; Ladies' $2.00 per box. Children's in extra fine and strong, long staple Cotton $2.00 per box. The Men's Hose are made in medium and light weights in all the ultra-fashionable shades. Women's in black, black with white feet, and tan. Children's in black and tan.

EVERWEAR HOSIERY COMPANY
Dept. 12, MILWAUKEE, WIS.

Everwear
TRADE MARK
HOSIERY
For Men, Women and Children

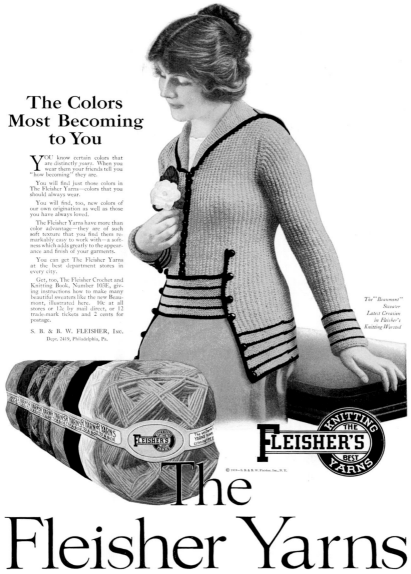

The Colors
Most Becoming
to You

YOU know certain colors that are distinctly *yours*. When you wear them your friends tell you "how becoming" they are.

You will find just those colors in The Fleisher Yarns—colors that you should always wear.

You will find, too, new colors of our own origination as well as those you have always loved.

The Fleisher Yarns have more than color advantage—they are of such soft texture that you find them remarkably easy to work with—a softness which adds greatly to the appearance and finish of your garments.

You can get The Fleisher Yarns at the best department stores in every city.

Get, too, The Fleisher Crochet and Knitting Book, Number 103E, giving instructions how to make many beautiful sweaters like the new Beaumont, illustrated here. 10c at all stores or 12c by mail direct, or 12 trade-mark tickets and 2 cents for postage.

S. B. & B. W. FLEISHER, Inc.
Dept. 2419, Philadelphia, Pa.

The "Beaumont" Sweater Latest Creation in Fleisher's Knitting Worsted

FLEISHER'S
KNITTING THE BEST YARNS

© 1919—S. B. & B. W. Fleisher, Inc., N. Y.

The
Fleisher Yarns

"Every Color in the Rainbow"

© 1919—S. B. & B. W. F., Inc., N. Y.

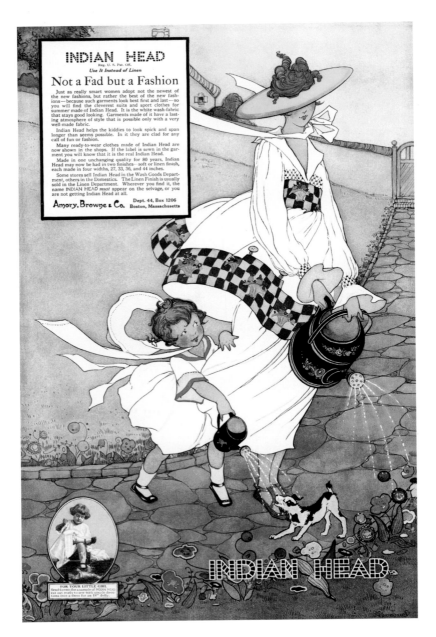

The advertisement text reads:

INDIAN HEAD
Reg. U. S. Pat. Off.

Use It Instead of Linen

Not a Fad but a Fashion

Just as really smart women adopt not the newest of the new fashions, but rather the best of the new fashions—because such garments look best first and last—so you will find the cleverest suits and sport clothes for summer made of Indian Head. It is the white wash-fabric that stays good looking. Garments made of it have a lasting atmosphere of style that is possible only with a very well-made fabric.

Indian Head helps the kiddies to look spick and span longer than seems possible. In it they are clad for any call of fun or fashion.

Many ready-to-wear clothes made of Indian Head are now shown in the shops. If the label is sewn in the garment you will know that it is the real Indian Head.

Made in one unchanging quality for 80 years, Indian Head may now be had in two finishes—soft or linen finish, each made in four widths, 27, 33, 36, and 44 inches.

Some stores sell Indian Head in the Wash Goods Department, others in the Domestics. The Linen Finish is usually sold in the Linen Department. Wherever you find it, the name INDIAN HEAD *must* appear on the selvage, or you are not getting Indian Head at all.

Amory, Browne & Co. Dept. 44, Box 1206
Boston, Massachusetts

FOR YOUR LITTLE GIRL.
Send 6 cents for a sample of INDIAN HEAD cut out, ready to sew with simple directions into a dress for an 18" dolly.

INDIAN HEAD

Indian Head Fabrics, 1918 ▶ Cheney Silks, 1918

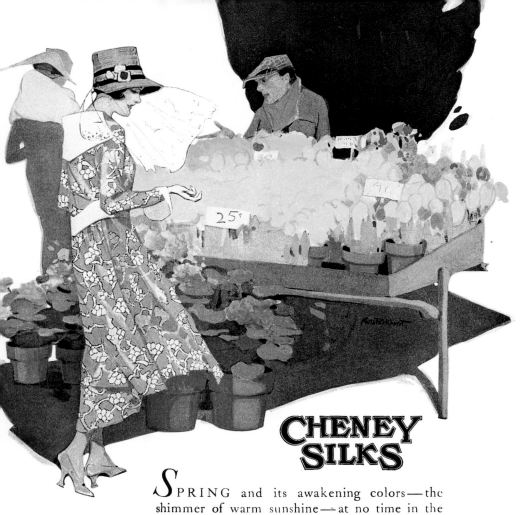

CHENEY SILKS

SPRING and its awakening colors—the shimmer of warm sunshine—at no time in the year does womanhood so wish to look her prettiest as in Spring.

A Cheney Silk Foulard

expresses Spring!—the ripple and soft fall of it, the beauty and smart newness of it. Here is *one* of the many new Cheney originations. All of them true in fashion, distinctive, shower-proof and of excellent quality. They are desired by most women who prefer and know the best. Look for a showing of Cheney Silks and take advantage of their many suggestions.

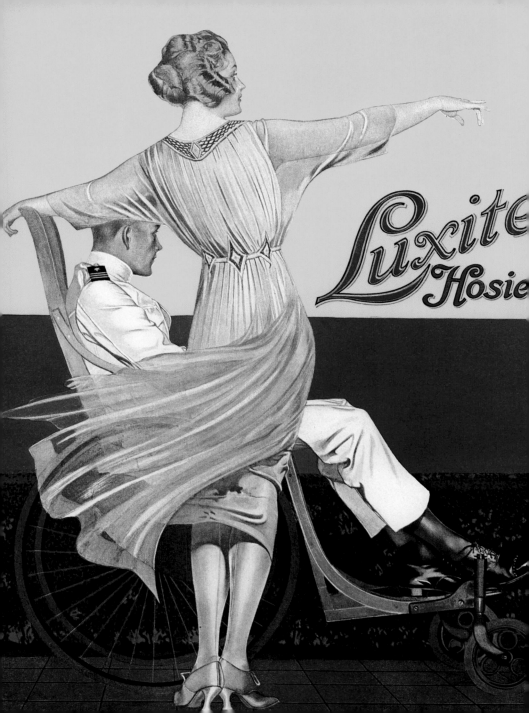

◄ Luxite Hosiery, 1919

Illustrator Coles Phillips, who also produced images for other hosiery brands, blended the look of a pinup—pretty girl in a diaphanous dress—with the sentimental image of an injured veteran. Phillips became known for the "fade away," in which the main figures' clothing is the same color as the background, allowing the elements to partially blend.

Der Illustrator Coles Phillips, der auch Bilder für andere Strumpfmarken produzierte, kombinierte den Anblick eines Pin-ups – hübsches Mädchen in durchsichtigem Kleid – mit dem sentimentalen Bild eines verletzten Veteranen. Phillips wurde mit dem Effekt des „Verblassens" bekannt, bei dem die Kleidung der Hauptfigur dieselbe Farbe aufweist wie der Hintergrund, so dass beide teilweise ineinander übergehen.

L'illustrateur Coles Phillips, qui travailla aussi pour d'autres marques de bonneterie, associait le look de la pin-up (jolie fille en robe diaphane) à l'image sentimentale d'un vétéran blessé. Phillips se fit connaître pour ses « fondus » où les vêtements des personnages principaux se fondaient partiellement dans un arrière-plan de la même couleur.

Luxite Hosiery, 1918

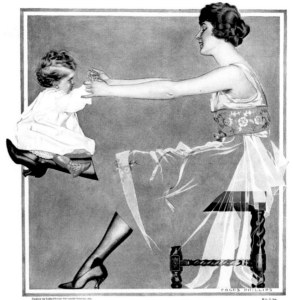

Painted by Coles Phillips for Luxite Textiles, Inc. © L. T. Inc.

Luxite Hosiery

For Men, Women and Children

SELDOM does your hosiery escape the attention of others, and if it be this captivating Luxite, wherever you go admiration follows.

Luxite has proved that silk hose will wear splendidly when made as we make Luxite, using the finest Japanese silk thread of many tightly spun strands, and pure dyes that cannot injure either the silk or your feet.

Men's Silk Faced 50c, and Pure Thread Silk 75c and $1.00. Other styles at 35c up. Women's Pure Thread Silk $1.10 to $2.50. Other styles 50c up. Children's 50c per pair and up.

Ask for Luxite Hosiery in the stores. If you cannot conveniently get it, write us for directions and illustrated book and prices.

LUXITE TEXTILES, Inc., 654 Fowler Street, Milwaukee, Wis.
Makers of High Grade Hosiery Since 1875

New York Chicago San Francisco Liverpool, England Sydney, Australia
LUXITE TEXTILES OF CANADA, Limited, London, Ont.

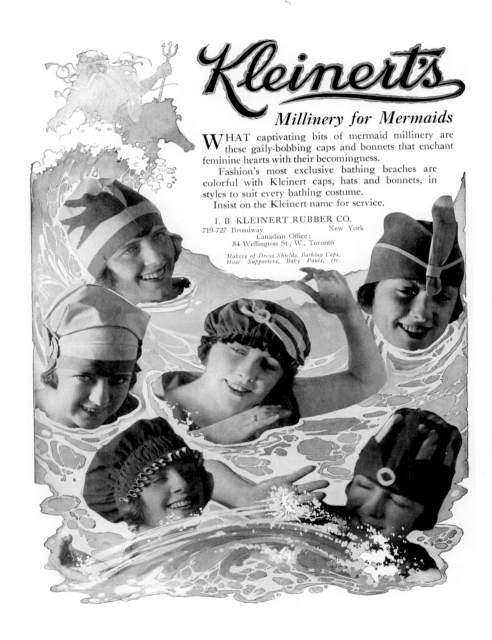

Kleinert's

Millinery for Mermaids

WHAT captivating bits of mermaid millinery are these gaily-bobbing caps and bonnets that enchant feminine hearts with their becomingness.

Fashion's most exclusive bathing beaches are colorful with Kleinert caps, hats and bonnets, in styles to suit every bathing costume.

Insist on the Kleinert name for service.

I. B. KLEINERT RUBBER CO.
719-727 Broadway New York
Canadian Office:
84 Wellington St., W., Toronto

*Makers of Dress Shields, Bathing Caps,
Hose Supporters, Baby Pants, etc.*

Kleinert's Swim Caps, 1919 ▶ McCallum Hosiery, 1917

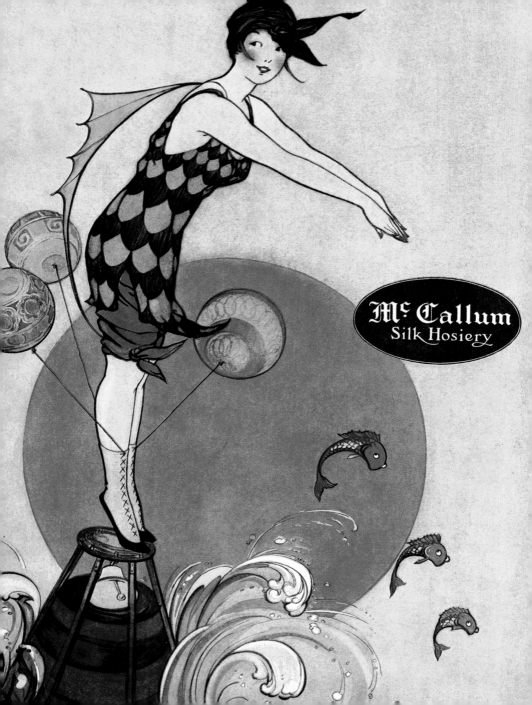

"Silk Stockings?"

Of course, some beautiful silk stockings would
be just the thing! Something a little better than
she would buy herself. She'd like McCallum's
No. 113—very fine black all silk hose, known
to be the most satisfactory silk stocking made.
Or, No 201—very sheer, with hand embroid-
ered clocks. McCallum's No. 153 are made
in any color to match shoes or gown on a few
days' notice.

Mc Callum
Silk Hosiery

If you're making gifts of men's hose—ask for
McCallum's No. 326—pure thread silk, heavy
weight, black and colors. And No. 329—rib-
shot silk, the most distinctive hose on the
market.

Sold at the Best Shops Everywhere

McCallum Hosiery Company, Northampton, Mass.

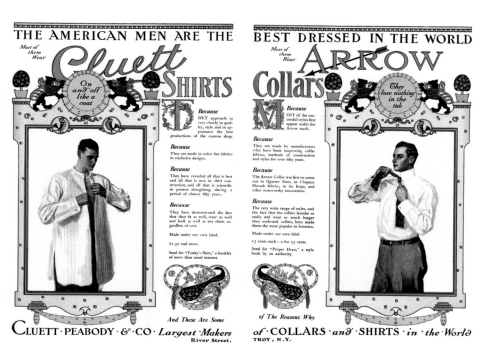

THE AMERICAN MEN ARE THE

Most of them Wear

Cluett SHIRTS

On and off like a coat

F Because

HEY approach so very closely in quality, style and in appearance the best productions of the custom shop.

Because

They are made in color fast fabrics in exclusive designs.

Because

They have revealed all that is best and all that is new in shirt construction, and all that is scientific in pattern draughting during a period of almost fifty years.

Because

They have demonstrated the fact that they fit as well, wear as well and look as well as any shirts regardless of cost.

Made under our own label.

$1.50 and more.

Send for "Today's Shirt," a booklet of more than usual interest.

And These Are Some

CLUETT · PEABODY · & · CO · *Largest Makers*
River Street.

BEST DRESSED IN THE WORLD

Most of them Wear

ARROW Collars

They lose nothing in the tub

M Because

OST of the succesful styles first appear under the Arrow mark.

Because

They are made by manufacturers who have been improving collar fabrics, methods of construction and styles for over fifty years.

Because

The Arrow Collar was first to come out in Quarter Sizes, in Clupeco Shrunk fabrics, in tie loops, and other noteworthy innovations.

Because

The very wide range of styles, and the fact that the collars launder so easily and wear so much longer than unshrunk collars, have made them the most popular in America.

Made under our own label.

15 cents each—2 for 25 cents.

Send for "Proper Dress," a style book by an authority.

of The Reasons Why

of · COLLARS · and · SHIRTS · in · the · World
TROY, N.Y.

◀ McCallum Hosiery, 1914

Cluett Shirts/Arrow Collars, ca. 1916

Advertising boomed with the proliferation of new magazines and new printing techniques, and advertisers found themselves in the position of having to differentiate their products from those of their competitors. This ad uses color illustrations to draw the reader in, and then lists the reasons why its products are superior.

Das Werbegeschäft blühte mit dem Aufkommen neuer Zeitschriften und Drucktechniken, und die Reklamemacher waren bald gezwungen, ihre Produkte von den Erzeugnissen der Konkurrenz abzugrenzen. Diese Annonce benutzt farbige Illustrationen, um die Aufmerksamkeit des Lesers zu gewinnen, und listet Gründe für die Überlegenheit der eigenen Produkte auf.

Face au boom de la publicité engendré par la prolifération de nouveaux magazines et de nouvelles techniques d'impression, les annonceurs se virent contraints de différencier leurs produits par rapport à ceux de leurs concurrents. Cette publicité utilise des illustrations en couleurs pour attirer l'attention du lecteur, puis énumère les raisons pour lesquelles ses produits sont les meilleurs.

Tom Wye
KNIT JACKET

TOM WYE Knit Utility Jackets combine custom-tailored smartness with the comfort of an old shooting-coat; they have a golfy knock-about quality without losing their air of swagger; they give warmth without bulk. Exclusive haberdashers everywhere carry them and will show them to you in blurry Heather mixtures that will make you think of the wind-swept uplands.

TOM WYE WINCHENDON, MASS.

Tom Wye Swimwear, ca. 1919

◄ Kilburnie Zephyr Fabrics, 1918

Bulloz of Paris, 1917

Even if many of his styles were considered extreme, couturier Paul Poiret's design ideas— including relaxed silhouettes, natural waistlines, and such exotic details as turbans and tasseled sleeves—were widely copied by other fashion houses of the era and filtered into everyday dress. By the early part of the decade, he had also experimented with the "lampshade" tunic and the "hobble" skirt.

Obwohl viele seiner Einfälle als extrem galten, wurden die Designideen des Couturiers Paul Poiret – darunter fließende Silhouetten, ungeschnürte Taillen und exotische Details wie Turbane und Ärmel mit Quasten – von anderen Modehäusern jener Ära vielfach kopiert und tauchten selbst in der Alltagskleidung auf. Zu Beginn des Jahrzehnts hatte er auch mit einer Tunika in Lampenschirmform und dem Humpelrock experimentiert.

Bien que ses vêtements fussent considérés comme extrêmes, les créations du couturier Paul Poiret – notamment ses silhouettes décontractées, les tailles naturelles et les détails exotiques comme les turbans et les manches à pompons – ont été largement copiées par les autres maisons de mode de l'époque, jusqu'à s'infiltrer dans l'habillement quotidien. Au début des années 1910, il avait aussi inventé la tunique « abat-jour » et la jupe dite « entravée ».

Created by ✦ Bulloz of Paris

COLES PHILLIPS *For description see page 57*

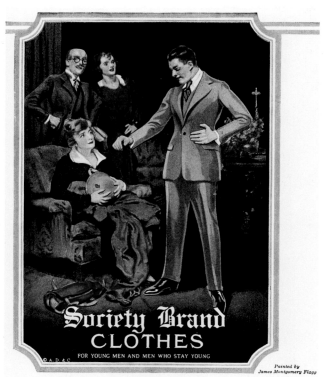

Painted by
James Montgomery Flagg

IN getting back to "Peace Clothes" there are joys of
the home-coming and hopes for the days ahead.

Society Brand Clothes, 1919

Alfred Decker, president of Society Brand Clothing, saw a business opportunity in the thousands of decommissioned fighter planes flown in the war. In 1920, the businessman purchased several planes, created an airfield outside of Chicago, and began air-shipping products to the company's retailers in large Midwestern cities and to smaller communities that were less accessible by rail or truck.

Alfred Decker, Präsident der Society Brand Clothing, sah eine geschäftliche Chance in den Tausenden von stillgelegten Kampfflugzeugen aus dem Krieg. 1920 kaufte der Geschäftsmann einige Flugzeuge, ließ außerhalb von Chicago einen Flugplatz anlegen und begann auf dem Luftweg Ware zu den Einzelhändlern in Großstädten des Mittleren Westens und zu kleineren Gemeinden, die via Bahn oder Lkw nur schwer erreichbar waren, zu transportieren.

Alfred Decker, le président de Society Brand Clothing, vit une opportunité commerciale dans la démobilisation des milliers d'avions de combat envoyés à la guerre. En 1920, l'homme d'affaires acheta plusieurs avions, fit construire un aérodrome à l'extérieur de Chicago et commença à envoyer ses produits par voie aérienne vers ses points de vente situés dans les grandes villes du Midwest et les petites communautés mal desservies par le train ou le réseau routier.

▶ Kuppenheimer Menswear, 1914

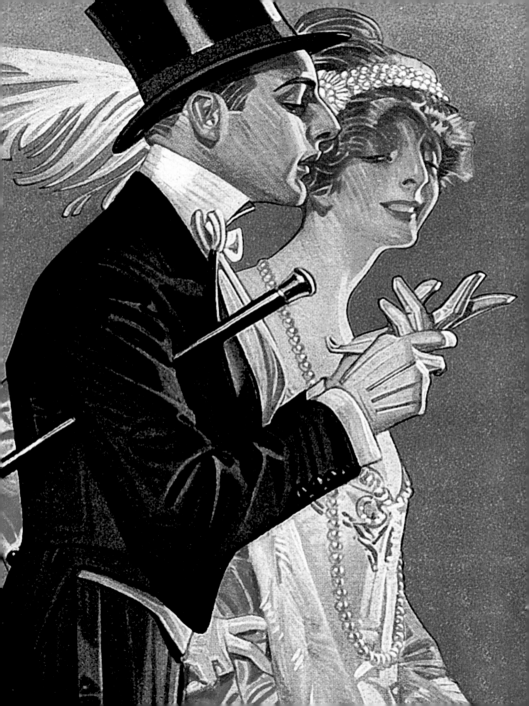

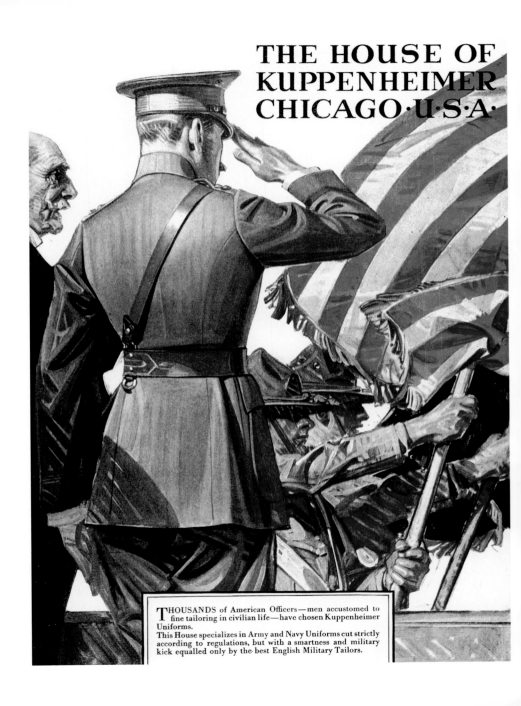

THE HOUSE OF KUPPENHEIMER CHICAGO·U·S·A·

THOUSANDS of American Officers—men accustomed to fine tailoring in civilian life—have chosen Kuppenheimer Uniforms.

This House specializes in Army and Navy Uniforms cut strictly according to regulations, but with a smartness and military kick equalled only by the best English Military Tailors.

◄ Kuppenheimer Uniforms, 1918

During the Great War, Chicago-based suit
maker Kuppenheimer was one of many
companies that manufactured uniforms for
American soldiers.

Im Ersten Weltkrieg zählte die Anzugfabrik
Kuppenheimer mit Sitz in Chicago zu den
vielen Firmen, die Uniformen für die amerika-
nischen Soldaten nähten.

Pendant la Grande Guerre, le fabricant de
costumes Kuppenheimer de Chicago compta
parmi les nombreuses entreprises produisant
des uniformes pour les soldats américains.

Kuppenheimer Menswear, 1919

►► Hart Schaffner & Marx Menswear, 1916

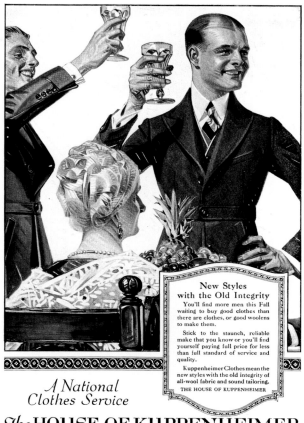

New Styles
with the Old Integrity

You'll find more men this Fall
waiting to buy good clothes than
there are clothes, or good woolens
to make them.

Stick to the staunch, reliable
make that you know or you'll find
yourself paying full price for less
than full standard of service and
quality.

Kuppenheimer Clothes mean the
new styles with the old integrity of
all-wool fabric and sound tailoring.
THE HOUSE OF KUPPENHEIMER

*A National
Clothes Service*

The HOUSE OF KUPPENHEIMER

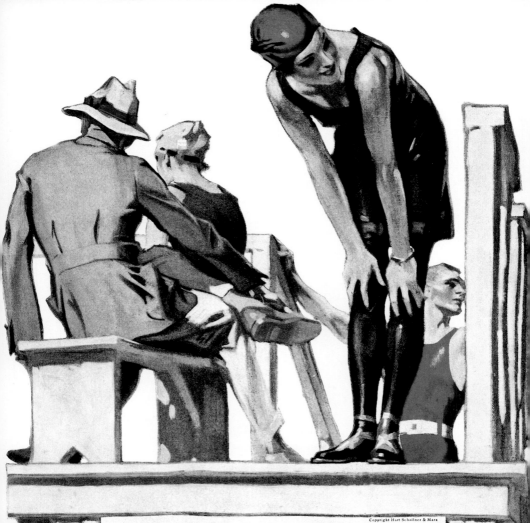

Hart Schaffner & Marx

Hart Schaffner & Marx
Chicago - New York

New Varsity Fifty Five
designs for Spring have
the style that young men
want.

Look for this picture in color, in the
window of the store that sells these clothes

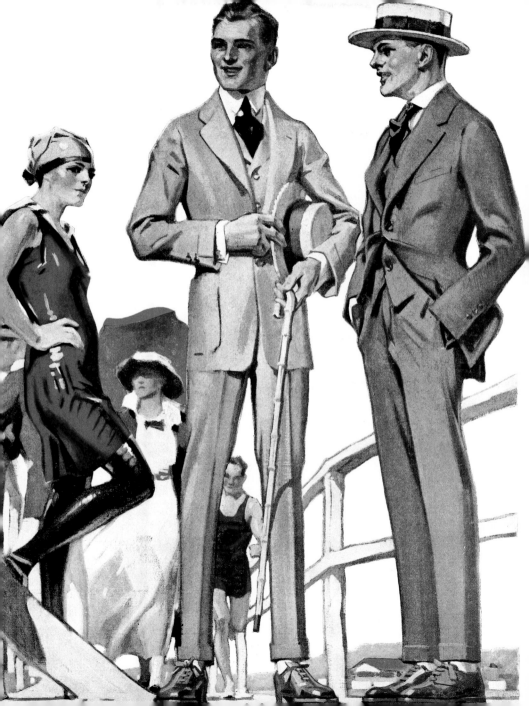

"YOUR DRESSES SHOULD BE
TIGHT ENOUGH TO SHOW
YOU'RE A WOMAN AND LOOSE
ENOUGH TO SHOW YOU'RE
A LADY."
– EDITH HEAD

„DEINE KLEIDUNG
SOLLTE ENG
GENUG SEIN, UM Z
ZEIGEN, DASS DU
EINE FRAU BIST –
ABER WEIT GENU
UM ZU ZEIGEN,
DASS DU EINE
DAME BIST."
– EDITH HEAD

1920

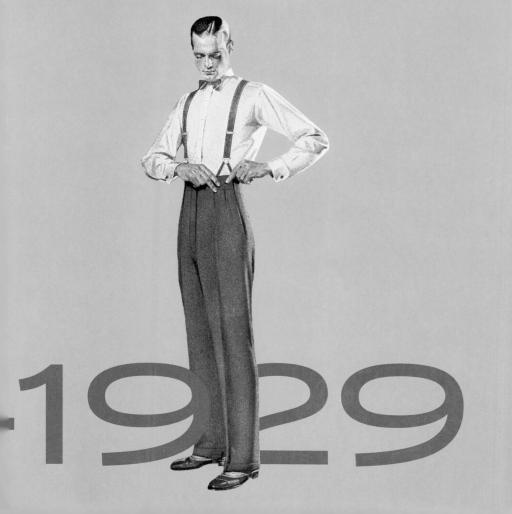

«VOS ROBES DOIVENT ÊTRE
ASSEZ PRÈS DU CORPS POUR
MONTRER QUE VOUS ÊTES
UNE FEMME, MAIS ASSEZ
AMPLES POUR PROUVER
QUE VOUS ÊTES UNE DAME.»
– EDITH HEAD

1929

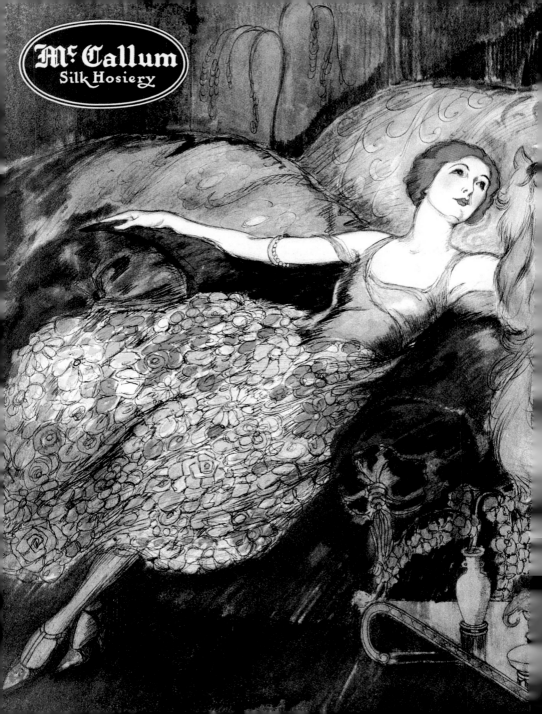

JAZZ BABIES AND COLLEGE BOYS

Skirts grew shockingly short. Only the most daring wore them above the knee, but even mid-calf styles were shorter than ever before, and with that much leg showing, stockings and shoes were gaining new attention.

THE 1920S WAS A DECADE OF CONTRADICTIONS. EUROPE, STILL RECOVERING FROM THE DEVASTATION OF THE GREAT WAR, SUFFERED A SERIES OF ECONOMIC CRISES. Yet it was an age of cultural high points, with great literary works coming from authors D. H. Lawrence, Marcel Proust, Virginia Woolf, and James Joyce, and an expansion of both modern and commercial art.

In America, the era opened with the passage of women's suffrage and Prohibition. It closed with the Wall Street stock-market collapse of 1929. In between, there was the flapper.

It was the Jazz Age, marked by an air of frivolity and an emphasis on youth. More and more people were flocking to the movies to see stars like Joan Crawford dance the Charleston in *Our Dancing Daughters*, or reading about her literary counterparts in F. Scott Fitzgerald's *The Great Gatsby*.

Young people flocked to colleges, sparking an interest in collegiate trends. Some were short-lived, like raccoon-skin coats, rolled-down stockings, and "Oxford bags" — extra-wide trousers with pleats and cuffs, worn with spectator shoes and cardigans. Bobbed hairstyles for women inspired new hat styles, including the popular, close-fitting cloche. And, of course, the skirts grew shockingly short. Only the most daring wore them above the knee, but even mid-calf styles were shorter than ever before, and with that much leg showing, stockings and shoes were suddenly gaining new attention. Most women wore sensible Oxford shoes during the day, but favored beautiful dancing shoes with dainty straps and Louis XIV heels in the evening.

England's Prince of Wales became a trendsetter, as men emulated his elegant, casual style: pullover sweaters worn under a jacket, belted trousers, and the so-called American collar. Collars had in fact become a subject of debate, with the older generation preferring a detachable, starched collar worn upright, and younger men preferring the attached collar worn folded over the tie. In 1924, American tailor Jesse Langsdorf patented a new construction of tie. Made from three pieces and cut on the bias, Langsdorf's ties retained their shape without the need of ironing.

Sports clothes also became fashionable, championed by athletes and celebrities. Golf's plus fours — baggy knickers that took their name from the length of fabric that fell below the knees — and the V-neck, cable-knit tennis sweater soon made their ways off the courses and courts and into men's casual wardrobes. French tennis star René Lacoste began capitalizing on his nickname, "Le Crocodile," by designing and then selling piqué tennis shirts with embroidered crocodile logos.

On the economic front, business was booming and credit was easy to get. Improvements in manufacturing and new innovations in retailing gave rise to the chain store, which offered a large selection and cheap prices. It was an advertiser's paradise. Advertisers shifted from quasi-scientific and testimonial-driven copy to the employment of psychological techniques to convey emotional attachment to a specific brand. And when it came to playing up snob appeal — and marketing styles as "chic" — no other sector could hold a candle to the fashion industry.

◄◄ McCallum Hosiery, 1922 ► Vode Kid Shoes, 1920

1920

1920

1920

Flappers' lean lines achieved with bust-reducing bras

Schmale Konturen der Flapper-Mode erzielt man mit Brustumfang verringernden BHs

La minceur de la mode garçonne s'imposant, les soutiens-gorge compriment la poitrine

Jantzen introduces Diving Girl logo, designed by George Petty

Jantzen präsentiert sein von George Petty entworfenes Logo Diving Girl

Jantzen présente son logo avec nageuse, dessiné par George Petty

Johnston & Murphy markets equestrian boots to country-club set

Johnston & Murphy bietet Reitstiefel für den Country-Club

Johnston & Murphy commercialise les bottes d'équitation dans les country clubs

JAZZ BABYS UND COLLEGE BOYS

Die Rocksäume rutschten in schockierende Höhen.
Nur die Mutigsten trugen kniekurz, aber selbst hal-
be Wade war noch kürzer als je zuvor, und weil man
dabei so viel Bein zeigte, erhielten Strümpfe und
Schuhwerk unversehens neue Aufmerksamkeit.

DIE 1920ER JAHRE WAREN EIN JAHRZEHNT DER WIDERSPRÜCHE. EUROPA WAR DAMALS NOCH DABEI, SICH VON DEN VERWÜSTUNGEN DES ERSTEN WELTKRIEGS ZU ERHOLEN UND ERLITT EINE REIHE VON WIRTSCHAFTSKRISEN. Dennoch handelte es sich um eine Epoche kultureller Höhepunkte mit großartigen literarischen Werken von Autoren wie D. H. Lawrence, Marcel Proust, Virginia Woolf und James Joyce sowie zunehmender Verbreitung sowohl der modernen als auch der kommerziellen Kunst.

In Amerika begann die Ära mit der Durchsetzung des Frauenwahlrechts und der Prohibition. An ihrem Ende stand der Börsencrash der Wall Street von 1929. Dazwischen gab es den „flapper" genannten Backfisch.

Es war das Jazz Age, geprägt von einer gewissen Frivolität und Betonung der Jugend. Die Menschen strömten in immer größerer Zahl in die Kinos, um Stars wie Joan Crawford in *Our Dancing Daughters* Charleston tanzen zu sehen. Oder sie lasen in F. Scott Fitzgeralds *Der große Gatsby* von ihren literarischen Pendants.

Die Jugend drängte in die Colleges und entwickelte zunehmend Interesse an dort herrschenden Trends. Einige davon erwiesen sich als sehr kurzlebig, etwa Mäntel aus Waschbärenfell, hinuntergerollte Strümpfe und „Oxford bags" – extrem weite Hosen mit Bügelfalte und Aufschlag, zu denen man zweifarbige Schuhe und Strickjacken trug. Die kinnlangen Frisuren der Damen brachten neue

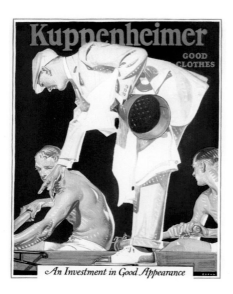

An Investment in Good Appearance

◄◄ Stehli Silks, 1929 Kuppenheimer Menswear, 1923

Hutmoden zutage, darunter der beliebte, eng anliegende Glockenhut. Und natürlich rutschten die Rocksäume in schockierende Höhen. Nur die Mutigsten trugen kniekurz, aber selbst halbe Wade war noch kürzer als je zuvor, und weil man dabei so viel Bein zeigte, erhielten Strümpfe und Schuhwerk unversehens neue Aufmerksamkeit. Die meisten Frauen wählten für tagsüber praktische Schnürschuhe, bevorzugten für den Abend jedoch schöne Tanzschuhe mit zierlichen Riemchen und Louis-XIV-Absätzen.

Der englische Prince of Wales wurde zum Trendsetter, als die Männerwelt begann, seinen elegant-lässigen Stil zu kopieren: Pullover unterm Jackett, Hosen mit Gürtel und den sogenannten amerikanischen Kragen. Kragen wurden ohnehin zum Gegenstand der Diskussion, weil die ältere Generation die abnehmbare, gestärkte Variante bevorzugte, die aufrecht getragen wurde, während jüngere Herren lieber fest angenähte Kragen trugen, die man über die Krawatte klappte. 1924 ließ sich der amerikanische Schneider Jesse Langsdorf eine neue Krawattenform patentieren. Sie war aus drei Teilen genäht, schräg geschnitten und behielt ihre Form auch ohne Aufbügeln.

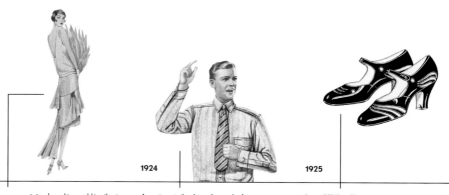

1920

Jazz Age woman introduced to world in silent film, *The Flapper*

Im Stummfilm *The Flapper* wird die typische Frau der Jazz-Ära präsentiert

Le monde découvre les jazzeuses dans le film muet *The Flapper*

1924

American tailor Jesse Langsdorf patents Resilient Construction necktie

US-Schneider Jesse Langsdorf: Patent für Krawattenmodell Resilient Construction

Le tailleur américain Jesse Langsdorf fait breveter la cravate souple

1925

Louis XIV heel becomes more slender; by 1931 called Spanish heel

Louis-XIV-Absätze werden schmaler und heißen ab 1931 spanischer Absatz

Le talon Louis XIV s'affine ; il sera rebaptisé talon espagnol en 1931

Von Athleten und anderen Prominenten bevorzugte Sportbekleidung kam ebenfalls in Mode. Weite Knickerbocker aus dem Golf und Strickpullover mit Zopfmuster und V-Ausschnitt, wie man sie zum Tennis trug, fanden bald ihren Weg von den Golf- und Tennisplätzen in die Freizeitgarderobe der Herren. Der französische Tennisstar René Lacoste begann aus seinem Spitznamen „Le Crocodile" Kapital zu schlagen, indem er Golfhemden aus Piqué, die mit einem gestickten Krokodil als Logo versehen waren, entwarf und verkaufte.

In wirtschaftlicher Hinsicht boomte der Markt und Kredite waren leicht zu bekommen. Verbesserungen in der Massenproduktion und Innovationen im Einzelhandel ermöglichten den Aufstieg von Handelsketten, die eine große Auswahl zu günstigen Preisen boten. Für die Reklamebranche war es das Paradies. Man wandte sich ab vom pseudo-wissenschaftlichen Abbild nach Art eines Empfehlungsschreibens und hin zur Verwendung psychologischer Methoden, um einer bestimmten Marke quasi einen emotionalen Zusatznutzen zu verpassen.

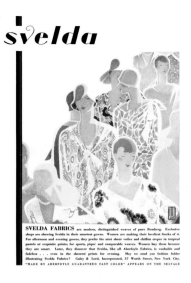

Svelda Fabrics, 1929

Und wo es um vermeintlichen Snobismus und die Vermarktung bestimmter Trends als „chic" ging, da konnte keine andere Branche der Modeindustrie das Wasser reichen.

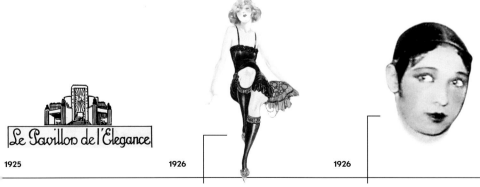

1925

1926

1926

Exposition Internationale des Arts Décoratifs et Industriels Modernes, Paris

Exposition Internationale des Arts Décoratifs et Industriels Modernes in Paris

Exposition Internationale des Arts Décoratifs et Industriels Modernes, Paris

Garters hold up stockings and hide small flasks of liquor during Prohibition era

Strumpfbänder halten Strümpfe und während der Prohibition auch kleine Schnapsflaschen

Sous la Prohibition, les jarretières servent à fixer les bas et à cacher de petites flasques d'alcool

Josephine Baker performs in Paris with hair cut in Eton crop bob

Josephine Baker tritt in Paris mit Bubikopf-Frisur auf

Josephine Baker apparaît sur les scènes parisiennes avec une coupe de garçonne

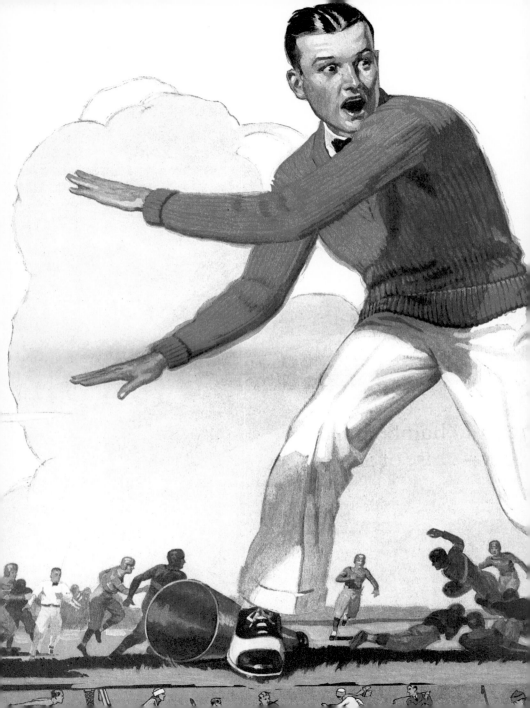

JAZZEUSES ET ÉTUDIANTS

*Les jupes choquent en ne cessant de raccourcir.
Seules les plus audacieuses osent les porter au-
dessus du genou, mais même les modèles tombant
à mi-mollet paraissent plus courts que jamais.
Comme les jambes s'exposent, les bas et les
chaussures suscitent soudain un nouvel intérêt.*

LES ANNÉES 20 REPRÉSENTENT UNE DÉCENNIE DE CONTRADICTIONS. À PEINE REMISE DES RAVAGES DE LA GRANDE GUERRE, L'EUROPE FAIT FACE À UNE SÉRIE DE CRISES ÉCONO-MIQUES. L'époque connaît toutefois de grands moments culturels grâce aux chefs-d'œuvre litté-raires d'auteurs tels D. H. Lawrence, Marcel Proust, Virginia Woolf et James Joyce, et à l'expansion de l'art moderne et commercial.

Aux États-Unis, la décennie s'ouvre sur le droit de vote des femmes et la Prohibition, et s'achève sur l'effondrement de la Bourse de Wall Street en 1929. Entre-temps, la jeune femme des années 20 est née.

L'ère du jazz est marquée par une certaine frivolité qui accorde la priorité à la jeunesse. Les foules sont de plus en plus nombreuses à fréquenter les cinémas pour voir des stars comme Joan Crawford danser le charleston dans *Les Nouvelles Vierges*, ou à lire les histoires de ses homologues littéraires dans *Gatsby le Magnifique* de F. Scott Fitzgerald.

Les jeunes fréquentent l'université en masse et on s'intéresse aux modes lancées sur les campus. Certaines ne sont qu'éphémères, par exemple les manteaux en peau de raton laveur, les bas roulés aux chevilles et le « pantalon Oxford » – ultra large, avec des plis et des revers, porté avec des chaus-sures bicolores et des cardigans. La coupe au bol des femmes inspire de nouveaux chapeaux, notam-ment le modèle cloche à succès. Et, bien sûr, les jupes choquent en ne cessant de raccourcir. Seules les

plus audacieuses osent les porter au-dessus du genou, mais même les modèles tombant à mi-mollet paraissent plus courts que jamais. Comme les jambes s'exposent, les bas et les chaussures suscitent soudain un nouvel intérêt. La plupart des femmes portent des richelieus confortables en journée, mais privilégient les chaussures de bal aux délicates lanières et à talons Louis XIV pour le soir.

Le prince de Galles devient un précurseur de tendances dans la mesure où les hommes s'approprient son style élégant et décontracté : les pulls portés sous une veste, le pantalon ceinturé et le soidisant « col américain ». En fait, les cols sont devenus l'objet d'un vrai débat : l'ancienne génération préfère le col montant amidonné et amovible, et les jeunes, le col intégré à la chemise, qui se replie par-dessus la cravate. En 1924, le tailleur américain Jesse Langsdorf fait breveter une nouvelle sorte de cravate. Fabriquée à partir de trois pièces et taillée en diagonale, la cravate de Langsdorf conserve sa forme sans besoin de repassage.

Défendus par les athlètes et les célébrités, les vêtements de sport deviennent à la mode. Les culottes de golf, ou « plus fours » – pantalon court qui doit son nom anglais à la longueur de tissu tombant sous le genou – et les pulls de tennis torsadés à col V se frayent rapidement un chemin en dehors des courts et des parcours dix-huit trous pour devenir des basiques de la garde-robe masculine. Le grand tennisman français René Lacoste mise sur son surnom, « Le Crocodile », en concevant et commercialisant des chemises de golf en coton piqué brodées d'un logo de crocodile.

Dans le domaine des affaires, l'économie est en plein boom et les banques font facilement crédit. Les progrès de l'industrie et les innovations en matière de distribution donnent naissance aux chaînes de magasins qui proposent un large choix de produits à des prix avantageux. C'est une époque bénie pour tous les publicitaires. La publicité délaisse les discours pseudoscientifiques reposant sur les témoignages et recoure aux techniques psychologiques pour que le consommateur s'attache émotionnellement à une marque spécifique. Quand il s'agit d'attirer l'attention des snobs – et de vendre des produits dits « chics » – aucun autre secteur n'arrive à la cheville de l'industrie de la mode.

◄◄ Bradley Knitwear, 1926 ► Stehli Silks, 1929 ►► Aberfoyle Fabrics, 1928

1927

Hollywood redefines sex appeal in Clara Bow film, *It*

Mit Clara Bows Film *Das gewisse Etwas* definiert Hollywood eine neue Form von Sexappeal

Hollywood redéfinit le sex-appeal à travers Clara Bow dans *Le Coup de Foudre*

1928

Levi Strauss & Co. registers Levi's as trademark

Levi Strauss & Co. lässt Levi's als Markenzeichen eintragen

Levi Strauss & Co. dépose la marque Levi's

1929

Irving Berlin celebrates spats in song, "Puttin' on the Ritz"

Irving Berlin singt in „Puttin' on the Ritz" ein Loblied auf die Gamasche

Irving Berlin fait l'apologie des guêtres dans sa chanson « Puttin' on the Ritz »

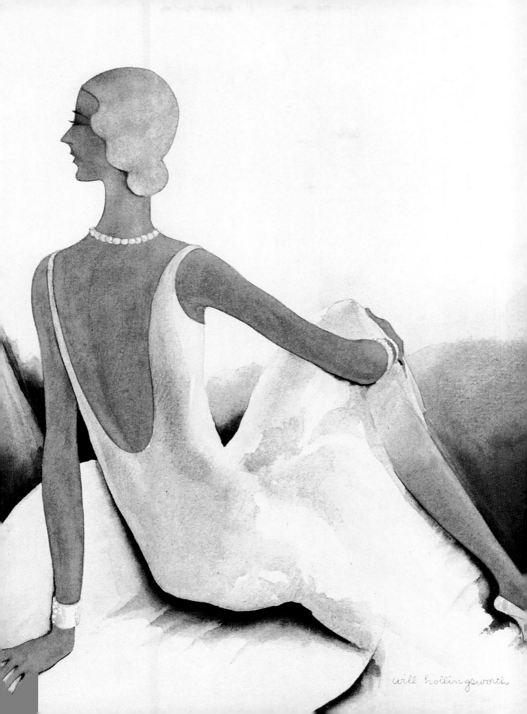

will hollingsworth

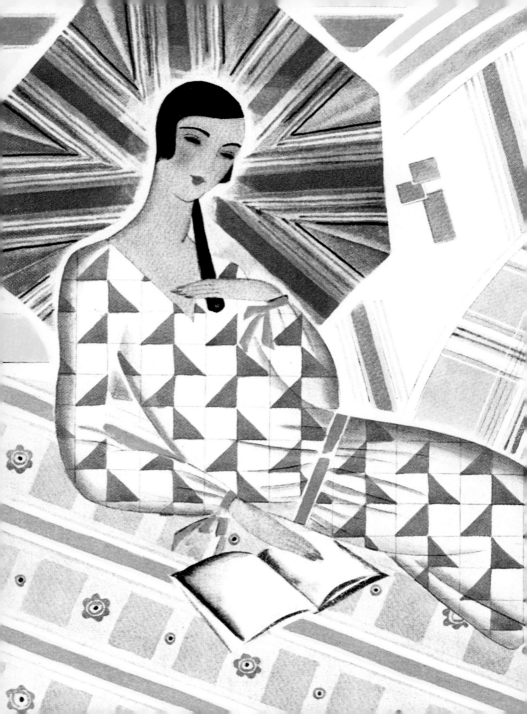

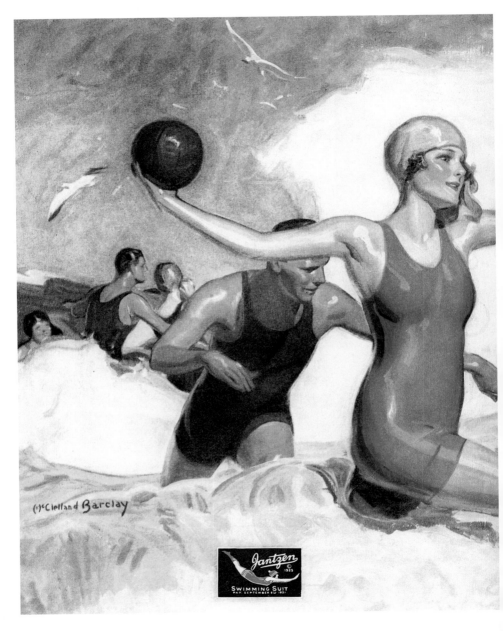

Jantzen Swimwear, 1926 ► Talon Slide-Fasteners, 1928

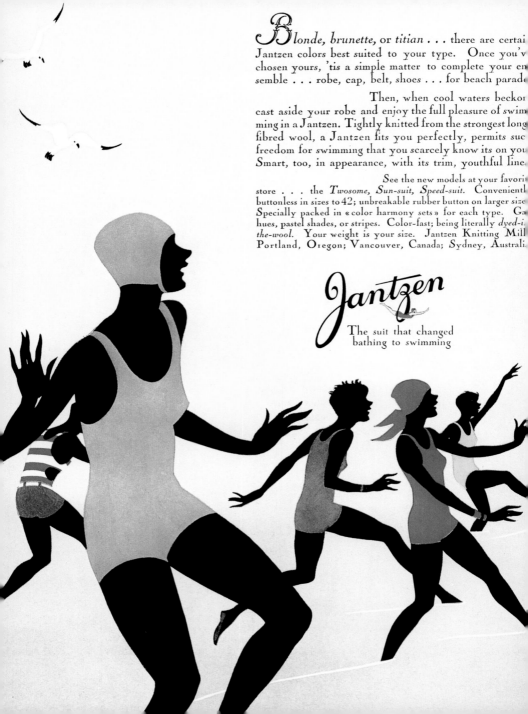

*B*londe, *brunette*, or *titian* . . . there are certai[n]
Jantzen colors best suited to your type. Once you'v[e]
chosen yours, 'tis a simple matter to complete your en[-]
semble . . . robe, cap, belt, shoes . . . for beach parade[.]

Then, when cool waters beckon[,]
cast aside your robe and enjoy the full pleasure of swim[-]
ming in a Jantzen. Tightly knitted from the strongest long[-]
fibred wool, a Jantzen fits you perfectly, permits suc[h]
freedom for swimming that you scarcely know its on you[.]
Smart, too, in appearance, with its trim, youthful line[.]

See the new models at your favori[te]
store . . . the *Twosome*, *Sun-suit*, *Speed-suit*. Convenientl[y]
buttonless in sizes to 42; unbreakable rubber button on larger size[s.]
Specially packed in «color harmony sets» for each type. Ga[y]
hues, pastel shades, or stripes. Color-fast; being literally *dyed-i[n]
the-wool*. Your weight is your size. Jantzen Knitting Mill[s,]
Portland, Oregon; Vancouver, Canada; Sydney, Australi[a.]

Jantzen

The suit that changed
bathing to swimming

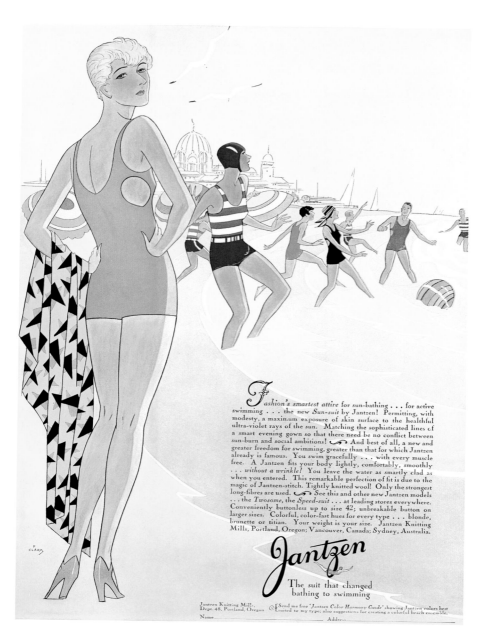

Fashion's smartest attire for sun-bathing . . . for active swimming . . . the new *Sun-suit* by Jantzen! Permitting, with modesty, a maximum exposure of skin surface to the healthful ultra-violet rays of the sun. Matching the sophisticated lines of a smart evening gown so that there need be no conflict between sun-burn and social ambitions! And best of all, a new and greater freedom for swimming, greater than that for which Jantzen already is famous. You swim gracefully . . . with every muscle free. A Jantzen fits your body lightly, comfortably, smoothly . . . *without a wrinkle!* You leave the water as smartly clad as when you entered. This remarkable perfection of fit is due to the magic of Jantzen-stitch. Tightly knitted wool! Only the strongest long-fibres are used. See this and other new Jantzen models . . . the *Twosome*, the *Speed-suit* . . . at leading stores everywhere. Conveniently buttonless up to size 42; unbreakable button on larger sizes. Colorful, color-fast hues for every type . . . blonde, brunette or titian. Your weight is your size. Jantzen Knitting Mills, Portland, Oregon; Vancouver, Canada; Sydney, Australia.

Jantzen

The suit that changed
bathing to swimming

Jantzen Knitting Mills,
Dept. 48, Portland, Oregon

Send me free 'Jantzen Color Harmony Guide' showing Jantzen colors best suited to my type; also suggestions for creating a colorful beach ensemble.

Name _____ Address _____

◄ Jantzen Swimwear, 1929 Jantzen Swimwear, 1929 ►► Gossard Corsets and Brasseries, 1926

The GOSSAR

COMBINATION
Gossard Combinations are so designed to give long, smooth, unbroken lines to the figure. They fit perfectly, and are astonishingly light in weight. They range in price from $1.50 to $25. Model number shown, 5430.

FRONT LACING CORSET
Light weight, dainty materials are used in Gossard front lacing corsets, which are lightly, scientifically boned. They range in price from $2.75 to $25. Model 1885 shown here.

CLASP-AROUND
Clasp-arounds are designed of all types of fabrics, and, as all Gossard garments, are exquisitely tailored, regardless of price. Prices range from $2 to $25. Model shown here, 1568.

GIRDLE
Girdles are designed for all types of figures, and either hook or clasp around. They range in price from $2 to $25. Model shown number 1074. Dainty uplift brassiere, Model 1224.

WORLD-FAMOUS GOSSAR ON THE RIVIERA

Nowhere perhaps in all the world c one find so smart and cosmopolitan exhibition of style on parade as alo the showplaces of the Mediterrane

Here, indoors and out, Gossard foun tion garments are verily at home, where fashion promenades there w Gossard foundations be found.

Whether on the Riviera or the Rue la Paix, Fifth Avenue or Regent Str Avenida Rio Branco—Rio de Janeiro,

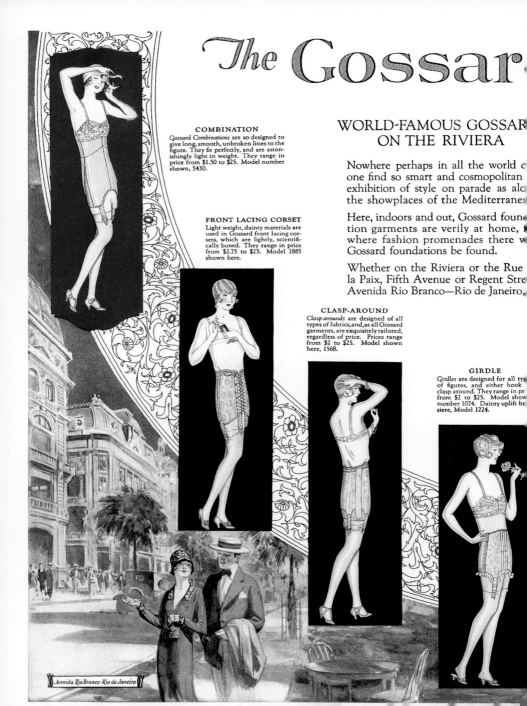

Avenida Rio Branco · Rio de Janeiro

Line of Beauty

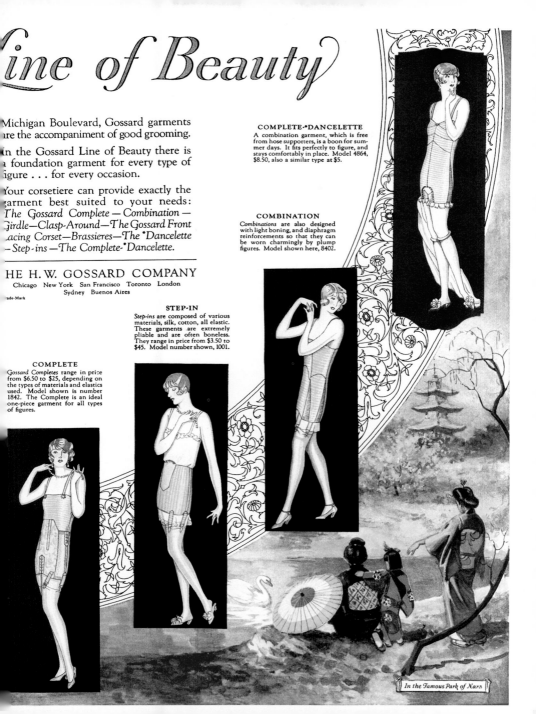

Michigan Boulevard, Gossard garments are the accompaniment of good grooming.

In the Gossard Line of Beauty there is a foundation garment for every type of figure . . . for every occasion.

Your corsetiere can provide exactly the garment best suited to your needs: The Gossard Complete — Combination — Girdle—Clasp-Around—The Gossard Front Lacing Corset—Brassieres—The *Dancelette—Step-ins—The Complete-*Dancelette.

THE H.W. GOSSARD COMPANY

Chicago New York San Francisco Toronto London
Sydney Buenos Aires

Trade-Mark

COMPLETE

Gossard Completes range in price from $6.50 to $25, depending on the types of materials and elastics used. Model shown is number 1842. The Complete is an ideal one-piece garment for all types of figures.

STEP-IN

Step-ins are composed of various materials, silk, cotton, all elastic. These garments are extremely pliable and are often boneless. They range in price from $3.50 to $45. Model number shown, 1001.

COMPLETE-*DANCELETTE

A combination garment, which is free from hose supporters, is a boon for summer days. It fits perfectly to figure, and stays comfortably in place. Model 4864, $8.50, also a similar type at $5.

COMBINATION

Combinations are also designed with light boning, and diaphragm reinforcements so that they can be worn charmingly by plump figures. Model shown here, 8402.

In the Famous Park of Nara

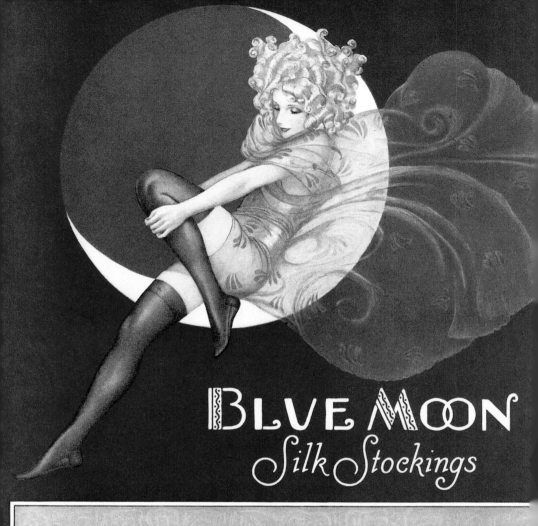

BLUE MOON
Silk Stockings

◄ Blue Moon Hosiery, 1926

McCallum Hosiery, 1922

Early advertising remained simple: Explain the product, its benefits, and why you need it. The look tended to be text-heavy, with few images, and the copy was straightforward. By the 1920s, new printing techniques and changes in the marketplace led to an advertising boom which would rely more on psychological motivation than literal displays of the product. McCallum had been using the "You just know she wears them" slogan for several years to sell its stockings — but, in this instance, the ad does not even show the product.

Frühe Reklame blieb schlicht: Erkläre das Produkt, seine Vorzüge und warum man es braucht. Das Erscheinungsbild war textlastig, mit wenig Bildern und einfachem Druck. Ab den 1920ern sorgten neue Drucktechniken und Veränderungen des Marktes für einen Werbe-Boom, der stärker auf psychologische Motive als auf die wirklichkeitsgetreue Darstellung des Produkts abzielte. McCallum hatte einige Jahre lang mit dem Slogan „You just know she wears them" für den Verkauf seiner Strümpfe geworben – in diesem Fall zeigt die Annonce das Produkt allerdings nicht einmal.

À ses débuts, la publicité était très simple : présenter le produit, ses avantages et les raisons pour lesquelles on en a besoin. Il y avait beaucoup de texte et peu d'images, et le ton employé était direct. Dans les années 20, les nouvelles techniques d'impression et les évolutions du marché déclenchèrent un boom publicitaire qui reposait plus sur la motivation psychologique que sur la présentation réelle des produits. McCallum utilisait le slogan « You just know she wears them » depuis plusieurs années pour vendre ses bas mais, dans cet exemple, le visuel publicitaire ne montre même pas le produit.

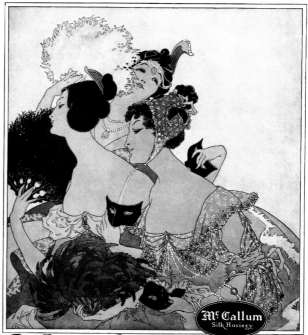

McCallum Silk Hosiery

You just know she wears them

Somewhere in the McCallum line is precisely the silk stocking you want. Numbers 105—113 122—199 in black, and 152—153—199 in colors are the most popular, and can be found in the best shops. You have confidence in wearing silk stockings with a name you are proud to tell your friends. McCALLUM HOSIERY COMPANY, Northampton, Mass.

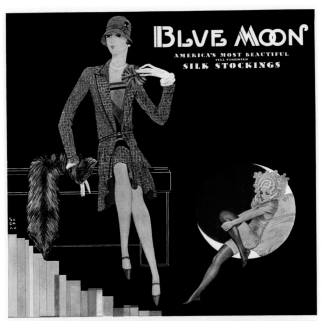

A NEW CREATION by BLUE MOON

Think of it ... exquisite stockings of finely woven chiffon, pure thread silk from top to toe, with a dainty Picot edge, at $1.65! For your smart Fall wardrobe, Blue Moon recommends Style 900, in all the newest shades dictated by Paris ...Woven into this new creation are hidden reinforcements at toe, sole, heel and top for long life at points of greatest wear.

Woven to fit, Blue Moon Silk Stockings hold their smart shapeliness without strain on the delicate threads, and enhance the beauty of any carefully planned ensemble ... chiffons and service weights, may be had from $1.35 to $2.50.

LARGMAN, GRAY CO., 389 Fifth Ave., N. Y.

Blue Moon Hosiery, 1929

Blue Moon silk stockings had used the Art Deco girl-in-the-moon image in previous ads. To underscore the "new creation," the old image appears within a more modern layout, featuring a fashionable 1920s woman in a short skirt and cloche hat.

Für die Seidenstrümpfe von Blue Moon hatte man in früheren Annoncen das Art-Deco-Bild vom Mädchen im Mond verwendet. Um die „neue Kreation" zu unterstreichen, erscheint das alte Bild mit einem moderneren Layout und zeigt eine modebewusste Frau in kurzem Rock und mit Glockenhut.

Les précédentes publicités pour les bas de soie Blue Moon utilisaient l'image Art Déco de la fille assise sur un croissant de lune. Pour valoriser la « nouvelle création », l'ancien visuel fut ici repris avec une disposition plus moderne, présentant une femme à la mode des années 20 vêtue d'une jupe courte et coiffée d'un chapeau cloche.

► McCallum Hosiery, 1921

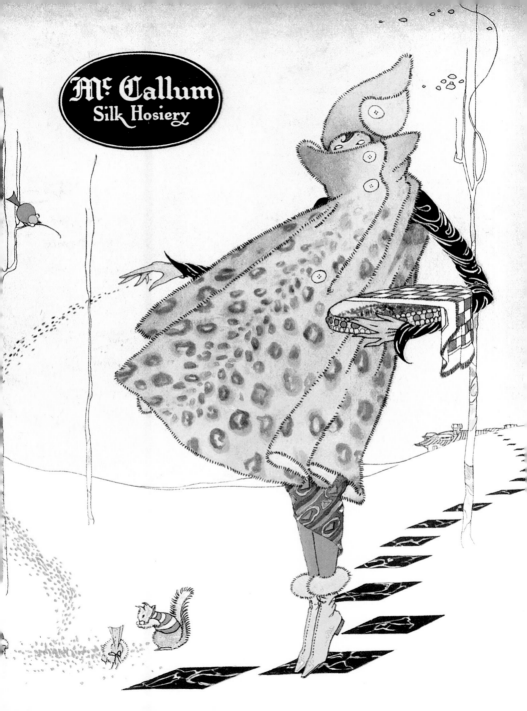

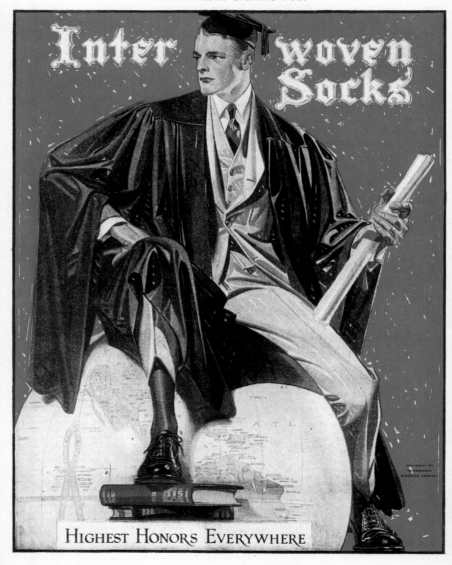

Interwoven Socks, 1922 ▸ Buster Brown Shoes, 1920

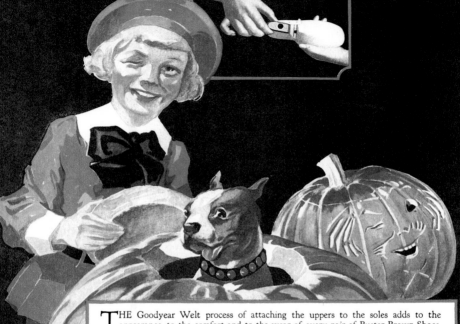

THE Goodyear Welt process of attaching the uppers to the soles adds to the appearance, to the comfort and to the wear of every pair of Buster Brown Shoes. Any shoe merchant will explain why this process excels and what it means to you.

Because they are made upon the famous Brown Shaping Lasts, these shoes fit perfectly, and throughout the growing years keep the feet free from corns, bunions, broken arches, weak ankles and tortured toes. Buster Brown Shoes are the only shoes that combine the important advantages of the Brown Shaping Lasts and

Genuine Goodyear Welt Construction

Good stores everywhere sell Buster Brown Shoes at $4.00, $5.00, $6.00 and up, in button, lace and blucher models—all with genuine Goodyear Welts and Government standard oak-tanned soles.

Style No. F-93

For detailed information regarding the Brown Shaping Lasts, and positive proof that wearing Buster Brown Shoes insures sound, healthy feet, write today for the free book on "Training the Growing Feet".

Brown Shoe Company, St. Louis, U. S. A.

Manufacturers of White House Shoes for Men, Maxine Shoes for Women, Buster Brown Shoes for Boys and for Girls, and Blue Ribbon Service Shoes

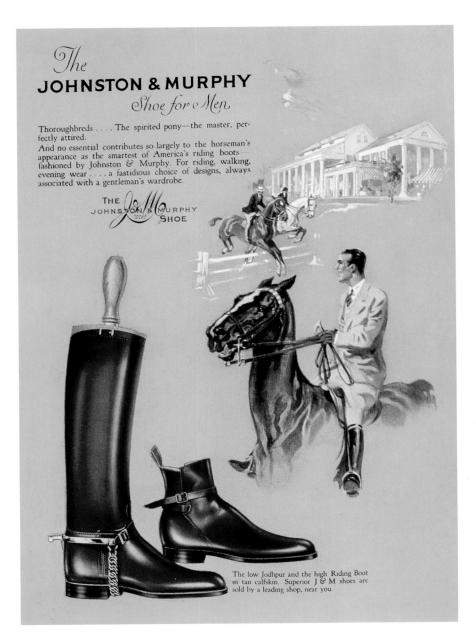

The
JOHNSTON & MURPHY
Shoe for Men

Thoroughbreds The spirited pony—the master, perfectly attired.

And no essential contributes so largely to the horseman's appearance as the smartest of America's riding boots—fashioned by Johnston & Murphy. For riding, walking, evening wear a fastidious choice of designs, always associated with a gentleman's wardrobe.

THE
JOHNSTON & MURPHY SHOE

The low Jodhpur and the high Riding Boot in tan calfskin. Superior J & M shoes are sold by a leading shop, near you.

Johnston & Murphy Shoes, 1927

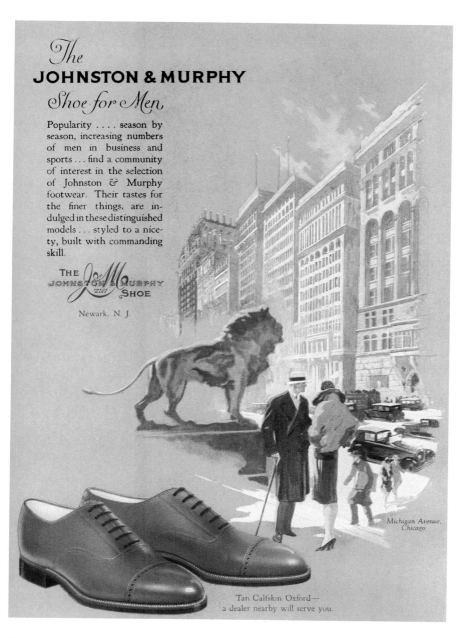

The
JOHNSTON & MURPHY
Shoe for Men

Popularity season by season, increasing numbers of men in business and sports ... find a community of interest in the selection of Johnston & Murphy footwear. Their tastes for the finer things, are indulged in these distinguished models ... styled to a nicety, built with commanding skill.

THE
JOHNSTON & MURPHY SHOE

Newark, N. J.

Michigan Avenue,
Chicago

Tan Calfskin Oxford—
a dealer nearby will serve you.

Johnston & Murphy Shoes, 1927

This New Galosh
sets the season's style!

When the ball is on the two-yard line and wintry blasts are breezing up the stadium, you find a snug *new* galosh setting the season's style — in colors, lightness, warmth and wear.

It's the *new* Hood galosh — feather light and winter warm — in the colors and fabrics of this ultra-smart season At your dealer's!

Made by HOOD RUBBER COMPANY
Watertown, Mass.

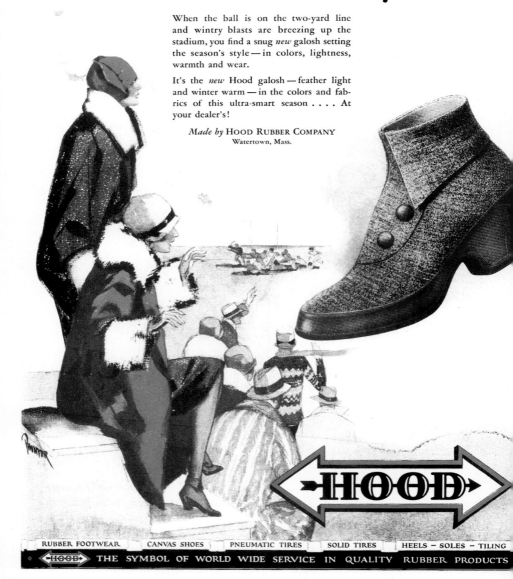

RUBBER FOOTWEAR | CANVAS SHOES | PNEUMATIC TIRES | SOLID TIRES | HEELS — SOLES — TILING

◇ HOOD THE SYMBOL OF WORLD WIDE SERVICE IN QUALITY RUBBER PRODUCTS

There's a shoe store in your neighborhood specializing in Athletic Footwear~ *Look for the oval sign*

The HOOD *Hyscore*

From the Daily Dozen to World's Championships

~the right shoe helps!

Health maintenance in the winter months is receiving nation-wide recognition: Few remain today who are not making some plans to keep vacation fitness throughout the entire year.

From the setting up exercises of the school children, through the period of gymnasium work, to the "keeping fit" exercises of the adult; and from "gym" hand or volley ball to expert basketball, squash or tennis, there is a HOOD Athletic Shoe, properly designed for the work.

It is particularly important for the beginner to start with the shoe which will give him confidence, add to his comfort, and save his strength. It is for these reasons that we have suggested that you go to the store where you will find expert advice and complete stocks to meet your exact needs.

The HOOD *Hyscore*

A professional basketball shoe. Sole grips and releases instantly. Helps a sure, fast game. Will last through a full playing schedule. Strongly reinforced.

The HOOD *Vantage*

A fine all-around indoor athletic shoe for men or women. Kendex insole and heavy cushion mid sole absorb the shocks. Tough rubber outsoles for wear.

The HOOD *Bayside*

Made for all, but recommended for women and children, where the amount and nature of the floor work does not demand a stronger shoe.

HOOD RUBBER PRODUCTS COMPANY, Inc.
Watertown, Massachusetts

Let us send you the Hood Athletic Footwear Buying Guides

INDOOR ATHLETIC HOOD FOOTWEAR

The HOOD
Vantage

Look for this oval sign it identifies the shoe store in your neighborhood specializing in Athletic Footwear

The HOOD
Bayside

◄ Hood Rubber Footwear, 1928 Hood Athletic Shoes, 1923

Grinnell
Gloves
"Best for every purpose"

Grinnell Driving Gloves Mean Wear and Comfort

Only actual Glove photographs are used in Grinnell Glove Advertisements.

The Grinnell Driving Glove illustrated is a favorite because it is cool, comfortable and durable. It is an extremely handsome glove, splendidly made, perfect in every detail.

It appeals to the driver who values not only the appearance of his hands but the real worth of the gloves he wears.

These gloves are made of Grinnell velvet coltskin—soft and pliable, yet wearing like iron.

They are also produced in choicest imported South African cape. We guarantee them not to shrink, peel, crack or harden. They wash in soap and water or gasoline and dry out like new.

This is only one of the 900 styles in Grinnell Gloves. If the Grinnell dealer in your community does not have the style you want write us for our special style book.

MORRISON-RICKER MANUFACTURING COMPANY
(Established 1856)
GRINNELL, IOWA, U. S. A.
200 FIFTH AVENUE, NEW YORK CITY

Copyright, 1920, by Morrison-Ricker Mfg. Co.

Grinnell Gloves, 1920

STYLED AND TAILORED
AS ONLY THE
ENGLISH KNOW HOW

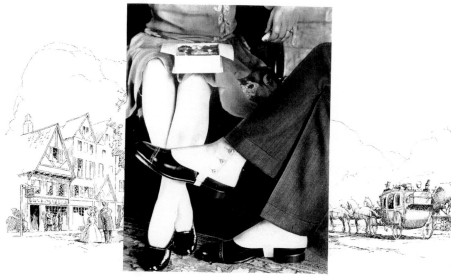

DO YOU insist on spats that fit snugly over instep and ankle with never a wrinkle? Do you like seams finished and edges bound so that there are apparently no seams or binding at all? Have you wished for soft leather straps that will not curl . . . sewed in so they do not draw the spat at the instep? If you have, you are a man made for BOND STREET spats . . . and BOND STREETS are made for you.

Here are spats with the style and smartness found heretofore only in English spats. Their tailoring,

too, conforms to the best English standards in every little detail. Fact is, BOND STREET spats are styled in England by a famous designer of correct anklewear and are equaled only by the finest imported product.

BOND STREET spats are sold at the best shoe stores and men's wear shops. Ask for them by name and look for the BOND STREET label inside. It is a guarantee of superior quality and smartness. The Williams Manufacturing Company, Portsmouth, Ohio, U. S. A.

Four of the many styles of BOND STREET spats are illustrated on this page. They are available in a wide range of prices.

Meticulous and flawless styling and tailoring characterize all BOND STREET spats, regardless of price.

BOND STREET

Spats

T H E C O R R E C T A N K L E W E A R

ond Street Spats, 1929

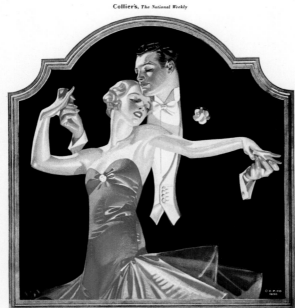

Arrow Shirts, 1929

Illustrator J. C. Leyendecker first began creating advertisements for Arrow shirts in 1906. The men and women depicted were singularly glamorous; in this case, evoking the style of popular husband-and-wife dance team Vernon and Irene Castle.

Der Illustrator J. C. Leyendecker entwarf 1906 die ersten Anzeigen für Arrow-Hemden. Die darauf dargestellten Herren und Damen waren ausgesprochen glamourös. In diesem Fall hat man sich an den Stil des bekannten Tanz- und Ehepaares Vernon und Irene Castle angelehnt

L'illustrateur J. C. Leyendecker commença à créer des publicités pour les chemises Arrow en 1906. Les hommes et les femmes illustrés étaient particulièrement glamour ; ici, les personnages évoquent le célèbre couple de danseurs Vernon et Irene Castle.

► Arrow Collars and Shirts, 1926

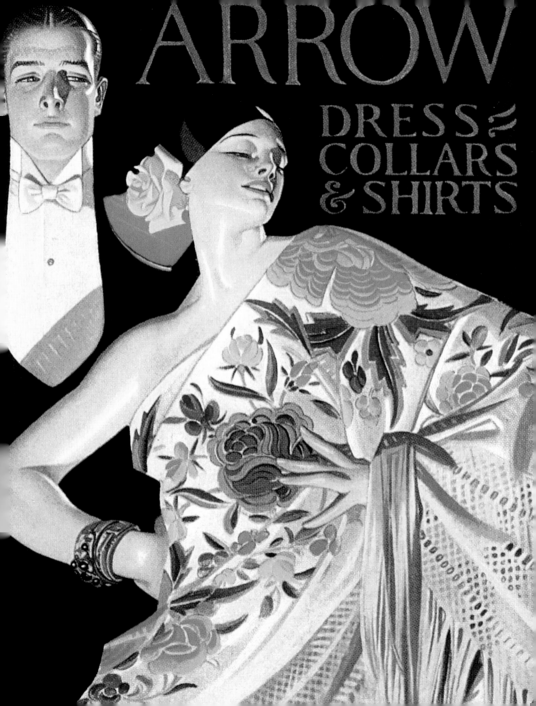

ARROW

DRESS COLLARS & SHIRTS

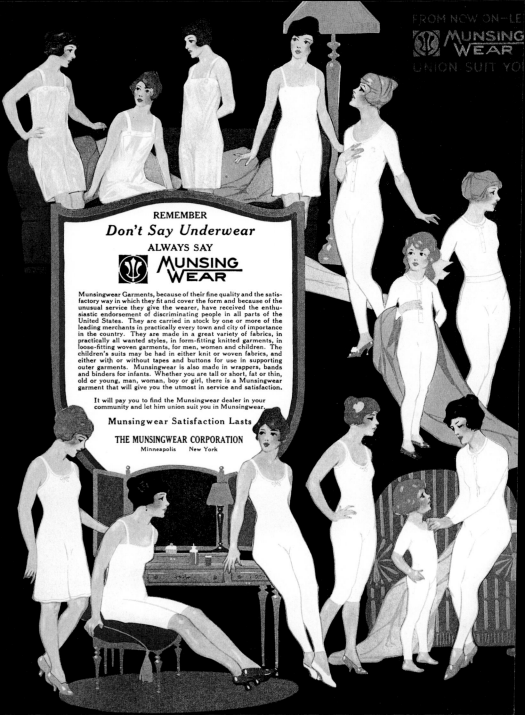

◄ Munsingwear Underwear, 1921

Holeproof Hosiery, 1923

Coles Phillips's pinup girls for Holeproof Hosiery are lovely in their wispy lingerie, with eyes demurely downcast. But shocking? For their time, they were. Only a few years before Phillips's ads began running, the glimpse of a woman's ankle was considered titillating. But as hemlines rose and rules for appropriate dress relaxed, advertisers had more leeway with what could be shown.

Coles Phillips Pin-up-Girls für Holeproof Hosiery in ihrer zarten Wäsche und mit züchtig niedergeschlagenen Augen sind hübsch anzusehen. Schockierend? Zur damaligen Zeit sehr wohl. Nur wenige Jahre vor der Veröffentlichung von Phillips Anzeigen galt schon der Blick auf eine weibliche Fessel als anzüglich. Doch als die Säume nach oben wanderten und die Regeln für angemessene Kleidung sich lockerten, bekamen auch die Werbeleute mehr Spielraum.

Dans leur lingerie vaporeuse, les yeux pudiquement baissés, les pin-up dessinées par Coles Phillips pour Holeproof Hosiery étaient irrésistibles. Mais étaient-elles choquantes ? Pour leur époque, oui. À peine quelques années avant la diffusion des publicités dessinées par Phillips, apercevoir les chevilles d'une femme suffisait à émoustiller les sens. Avec le raccourcissement des jupes et la décontraction des codes vestimentaires, les annonceurs disposaient néanmoins d'une plus grande marge de liberté.

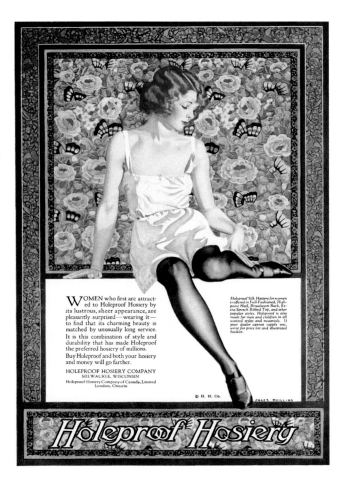

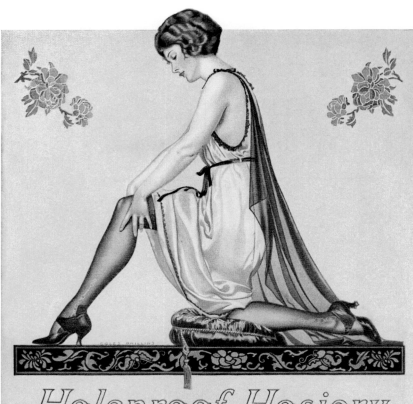

Holeproof Hosiery

HOLEPROOF offers women a sensible combination in hosiery that can be found in no other makes—long wear and beautiful appearance.

Some hose may equal Holeproof in appearance but they lack the phenomenal durability that has made Holeproof famous. Others may approach Holeproof in wearing quality, but at the sacrifice of fine texture and sheerness.

If you are interested in getting hosiery that will give extraordinary wear and at the same time is sheer and beautiful, ask for Holeproof.

At all good stores—in many styles, in all approved colors. Silk, silk-and-wool, wool, silk-faced, and lusterized lisle. Styles also for men and children. If not available locally, write for booklet and prices.

HOLEPROOF HOSIERY COMPANY, MILWAUKEE, WISCONSIN
Holeproof Hosiery Company of Canada, Limited, London, Ontario

© H. H. Co.

Holeproof Hosiery, 1923

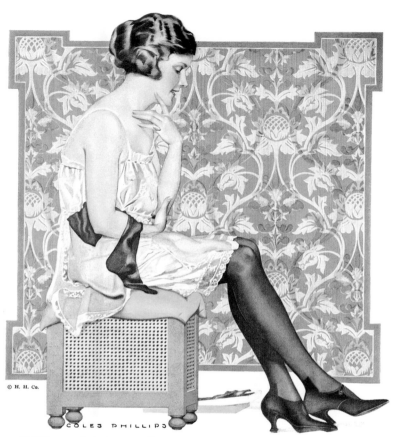

© H. H. Co.

COLES PHILLIPS

THE secret of trim lustrous ankles with many well-dressed women is not a matter of what they pay for their hose, but what kind they get.

More and more, women are discovering that Holeproof Hosiery offers all the style, sheerness and lustrous beauty that fashion demands, in combination with a fine-spun strength that gives extraordinarily long service.

Leading stores are now showing the newest ideas in regular and fancy styles in Silk, Silk Faced, Silk and Wool, Wool Mixtures and Lisles, for men, women and children

HOLEPROOF HOSIERY COMPANY, MILWAUKEE, WISCONSIN
Holeproof Hosiery Company of Canada, Limited, London, Ont.

*Holeproof
Hosiery*

Holeproof Hosiery, 1921

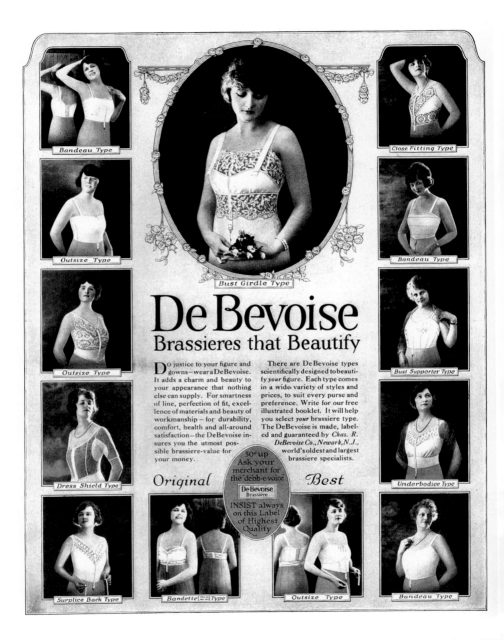

Bandeau Type

Outsize Type

Outsize Type

Dress Shield Type

Surplice Back Type

Bust Girdle Type

Bandette Type

De Bevoise
Brassieres that Beautify

Do justice to your figure and gowns—wear a De Bevoise. It adds a charm and beauty to your appearance that nothing else can supply. For smartness of line, perfection of fit, excellence of materials and beauty of workmanship – for durability, comfort, health and all-around satisfaction – the De Bevoise insures you the utmost possible brassiere-value for your money.

There are De Bevoise types scientifically designed to beautify *your* figure. Each type comes in a wide variety of styles and prices, to suit every purse and preference. Write for our free illustrated booklet. It will help you select *your* brassiere type. The De Bevoise is made, labeled and guaranteed by *Chas. R. DeBevoise Co., Newark, N.J.*, world's oldest and largest brassiere specialists.

Original

Best

50¢ up
Ask your merchant for the "debb-e-voice"
De Bevoise Brassiere
INSIST always on this Label of Highest Quality

Outsize Type

Close Fitting Type

Bandeau Type

Bust Supporter Type

Underbodice Type

Bandeau Type

DeBevoise Brassieres, 1921 ▶ Nufashond Garters, 1925

Nufashond

TRADE MARK REG. U.S. PAT. OFF.

GARTERS

Fancy garters were never so popular, and Nufashond Garters are the last word.

Nufashond, leading manufacturer of garter elastic, has produced a wonderful assortment of beautiful finished garters in glorious colors. Ask to see them at your store. Though bewitchingly pretty, they're modestly priced.

But the beauty of Nufashond Garters is only one of their virtues. Bear in mind that they are made of the famous Nufashond Elastic, which means more stretch and snap and longer wear.

Or you can buy Nufashond Garter Elastic by the piece and make garters for yourself or your friends.

Dept. L5, Nufashond
READING, PA.

or this sign on *aler's door or* *w. If he han-* *e best in little* *s you can de-* *pon the quality* *his merchan-*

fashond NOTIONS

we will send you *of beautiful Roll* *arters, made up* *ttractive orna-* *ttached, or, for* *cient material for* *a pair of garters.* *color desired.*

Nufashond

TRADE MARK REG. U.S. PAT OFF

GARTER ELASTIC

401 *Garter* *plain* *terns;* *ngths.*

5123 *d Garters,* *d in pat-* *27-inch* *nd made-* *rs.*

No. 5126
Shirred ribbon
made-up Garters
and 27-inch
lengths.

Look for
"TALON"
or
"HOOKLESS"
on the
pull

TALON

The lightning rapidity with which Talon Slide-Fasten
open and close, pleases men—and women too—

Speed! Action! You get both in Talon Slide-Fasteners. A swift, gentle pull, and g
golf-bags, etc., are open, their contents instantly available. You've seen these quick,
venient Talon Slide-Fasteners on bags, luggage, overshoes, etc., but they are not restri
to these alone. Today Talon Slide-Fasteners are the accepted method of fastenin
frocks, for women and children; work and sports clothes for men and boys; utility i
for household purposes, etc. There are literally hundreds of Talon-fastened art
and garments that you can buy ready-made or make at home yourself, using T
Slide-Fasteners which you can buy at any notion counter.

Buy Ready-for-Service Talon-Fastened garments and articles, or m
them at home yourself

Trim, convenient, Talon Slide-Fasteners are featured on the clothes smart people wear—o
fashion accessories they use; and now Talon Slide-Fasteners are available for all kinds of h
sewing use. Unlike all old-fashioned fasteners Talon Slide-Fasteners prevent gaping e
because each tight-gripping coupling is machined and matched with almost a fine watchma
care and precision. Flexible, unbreakable, they can be run through a wringer and still
will work smoothly and quickly. Rustless, they launder or dry-clean perfectly.

Identify these fasteners by "Talon" or "Hookless" on the slider-pull. If your departme
general store does not stock Talon Slide-Fasteners for home-sewing, write us. Send us your i
and address and we will mail you an illustrated catalog giving the names of companies ma
Talon-fastened articles.

HOOKLESS FASTENER COMPANY, 623 ARCH STREET, MEADVILLE, PE

The Pioneer Manufacturers of Slide-Fasteners

Knockabout Bag; Riding Breeches; Tobacco Pouch;
Men's Toilet Kit; equipped with Talon Slide-Fasteners.

Delineator
Home Institute

TALON

REG. U.S. PAT. OFF

THE ORIGINAL

SLIDE FASTENER ...

TALON
SLIDE
FASTENER

© 1929 Hookless Fastener Co.

◄ Talon Slide-Fasteners, 1929

The first variation of the zipper dates back to 1851, but the Hookless Fastener Company— later renamed Talon—patented its product in 1913. The B. F. Goodrich Company came up with the "zipper" name for the product, but it wasn't widely used until Hart Schaffner & Marx created the first zip-fly trouser in 1936.

Der erste Reißverschluss stammt zwar aus dem Jahre 1851, allerdings ließ sich die Hookless Fastener Company—später in Talon umbenannt— ihr Produkt 1913 patentieren. Die B. F. Goodrich Company kam auf den Namen „Zipper", der jedoch nicht sehr verbreitet war, bis Hart Schaffner & Marx 1936 die erste „zip-fly trouser" herausbrachte.

Si la première version de la fermeture à zip remontait à 1851, la société Hookless Fastener Company, plus tard rebaptisée Talon, ne fit breveter son produit qu'en 1913. Ce fut B. F. Goodrich Company qui eut l'idée d'appeler ce produit « zipper », mais son usage ne se répandit qu'en 1936, quand Hart Schaffner & Marx créa le premier pantalon à fermeture Éclair.

Holeproof Hosiery 1920

►► Gordon Hosiery, 1929

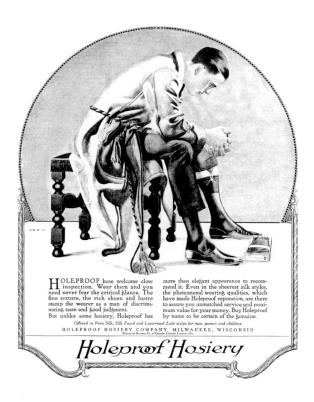

HOLEPROOF hose welcome close inspection. Wear them and you need never fear the critical glance. The fine texture, the rich sheen and lustre stamp the wearer as a man of discriminating taste and good judgment. But unlike some hosiery, Holeproof has more than elegant appearance to recommend it. Even in the sheerest silk styles, the phenomenal wearing qualities, which have made Holeproof reputation, are there to assure you unmatched service and maximum value for your money. Buy Holeproof by name to be certain of the genuine.

Offered in Pure Silk, Silk Faced and Lusterized Lisle styles for men, women and children
HOLEPROOF HOSIERY COMPANY, MILWAUKEE, WISCONSIN
Holeproof Hosiery Co. of Canada, Limited, London, Ont.

Holeproof Hosiery

FOR EACH .. HER <u>OWN</u> INDIVIDU

NOW . . . for the first time in costume history . . . stockings are made in two varying dimensions—and in four groups— as explained on the opposite page. For these Gordon Individually-Proportioned Stockings are dimensioned for the proportions of individual legs —as well as of individual feet.

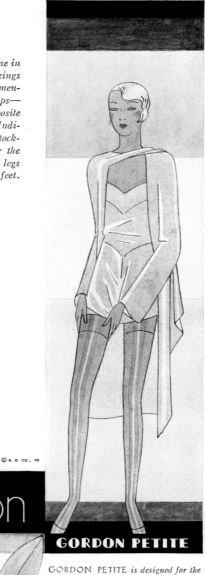

© S. D CO., 99

Gordon

GORDON PETITE

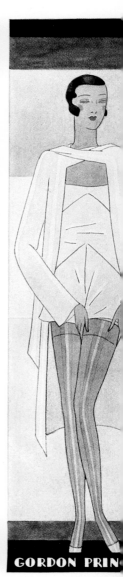

GORDON PRIN

GORDON PETITE *is designed for the short woman with average leg measurements . . . for the woman of average height with very slim legs . . . for the growing girl.*

GORDON PRINCESS *is d women of average height an urements; for the short w plump legs and thighs; for the whose skirts are brief.*

ROPORTIONED STOCKINGS by Gordon

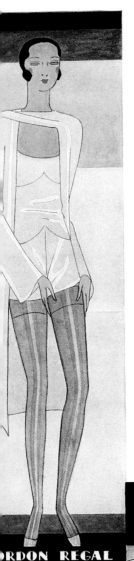

Shoes have always been made—and ordered—in *two* measurements—length and width. But Stockings . . . the important "Third" of the modern woman's ensemble . . . have hitherto concerned themselves with only the *foot* size. Yet . . . some women are diminutive with slim legs. Others . . . just as tiny, and with the same 9 foot-size . . . have wide thighs and thin ankles. Still others . . . wearing the 9 foot-size . . . are tall and regally proportioned.

So—Gordon has designed these Individually-Proportioned Stockings—in four leg-sizes and all foot-sizes. These are so scientifically worked out that . . . whatever your type of figure . . . some one of these proportions will give you stocking-smoothness . . . freedom from strain or binding, from surplus that needs to be rolled . . . and . . . you will enjoy their longer wear.

These new stockings . . . to be found at the shops you prefer . . . are called *Gordon Petite, Gordon Princess, Gordon Regal* and *Gordon Splendide.* The *Gordon Splendide* is particularly designed for the thousands of American women who . . . whether tall or short . . . are *generously proportioned* throughout the lower part of their bodies.

RDON REGAL

>N REGAL *is designed for the
>an with average leg measure-
>or the woman of average height
>newhat heavy calves or thighs.*

Now You Can Buy It in Colors

It is made in

Pink	Rose
Helio	Cadet
Biscuit	Tan
Pearl	Linen
Reseda	Ciel
Copen	Brown

Now for the first time you can buy Indian Head in colors, and in colors guaranteed fast. By "fast colors" we mean colors that will hold bright and true through seasons of sun, sea air, dampness, and washing.

We guarantee: If any garment made of Indian Head fails to give proper service because of the fading or running of Indian Head colors, we will make good the total cost of the garment.

Fifty-nine cents a yard is the price of guaranteed fast-color Indian Head, 36 inches wide —a value that you will appreciate more fully after months of wear. If your store does not carry Indian Head in fast colors, write us giving your dealer's name. We will see that you are supplied.

"The Girl Who Loved Pink" tells the story of colored Indian Head and has a sample of the material. It also shows the complete color range. It is sent free upon request.

Amory, Browne & Co., Department 234, Box 1206, Boston, Mass.

Copyright, Amory, Browne & Co., Boston and New York

Nashua Blankets *Parkhill Fine Ginghams* *Lancaster Kalburnie Gingham* *Gilbrae Gingham*

INDIAN HEAD CLOTH
Reg. U.S.Pat.Off.
Always on the Selvage

Indian Head Fabrics, 1922

Textile company Amory Browne & Co., based in Boston, Massachusetts, produced fabrics under a variety of names, including Indian Head cloth, a fine muslin fabric that was said to resemble linen but was less expensive. The fabric became a favorite of quilters. Among Amory Browne's other products were Kalburnie Zephyr ginghams and Nashua Woolnap blankets, which were marketed as being made from "pure cotton to keep you warm."

Das Textilunternehmen Amory Browne & Co. mit Sitz in Boston, Massachusetts, produzierte Stoffe mit einer Vielzahl von Namen, darunter Indian Head, ein feiner Musselin, der Ähnlichkeit mit Leinen hatte, aber preiswerter war. Der Stoff wurde zum Lieblingsmaterial fürs Quilten. Andere Produkte von Amory Browne waren Karostoffe namens Kalburnie Zephyr und Decken unter der Bezeichnung Nashua Woolnap, die, wie es hieß, aus reiner Baumwolle gemacht waren, „um Sie warmzuhalten".

Basé à Boston, Massachusetts, le fabricant textile Amory Browne & Co. produisait des tissus sous une variété de noms, notamment Indian Head, une fine mousseline supposée ressembler au lin tout en étant moins chère, qui remporta un franc succès auprès des quilteurs. Amory Browne proposait aussi le tissu à carreaux vichy Kalburnie Zephyr et les couvertures Nashua Woolnap, vendues avec l'argument du « 100 % coton qui vous tient chaud ».

▶ Indian Head Fabrics, 1920

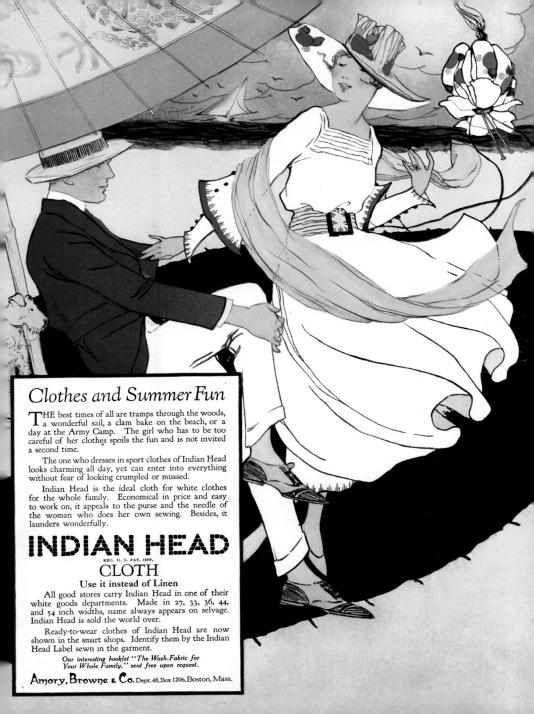

Clothes and Summer Fun

THE best times of all are tramps through the woods, a wonderful sail, a clam bake on the beach, or a day at the Army Camp. The girl who has to be too careful of her clothes spoils the fun and is not invited a second time.

The one who dresses in sport clothes of Indian Head looks charming all day, yet can enter into everything without fear of looking crumpled or mussed.

Indian Head is the ideal cloth for white clothes for the whole family. Economical in price and easy to work on, it appeals to the purse and the needle of the woman who does her own sewing. Besides, it launders wonderfully.

INDIAN HEAD
REG. U. S. PAT. OFF.
CLOTH
Use it instead of Linen

All good stores carry Indian Head in one of their white goods departments. Made in 27, 33, 36, 44, and 54 inch widths, name always appears on selvage. Indian Head is sold the world over.

Ready-to-wear clothes of Indian Head are now shown in the smart shops. Identify them by the Indian Head Label sewn in the garment.

Our interesting booklet "The Wash-Fabric for Your Whole Family," sent free upon request.

Amory, Browne & Co. Dept. 48, Box 1206, Boston, Mass.

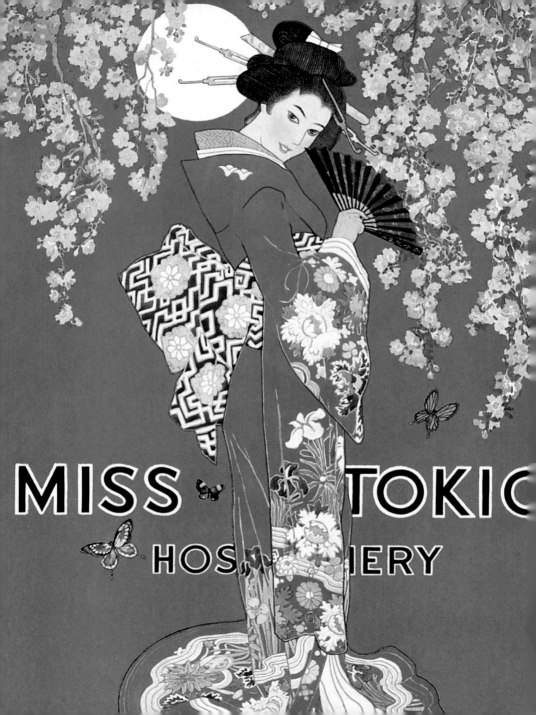

MISS TOKIO

HOSIERY

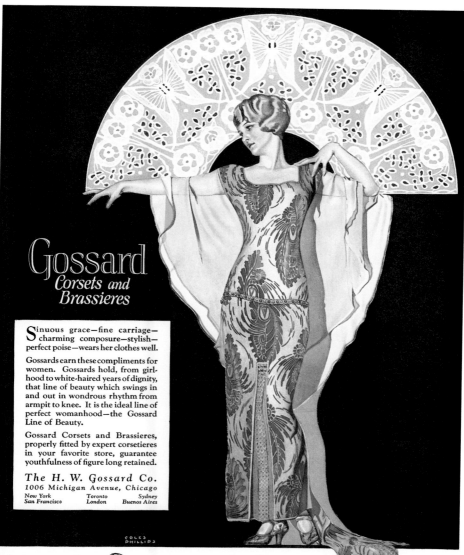

Gossard
Corsets and Brassieres

Sinuous grace—fine carriage—charming composure—stylish—perfect poise—wears her clothes well.

Gossards earn these compliments for women. Gossards hold, from girlhood to white-haired years of dignity, that line of beauty which swings in and out in wondrous rhythm from armpit to knee. It is the ideal line of perfect womanhood—the Gossard Line of Beauty.

Gossard Corsets and Brassieres, properly fitted by expert corsetieres in your favorite store, guarantee youthfulness of figure long retained.

The H. W. Gossard Co.
1006 Michigan Avenue, Chicago

| New York | Toronto | Sydney |
| San Francisco | London | Buenos Aires |

The Gossard Line *of* Beauty

◄ Miss Tokio Hosiery, 1927 Gossard Corsets and Brassieres, 1924

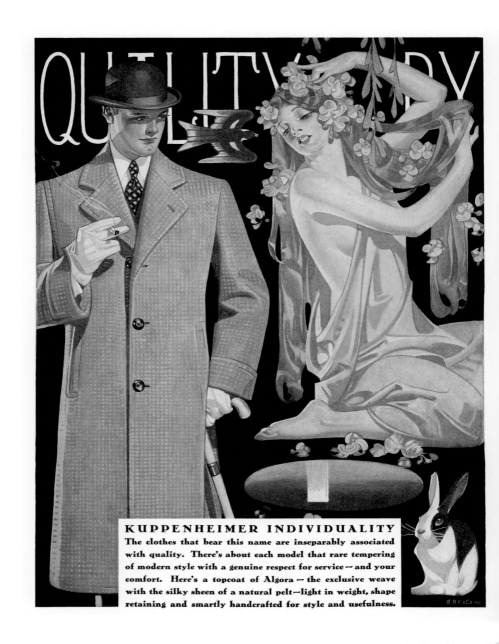

KUPPENHEIMER INDIVIDUALITY
The clothes that bear this name are inseparably associated with quality. There's about each model that rare tempering of modern style with a genuine respect for service — and your comfort. Here's a topcoat of Algora — the exclusive weave with the silky sheen of a natural pelt — light in weight, shape retaining and smartly handcrafted for style and usefulness.

Kuppenheimer Menswear, 192

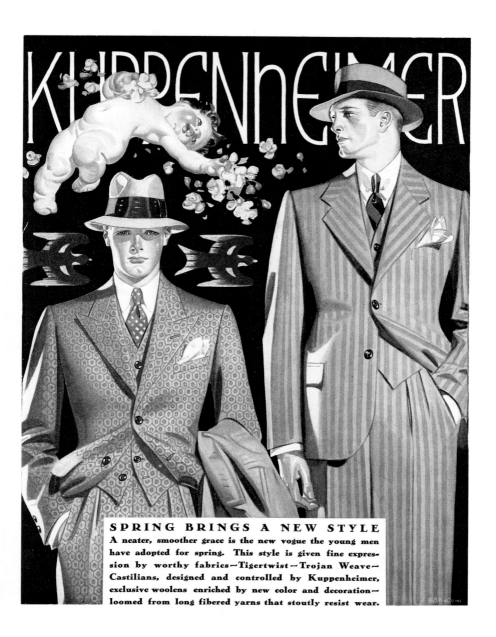

KUPPENHEIMER

SPRING BRINGS A NEW STYLE

A neater, smoother grace is the new vogue the young men have adopted for spring. This style is given fine expression by worthy fabrics—Tigertwist—Trojan Weave—Castilians, designed and controlled by Kuppenheimer, exclusive woolens enriched by new color and decoration—loomed from long fibered yarns that stoutly resist wear.

Kuppenheimer Menswear, 1929

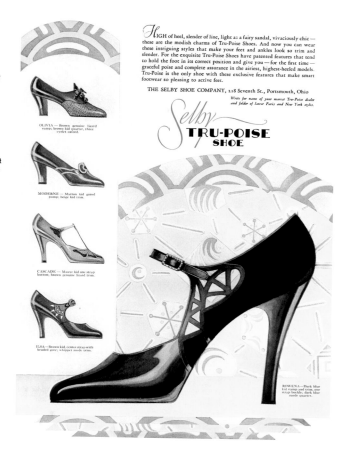

◄ Riley Shoes, 1927

Selby Shoes, 1929

The 1930s silhouette—long, lean, and graceful—replaced the short, flirty, and free-wheeling look of the 1920s. New shoe styles followed suit, shifting away from the Louis XIV heel to a slimmer line.

Die Silhouette der 1930er – lang, schmal und graziös – ersetzte den kurzen, koketten und flatterhaften Look der Zwanziger. Neue Schuhmoden folgten und bedeuteten die Abkehr vom Absatz à la Ludwig XIV. hin zu einer schlankeren Form.

La silhouette des années 30 – longue, svelte et gracieuse – remplaça le look court, aguicheur et relâché de la décennie précédente, suivie par de nouveaux modèles de chaussures s'éloignant du talon Louis XIV au profit d'une ligne plus fine.

*H*IGH of heel, slender of line, light as a fairy sandal, vivaciously chic — these are the modish charms of Tru-Poise Shoes. And now you can wear these intriguing styles that make your feet and ankles look so trim and slender. For the exquisite Tru-Poise Shoes have patented features that tend to hold the foot in its correct position and give you — for the first time — graceful poise and complete assurance in the airiest, highest-heeled models. Tru-Poise is the only shoe with these exclusive features that make smart footwear so pleasing to active feet.

THE SELBY SHOE COMPANY, 218 Seventh St., Portsmouth, Ohio

Write for name of your nearest Tru-Poise dealer and folder of latest Paris and New York styles.

Selby
TRU-POISE
SHOE

OLIVIA — Brown genuine lizard vamp; brown kid quarter, three eyelet oxford.

MODERNE — Marron kid gored pump; beige kid trim.

CASCADE — Mauve kid one strap button; brown genuine lizard trim.

ILSA — Brown kid, center strap with beaded gore; whippet suede trim.

ROWENA — Dark blue kid vamp and trim, one strap buckle; dark blue suede quarter.

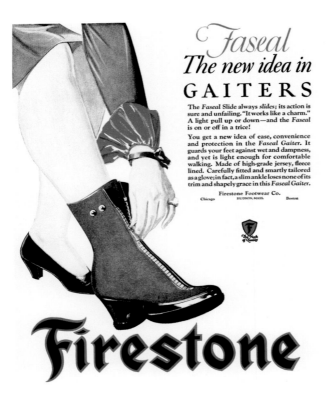

Faseal
The new idea in
GAITERS

The *Faseal* Slide always *slides*; its action is sure and unfailing. "It works like a charm." A light pull up or down—and the *Faseal* is on or off in a trice!

You get a new idea of ease, convenience and protection in the *Faseal* Gaiter. It guards your feet against wet and dampness, and yet is light enough for comfortable walking. Made of high-grade jersey, fleece lined. Carefully fitted and smartly tailored as a glove; in fact, a slim ankle loses none of its trim and shapely grace in this *Faseal* Gaiter.

Firestone Footwear Co.
Chicago HUDSON, MASS. Boston

Firestone

Firestone Footwear, 1926

▶ Interwoven Socks, 1929

The 1920s was the era of the college man, and this Interwoven ad, illustrated by J. C. Leyendecker, perfectly captures a campus scene. At the time, young men had begun to wear extremely wide-legged trousers called "Oxford bags," in honor of the university where the style originated.

Die 1920er waren die Ära des Collegestudenten, und diese von J. C. Leyendecker illustrierte Interwoven-Anzeige erfasst eine Campus-Szene auf perfekte Weise. Damals hatten junge Männer gerade begonnen, Hosen mit extrem weitem Bein zu tragen, die man zu Ehren der Universität, an der diese Mode aufgekommen war, „Oxford bags" nannte.

Les années 20 mirent l'étudiant d'université à l'honneur et cette publicité pour Interwoven, dessinée par J. C. Leyendecker, illustrait parfaitement le mode de vie sur les campus. À l'époque, les jeunes hommes commencèrent à porter des pantalons à jambe très large, appelés « Oxford bags » en référence à l'université où était né ce modèle.

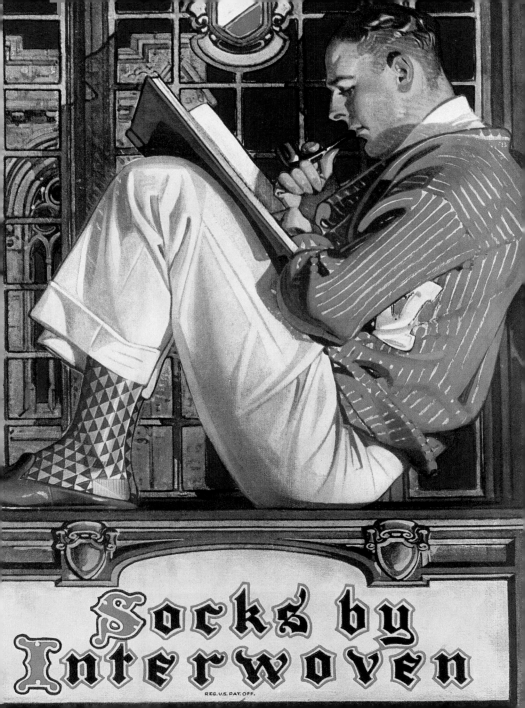

Socks by Interwoven

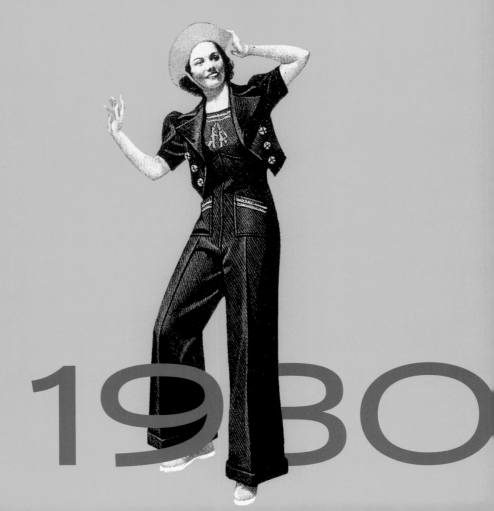

"IN DIFFICULT TIMES FASHION
IS ALWAYS OUTRAGEOUS."
— ELSA SCHIAPARELLI

1930

«QUAND LES TEMPS SONT
DURS, LA MODE EST TOU-
JOURS SCANDALEUSE.»
– ELSA SCHIAPARELLI

„IN HARTEN ZEITEN IST
 MODE STETS UNERHÖRT.“
– ELSA SCHIAPARELLI

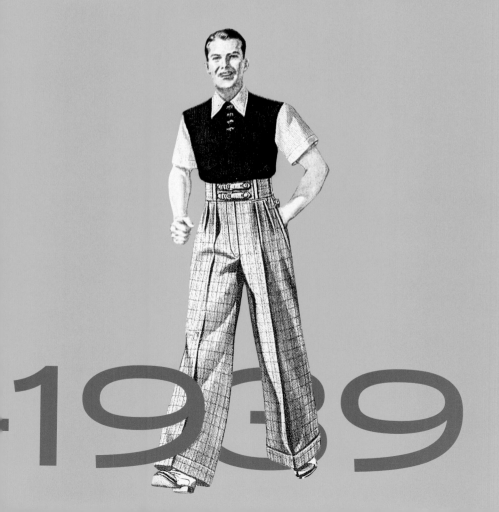

1939

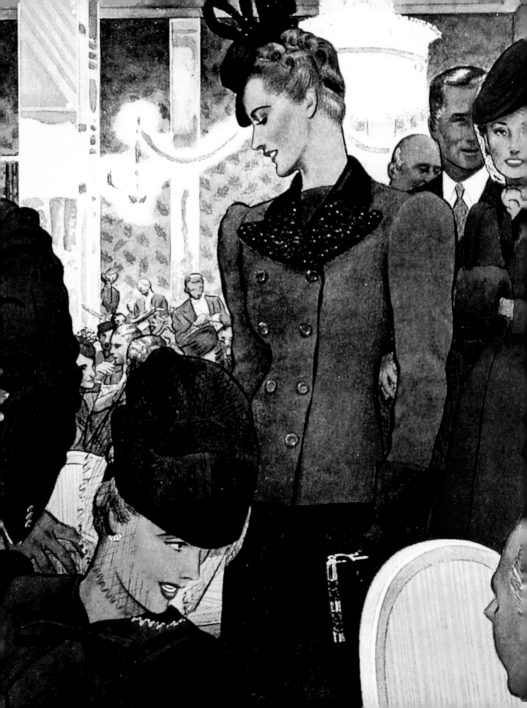

ESCAPING ECONOMIC REALITY

The decade had a romantic scandal nonpareil when England's newly crowned King Edward abdicated his throne to marry American divorcée Wallis Simpson in 1936. Taking the titles Duke and Duchess of Windsor, the pair's aristocratic style became synonymous with the decade.

IN THE 1930S, THE UNITED STATES SLOWLY SANK INTO THE GREAT DEPRESSION WHILE THE SEEDS OF ANOTHER WAR WERE SOWN in a still-recovering Europe and points beyond. Civil war erupted in Spain; India continued its fight for independence; Japan invaded Manchuria; Italy invaded Ethiopia; and Germany had its eye on neighboring countries. In America, Franklin Delano Roosevelt was elected president on his New Deal platform, but on the day he took office, most of the national banks failed.

The radio, a new technology in the 1920s, boomed in the 1930s, as producers developed sophisticated programming ranging from music and comedy to news and sports. Children tuned in for the ongoing adventures of cowboys, while their mothers listened to the trials and tribulations of characters in soap operas. Sound had been introduced to movies in the late 1920s, putting an end to the silent-film era; by 1930, 85 million people were going to the movies weekly. Entertainment remained largely escapist—from Busby Berkeley's elaborately staged musicals to Shirley Temple's cloyingly cute stranglehold on the box office. Greta Garbo made a successful transition to the talkies, and Jean Harlow defined the decade's sex symbol as brash and independent.

The decade had a romantic scandal nonpareil when England's newly crowned King Edward abdicated his throne to marry American divorcée Wallis Simpson in 1936. Taking the titles Duke and Duchess of Windsor, the pair's aristocratic style became synonymous with the decade.

For men, the silhouette became overtly masculine. A good tailor could re-create the broad-shouldered and narrow-hipped look of athlete/actor Johnny Weissmuller. Double-breasted suits became more popular, some with wide-peaked or pointed lapels. For women, skirts were long and slim, jackets were fitted, and accessories were de rigueur: hats, gloves, furs, scarves, handbags, and shoes — low-heeled for day, but towering for evening. Hats evolved from the 1920s: brimless styles, and others with a folded brim, framed the face. As the decade progressed, hats grew more structured, with taller crowns and wider brims. Exotic styles featured veils and ribbon trim.

Taking a cue from menswear, designer Elsa Schiaparelli began padding the shoulders of women's suits. In 1931, tennis player Lili de Alvarez wore a Schiaparelli-designed split skirt to play at Wimbledon. A year later, tennis champ Henry "Bunny" Austin wore shorts to play at the U.S. Open Men's Championships in New York City.

The range of women's fashion — from smartly fitted suits to fantasy lingerie and dramatic evening gowns — got the star treatment in the 1939 film *The Women*, which featured the work of Hollywood costume designer Adrian, who often took his cues from French designer Madeleine Vionnet's sensual, bias-cut satin gowns. Starring Norma Shearer, Joan Crawford, and Rosalind Russell, the otherwise black-and-white film included a fashion-show segment filmed in color.

The glamorous fashions on the silver screen, however, did not reflect the wardrobes of mainstream America. It was the ads for workwear — touting brands' durability and bargain prices — not dresswear, that reflected the economic reality of the Great Depression.

◄◄ Hockanum Woolens, 1939 ► DuPont Acele Acetate, 1936

1930

Jean Harlow's platinum-blonde Marcel wave sets trend

Jean Harlows platinblonde ondulierte Welle wird zum Modetrend

Jean Harlow lance la mode des cheveux blond platine coupés courts et ondulés

1930

Madeleine Vionnet's bias-cut silhouette defines the decade's style

Madeleine Vionnets schräg geschnittenes Kleid ist die dominierende Silhouette des Jahrzehnts

La robe taillée dans le biais de Madeleine Vionnet devient la silhouette de la décennie

1931

Elsa Schiaparelli creates the shoulder-padded power suit

Elsa Schiaparelli entwirft ein Kostüm mit Schulterpolstern

Elsa Schiaparelli crée le tailleur à épaulettes

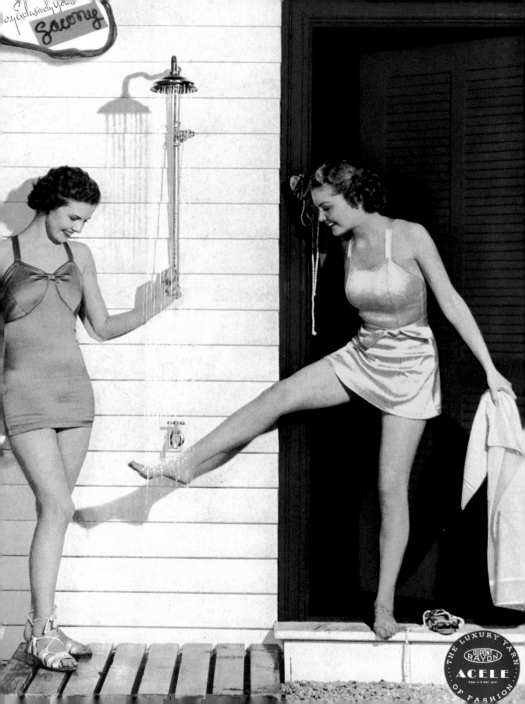

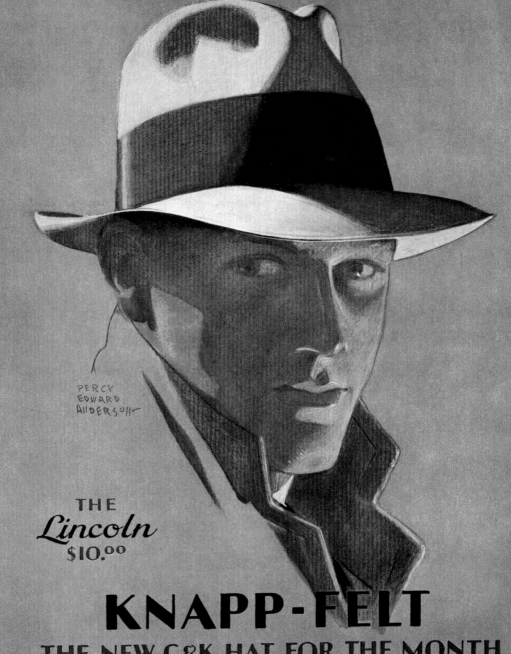

THE
Lincoln
$10.⁰⁰

KNAPP-FELT
THE NEW C&K HAT FOR THE MONTH
MADE BY THE CROFUT & KNAPP CO., FIFTH AVENUE NEW YO

DER HARTEN
REALITÄT
ENTFLIEHEN

Einen unvergleichlich romantischen Skandal erlebte das Jahrzehnt, als Englands neu gekrönter König Edward auf seinen Thron verzichtete, um 1936 die geschiedene Amerikanerin Wallis Simpson zu heiraten. Nachdem sie die Titel Herzog und Herzogin von Windsor angenommen hatten, wurde der aristokratische Lebensstil des Paares zum Synonym jener Dekade.

IN DEN 1930ERN VERSANKEN DIE USA LANGSAM IN DER DEPRESSION, WÄHREND IN EINEM NOCH UNTER DEN KRIEGSFOLGEN LEIDENDEN EUROPA BEREITS DIE SAAT FÜR EINEN NEUEN KRIEG GELEGT WURDE. In Spanien brach der Bürgerkrieg aus; Indien setzte seinen Kampf um Unabhängigkeit fort; Japan besetzte die Mandschurei, Italien okkupierte Äthiopien, während Deutschland seine Nachbarn ins Visier nahm. In Amerika wurde Franklin Delano Roosevelt mit seinem Programm eines New Deal zum Präsidenten gewählt. Allerdings gingen am Tag seiner Amtsübernahme die meisten Banken des Landes bankrott.

Das Radio, eine technische Erfindung der 20er, erlebte in den 30er Jahren einen regelrechten Boom, weil die Produzenten das Programm durchdacht gestalteten und Unterhaltung von Musik und Comedy bis hin zu Nachrichten und Sportberichterstattung anboten. Kinder lauschten den Fortsetzungsabenteuern von Cowboys, während ihre Mütter sich die Probleme und Sorgen der Charaktere von Seifenopern anhörten. In den späten Zwanzigerjahren hatte der aufkommende Ton im Kino die Stummfilmära beendet. Im Jahr 1930 besuchten allwöchentlich an die 85 Millionen Menschen die Kinos. Unterhaltung besaß nach wie vor hauptsächlich realitätsfernen Charakter – ob in Form von Busby Berkeleys erlesenen Bühnenmusicals bis hin zu Shirley Temples süßlichem Würgegriff um die Kinokassen. Greta Garbo gelang der Übergang zum Tonfilm erfolgreich, und Jean Harlow avancierte frech und unabhängig zum Sexsymbol des Jahrzehnts.

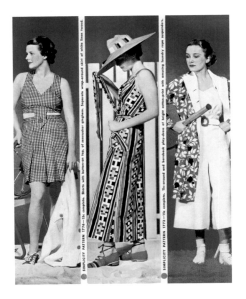

◄◄ Knapp-Felt Hats, 1930 Simplicity Patterns, 1935

Einen unvergleichlich romantischen Skandal erlebte das Jahrzehnt, als Englands neu gekrönter König Edward auf seinen Thron verzichtete, um 1936 die geschiedene Amerikanerin Wallis Simpson zu heiraten. Nachdem sie die Titel Herzog und Herzogin von Windsor angenommen hatten, wurde der aristokratische Lebensstil des Paares zum Synonym jener Dekade.

Die Silhouette der Männer war betont maskulin. Und ein guter Schneider schaffte es, mit breiten Schultern und schmalen Hüften die Figur des Schauspielers und Athleten Johnny Weissmueller nachzuempfinden. Zweireiher waren zunehmend gefragt, teilweise mit spitz zulaufenden Revers. Die Damen trugen lange, schmale Röcke, figurnahe Jacken und obligatorische Accessoires: Hüte, Handschuhe, Pelze, Schals, Handtaschen und Schuhe – tagsüber mit kleinem Absatz, am Abend turmhoch. Seit den 20ern entwickelten sich die Hüte ohne Krempen. Es gab solche ganz ohne und andere mit gefalteter Krempe, die das Gesicht umrahmte. Im weiteren Verlauf des Jahrzehnts wurden die Hüte aufwändiger, mit höherer Krone und breiterer Krempe. Exotischere Modelle waren zusätzlich mit Schleiern und Bändern verziert.

In Anlehnung an die Herrenmode begann die Designerin Elsa Schiaparelli die Schultern von Damenkostümen auszupolstern. 1931 trug die Tennisspielerin Lili de Alvarez einen von Schiapa-

1931

Charlie Chaplin dons signature bowler hat as "The Tramp" in *City Lights*

Charlie Chaplin trägt als Tramp in *Lichter der Großstadt* die unverwechselbare Melone

Dans *Les Lumières de la ville*, Charlie Chaplin arbore le fameux chapeau melon

1932

Katharine Hepburn wears trousers in debut film role; women wear pants

Katharine Hepburn trägt im Film Hosen; Frauen fangen an, Hosen zu tragen

Katharine Hepburn porte des pantalons dans un rôle au cinéma; les femmes la suivent

1933

Depression-era magazines publish tips for altering existing clothes

Zeitschriften zeigen während der Depression Tipps zum Ändern von Kleidung zu neuen Trends

Pendant la Grande Dépression, les vieux vêtements sont rajeunis à la mode du moment

elli kreierten Hosenrock. Im Jahr darauf spielte
der Tennischampion Henry „Bunny" Austin bei
den Herrenmeisterschaften der U. S. Open in New
York bereits in Shorts.

Das Spektrum der Damenmode – von ele-
gant geschnittenen Kostümen über fantasievolle
Dessous bis hin zu dramatischen Abendroben –
genoss in dem Film *Die Frauen* von 1939 Starkult.
Darin waren die Arbeiten des Hollywood-Kostüm-
bildners Adrian zu sehen, der sich oft Anregun-
gen bei den sinnlichen, schräg geschnittenen Sa-
tinroben der französischen Designerin Madeleine
Vionnet holte. In dem ansonsten in Schwarzweiß
gedrehten Film mit den Stars Norma Shearer, Joan
Crawford und Rosalind Russell gab es die in Farbe
aufgenommene Sequenz einer Modenschau.

Die glamourösen Trends auf der Leinwand
spiegelten aber natürlich nicht den Kleidungsstil
der breiten Masse Amerikas wider, wo die Arbeits-
losigkeit inzwischen 25 Prozent betrug. In den An-
zeigen für Arbeitskleidung – die die Haltbarkeit
und den günstigen Preisen der jeweiligen Marke
priesen – ließ sich die ökonomische Realität der
Großen Depression erkennen.

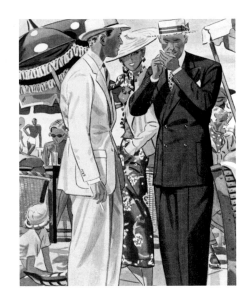

Priestley's Nor-East Suits, 1938

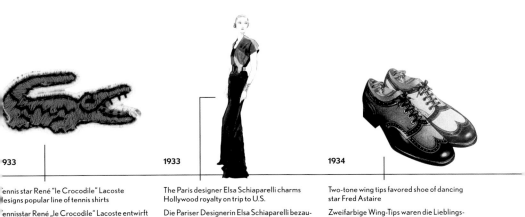

933

tennis star René "le Crocodile" Lacoste
designs popular line of tennis shirts

Tennisstar René „le Crocodile" Lacoste entwirft
eine erfolgreiche Kollektion von Tennishemden

a star du tennis René « le Crocodile » Lacoste
ance une ligne de chemises à succès

1933

The Paris designer Elsa Schiaparelli charms
Hollywood royalty on trip to U.S.

Die Pariser Designerin Elsa Schiaparelli bezau-
bert auf ihrer Amerikareise ganz Hollywood

Elsa Schiaparelli charme l'élite d'Hollywood
lors d'un voyage aux États-Unis

1934

Two-tone wing tips favored shoe of dancing
star Fred Astaire

Zweifarbige Wing-Tips waren die Lieblings-
schuhe des tanzenden Stars Fred Astaire

Star de la danse Fred Astaire privilégie les
chaussures bicolores à bout golf

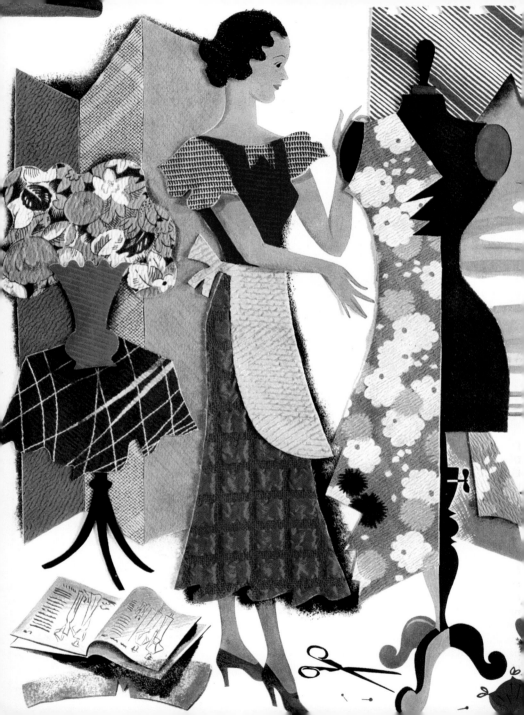

UNE DURE RÉALITÉ ÉCONOMIQUE

Cette période connaît un scandale romantique sans pareil quand, en 1936, le Roi Édouard d'Angleterre fraîchement couronné renonce au trône pour épouser Wallis Simpson, une Américaine divorcée. Sous les titres de Duc et Duchesse de Windsor, le coupe se distingue par un style aristocratique devenu synonyme des années 30.

PENDANT LES ANNÉES 30, LES ÉTATS-UNIS S'ENFONCENT LENTEMENT DANS LA GRANDE DÉPRESSION, TANDIS QUE LES GRAINES D'UNE AUTRE GUERRE GERMENT DANS UNE EUROPE ENCORE FRAGILISÉE PAR LA PRÉCÉDENTE. L'Espagne est en proie à la guerre civile ; l'Inde lutte toujours pour son indépendance ; le Japon envahit la Mandchourie ; l'Italie s'empare de l'Éthiopie ; l'Allemagne a des vues sur ses voisins. Aux États-Unis, Franklin Delano Roosevelt est élu président sur la base de son New Deal mais, le jour de son investiture, la plupart des banques nationales font faillite.

Nouvelle technologie inventée dans les années 20, la radio connaît un véritable boom pendant les années 30 quand les producteurs commencent à diffuser des programmes sophistiqués, de la musique à la comédie en passant par les actualités et le sport. Les enfants suivent les feuilletons relatant les aventures des cow-boys, tandis que leurs mères se passionnent pour les épreuves et les tribulations des personnages de soap-opéras. Le son, qui a fait son apparition dans les films à la fin de la décennie précédente, met un terme à l'ère du cinéma muet. En 1930, 85 millions de personnes se rendent au cinéma chaque semaine. Dans une large mesure, le monde du spectacle reste une façon d'échapper au quotidien, des comédies musicales élaborées mises en scène par Busby Berkeley à la prédominance au box-office d'une Shirley Temple à l'écœurante mièvrerie. Greta Garbo réussit le passage au film parlant et Jean Harlow définit les canons du sex-symbol de la décennie en femme effrontée et indépendante.

Cette période connaît un scandale romantique sans pareil quand, en 1936, le roi Édouard d'Angleterre fraîchement couronné renonce au trône pour épouser Wallis Simpson, une Américaine divorcée. Sous les titres de duc et duchesse de Windsor, le couple se distingue par un style aristocratique devenu synonyme des années 30.

Pour les hommes, la silhouette devient ouvertement masculine. Tout bon tailleur est capable de recréer le look de l'athlète sporty et acteur Johnny Weissmueller, avec ses larges épaules et ses hanches étroites. Le costume croisé gagne en popularité, parfois avec de larges revers ou revers à pointes. Pour les femmes, la jupe se porte longue et près du corps, la veste est ajustée et les accessoires sont de rigueur : chapeaux, gants, fourrures, foulards, sacs à main et chaussures, plates en journée, mais à talons hauts le soir. La forme cloche des chapeaux des années 20 évolue. Les visages s'encadrent de modèles sans bords ou à bords pliés. Au fil de la décennie, les chapeaux deviennent plus structurés et plus profonds avec des bords élargis. Les modèles plus exotiques comportent une voilette et sont gansés de ruban.

S'inspirant de la mode pour homme, la styliste Elsa Schiaparelli ajoute des épaulettes à ses tailleurs pour dame. En 1931, la joueuse de tennis Lili de Alvarez dispute le tournoi de Wimbledon dans une jupe fendue signée Schiaparelli. Un an plus tard, le champion de tennis Henry « Bunny » Austin joue en short au championnat des U. S. Open à New York.

Du tailleur ingénieusement flatteur à la lingerie fantaisie en passant par les spectaculaires robes du soir, toute la garde-robe féminine crève l'écran dans *Femmes*, un film de 1939 où s'exprime le talent d'Adrian, le chef costumier d'Hollywood qui s'inspire souvent des robes sensuelles en satin taillés en biais de la créatrice française Madeleine Vionnet. Ce film en noir et blanc avec Norma Shearer, Joan Crawford et Rosalind Russell inclut même une séquence de défilé de mode tournée en Technicolor.

Les tenues glamour du grand écran ne reflètent cependant pas la véritable garde-robe de l'Américaine de la rue, le taux de chômage atteignant 25 %. Faisant la réclame de la longévité des marques et de leurs prix abordables, ce sont les publicités pour les vêtements utilitaires, et non les tenues de soirée, qui reflètent la réalité économique de la Grande Dépression.

◄◄ McCall's Patterns, 1933 ► Jantzen Swimwear, 1937

1936

1936

1937

Open sandals transition from outdoor wear to evening wear

Offene Sandalen schaffen den Schritt von der Freizeit- zur Abendmode

Les sandales ouvertes délaissent les activités de plein air et s'intègrent aux tenues de soirée

Duke and Duchess of Windsor embody aristocratic style

Herzog und Herzogin von Windsor prägen den aristokratischen Stil des Jahrzehnts

Le duc et la duchesse de Windsor se marient et incarnent le style aristocratique de la décennie

Ray-Ban's aviators, developed for U.S. Air Force, released to public

Ray-Bans für die U.S. Air Force entwickelte Piloten-Sonnenbrille wird publik

Les lunettes de pilote de Ray-Ban sont commercialisées pour le grand public

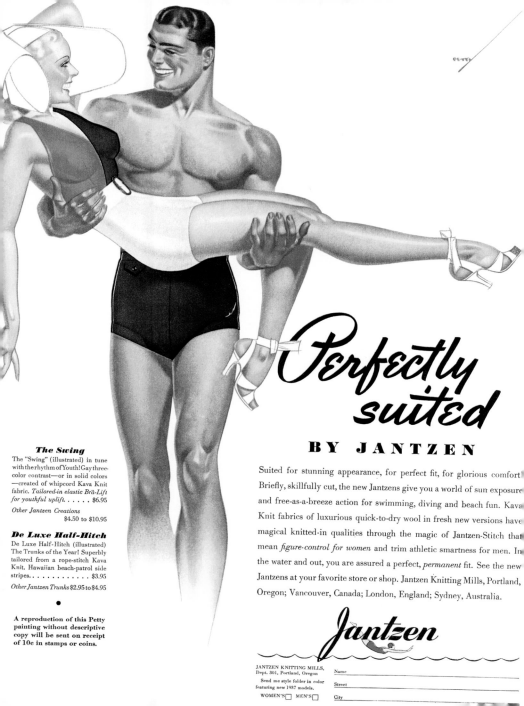

Perfectly suited

BY JANTZEN

The Swing
The "Swing" (illustrated) in tune with the rhythm of Youth! Gay three-color contrast—or in solid colors—created of whipcord Kava Knit fabric. *Tailored-in elastic Brä-Lift for youthful uplift.* $6.95

Other Jantzen Creations $4.50 to $10.95

De Luxe Half-Hitch
De Luxe Half-Hitch (illustrated) The Trunks of the Year! Superbly tailored from a rope-stitch Kava Knit. Hawaiian beach-patrol side stripes. $3.95

Other Jantzen Trunks $2.95 to $4.95

A reproduction of this Petty painting without descriptive copy will be sent on receipt of 10c in stamps or coins.

Suited for stunning appearance, for perfect fit, for glorious comfort! Briefly, skillfully cut, the new Jantzens give you a world of sun exposure and free-as-a-breeze action for swimming, diving and beach fun. Kava Knit fabrics of luxurious quick-to-dry wool in fresh new versions have magical knitted-in qualities through the magic of Jantzen-Stitch that mean *figure-control for women* and trim athletic smartness for men. In the water and out, you are assured a perfect, *permanent* fit. See the new Jantzens at your favorite store or shop. Jantzen Knitting Mills, Portland, Oregon; Vancouver, Canada; London, England; Sydney, Australia.

Jantzen

JANTZEN KNITTING MILLS, Dept. 301, Portland, Oregon

Send me style folder in color featuring new 1937 models.

WOMEN'S ☐ MEN'S ☐

Name _____

Street _____

City _____

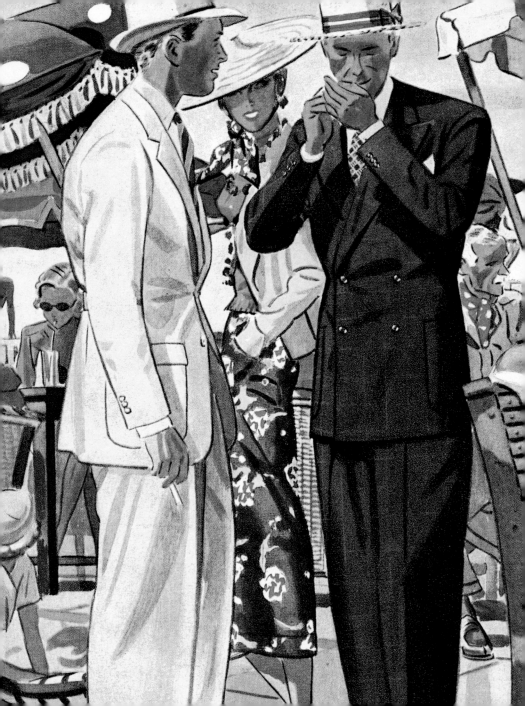

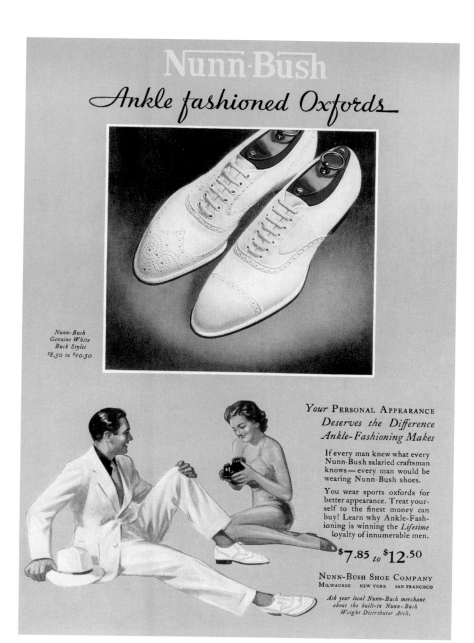

Nunn·Bush

Ankle fashioned Oxfords

Nunn-Bush
Genuine White
Buck Styles
$8.50 to $10.50

Your PERSONAL APPEARANCE
Deserves the Difference
Ankle-Fashioning Makes

If every man knew what every
Nunn-Bush salaried craftsman
knows — every man would be
wearing Nunn-Bush shoes.

You wear sports oxfords for
better appearance. Treat your-
self to the finest money can
buy! Learn why Ankle-Fash-
ioning is winning the *Lifetime*
loyalty of innumerable men.

$7.85 *to* $12.50

NUNN-BUSH SHOE COMPANY
MILWAUKEE NEW YORK SAN FRANCISCO

*Ask your local Nunn-Bush merchant
about the built-in Nunn-Bush
Weight Distributor Arch.*

◄ Priestley's Nor-East Suits, 1938 Nunn-Bush Shoes, 1937

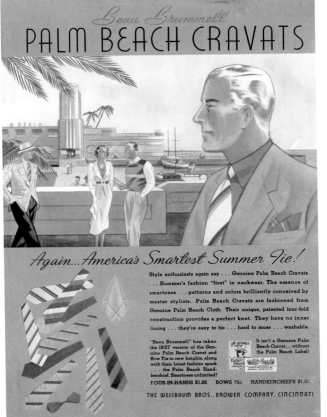

Weisbaum Bros. Ties, 1937

▸ Priestley's Nor-East Suits, 1939

The 1930s saw the birth of the summer-weight
suit, called the Palm Beach suit, in honor of the
resort town in Florida. Made of seersucker,
linen, shantung, or other lightweight fabrics,
these suits tended to be double-breasted and
featured open-notch lapels.

In den 1930ern kam erstmals der sommerlich
leichte sogenannte Palm-Beach-Anzug auf,
der nach dem Urlaubsort in Florida benannt
war. Aus Seersucker, Leinen, Shantung oder
anderen leichten Stoffen gefertigt waren diese
Anzüge meist zweireihig und mit eingeschnit-
tenem Revers versehen.

Les années 30 virent la naissance du costume
estival léger, baptisé le Palm Beach en hom-
mage à la station balnéaire de Floride. Taillés
dans du seersucker, du lin, de la soie shantung
ou d'autres tissus légers, ces costumes com-
portaient en général une veste croisée avec
revers à crans ouverts.

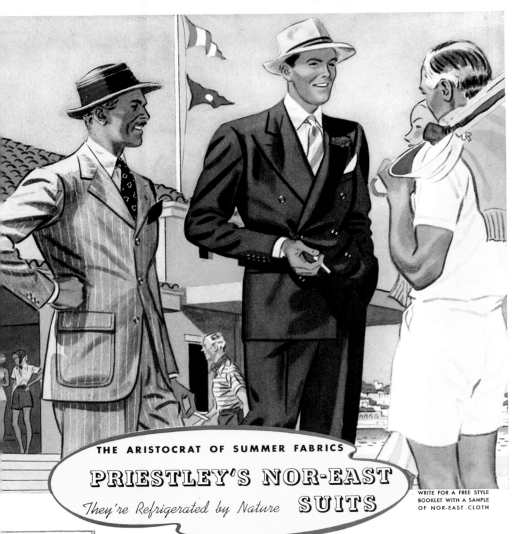

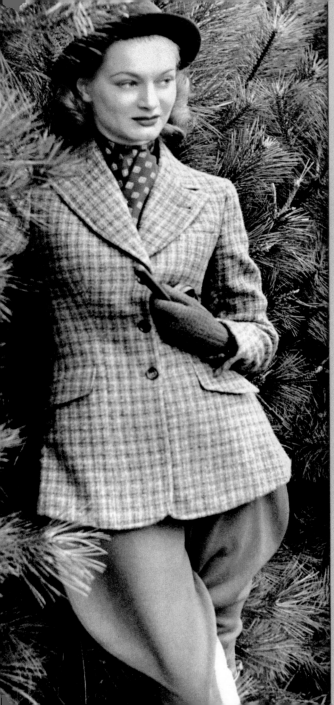

Promise....

*and fulfillment await the woman
just discovering the
telling power of figure beauty.
For her, the modern way of youthful
figure discipline...Foundettes.*

*There are glamour and good form
for figures in this new Foundette
pantie-girdle by MUNSINGWEAR.
The new feature "Lastex"* batiste
panel stretches up and down...
extends into a horizontal-stretch
yoke over the hips. Zipper in back;
net fabric sides of "Lastex"* and
"Cordura" Rayon. Style 4215. At all
better stores. *Woven or knit of
"Lastex" yarn.*

Foundettes
BY MUNSINGWEAR

Minneapolis New York

◄ Munsingwear Foundettes Undergarments, 1939

C. M. O. Womenswear, ca. 1938

Although Katharine Hepburn is the best-known actress to introduce trousers into the mainstream, many other Hollywood actresses were known for wearing pants, including Jean Harlow and Marlene Dietrich. The real world, however, was still far behind the silver screen, and it was uncommon for everyday women to don slacks for anything other than sporting occasions for several decades to come.

Obwohl Katharine Hepburn die wohl bekannteste Schauspielerin ist, die Hosen für die breite Masse tragbar machte, gab es auch viele andere Hollywooddarstellerinnen, die Hosen trugen, u. a. Jean Harlow und Marlene Dietrich. Die Realität blieb allerdings weit hinter der Leinwand zurück, und es sollte noch einige Jahrzehnte lang als unüblich gelten, dass normale Frauen zu anderen Anlässen als zum Sport lange Hosen anzogen.

Si l'on se souvient de Katharine Hepburn comme l'actrice qui a démocratisé le pantalon pour femme, bien d'autres comédiennes d'Hollywood étaient connues pour en porter, notamment Jean Harlow et Marlene Dietrich. La mode de la rue accusait néanmoins un grand retard sur celle du grand écran, et il fallut attendre plusieurs décennies avant que les femmes arborent le pantalon en dehors des activités sportives.

►► Arrow Shirts, 1935

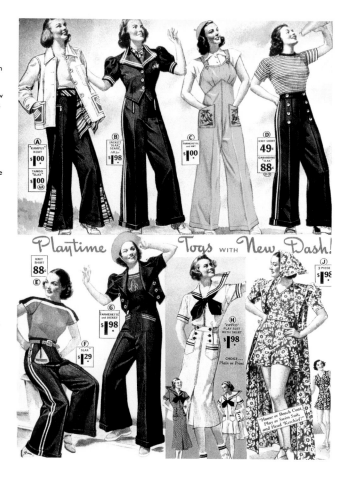

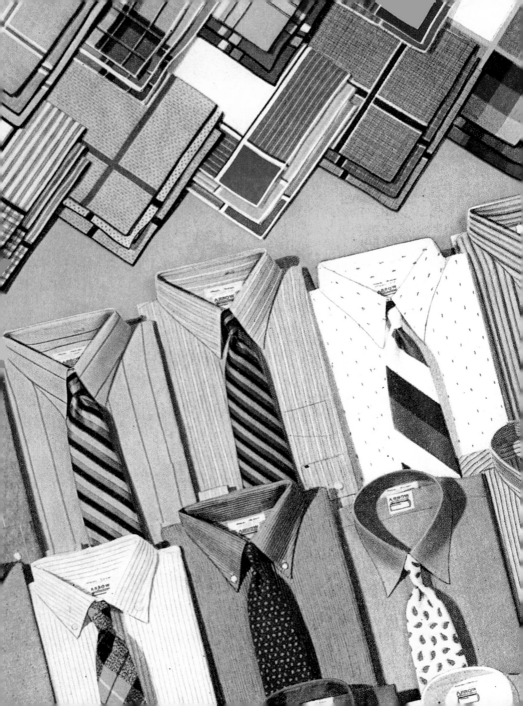

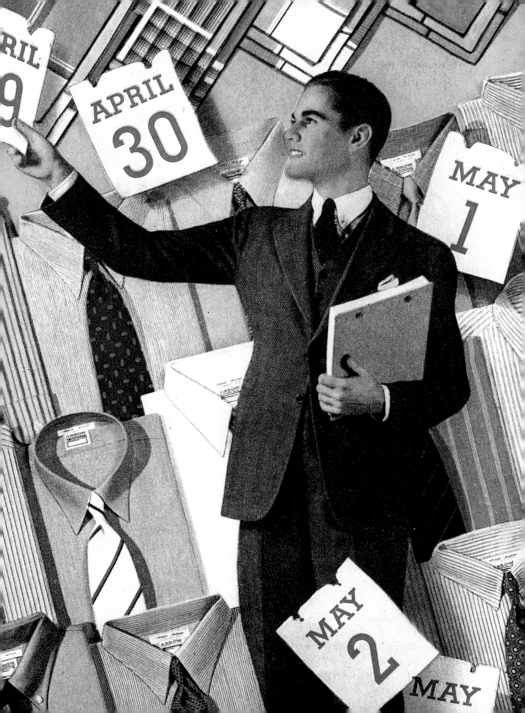

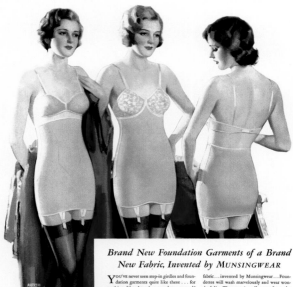

MUNSING *Wear* *presents* Foundettes

Brand New Foundation Garments of a Brand New Fabric, Invented by MUNSINGWEAR

YOU'VE never seen step-in girdles and foundation garments quite like these . . . for nothing like them has ever been created! Foundettes slim the hips, trim the waist, flatten the diaphragm and smooth the silhouette into smart and lovely lines. Yet, you've never worn anything quite so comfortable! Fashioned of specially processed two-way-stretch fabric . . . invented by Munsingwear . . . Foundettes will wash marvelously and wear wonderfully. They won't pull away from the seams or ravel back or curl. You'll like Munsingwear Foundettes for slimmer figures. And they're priced for slimmer purses. See these new Foundettes at a Munsingwear dealer near you. Munsingwear, Minneapolis.

Munsingwear makes all styles of smart undergarments in all types of fabrics. For men, women and children.

LET MUNSINGWEAR COVER YOU WITH SATISFACTION

Munsingwear Foundettes Undergarments, 1933

Famous for its men's one-piece union suits, Minneapolis-based Munsingwear Inc. was founded in 1886 as Northwestern Knitting Company. The company changed its name in 1923 and went on to grow its business through a series of acquisitions of other knitting mills and apparel makers. Eventually, the company grew to produce men's and children's underwear, sleepwear, and sportswear; and women's lingerie and sleepwear.

Die für ihre einteilige Herrenunterwäsche berühmte Munsingwear Inc. mit Sitz in Minneapolis wurde 1886 als Northwestern Knitting Company gegründet. 1923 änderte das Unternehmen seinen Namen und erweiterte sein Sortiment durch den Zukauf anderer Strickereien und Bekleidungshersteller. Schließlich umfasste die Produktion Unterwäsche, Nachtwäsche und Sportbekleidung für Herren und Kinder sowie Dessous und Nachtwäsche für Damen.

Réputée pour ses combinaisons longues pour homme, la société Munsingwear Inc. de Minneapolis fut fondée en 1886 sous le nom de Northwestern Knitting Company. Rebaptisée Munsingwear Inc. en 1923, elle diversifia ses activités en rachetant plusieurs manufactures de tricot et fabricants de vêtements. L'entreprise finit par produire des sous-vêtements, du pyjamas et du sportswear pour homme et pour enfant, ainsi que de la lingerie et des vêtements de nuit pour femme.

▶ Foot Saver Shoes, 1939

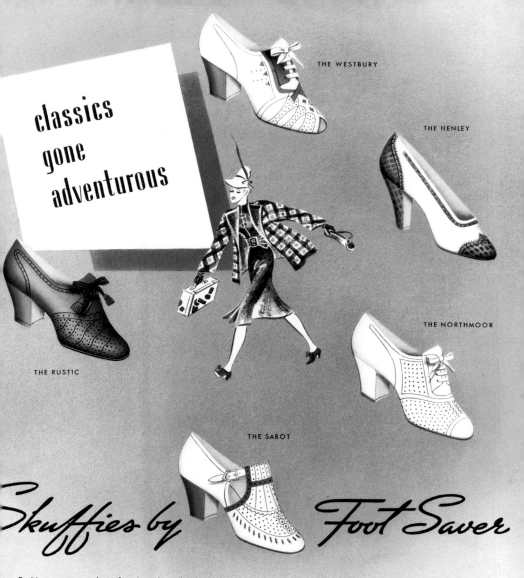

classics
gone
adventurous

THE WESTBURY

THE HENLEY

THE RUSTIC

THE NORTHMOOR

THE SABOT

Skuffies by *Foot Saver*

Exciting, unexpected perforations, bracelet buckles, sudden color at your instep! Foot Saver dramatizes the

classics, makes your walking shoes gay shoes—lighter, softer, smarter. All made over Foot Saver's won-

derful Shortback* Last that fits your foot like a stocking. No gap, no slip, no pinch! Write

for our Spring Fashion Folio and name of the store nearest you. The Julian & Kokenge Company,

makers of Foot Saver Shoes and Foot Saver Skuffies, 61 W. Main Street, Columbus, Ohio.

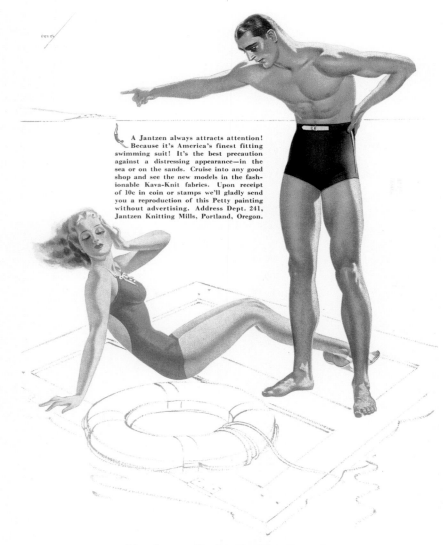

A Jantzen always attracts attention! Because it's America's finest fitting swimming suit! It's the best precaution against a distressing appearance—in the sea or on the sands. Cruise into any good shop and see the new models in the fashionable Kava-Knit fabrics. Upon receipt of 10c in coin or stamps we'll gladly send you a reproduction of this Petty painting without advertising. Address Dept. 241, Jantzen Knitting Mills, Portland, Oregon.

"One of us must flag that ship with our Jantzen"

Jantzen Swimwear, 193

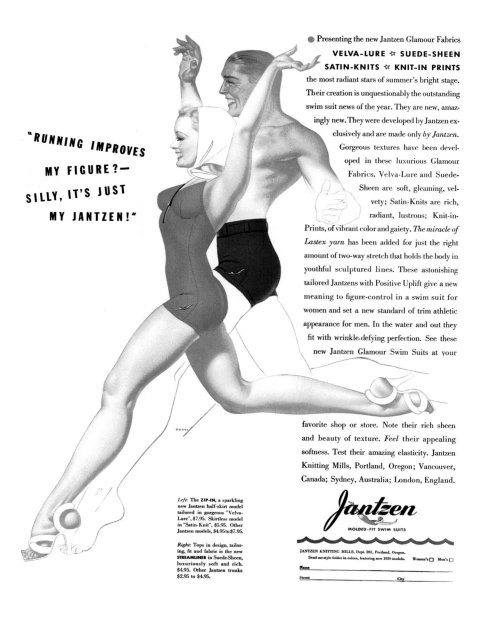

"RUNNING IMPROVES MY FIGURE?— SILLY, IT'S JUST MY JANTZEN!"

● Presenting the new Jantzen Glamour Fabrics

VELVA-LURE ☆ SUEDE-SHEEN SATIN-KNITS ☆ KNIT-IN PRINTS

the most radiant stars of summer's bright stage. Their creation is unquestionably the outstanding swim suit news of the year. They are new, amazingly new. They were developed by Jantzen exclusively and are made only *by Jantzen*. Gorgeous textures have been developed in these luxurious Glamour Fabrics. Velva-Lure and Suede-Sheen are soft, gleaming, velvety; Satin-Knits are rich, radiant, lustrous; Knit-in-Prints, of vibrant color and gaiety. *The miracle of Lastex yarn* has been added for just the right amount of two-way stretch that holds the body in youthful sculptured lines. These astonishing tailored Jantzens with Positive Uplift give a new meaning to figure-control in a swim suit for women and set a new standard of trim athletic appearance for men. In the water and out they fit with wrinkle-defying perfection. See these new Jantzen Glamour Swim Suits at your favorite shop or store. Note their rich sheen and beauty of texture. *Feel* their appealing softness. Test their amazing elasticity. Jantzen Knitting Mills, Portland, Oregon; Vancouver, Canada; Sydney, Australia; London, England.

Left: The **ZIP-IN**, a sparkling new Jantzen half-skirt model tailored in gorgeous "Velva-Lure", $7.95. Skirtless model in "Satin-Knit", $5.95. Other Jantzen models, $4.95 to $7.95.

Right: Tops in design, tailoring, fit and fabric is the new **STREAMLINER** in Suede-Sheen, luxuriously soft and rich. $4.95. Other Jantzen trunks $2.95 to $4.95.

Jantzen

MOLDED-FIT SWIM SUITS

JANTZEN KNITTING MILLS, Dept. 281, Portland, Oregon.
Send me style folder in colors, featuring new 1939 models. Women's ☐ Men's ☐

Name

Street City

Jantzen Swimwear, 1939

Exquisite colors . . wondrously lovely details of texture and finish . . Realsilk Hosiery pleases more women than any other hosiery sold! Perhaps because women have had a voice in its perfecting, during these ten years that Realsilk Hosiery has been sold to them by Realsilk Representatives in their own homes. Their comments . . suggestions . . have helped to make Realsilk the favorite hosiery of *chic* women everywhere. Why not see these smart stockings, sponsored by a Fashion Committee of five famous women, in your own home, with your shoes and frocks? Realsilk Hosiery is sold only by Realsilk Representatives who call at your home. Branch offices in 250 cities in the United States and Canada. The Real Silk Hosiery Mills, Inc., Indianapolis, Indiana, U. S. A.

Lady Egerton
Neysa McMein
Lynn Fontanne
Elinor Patterson
Katherine Harford
the Realsilk Fashion Committee . .

Ask the Realsilk Representative to show you Realsilk's newest, sheerest stocking—style 100—*invisibly* reenforced for wear with low cut sandals. If he is not calling at your home regularly, 'phone your local Realsilk office.

the new **REALSILK** hosiery

Real Silk Hosiery, 1930

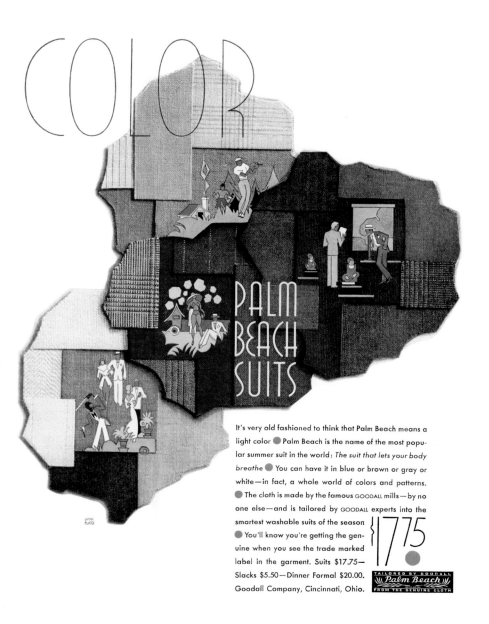

COLOR

PALM
BEACH
SUITS

It's very old fashioned to think that Palm Beach means a light color ● Palm Beach is the name of the most popular summer suit in the world: *The suit that lets your body breathe* ● You can have it in blue or brown or gray or white—in fact, a whole world of colors and patterns. ● The cloth is made by the famous GOODALL mills—by no one else—and is tailored by GOODALL experts into the smartest washable suits of the season ● You'll know you're getting the genuine when you see the trade marked label in the garment. Suits $17.75— Slacks $5.50—Dinner Formal $20.00. Goodall Company, Cincinnati, Ohio.

$17.75

TAILORED BY GOODALL
Palm Beach
FROM THE GENUINE CLOTH

Palm Beach Suits/Goodall Mills, 1938

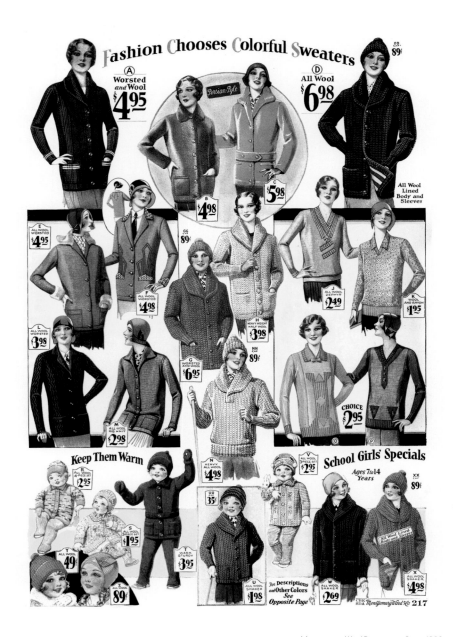

Fashion Chooses Colorful Sweaters

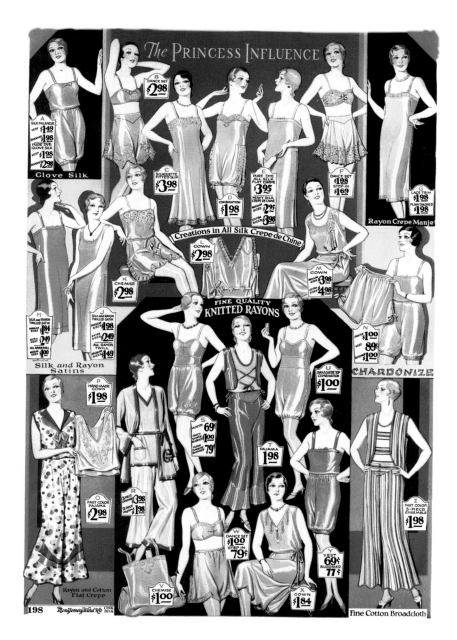

The PRINCESS INFLUENCE

A SILK MILANESE
VEST $1.49
BLOOMERS $1.98
PURE DYE GLOVE SILK
VEST $1.98
BLOOMERS $2.95
Glove Silk

B DANCE SET $2.98

C SILHOUETTE FITTED SLIP $3.98

D COMBINATION $1.98

E PURE DYE ALL SILK FLAT CREPE $3.95
HEAVY SILK CREPE DE CHINE
REGULAR SIZES $2.95
EXTRA SIZES $3.98

F DANCE SET $1.98
STEP-IN $1.69

G LACE TRIM $1.98
PLAIN TAILORED $1.98
Rayon Crepe Manje

Creations in All Silk Crepe de Chine

K CHEMISE $2.98

L GOWN $2.98

M GOWN $3.98
EXTRA SIZES $4.98

H SILK and RAYON TWILLED SATIN
REGULAR SIZES $1.84
EXTRA SIZES $1.00
ALL RAYON TWILL REGULAR SIZES $1.00

J SILK AND RAYON TWILLED SATIN
REGULAR SIZES $1.98
EXTRA SIZES $2.49
ALL RAYON TWILL REGULAR SIZES $1.49
Silk and Rayon Satins

N $1.00
VEST 89¢
$1.00

FINE QUALITY KNITTED RAYONS

U BRASSIERE TOP COMBINATION $1.00

CHARDONIZE

P HAND MADE GOWN $1.98

S VESTETTE 69¢
FANCY BLOOMERS $1.00
PLAIN BLOOMERS 79¢

T PAJAMA $1.98

O FAST COLOR PAJAMA $2.98
Rayon and Cotton Flat Crepe

R 3 PIECE PAJAMA $3.98
2 PIECE PAJAMA $1.98

W DANCE SET $1.00
STEP IN 79¢

X GOWN $1.84

Y VEST 69¢
BLOOMER 77¢

Z FAST COLOR 3-PIECE ENSEMBLE $1.98

V CHEMISE $1.00

Fine Cotton Broadcloth

198 Montgomery Ward & Co CBK SDA

Montgomery Ward Department Store, 1930

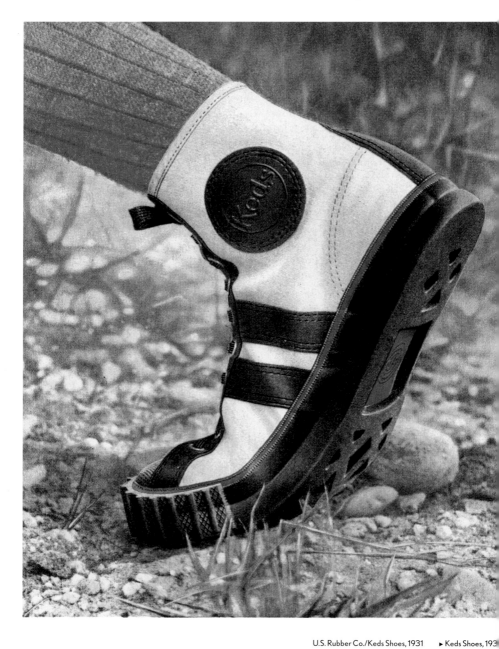

U.S. Rubber Co./Keds Shoes, 1931 ▸ Keds Shoes, 193

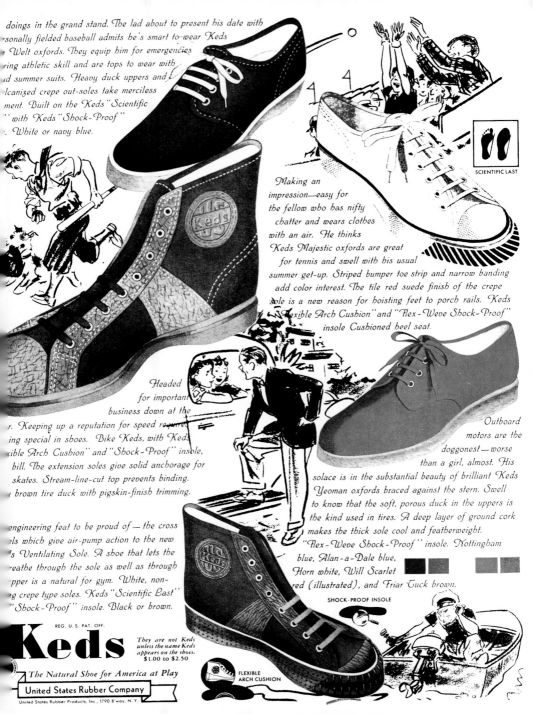

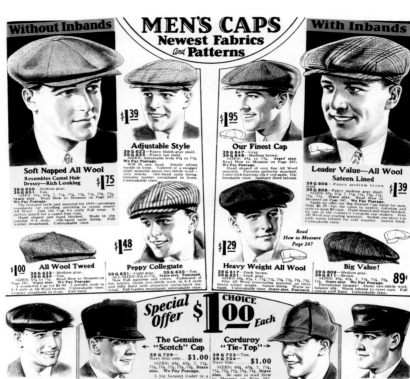

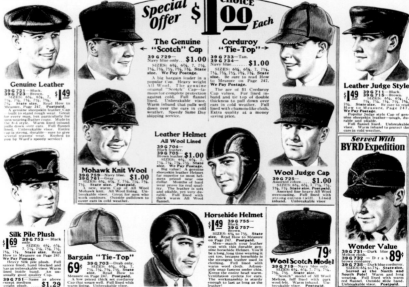

Montgomery Ward Department Store, 1930 ▶ Knox Hats, 1939

Exclusive
Interpretations of the
Ruling Fashion

KNOX

Semi-Sport Hats

FOR TOWN AND COUNTRY

KNOX THE HATTER
Fifth Avenue at 40th Street

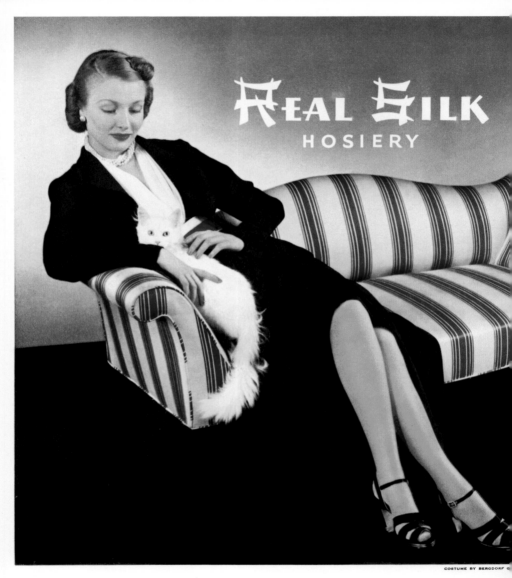

REAL SILK
HOSIERY

COSTUME BY BERGDORF G

Our Shop-at-Home Service makes it easier for women to buy—Realsilk Representatives call on you—no shopping

—no parking worry . . . ***Our Way*** of manufacturing stockings makes them more economical for women to buy—pure, fresh

more snag-resistant twist—best and most permanent dyes . . . ***These qualities*** every time mean longer average

World's largest manufacturer of silk hosiery for men and women.
Real Silk Hosiery Mills, Inc., Indianapolis, Ind. Branch Sales Offices in 200

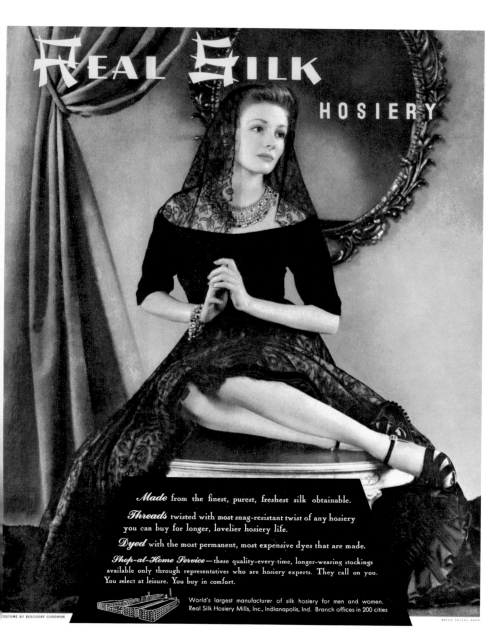

Made from the finest, purest, freshest silk obtainable.

Threads twisted with most snag-resistant twist of any hosiery you can buy for longer, lovelier hosiery life.

Dyed with the most permanent, most expensive dyes that are made.

Shop-at-Home Service—these quality-every-time, longer-wearing stockings available only through representatives who are hosiery experts. They call on you. You select at leisure. You buy in comfort.

World's largest manufacturer of silk hosiery for men and women. Real Silk Hosiery Mills, Inc., Indianapolis, Ind. Branch offices in 200 cities

ANTON BRUEHL PHOT.

◄ Real Silk Hosiery, 1939 Real Silk Hosiery, 1939

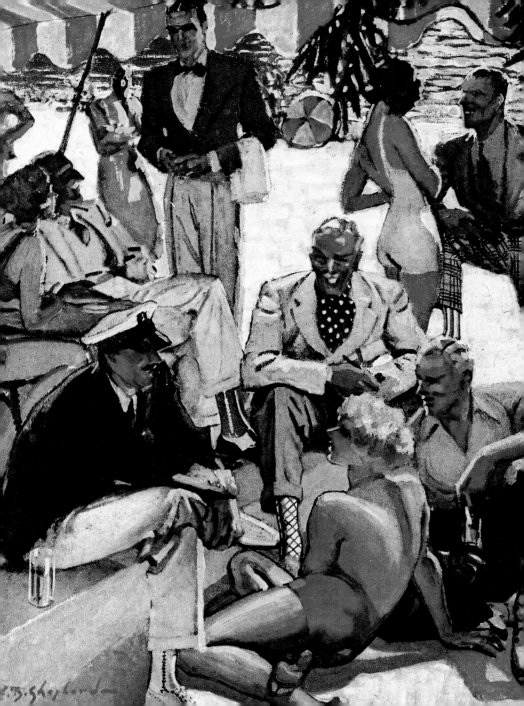

◄ Interwoven Socks, 1934

Puritan Skiwear, 1939

Skiing has a long history in Scandinavian coun-
tries, but in the 1930s the sport was still relatively
new in the U.S. Downhill and combined slalom
events were first added to the Olympic Games
in Garmisch-Partenkirchen, Germany, in 1936.
Aimed at a burgeoning amateur ski market, this
Puritan advertisement touts its skiwear's use of
rayon, a fabric invented in the mid-19th century
as an "artificial silk," which is not typically consid-
ered to be a cold-weather fabric.

Das Skifahren hat in den Ländern Skandina-
viens lange Tradition, in den 1930er Jahren
war es in den USA allerdings noch ein relativ
junger Sport. Abfahrt und Kombinationsslalom
standen erstmals bei den Olympischen Spielen
1936 in Garmisch-Partenkirchen auf dem
Programm. Der wachsenden Zielgruppe der
Amateurskifahrer verkündet diese Werbung
von Puritan, dass man für seine Skibekleidung
Rayon verwendet. Der Stoff wurde Mitte des
19. Jahrhunderts als eine Form von „Kunst-
seide" erfunden und galt nicht gerade als prä-
destiniertes Material für kalte Temperaturen.

Pratiqué depuis longtemps dans les pays
scandinaves, le ski était un sport relativement
nouveau aux États-Unis dans les années 30.
Les premières compétitions olympiques de
descente et de slalom eurent lieu aux Jeux
de Garmisch-Partenkirchen en Allemagne
en 1936. Ciblant le marché émergent des
amateurs de ski, cette publicité de Puritan pro-
mouvait ses vêtements de ski en rayonne, un
tissu inventé au milieu du 19ème siècle comme
une « soie artificielle » qui, pourtant, n'était
généralement pas considéré comme adapté
aux climats froids.

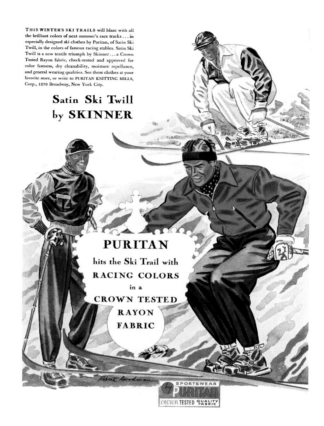

THIS WINTER'S SKI TRAILS will blaze with all
the brilliant colors of next summer's race tracks . . . in
especially designed ski clothes by Puritan, of Satin Ski
Twill, in the colors of famous racing stables. Satin Ski
Twill is a new textile triumph by Skinner . . . a Crown
Tested Rayon fabric, check-tested and approved for
color fastness, dry cleanability, moisture repellance,
and general wearing qualities. See these clothes at your
favorite store, or write to PURITAN KNITTING MILLS,
Corp., 1270 Broadway, New York City.

Satin Ski Twill
by SKINNER

PURITAN
hits the Ski Trail with
RACING COLORS
in a
CROWN TESTED
RAYON
FABRIC

SPORTSWEAR
by PURITAN
CROWN TESTED QUALITY FABRIC

C. M. O. for Gay Variety in Smart New

TOPPERS

• SMART STYLES • SMART LENGTHS • SMART SHADES

C
ALL-WOOL SMARTOWNE SUEDE
$5.98

B
Voguish SHAG-FLEECE
$4.98

A
Popular CHARMOOR-FLEECE
$3.98
RAY-BEST LINED

E
Fine, Soft ALL-WOOL SHAG-FLEECE
$7.98
RAY-BEST LINED

F
Popular CHARMOOR-FLEECE
$4.98
RAY-BEST LINED

FOR DESCRIPTIONS PLEASE SEE OPPOSITE PAGE

G
ALL-WOOL SHAG-FLEECE
$5.98
RAY-BEST LINED

C. M. O. Toppers, ca. 1938

Designer Elsa Schiaparelli was one of several expat European designers living and working in the United States. A friend of artists Salvador Dalí, Man Ray, and Jean Cocteau, Schiaparelli designed avant-garde apparel with details that had an uncanny knack for filtering into the mainstream. Among "Schiap's" inventions: the padded shoulder.

Die Designerin Elsa Schiaparelli war eine von vielen emigrierten europäischen Modeschöpfern, die in den Vereinigten Staaten lebten und arbeiteten. Als Freundin von Künstlern wie Salvador Dalí, Man Ray und Jean Cocteau entwarf Schiaparelli Avantgarde-Mode mit Details, die verblüffend oft ihren Weg in den Massengeschmack fanden. Eine von „Schiaps" Erfindungen: Schulterpolster.

Elsa Schiaparelli compta parmi les couturiers qui fuirent l'Europe pour venir vivre et travailler aux États-Unis. Amie des artistes Salvador Dalí, Man Ray et Jean Cocteau, elle conçut des vêtements avant-gardistes dont les détails réussirent à s'infiltrer dans la mode du quotidien. Parmi les inventions d'Elsa Schiaparelli: l'épaulette.

▶ Nettleton Shoes, 1936

They never tread the beaten path

As mass manufacture reduces more and more things to a dead level of similarity, the product of individual craftsmanship stands out in sharp relief. Fine leather working is not a lost art in the making of Nettleton Shoes. They, like the men who wear them, reflect character which does not tread the beaten path. A. E. Nettleton Co., H. W. Cook, Pres., Syracuse, N.Y.

The ALGONQUIN
Hand-sewed vamp. Remarkably comfortable. An exclusive Nettleton Pattern. Ten Dollars

Nettleton

GENTLEMEN'S FINE SHOES
PRICED TEN TO TWENTY DOLLARS

TRY THE PENCIL TEST

UNNECESSARY EMBARRASSMENT

Number 742

SHUGLOV—Alligator Zipper Model—exact replica in light, supple rubber of the pattern and color of alligator! Genuine Talon Fastener.

CAN you tell *galoshes* from *shoes*, when you see them? The answer to that of course, is "don't be silly."

But it's a hundred to one, the first time you see the new Shuglovs you'll think they are really *leather* shoes!

For they look like *leather* and they *fit* like shoes!

There's one model that's for all the world like fine *kid*; another you'll be sure is made of alligator skin, till you weigh its feather lightness in your hand. (These leather effects are obtained by the patented Textran process exclusive with Goodrich.)

This year it will be just as embarrassing to appear in the typical clumsy old "galosh" as it would be to wear your grandmother's poke bonnet with a smart fall suit!

One glimpse of Shuglovs and you'll *have* to have a pair. Maybe two!

. . . and you'll find them as trim and comfortable as they are smart. They slip over your shoes as smoothly as a kid glove slips over your hand.

Another surprise about Shuglovs! That unpleasant *rubber-smell* simply isn't there. It's gone, completely. In its place is just a hint of a pleasing delicate scent!

Choose your Shuglovs now — don't let the next rainstorm catch you without smart wet-weather footwear!

Shuglov

by GOODRICH

**LIGHT AS AN EVENING SLIPPER
FITS LIKE A KID GLOVE**

6 inches of snow on the day of An... tea! You dig out your old galoshes...

You'd forgotten how bulgy they we... Oh, well, galoshes don't matter. . . .

You meet Janet. Can those slim thin... she's wearing be galo-hes?

You meet Nancy. And discover ... galoshes, too, have that slick, pou... in look. One of life's embarrass... moments you're NOT going to repe...

Well, give your galoshes to the l... dress and get a pair of Shuglovs!

THERE ARE MANY OTHER STYLES OF GOODRICH WATERPROOF FOOTWE...
ZIPPERS • SHOWER BOOTS • LIGHT RUBBERS • FOR ALL THE FAMI...

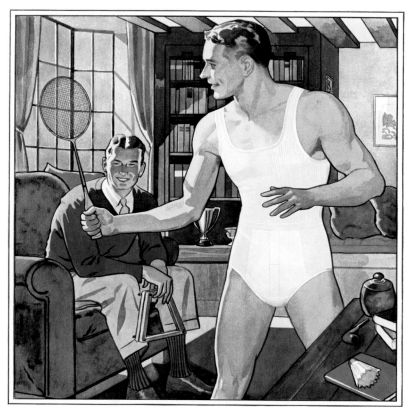

THEY FEEL RIGHT—A WELL-BALANCED RACQUET
AND THIS WELL-CUT *Skit-Suit*

HERE'S cool comfort and body ease you've never had before. SKIT-Suits by Munsingwear that look like shirts and shorts—so brief you don't know you're wearing them—so expertly cut and tailored they can't bag or bunch. And note the three special comfort features... no-gap buttonless fly ... elastic leg-openings and waist band ... full seat coverage with elastic drop seat. Treat yourself to perfect comfort with SKIT-Suits. Also "by Munsingwear" is a complete line for men . . . SKIT-Shorts, fancy shorts, knit underwear of every type as well as smart sox. Treat yourself to comfort and quality by asking for "Munsingwear." At quality stores.

MUNSINGWEAR, Minneapolis.

Goodrich Footwear, 1932 Munsingwear Underwear, 1937

This is a BOW TIE *year!*

IN HOLLYWOOD, Palm Beach and Broadway—the *bow* tie is unmistakably *the* tie style. And how fortunate for mankind that this week—and each succeeding week—you'll see a pronouncedly larger number of young men wearing smart bow ties.

In the first place, a bow tie is the most sensible tie any man can wear. It is truly correct. It is jaunty. A horizontal dash of tie-color is the dominant note of man's otherwise drab attire—and it relieves the monotony of vertical lines. It registers alertness. It breathes good grooming. It brings out the best in any man's face. It's on in a jiffy and amazingly comfortable with soft, semi-soft or starched collar.

The smartest bow ties are Spur Ties—the choice of millions. Tied by expert feminine fingers—they stay tied. And that secret of the phenomenal success of Spur Tie—the concealed, patented "Innerform" —permits you to adjust the wings to suit your *personal* fancy. You owe it to yourself to wear a Spur Tie—the smartest tie that ever set tie style. Step into a young men's store today and see those wonderful new spring Spur Tie colors and patterns —the smartest and most sensible ties that ever adorned masculine necks.

JOHN BOLES
Star in the Universal Picture Triumph "La Marseillaise"

John Boles, "The Golden Tenor of the talking screen," caps his great successes in "The Desert Song" and "Rio Rita" with "La Marseillaise"—the story of the song that inflamed a nation to red revolt and triumph. Laura LaPlante is the co-star in this burning love story.

Insist that the Spur Tie red label shown above is on every tie and avoid inferior imitations. You can shape a Spur Tie in any way you like—fluffy or flat, severe or sportive—and the patented H-shaped Innerform holds it that way.

FREE
You'll enjoy this fascinating little book, "Off the Lot." Full of charming photographs. All about motion picture stars. For your copy write to Hewes & Potter, Inc., 65-SB Bedford Street, Boston, Massachusetts.

Spur Tie

50¢ 75¢ $100
TIED BY HAND · · · IT STAYS TIED

Spur Tie Bowties, 193

CORONATION
Action BAK *Braces*

LONDON STYLE...LUXURIOUS COMFORT

Sheer splendor...with deep regard for the proper thing!...that's the Coronation —the inspiration for the Hickok styles of the season. Correct color schemes of royal richness. Jewelry-like fittings ... all incorporated with matchless *ActionBAK* comfort —exclusively Hickok.

Unhampered *action*—you move as you please and *ActionBAK* smoothly conforms. No nagging pull at hips or shoulders—no sagging trousers. This faultless service lasts, and *ActionBAK* style stays "like new" —because of Hickok long-life webbing, and extra-durable cable elastic cords. You will want more than just one pair of Hickok *ActionBAK* braces. HICKOK, Rochester, N.Y.

HICKOK
Action BAK *Braces*

BELTS · BUCKLES · BRACES · GARTERS · JEWELRY

STYLE LEADERSHIP

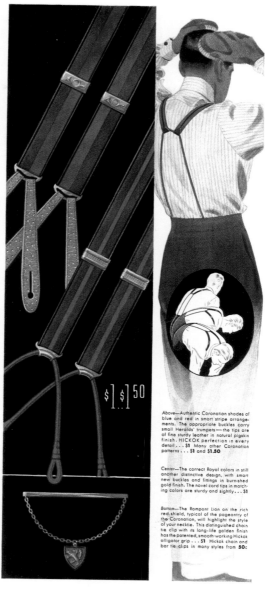

$1 .. $1 50

Above—Authentic Coronation shades of blue and red in smart stripe arrangements. The appropriate buckles carry small Heralds' trumpets—the tips are of fine sturdy leather in natural pigskin finish. HICKOK perfection in every detail...$1 Many other Coronation patterns...$1 and $1.50

Center—The correct Royal colors in still another distinctive design, with smart new buckles and fittings in burnished gold finish. The novel cord tips in matching colors are sturdy and sightly...$1

Bottom—The Rampant Lion on the rich red shield, typical of the pageantry of the Coronation, will highlight the style of your necktie. This distinguished chain tie clip with its long-life golden finish has the patented, smooth-working Hickok alligator grip...$1 Hickok chain and bar tie clips in many styles from **50c**

Hickok Braces, 1937

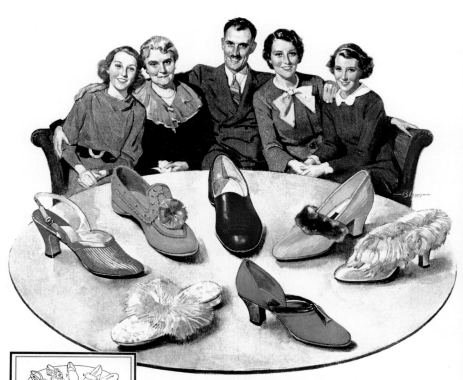

DANIEL GREENS make *Better* gifts

BECAUSE DANIEL GREEN MAKES BETTER SLIPPERS

WHEN people find DANIEL GREEN on the sole of a slipper they know you want them to have the best.

Everyone knows what the name Daniel Green means, not only because it has been famous for fifty years but because it guarantees that a slipper is the finest quality.

Nothing but the best goes into the

making of a Daniel Green . . . and there is a smart style, a perfect fitting size, and a favorite color for every person on your list, man or woman, young or old.

Just to show how easy a Daniel Green dealer can make your shopping, a few of the most popular styles for Christmas gifts are shown and described here.

LOOK FOR THE NAME — NONE GENUINE WITHOUT IT

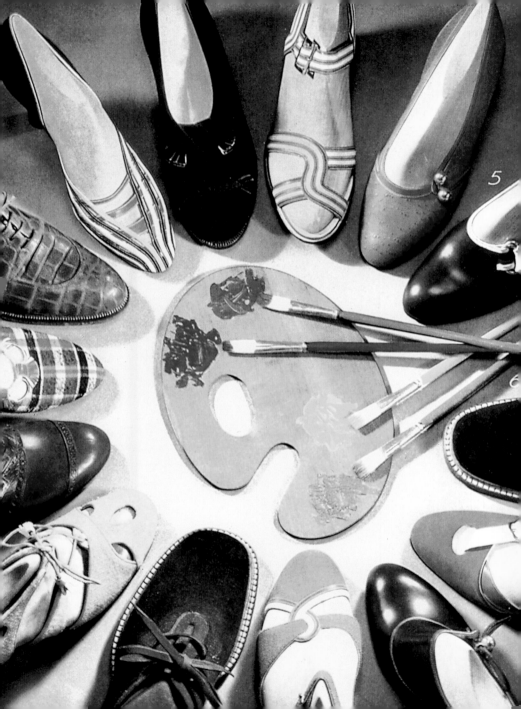

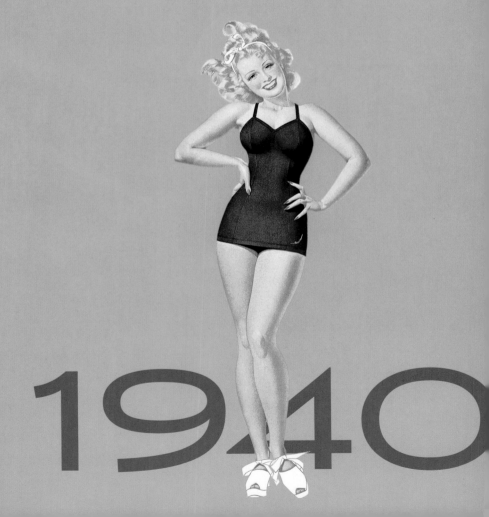

"WITHOUT FOUNDATION
THERE CAN BE NO FASHION."
– CHRISTIAN DIOR

1940

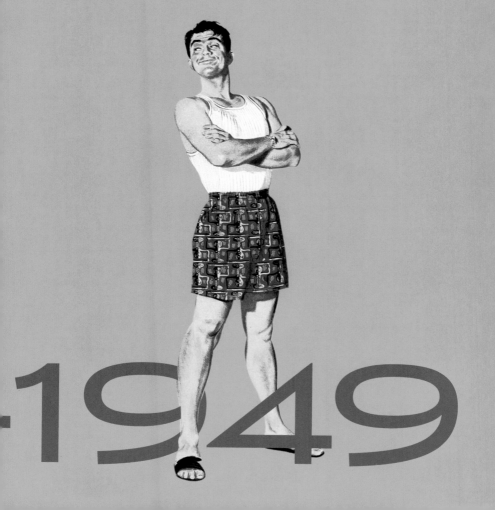

„ES GIBT KEINE MODE
OHNE GRUNDLAGE."
– CHRISTIAN DIOR

«PAS DE MODE SANS
SOUS-VÊTEMENTS.»
– CHRISTIAN DIOR

1949

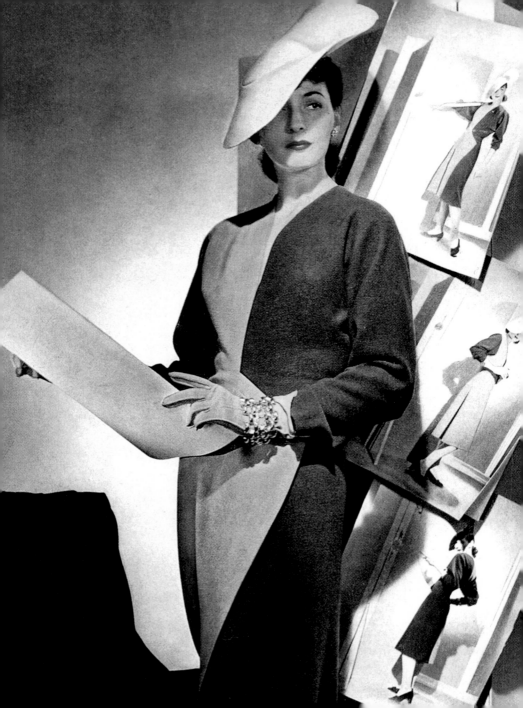

A WORLD WAR
AND A NEW LOOK

*After the war, Paris designer Christian Dior
wisely calculated that returning veterans would
be picturing an idealized woman waiting back
home — and women, many of whom had been
working or serving in the armed forces, were
eager to return to a more feminine look.*

1940S FASHIONS WERE, BY AND LARGE, CONSTRAINED BY TURBULENT TIMES. War
between England and Germany began in 1939, and, in 1941, Japan bombed Pearl Harbor, bring-
ing the Japanese and Americans into the conflict. Until then, Paris had remained the undis-
puted center of fashion, but with the start of the war, many designers, including Chanel, closed
shop. Mainbocher, the designer of the Duchess of Windsor's wedding dress, moved to New York,
where he continued designing his own collection, as well as uniforms for the Girl Scouts, the
Red Cross, and the WAVES (the U.S. Navy's women's corps).

Americans had plenty of local talent as well, including Hattie Carnegie, Norman Norell, and
Claire McCardell, the inventor of American sportswear, whose introductions to the fashion lexicon
include mix-and-match separates and the ballet-slipper flat.

Although the Oscar-winning film *Gone with the Wind* was ostensibly a period piece, styles
from the blockbuster film had made their way into fashions. Vivien Leigh's bonnets, trimmed in
ribbons, feathers, and lace veils, were designed by John P. John under his label John-Frederics, and
they provided inspiration for modern-day women, as did Leigh's rolled hairstyle and snoods.

If the emphasis in the 1920s was on the collegiate set, by the 1940s the notion of the "youth
market" was considerably younger. In the popular Andy Hardy movies, a teenage Mickey Rooney
was winning fans — as his character won over co-stars Judy Garland, Lana Turner, and Ava Gardner.

Crooner Frank Sinatra was drawing crowds of swooning fans dubbed "bobby-soxers" because o their short socks and saddle shoes. *Seventeen* magazine was introduced in 1944 to cater to the tee market, and *Harper's Bazaar* launched its own teen magazine, called *Junior Bazaar*.

During the war, manufacturers were under strict materials-rationing guidelines, putting an en to dramatic but wasteful features such as hoods and shawls, full skirts, wide belts, and cuffed coa sleeves. The use of zippers and metal fasteners was also curtailed, which gave rise to new innovations like the wraparound skirt. Rationing also led to the concept of "day-to-night" dressing. And th shortage of nylon for stockings inspired a short-lived leg-makeup trend — seams were drawn on with an eyebrow pencil. Indeed, the 1940s was a great time for fads. For women, there were turbans, sailo hats, and adhesive "beauty marks" made from tiny bits of cut silk. For teens, there were army boots fo boys and rolled blue jeans and oversize men's shirts for girls.

The mood of women's fashion in the war years reflected the mood of the country: sensible and austere. But after the war, Paris designer Christian Dior wisely calculated that returning veteran would be picturing an idealized woman waiting back home — and women, many of whom had bee working or serving in the armed forces, were eager to return to a more feminine look. Dior's firs postwar collection, in 1947, is the one he is best remembered for. The look was a radical departure with longer, fuller skirts; soft-shouldered jackets that emphasized a padded bust; and a tiny, corseted wasp waist — all atop pointed-toe, spike-heel shoes. *Harper's Bazaar* editor Carmel Snow dubbed i the "New Look".

◄◄ Forstmann Woolen Co., 1941 ► Worumbo Fabric/Eagle Clothes/Lo Balbo Coats, 194

1940

Nylon stockings available to American women nationwide

Nylonstrümpfe gibt es für Frauen in ganz Amerika zu kaufen

On trouve désormais des bas en nylon à travers tous les États-Unis

1942

American women serve war effort as Women Airforce Service Pilots (WASPs)

Amerikanerinnen leisten Kriegsdienst als Women Airforce Service Pilots (WASPs)

Les Américaines participent à l'effort de guerre en tant que pilotes WASP

1943

Frank Sinatra's teenage fans dubbed "bobby-soxers"

Frank Sinatras Teenager-Fans werden „bobby-soxers" genannt

Les adolescentes fans de Frank Sinatra sont surnommées les « bobby-soxers »

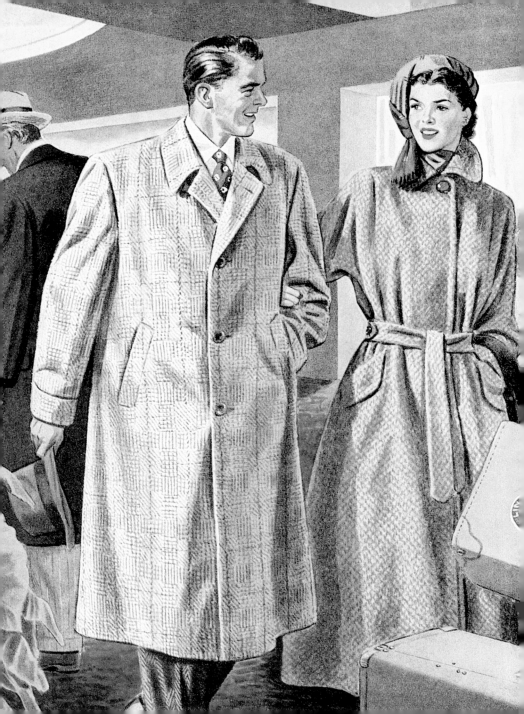

DER ZWEITE WELTKRIEG UND DER NEW LOOK

Nach dem Krieg, so hatte der Pariser Designer Christian Dior weise vorhergesehen, würden die heimkehrenden Veteranen sich eine idealisierte Frau ausmalen, die sie zu Hause erwartete. Und die Frauen, von denen viele berufstätig waren oder bei den Streitkräften gedient hatten, waren ebenfalls bestrebt, zu einem feminineren Look zurückzukehren.

DIE MODE DER 1940ER JAHRE WAR IM GROSSEN UND GANZEN VON DEN HERRSCHENDEN SCHWEREN ZEITEN BESTIMMT. DER KRIEG ZWISCHEN ENGLAND UND DEUTSCHLAND BEGANN 1939; 1942 BOMBARDIERTE JAPAN PEARL HARBOR, was zum offenen Konflikt zwischen Japanern und Amerikanern führte. Bis dahin hatte Paris als unangefochtenes Zentrum der Mode gegolten. Mit Kriegsbeginn schlossen jedoch viele Designer, darunter auch Chanel, ihre Läden. Mainbocher, der das Hochzeitskleid der Herzogin von Windsor entworfen hatte, verlegte seinen Wohnsitz nach New York, wo er weiterhin seine eigene Kollektion kreierte, aber auch Uniformen für die Pfadfinderinnen, das Rote Kreuz und für WAVES (das weibliche Freiwilligenkorps der US-Marine) designte.

In Amerika gab es allerdings auch zahlreiche einheimische Talente wie Hattie Carnegie, Norman Norell und Claire McCardell, die Erfinderin der amerikanischen Sportswear, die sich unter anderem mit kombinierbaren Basics und den flachen Ballerinas einen Platz in den Modelexika sicherte.

Auch wenn der Oscar-prämierte Blockbuster *Vom Winde verweht* offensichtlich ein Historienfilm war, schafften es einige modische Trends aus dem Kassenschlager in die aktuelle Mode. Vivien Leighs mit Bändern, Federn und Spitzenschleiern verzierte Hauben waren Entwürfe von John P. John für sein Label John-Frederics; sie dienten modernen Frauen ebenso als Inspiration wie Leighs Lockenfrisuren und Haarnetze.

Während sich die 1920er noch eher studentisch präsentierten, war das Verständnis des „jugendlichen Marktes" in den Vierzigern ein deutlich jüngeres. In den beliebten Filmen von Andy Hardy eroberte der Teenager Mickey Rooney die Herzen der Fans wie auch die seiner Co-Stars Judy Garland, Lana Turner und Ava Gardner. Der singende Frank Sinatra lockte massenhaft in Ohnmacht fallende Fans an, die man wegen ihrer kurzen Socken und Sattelschuhe „bobby soxers" nannte. 1944 kam speziell für das Teenager-Publikum die Zeitschrift *Seventeen* auf den Markt; und *Harper's Bazaar* lieferte mit *Junior Bazaar* sein eigenes Teenager-Magazin.

Während des Krieges waren die Hersteller strikten Rationierungsvorschriften unterworfen, die verschwenderischen Effekten mit dramatischer Wirkung wie Kapuzen und Schals, weiten Röcken, breiten Gürteln oder Ärmelaufschlägen ein Ende machten. Die Verwendung von Reißverschlüssen und metallenen Haken und Ösen war ebenfalls eingeschränkt, was Spielraum für Innovationen wie den Wickelrock bot. Die Rationierung förderte auch das Konzept einer Garderobe, die „von morgens bis abends" tragbar war. Der Mangel an Nylon für Strümpfe brachte einen kurzlebigen Make-up-Trend hervor – mit Augenbrauen-

◄◄ Cutex Nail Polish, 1946 Pacer, 1936

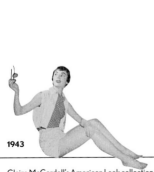

1943

Claire McCardell's American Look collection debuts at Lord & Taylor

Claire McCardell gibt mit ihrer Kollektion American Look ihr Debut bei Lord & Taylor

Lord & Taylor lance la collection American Look de Claire McCardell

1945

Wide postwar ties get bolder, including Art Deco and Asian prints

Breite Krawatten der Nachkriegszeit zeigen kräftige asiatische und Jugendstil-Muster

Les cravates larges de l'après-guerre arborent des dessins Art Déco et asiatiques

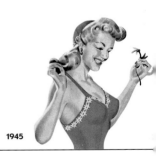

1945

"Victory Rolls" hairstyle celebrates Allies' victory in World War II

Die Frisur namens „Victory Rolls" feiert den Sieg der Alliierten im 2. Weltkrieg

La coiffure « Victory Rolls » célèbre la victoire des Alliés

ift auf die nackten Beine gemalte Strumpfnähte. In der Tat waren die 40er eine Zeit der Modetorheiten. Für Frauen gab es Turbane, Matrosenmützen und selbstklebende Schönheitspflaster aus winzigen Stückchen Seide. Teenagerjungs trugen Soldatenstiefel, Mädchen hochgerollte Bluejeans und übergroße Herrenhemden.

Die Stimmung in der Damenmode während der Kriegsjahre spiegelte in den USA die Atmosphäre im Land wider: vernünftig und von Entsagung geprägt. Nach dem Krieg jedoch, so hatte der Pariser Designer Christian Dior weise vorhergesehen, würden die heimkehrenden Veteranen sich eine idealisierte Frau ausmalen, die sie zu Hause erwartete. Und die Frauen, von denen viele berufstätig waren oder bei den Streitkräften gedient hatten, waren ebenfalls bestrebt, zu einem femininen Look zurückzukehren. Diors erste Nachkriegskollektion von 1947 ist dabei am deutlichsten in Erinnerung geblieben. Der Look bedeutete eine radikale Abkehr von der aktuellen Mode, mit längeren, weiteren Röcken, Jacken mit weicher Schulterpartie, die die ausgepolsterte

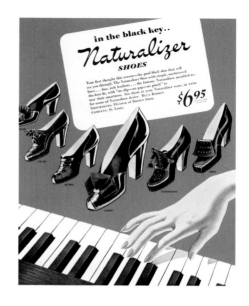

Naturalizer Shoes, 1943

Büste noch betonten, und einer winzigen, geschnürten Wespentaille – dazu spitze Schuhe mit Pfennigabsätzen. Carmel Snow, die Herausgeberin von *Harper's Bazaar*, taufte das Ganze New Look.

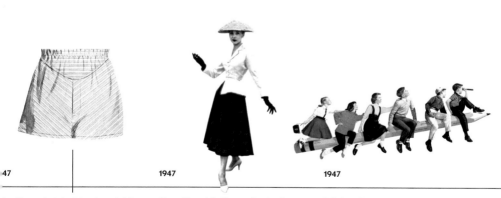

| 47 | 1947 | 1947 |

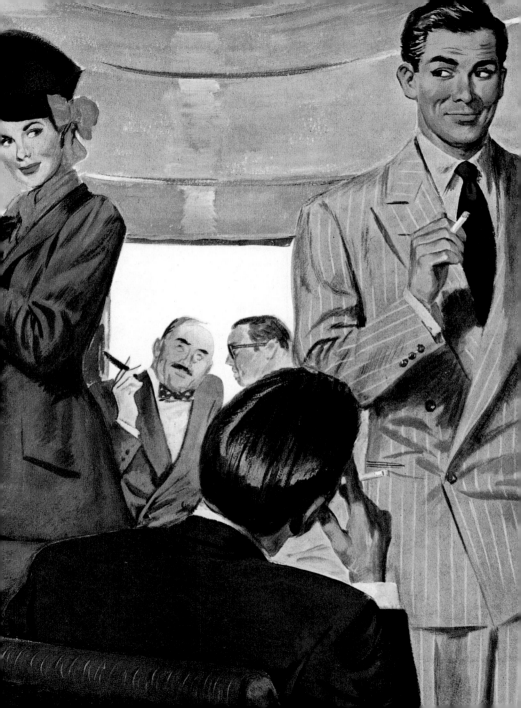

SECONDE GUERRE MONDIALE ET NEW LOOK

Une fois la paix restaurée, le couturier parisien Christian Dior prédit avec sagesse qu'à leur retour, les soldats auront envie de retrouver l'image d'une femme idéalisée à la maison ; quant aux femmes, dont un grand nombre a travaillé ou servi dans les forces armées, elles sont impatientes de revenir à un look plus féminin.

LA MODE DES ANNÉES 40 EST LARGEMENT DICTÉE PAR LES CONTRAINTES D'UNE PÉRIODE DE CONFLITS. LA GUERRE ENTRE L'ANGLETERRE ET L'ALLEMAGNE DÉBUTE EN 1939 ET, EN 1942, LE JAPON BOMBARDE PEARL HARBOR, entraînant les Japonais et les Américains dans la Seconde Guerre mondiale. Si Paris était restée la capitale incontestée de la mode, l'entrée en guerre voit de nombreux couturiers fermer boutique, dont Chanel. Le couturier Mainbocher, qui avait conçu la robe de mariée de la duchesse de Windsor, s'installe à New York où il continue à créer sa propre collection, ainsi que des uniformes pour les Girl Scouts, la Croix-Rouge et le WAVES (division de l'U.S. Navy uniquement composée de femmes volontaires).

Les États-Unis ne manquent pas non plus de talents : Hattie Carnegie, Norman Norell et Claire McCardell, l'inventrice du sportswear américain, dont les entrées au grand dictionnaire de la mode incluent les twinsets et les ballerines plates.

Bien qu'*Autant en emporte le vent* soit évidemment un film d'époque, les costumes de cet immense succès du cinéma aux multiples Oscars trouvent leur imitation dans la mode du moment. Ornés de rubans, de plumes et de voilettes en dentelle, les bonnets de Vivien Leigh conçus par John P. John sous sa marque John-Frederics inspirent les femmes, tout comme les chignons et les résilles à cheveux de l'actrice.

Alors que les années 20 avaient mis à l'honneur l'accoutrement des étudiants, la notion de « marché jeune » prend un vrai bain de jouvence dans les années 40. Dans la saga à succès des films Andy

Hardy, un Mickey Rooney adolescent gagne de nombreux fans, son personnage donnant brillamment la réplique à Judy Garland, Lana Turner et Ava Gardner. Le crooner Frank Sinatra attire des foules d'admiratrices en délire surnommées les « bobby soxers » parce qu'elles portent des socquettes et des richelieus. Le magazine *Seventeen* est lancé en 1944 pour cibler le marché des adolescents, ainsi que *Junior Bazaar*, la revue pour ados créée par *Harper's Bazaar*.

Pendant la guerre, l'industrie est soumise à des directives très strictes en raison du rationnement des matériaux, ce qui met un terme à la production des vêtements spectaculaires mais trop gourmands en tissu, par exemple les capuches et les châles, les jupes amples, les ceintures larges et les manches de manteau à revers. Comme on utilise moins de fermetures à zip et de boutons en métal, des innovations telles que la jupe portefeuille voient le jour. Le rationnement fait aussi émerger le concept de l'habillement adapté « du matin au soir ». Quant à la pénurie de nylon pour les bas, elle inspire la tendance éphémère du maquillage des jambes, les femmes se dessinant une fausse couture à l'aide d'un crayon à sourcils. Les années 40 voient en fait proliférer toutes sortes de folies. Les femmes se coiffent de turbans ou de casquettes de marin, et on trouve aussi des « grains de beauté » adhésifs coupés dans de minuscules morceaux de soie. Côté ados, les garçons portent des brodequins militaires, et les filles, des jeans roulés à l'ourlet avec des chemises d'homme trop grandes pour elles.

Pendant les années de guerre, l'humeur de la mode féminine reflète celle du pays : sensée et austère. Une fois la paix restaurée, le couturier parisien Christian Dior prédit avec sagesse qu'à leur retour les soldats auront envie de retrouver l'image d'une femme idéalisée à la maison ; quant aux femmes, dont un grand nombre ont travaillé ou servi dans les forces armées, elles sont impatientes de revenir à un look plus féminin. En 1947, la première collection Dior d'après-guerre est celle qui le fera passer à la postérité. Il propose un look radicalement différent, avec des jupes plus longues et plus amples, des vestes aux épaules douces qui soulignent une poitrine rehaussée et une taille de guêpe corsetée, le tout porté avec des chaussures à bouts pointus et talons aiguilles. C'est Carmel Snow, la rédactrice en chef d'*Harper's Bazaar*, qui qualifie cette silhouette de « New Look ».

◀◀ Hart Schaffner & Marx Menswear, 1946 ▶ Hart Schaffner & Marx Menswear, 1946 ▶▶ Color Affiliates, 1940

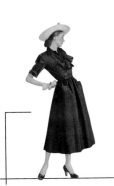

1948

Dior's feminine, nipped-waist "New Look" hits mass market

Diors femininer, taillenbetonter New Look erreicht den Massenmarkt

Le New Look féminin à taille de guêpe de Dior descend dans la rue

1948

Peep-toe heels reach peak popularity

Zehenfreie High-Heels erreichen den Gipfel ihrer Beliebtheit

Les chaussures à talon ouvertes sur les orteils atteignent des sommets de popularité

1949

Introduction of stitched, long-line cone (or "bullet") bra

Markteinführung des abgenähten, länglich konischen Spitz-BHs (engl. „bullet" bra)

Lancement du soutien-gorge à bonnets « en obus »

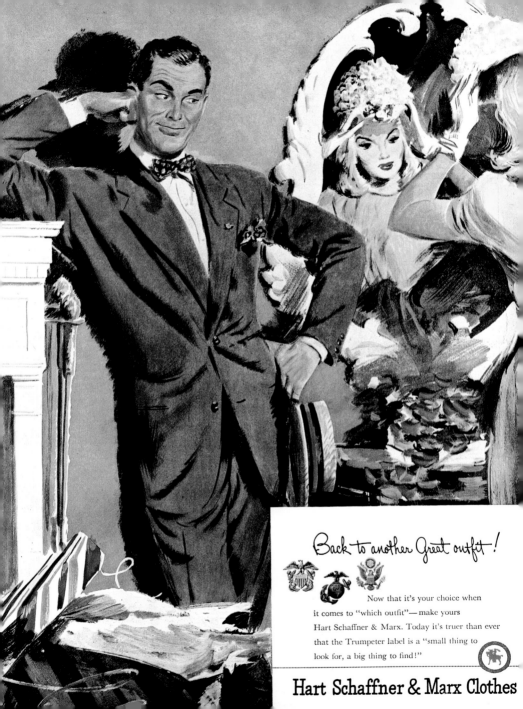

color matching...A PROBLEM

*R*emember when color matching of gloves, hat, shoes or bag to go with your new costume meant tramping-the-town . . . then wearily compromising on a "near match"?

COLOR AFFILIATES *have changed all that!*

Imagine the head of the great house of Stroock woolens . . . Koret, who makes the finest bags the world over . . . Mallinson's silk color experts . . Kislav gloves, style and color *right* for a generation . . . two top-flight shoe creators, Delman and Palter DeLiso . . . the head of the famous house of G. Howard Hodge hats . . . Elizabeth Arden . . . all getting together, pooling their resources, their talents, their capabilities . . . making available to you *now* for fall and winter wear, colors that are right from tip to toe!

That's great news... *important* news! So exciting, that leading fashion magazines write editorials about it! And *these* are the colors:

DELMAN

INDIAN SUMMER
rich, ripe russet

BARK BROWN
mellow, harvest brown

NIGHTFLIGHT BLUE
dark autumn navy

JUNIPER GREEN
autumn forest green

HUCKLEBERRY
frost-nipped purple

SCARECROW GREY
soft, flattering grey

Match them! Mix them! They're *planned, dyed, fashioned* for wear with each other. And to *complete* this symphony of color, wear Elizabeth Arden's new fall make-up, Cinnabar, created *for* Color Affiliates colors!

for that "custom" look, just follow Color Affiliates!

COLOR *affiliates*

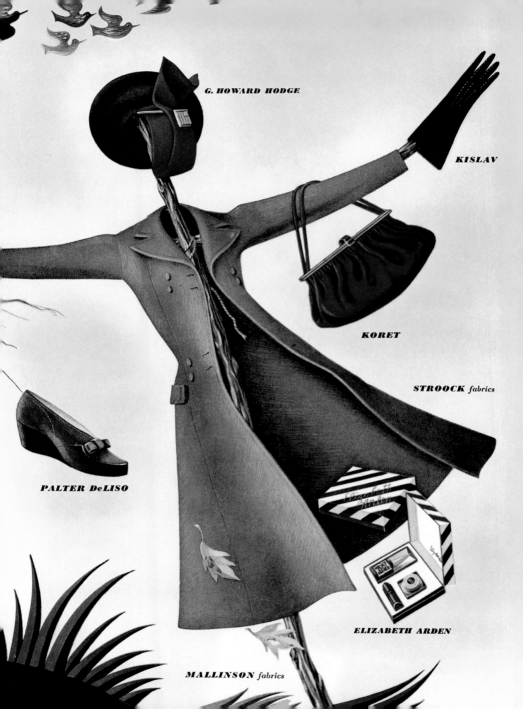

G. HOWARD HODGE

KISLAV

KORET

STROOCK *fabrics*

PALTER DeLISO

ELIZABETH ARDEN

MALLINSON *fabrics*

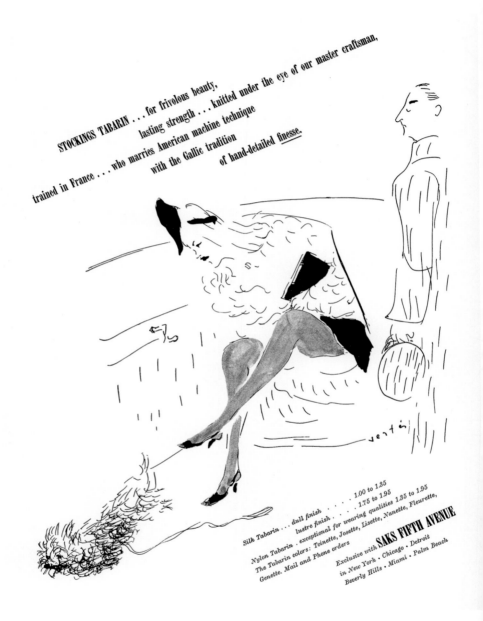

STOCKINGS TABARIN . . . for frivolous beauty, lasting strength . . . knitted under the eye of our master craftsman, trained in France . . . who marries American machine technique with the Gallic tradition of hand-detailed finesse.

Silk Tabarin . . . dull finish 1.00 to 1.35
lustre finish 1.75 to 1.95
Nylon Tabarin . exceptional for wearing qualities 1.35 to 1.95
The Tabarin colors: Toinette, Josette, Lisette, Nanette, Fleurette, Genette. Mail and Phone orders

SAKS FIFTH AVENUE
Exclusive with
in New York · Chicago · Detroit
Beverly Hills · Miami · Palm Beach

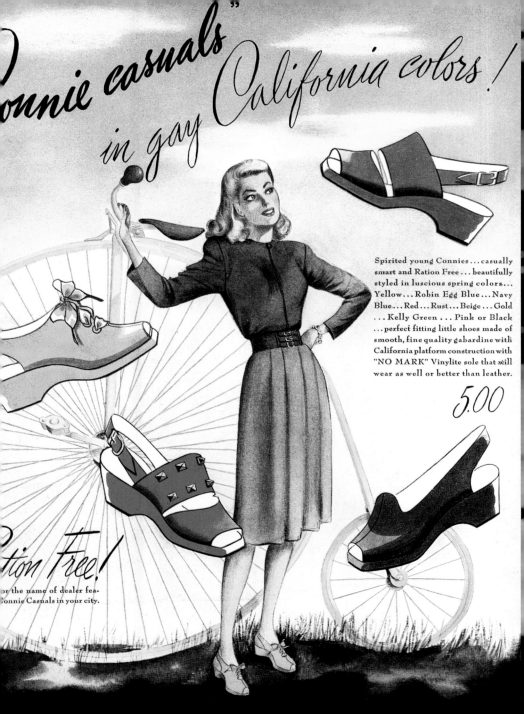

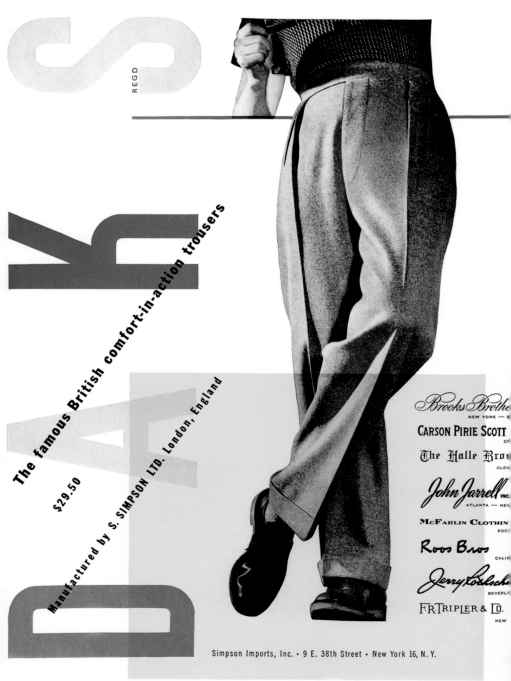

S REGD

DAKS

The famous British comfort-in-action trousers

$29.50

Manufactured by S. SIMPSON LTD. London, England

Brooks Brothe
NEW YORK — E

CARSON PIRIE SCOTT
CH

The Halle Bro
CLEV

John Jarrell INC
ATLANTA — NEV

McFarlin Clothin
ROC

Roos Bros
CALIF

Jerry Rothsch
BEVERLY

F. R. Tripler & Co.
NEW

Simpson Imports, Inc. • 9 E. 38th Street • New York 16, N. Y.

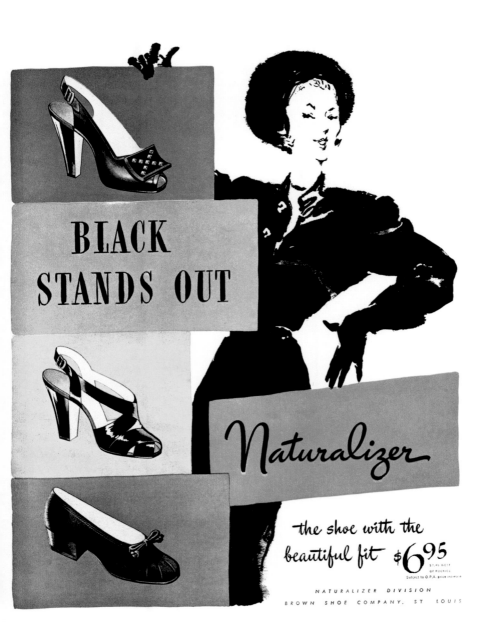

Daks Trousers, 1948 Naturalizer Shoes, 1946

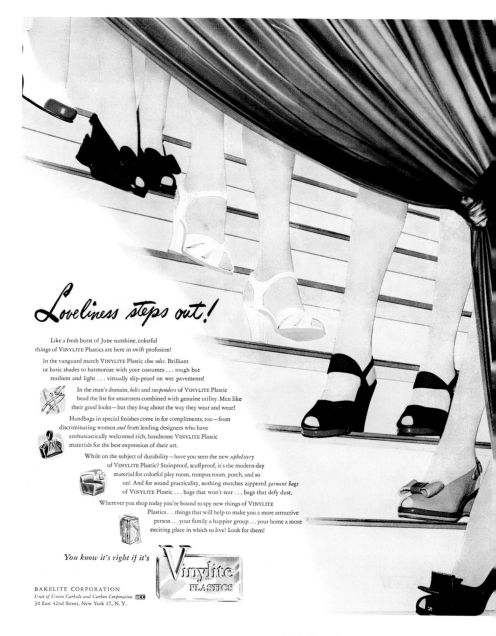

Loveliness steps out!

Like a fresh burst of June sunshine, colorful
things of VINYLITE Plastics are here in swift profusion!

In the vanguard march VINYLITE Plastic *shoe soles*. Brilliant
or basic shades to harmonize with your costumes . . . tough but
resilient and light . . . virtually slip-proof on wet pavements!

In the man's domain, *belts* and *suspenders* of VINYLITE Plastic
head the list for smartness combined with genuine utility. Men like
their good looks — but they *brag* about the way they wear and wear!

Handbags in special finishes come in for compliments, too — from
discriminating women *and* from leading designers who have
enthusiastically welcomed rich, handsome VINYLITE Plastic
materials for the best expression of their art.

While on the subject of durability — have you seen the new *upholstery*
of VINYLITE Plastic? Stainproof, scuffproof, it's the modern day
material for colorful play room, rumpus room, porch, and so
on! And for sound practicality, nothing matches zippered *garment bags*
of VINYLITE Plastic . . . bags that won't tear . . . bags that defy dust.

Wherever you shop today you're bound to spy new things of VINYLITE
Plastics . . . things that will help to make you a more attractive
person . . . your family a happier group . . . your home a more
exciting place in which to live! Look for them!

You know it's right if it's

Vinylite PLASTICS

BAKELITE CORPORATION
Unit of Union Carbide and Carbon Corporation UCC
30 East 42nd Street, New York 17, N. Y.

Vinylite Plastics Shoes, 1946 ▸ Vinylite Plastics Raingear, 194[.]

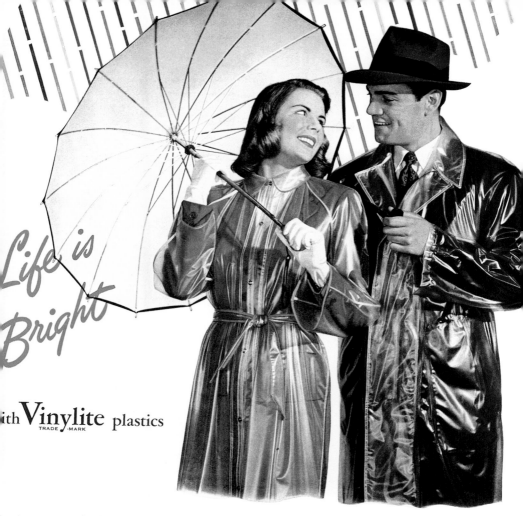

Life is Bright

with **Vinylite** plastics
TRADE-MARK

Every time you turn around you find something made of VINYLITE Plastics . . . something bright and colorful . . . something rich and handsome . . . something to protect you . . . something to make your home happier.

Among them are VINYLITE Plastic *raincoats* that wear well, keep you *desert-dry* . . . high-gloss *shoes* that start smart and end smart, holding their beauty of line and brilliant luster without cracking and without scuffing.

The sleek richness of those glistening new *handbags* made of VINYLITE plastics is something new, too. Their weather-wise quality outlives their style!

And in your bathroom a *shower curtain* that keeps its youth...its enduring beauty! Completely waterproof shower curtains made of VINYLITE Plastics don't crack or stiffen . . . will not mildew!

Almost beyond belief are the new non-shatterable VINYLITE Plastic phonograph *records*. They give matchless high-fidelity tones because needle noise is almost completely eliminated.

And now you're familiar with just a few of the wonderful things made with and from VINYLITE Plastics. But don't stop here. Look for the trademark "VINYLITE" wherever you go shopping. You'll find it on more and more outstanding articles made of this superior brand of plastic.

BAKELITE CORPORATION
UCC *Unit of Union Carbide and Carbon Corporation*
30 East 42nd Street, New York 17, N. Y.

You know it's right if it's

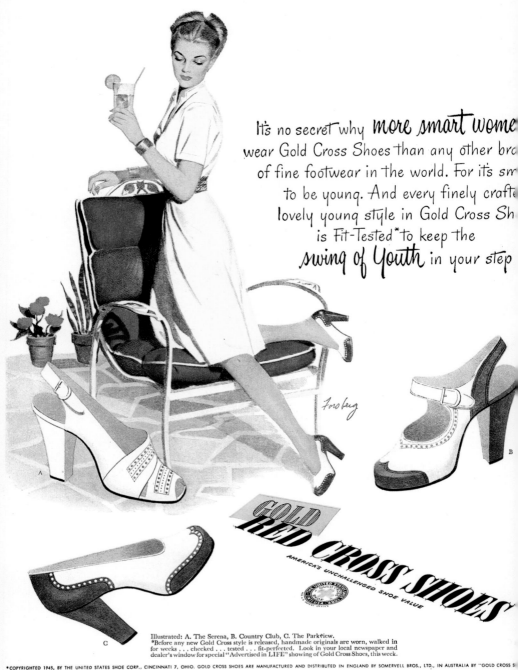

It's no secret why **more smart wome**
wear Gold Cross Shoes than any other br
of fine footwear in the world. For it's sm
to be young. And every finely craft
lovely young style in Gold Cross Sh
is Fit-Tested* to keep the
swing of Youth in your step

GOLD RED CROSS SHOES

AMERICA'S UNCHALLENGED SHOE VALUE

Illustrated: A. The Serena, B. Country Club, C. The Parkview.
*Before any new Gold Cross style is released, handmade originals are worn, walked in
for weeks . . . checked . . . tested . . . fit-perfected. Look in your local newspaper and
dealer's window for special "Advertised in LIFE" showing of Gold Cross Shoes, this week.

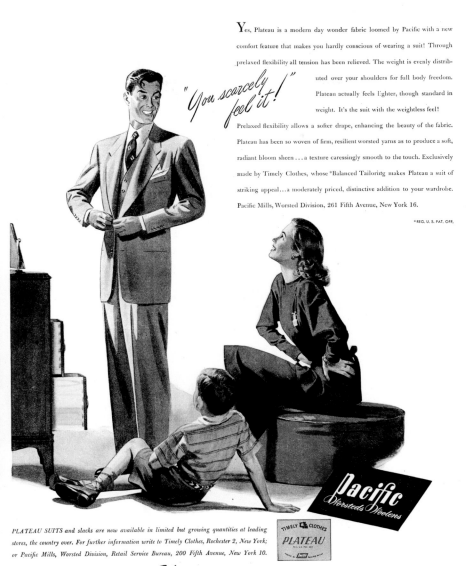

Yes, Plateau is a modern day wonder fabric loomed by Pacific with a new comfort feature that makes you hardly conscious of wearing a suit! Through prelaxed flexibility all tension has been relieved. The weight is evenly distributed over your shoulders for full body freedom. Plateau actually feels lighter, though standard in weight. It's the suit with the weightless feel!

Prelaxed flexibility allows a softer drape, enhancing the beauty of the fabric. Plateau has been so woven of firm, resilient worsted yarns as to produce a soft, radiant bloom sheen . . . a texture caressingly smooth to the touch. Exclusively made by Timely Clothes, whose *Balanced Tailoring makes Plateau a suit of striking appeal . . . a moderately priced, distinctive addition to your wardrobe. Pacific Mills, Worsted Division, 261 Fifth Avenue, New York 16.

*REG. U. S. PAT. OFF.

"You scarcely feel it!"

PLATEAU SUITS and slacks are now available in limited but growing quantities at leading stores, the country over. For further information write to Timely Clothes, Rochester 2, New York; or Pacific Mills, Worsted Division, Retail Service Bureau, 200 Fifth Avenue, New York 10.

LOOK TO THE *Fabric* FIRST—BUY PACIFIC

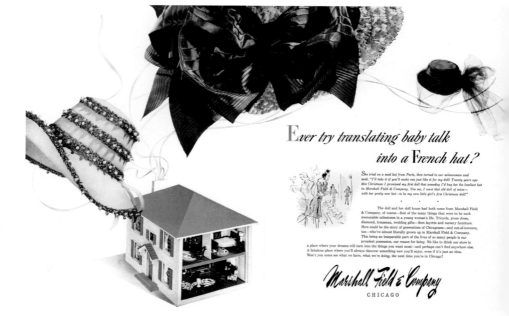

Ever try translating baby talk into a French hat?

She tried on a mad hat from Paris, then turned to our saleswoman and said, "I'll take it if you'll make one just like it for my doll! Twenty years ago this Christmas I promised my first doll that someday I'd buy her the loveliest hat in Marshall Field & Company. You see, I want that old doll of mine—with her pretty new hat—to be my own little girl's first Christmas doll!"

The doll and her doll house had both come from Marshall Field & Company, of course—first of the many things that were to be such memorable milestones in a young woman's life. Tricycle, prom dress, diamond, trousseau, wedding gifts—then layette and nursery furniture. Here could be the story of generations of Chicagoans—and out-of-towners, too—who've almost literally grown up in Marshall Field & Company. This being an inseparable part of the lives of so many people is our proudest possession, our reason for being. We like to think our store is a place where your dreams will turn into the things you want most—and perhaps can't find anywhere else. A fabulous place where you'll always discover something new you'll enjoy, even if it's just an idea. Won't you come see what we have, what we're doing, the next time you're in Chicago?

Marshall Field & Company

CHICAGO

Marshall Field & Co. Department Store, 1946

John P. John and Frederic Hirst, the design team behind millinery label John-Frederics, created Vivien Leigh's hats for the Academy Award–winning film *Gone with the Wind*. Though a period piece, the 1939 film inspired hat and hair trends for most of the 1940s, including ribbon-trimmed bonnets and snoods.

John P. John und Frederic Hirst, das Designer-team hinter dem Modelabel John-Frederics, entwarf Vivien Leighs Hüte für den Oscar-prämierten Streifen *Vom Winde verweht*. Und obwohl es sich um einen Historienschinken handelte, lieferte der Film von 1939 die meisten Hut- und Frisurentrends der 1940er Jahre, etwa die bändergeschmückten Hauben und Haarnetze.

John P. John et Frederic Hirst, le duo de concepteurs travaillant pour la marque de chapeaux John-Frederics, créèrent les modèles portés par Vivien Leigh dans le film multi-oscarisé *Autant en emporte le vent*. Sorti en 1939, ce film en costumes d'époque inspira pourtant les tendances de coiffures et de chapeaux pendant la majeure partie des années 40, y compris les bonnets passepoilés de ruban et les résilles pour cheveux.

▸ Lilly Daché Hair Nets, 1944

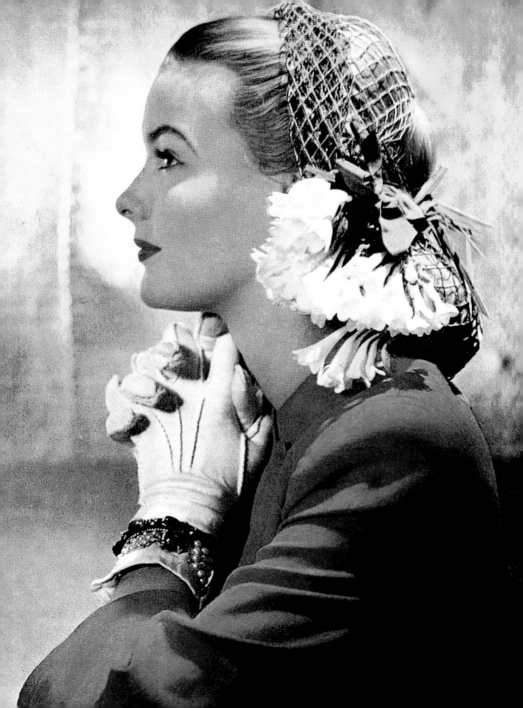

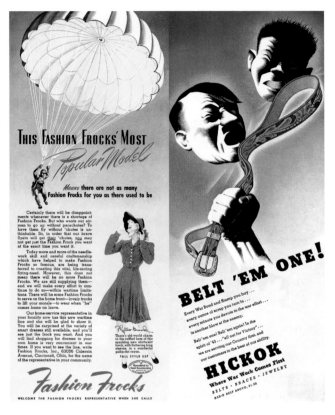

Fashion Frocks, 1943

Hickok Belts, 1943

By 1943, Hollywood was releasing pro-America propaganda films designed to boost morale at home during the war. Fashion manufacturers got into the act with ads crafted to appeal to consumers' patriotism as well as the pocketbooks.

Ab 1943 brachte Hollywood patriotische Propagandafilme heraus, die dazu gedacht waren, während des Krieges die Moral im eigenen Land zu stärken. Die Modehersteller schlossen sich mit Anzeigen an, die darauf abzielten, an den Patriotismus der Konsumenten zu appellieren, aber auch deren Geldbörsen im Visier hatten.

En 1943, Hollywood sortit des films de propagande pro-américaine conçus pour remonter le moral de la nation pendant la guerre. Les fabricants de vêtements y participèrent avec des publicités misant sur le patriotisme des consommateurs et leur besoin de faire des économies.

▶ Lee Workwear, 1943

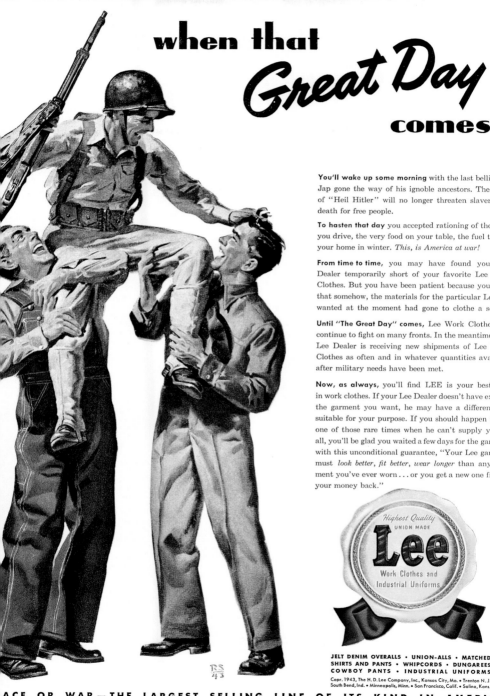

when that
Great Day
comes!

You'll wake up some morning with the last belligerent Jap gone the way of his ignoble ancestors. The shout of "Heil Hitler" will no longer threaten slavery and death for free people.

To hasten that day you accepted rationing of the miles you drive, the very food on your table, the fuel to heat your home in winter. *This, is America at war!*

From time to time, you may have found your Lee Dealer temporarily short of your favorite Lee Work Clothes. But you have been patient because you knew that somehow, the materials for the particular Lee you wanted at the moment had gone to clothe a soldier.

Until "The Great Day" comes, Lee Work Clothes will continue to fight on many fronts. In the meantime your Lee Dealer is receiving new shipments of Lee Work Clothes as often and in whatever quantities available after military needs have been met.

Now, as always, you'll find LEE is your best buy in work clothes. If your Lee Dealer doesn't have exactly the garment you want, he may have a different one suitable for your purpose. If you should happen to hit one of those rare times when he can't supply you at all, you'll be glad you waited a few days for the garment with this unconditional guarantee, "Your Lee garment must *look better, fit better, wear longer* than any garment you've ever worn . . . or you get a new one free or your money back."

Highest Quality
UNION MADE
Lee
Work Clothes and
Industrial Uniforms

JELT DENIM OVERALLS • UNION-ALLS • MATCHED
SHIRTS AND PANTS • WHIPCORDS • DUNGAREES
COWBOY PANTS • INDUSTRIAL UNIFORMS
Copr. 1943, The H. D. Lee Company, Inc., Kansas City, Mo. • Trenton N. J.
South Bend, Ind. • Minneapolis, Minn. • San Francisco, Calif. • Salina, Kans.

ACE OR WAR — THE LARGEST SELLING LINE OF ITS KIND IN AMERICA

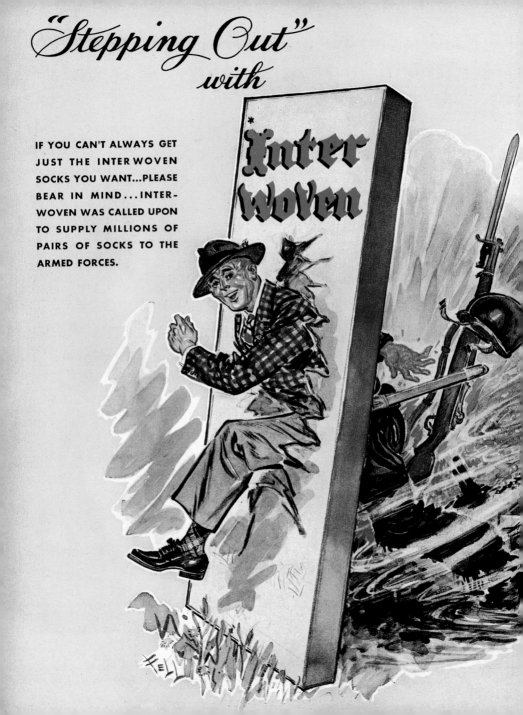

It's **Lee** 6 to 1

UNION MADE
Lee
Highest Quality
WORK CLOTHES

COPYRIGHT 1946
THE H. D. LEE CO., INC.

THE H. D. LEE COMPANY

Kansas City, Mo. • South Bend, Ind. • Trenton, N. J.
Minneapolis, Minn. • San Francisco, Calif. • Salina, Kansas

In a nationwide survey* among thousands of men doing all types of work, the question was asked . . . "What brand of overalls do *you* prefer?" Lee Jelt Denim Overalls led the next brand by a margin of *6 to 1*.

Why is Lee the choice of commonsense, money-wise workingmen? Because they *know* bedrock work clothes value! They know Lee's exclu-

Survey made by a prominent publishing company.

sive fabrics wear longer and wash better. They know Lee "Tailored Sizes" mean perfect fit, lasting comfort and better appearance.

Buy Lee Work Clothes . . . at leading stores coast-to-coast.

* * *

THERE'S A LEE FOR EVERY JOB!
JELT DENIM OVERALLS • UNION-ALLS • MATCHED
SHIRTS AND PANTS • DUNGAREES • COWBOY PANTS

WORLD'S LARGEST MANUFACTURERS OF UNION-MADE WORK CLOTHES

Interwoven Socks, 1945 Lee Workwear, 1946

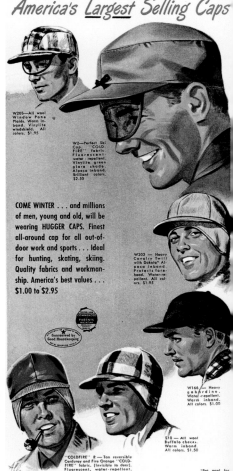

BIG DEEDS ARE OFTEN BORN IN DREAMS

o a young football coach came into our office.
o impressed with his character and intelligence,
n to become head of our Keds Sports Depart-
ition he still holds—to such extent as his coach-
ities permit. You know Frank Leahy as coach
Blocks of Granite," as coach of the winning
test Sugar Bowl contest. We know him as an
d pupil of Knute Rockne; as the man who,

working with Stephen Epler, produced the Epler six-man foot-
ball shoe; as the expert coach who developed a brand new
last for Keds basketball shoes. To the boys of America, we
give "Frank Leahy." And for 1941, we give you a booklet
on football that Frank Leahy is now preparing. If you wish
us to reserve a copy for you, or if you would like a copy of
the above illustration, suitable for framing, just send your
name and address to Keds Sports Department. Both are free.

Keds
REG. U.S. PAT. OFF.
The Shoe of Champions

Jnited States Rubber Company · Rockefeller Center, New York, N. Y.

KNOX

Foxhound

Latest style expression of this famous
Knox-exclusive snap-brim, in fine
felt finished to a new silky softness. Illustrated,
in "Citron," and in "Hickory." $10.00 and $12.50
Knox the Hatter, 452 Fifth Avenue, New York
Now being shown by your Knox dealer.

"Hats made so fine that all others
must be compared to them."
Charles Knox 1838

Knox Hats, 1947

etson Hats, 1949

ritish-born Hollywood actor David Niven
as known for his cool demeanor and suave
phistication. By teaming with Niven, Texas
mpany Stetson — manufacturer of the "hat
the West" — hoped to capture some of the
:tor's panache.

er in Großbritannien geborene Hollywood-
:hauspieler David Niven war berühmt für sein
geklärtes Auftreten und seine weltmänni-
he Eleganz. Indem sie sich mit ihm zusam-
entat, erhoffte sich die texanische Firma
etson – Hersteller des „Hat of the West" –,
was von der Extravaganz des Schauspielers
szustrahlen.

origine britannique, l'acteur hollywoodien
vid Niven était connu pour son flegme et son
ffinement. En s'associant avec lui, l'entre-
se texane Stetson, fabricant du « chapeau
l'Ouest », espérait s'approprier un peu de
n panache.

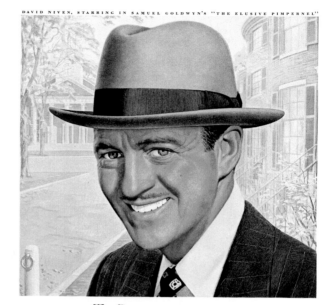

DAVID NIVEN, STARRING IN SAMUEL GOLDWYN'S "THE ELUSIVE PIMPERNEL"

The Stetson is part of the man

David Niven wouldn't consider himself well dressed if he went out without his
Stetson. Famous Stetson quality gives him that important "well-dressed feel-
ing." With faultless Stetson styling, he *knows* he looks his best. See what this
smartly formal *Squire* in *Sky Grey* does for David? See what it can do for you!

The Squire by **STETSON** *in Sky Grey* $45

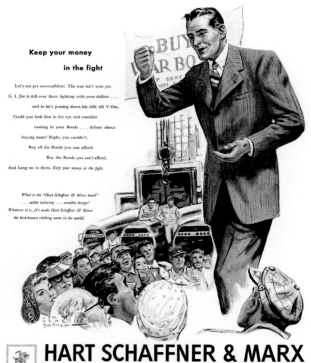

Keep your money

in the fight

Let's not get overconfident. The war isn't won yet.

G. I. Joe is still over there fighting with your dollars . . .

and *he* isn't putting down his rifle till V-Day.

Could you look him in the eye and consider

cashing in your Bonds . . . debate about

buying more? Right, you couldn't.

Buy all the Bonds you can afford.

Buy the Bonds you *can't* afford.

And hang on to them. *Keep your money in the fight.*

What is the "Hart Schaffner & Marx touch"

. . . subtle tailoring . . . sensible design?

Whatever it is, it's made Hart Schaffner & Marx

the best-known clothing name in the world.

HART SCHAFFNER & MARX

The Trumpeter Label . . . a small thing to look for . . . a big thing to find

Hart Schaffner & Marx Menswear, 1944

Hart Schaffner & Marx was one of many U.S. companies producing patriotic ads during the World War II. The Chicago suitmaker's approach was curious: It appears to be telling the consumer not to buy its product, but to bu war bonds instead.

Hart Schaffner & Marx war eine der vielen US-Firmen, die während des Zweiten Welt-kriegs patriotische Annoncen schalteten. De Anzughersteller aus Chicago wählte einen kuriosen Ansatz: Er scheint der Kundschaft z raten, nicht seine Produkte zu kaufen, sonder stattdessen Kriegsanleihen zu erwerben.

Hart Schaffner & Marx, tailleur pour homme Chicago, fut l'une des nombreuses entreprise américaines à produire des publicités patrio-tiques pendant la Seconde Guerre mondiale. Son approche était étrange : elle semble inci le consommateur à acheter des bons de guer plutôt que ses produits.

▶ Berkshire Hosiery, 1948

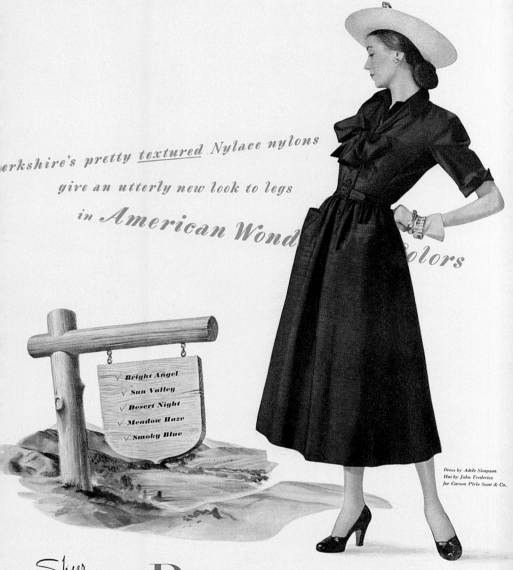

erkshire's pretty *textured* Nylace nylons

give an utterly new look to legs

in *American Wond* olors

✓ **Bright Angel**
✓ **Sun Valley**
✓ **Desert Night**
✓ **Meadow Haze**
✓ **Smoky Blue**

*Dress by Adele Simpson
Hat by John Frederics
for Carson Pirie Scott & Co.*

Sheer...
Sheer... Berkshire *Stockings*

for the loveliest legs in the world . . . by the world's largest manufacturers of full-fashioned stockings.

Berkshire Knitting Mills, Reading, Pa. *Nylace Reg. U. S. Pat. Off.*

BE PROTECTED

Elliott Springs, president
of The Springs Cotton Mills,
says he is prepared to make
everything shown in the picture.

During the war, The Springs Cotton Mills was called upon to develop a crease-proof cotton fabric. It was used with great success as a backing for maps, photographs, and other valuable assets. This fabric has now been further perfected and made available to the torso-twister trade.

After a convention, a clam-bake, or a day in the Pentagon Building, you need not eat off the mantel if you have your foundation co with SPRINGMAID *POKER* woven of combed yarns 37″ wide, 15. count, in tearose, white, nude, and black, light and medium If you bruise easily, you can face the future confidently wi SPRINGMAID trademark.

SPRINGS MILLS

200 Church Street · New York 13, New York

Chicago Dallas Los Angeles

Coming soon: SPRINGMAID *sheets, pillowcases, diapers, broadcloth, poplins and tubings.*

◄ Springs Mills Springmaid Fabrics, 1948

Springs Mills Springmaid Fabrics, 1948

Throughout the late 1940s and 1950s, textile maker Springs Mills ran a risqué campaign conceived and written by company owner Elliot Springs. Springs had some difficulty convincing his ad agency of the value of the concept, explaining in a 1947 letter, "A lot of dumb bunnies will … write in and bawl us out for being vulgar and stupid. Then some people will take a second look and catch the burlesque, and be very proud that they're so smart. They'll think they are the only one to get it, and write to tell us about it."

In den späten 1940ern und den 50ern fuhr der Textilhersteller Springs Mills eine riskante Kampagne, die der Besitzer des Unternehmens Elliot Springs selbst konzipiert und geschrieben hatte. Springs hatte einige Mühe, seine Werbeagentur vom Wert des Konzepts zu überzeugen und führte in einem Brief von 1947 aus: „Eine Menge dummer Gänse wird … uns anschreiben und uns als vulgär und blöd niedermachen. Dann werden einige Leute einen zweiten Blick riskieren und die Posse durchschauen und sehr stolz darauf sein, dass sie so clever sind. Sie werden denken, dass sie die einzigen sind, die es kapiert haben, und uns schreiben, um uns eben dies zu vermelden."

À la fin des années 40 et tout au long des années 50, le fabricant textile Springs Mills utilisa une audacieuse campagne conçue et rédigée par le propriétaire de l'entreprise, Elliot Springs. Ce dernier eut du mal à convaincre son agence publicitaire de la valeur de son concept, comme il l'expliqua dans une lettre de 1947 : « Des tas de crétins vont… se plaindre et nous hurler dessus en nous accusant d'être bêtes et vulgaires. Puis, certaines personnes y réfléchiront à deux fois, saisiront l'aspect burlesque et se féliciteront d'être aussi intelligentes. Elles penseront être les seules à nous comprendre et nous écriront pour nous le faire savoir. »

Perfume and Parabolics

During the war, The Springs Cotton Mills was called upon to develop a special fabric for camouflage. It was used in the Pacific to conceal ammunition dumps and gun emplacements, but the Japanese learned to detect it because of its lack of jungle smells. To overcome this, when the fabric was dyed, it was also impregnated with a permanent odor of hibiscus, hydrangea, and old rubber boots. The deception was so successful that when Tokyo fell, the victorious invaders hung a piece of this fabric on a Japanese flagpole.

This process has been patented, and the fabric is now available to the false bottom and bust bucket business as SPRINGMAID PERKER, made of combed yarns, 37" wide, 152 x 68 approximate count, weight about 3.30, the pink with camellia, the blush with jasmine, and the nude dusty.

If you want to achieve that careless look and avoid skater's steam, kill two birds with one stone by getting a camouflaged callypigian camisole with the SPRINGMAID label on the bottom of your trademark.

SPRINGMAID FABRICS
THE SPRINGS COTTON MILLS

SPRINGS MILLS
200 CHURCH STREET • NEW YORK 13, NEW YORK
CHICAGO DALLAS LOS ANGELES
Coming soon… SPRINGMAID sheets, pillowcases, diapers, broadcloth, poplins, and tubings.

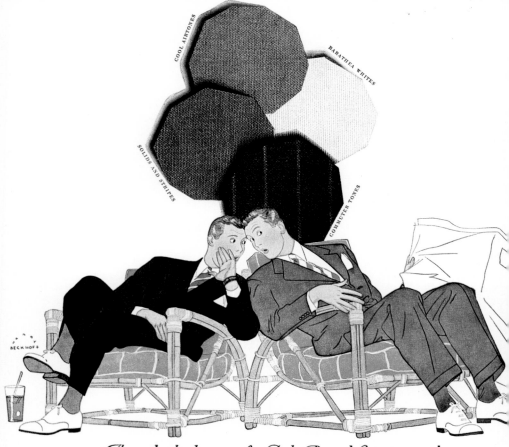

The only duplicate of a Palm Beach Suit is another

PALM BEACH SUIT

AND HAVING TWO isn't a bad idea—for then there's one for town and one for country—and a welcome third or fourth can be made in a twinkling, (by mixing the coat of one with the trousers of the other). Two suits offer you four changes—

And that's quite a wardrobe, quite an economy—for the price of the new Palm Beach is just **$17.75**

You'll know it by the "open-windowed" weave that lets your body breathe—by the wealth of colors for all occasions—by its perfect washability and splendid fit: But still easier—you'll know it by the label— sewn in every real Palm Beach garment.

See it at your clothier's in the softer, lighter Airtones for Sports—in Commuter tones for town. And the new smart Whites.

Palm Beach slacks $5.50 • Sport coats $13.50 • Evening Formals $20.00 • Students' suits (sizes 16 to 22) $16.50

$3250 IN PRIZES
Enter the Palm Beach contest. First prize, $1000. Second prize, $500. 235 other cash awards. Your clothier has Entry Blank and complete details.

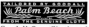

TAILORED BY GOODALL
Palm Beach
FROM THE GENUINE CLOTH
Goodall Co. · Cincinnati

NEW DISCOVERIES
See the tropical worsted discoveries of 1941: Goodall Tropic Weight at $25. Tropic Weight De Luxe at $32.50. At your clothier's—today.

A GREAT GIFT FOR DAD

Palm Beach Suits/Goodall Mills, 1941

ntzen Swimwear, 1940

pular pinup artist George Petty created
e red diving girl in the Jantzen logo, as well
illustrations for many of the company's ads
the 1940s. His style was so ubiquitous that
ntzen commissioned him to design this "Suit
Youth" swimsuit. The popular ad ran in major
merican magazines for months.

er bekannte Pin-up-Künstler George Petty
twarf das rote tauchende Mädchen des
ntzen-Logos sowie Illustrationen für viele
nzeigen der Firma in den 1940er Jahren. Sein
l war so allgegenwärtig, dass Jantzen ihn
auftragte, diesen „Suit of Youth"-Badeanzug
entwerfen. Die beliebte Anzeige wurde
den großen amerikanischen Zeitschriften
onatelang geschaltet.

célèbre dessinateur de pin-up George
tty créa la plongeuse en maillot rouge du
go Jantzen, ainsi que des illustrations pour
nombreuses publicités de l'entreprise dans
s années 40. Son style était si universel que
ntzen lui demanda de concevoir ce maillot
bain « Suit of Youth ». Ce célèbre visuel fut
blié dans les plus grands magazines améri-
ins pendant des mois.

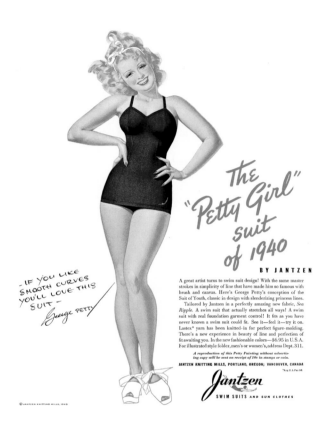

- IF YOU LIKE
SMOOTH CURVES
YOU'LL LOVE THIS
SUIT -
George PETTY

The
"Petty Girl"
suit
of 1940

BY JANTZEN

A great artist turns to swim suit design! With the same master
strokes in simplicity of line that have made him so famous with
brush and canvas. Here's George Petty's conception of the
Suit of Youth, classic in design with slenderizing princess lines.
 Tailored by Jantzen in a perfectly amazing new fabric, Sea
Ripple. A swim suit that actually stretches all ways! A swim
suit with real foundation garment control! It fits as you have
never known a swim suit could fit. See it—feel it—try it on.
Lastex* yarn has been knitted-in for perfect figure-molding.
There's a new experience in beauty of line and perfection of
fit awaiting you. In the new fashionable colors—$6.95 in U.S.A.
For illustrated style folder, men's or women's, address Dept. 311.

 A reproduction of this Petty Painting without advertis-
ing copy will be sent on receipt of 10c in stamps or coin.

JANTZEN KNITTING MILLS, PORTLAND, OREGON; VANCOUVER, CANADA
 *Reg. U.S. Pat. Off.

Jantzen
SWIM SUITS and SUN CLOTHES

Something to remember...

it's a new kind of summer but you have the same kind of sun, the same kind of sky, water for swimming and thrilling new Jantzen swim suits to make a girl lovely for a man on leave . . . to give a man something to remember. Wonderful slimming knitted fabrics, unforgettable colors, marvelous bras for the girls. For men, the smartest trim-tailored knitted trunks in America.

COQUETTE FLARE Velva-lure 9.95
COMMANDER all-wool trunks 5.00

pete hawley

Jantzen AMERICA'S SWIM SUIT

JANTZEN KNITTING MILLS, PORTLAND, OREGON · VANCOUVER, CANADA
TO BE FREE TO ENJOY TOMORROW...BUY BONDS TODAY!

Jantzen Swimwear, 194

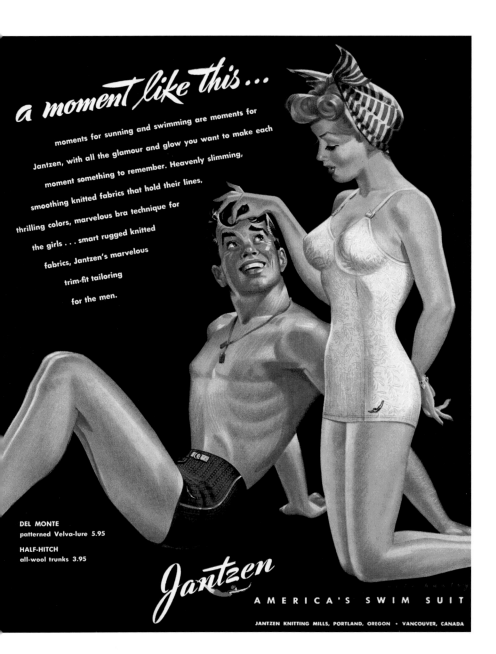

a moment like this...

moments for sunning and swimming are moments for Jantzen, with all the glamour and glow you want to make each moment something to remember. Heavenly slimming, smoothing knitted fabrics that hold their lines, thrilling colors, marvelous bra technique for the girls . . . smart rugged knitted fabrics, Jantzen's marvelous trim-fit tailoring for the men.

DEL MONTE
patterned Velva-lure 5.95

HALF-HITCH
all-wool trunks 3.95

Jantzen

AMERICA'S SWIM SUIT

JANTZEN KNITTING MILLS, PORTLAND, OREGON · VANCOUVER, CANADA

Jantzen Swimwear, 1943

Little Boy Blu[e]

Little Boy Blue,
 Awake from your sleep;
The girl of your dreams
 Is bewitching your sheep.

How does she do it?
 That's plain to see;
It's the glamour she gets
 From her Life Bras three.

From morn, 'til night,
 At work, at play,
Be a dream girl too
 The Formfit way.

Life BY Formfit

LOOK FOR **Life** THIS LABEL
KEEP A BRA WARDROBE
Day Life—Sports Life—Night Life
$1.25—$1.75—$2.50—$3.50

FLAT CHESTED? WRITE FOR INFORMATION ABOUT INFLATION
—THE BRASSIERE FOR FLAT CHESTED WOMEN

MADE BY THE FORMFIT COMPANY • CHICAGO • NEW Y[ORK]

◄ Formfit Brassieres, 1942

The silhouette of the 1940s was a marked departure from the 1930s long-and-lean-look. Clothing was more structured, with strong shoulders and a full bust. Where undergarments of the previous decade emphasized a smooth line and flat stomach, in the 1940s lingerie began to provide more support for the bust.

Die Silhouette der 1940er war eine klare Abkehr von dem Lang-und-dünn-Look der Dreißigerjahre. Die Kleidung war stärker strukturiert, kräftige Schultern und üppige Oberweite wurden betont. Während die Unterkleider des vorangegangenen Jahrzehnts eine weiche Linie und einen flachen Bauch betonten, dienten die Dessous der 40er Jahre eher dem Halt der Brust.

La silhouette des années 40 se démarque nettement du look long et frêle des années 30. Les vêtements étaient plus structurés, renforçant les épaules et la poitrine. Alors que les sous-vêtements de la décade précédente soulignaient une ligne lisse et un torse plat, la lingerie commença, au cours des années 40, à accentuer davantage le soutien du buste.

Jantzen Swimwear, 1946

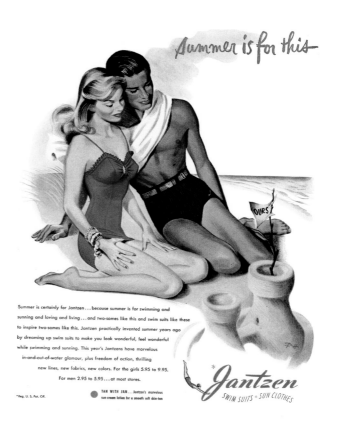

Summer is for this

Summer is certainly for Jantzen . . . because summer is for swimming and sunning and loving and living . . . and two-somes like this and swim suits like these to inspire two-somes like this. Jantzen practically invented summer years ago by dreaming up swim suits to make you look wonderful, feel wonderful while swimming and sunning. This year's Jantzens have marvelous in-and-out-of-water glamour, plus freedom of action, thrilling new lines, new fabrics, new colors. For the girls 5.95 to 9.95. For men 2.95 to 5.95 . . . at most stores.

*Reg. U. S. Pat. Off.

TAN WITH JAN . . . Jantzen's marvelous sun-cream lotion for a smooth soft skin-tan

Jantzen
SWIM SUITS • SUN CLOTHES

YOU FLOAT

with Float·ees*
the swim trunks with
built-in "FLOATING POWER"

Inside-out view showing how pontoons slip into specially designed pockets INSIDE the trunks. Inflating tube also tucks out of sight.

These amazing new swim trunks* offer beginners or experts endless hours of effortless swimming pleasure and safety with a single lungfull of air. Completely hidden vinyl-plastic pontoons can be inflated or deflated at will, in or out of the water. Fashion-styled boxer trunks, Zelan treated, in prints and solid colors. Men's sizes (30-46) $7.50 . . . Boys' (6-16) $6.50 at stores everywhere or write.

Endorsed by leading coaches and swimmers. Send for *Free* illustrated Booklet "A" with swimming lesson by Adolph Kiefer, Olympic Champion.

SWIM SUITS *Pat.applied for.

FLOAT-EES CORPORATION · 1745 BROADWAY, NEW YORK 19, N. Y.

Float-ees Swimwear, 1947 ▶ Jantzen Swimwear, 1941 ▶▶ Jantzen Swimwear, 1949

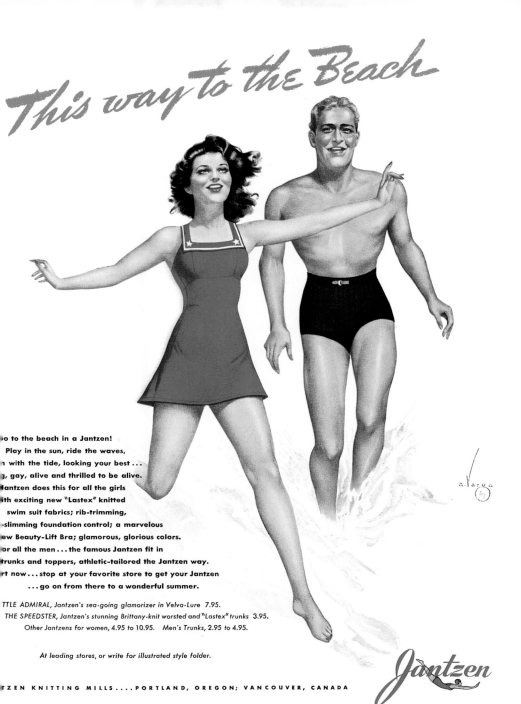

This way to the Beach

o to the beach in a Jantzen!

Play in the sun, ride the waves,
n with the tide, looking your best . . .
g, gay, alive and thrilled to be alive.
Jantzen does this for all the girls
ith exciting new "Lastex" knitted
swim suit fabrics; rib-trimming,
slimming foundation control; a marvelous
ew Beauty-Lift Bra; glamorous, glorious colors.
or all the men . . . the famous Jantzen fit in
runks and toppers, athletic-tailored the Jantzen way.
rt now . . . stop at your favorite store to get your Jantzen
. . . go on from there to a wonderful summer.

TTLE ADMIRAL, Jantzen's sea-going glamorizer in Velva-Lure 7.95.
THE SPEEDSTER, Jantzen's stunning Brittany-knit worsted and "Lastex" trunks 3.95.
Other Jantzens for women, 4.95 to 10.95. Men's Trunks, 2.95 to 4.95.

At leading stores, or write for illustrated style folder.

Jantzen

TZEN KNITTING MILLS PORTLAND, OREGON; VANCOUVER, CANADA

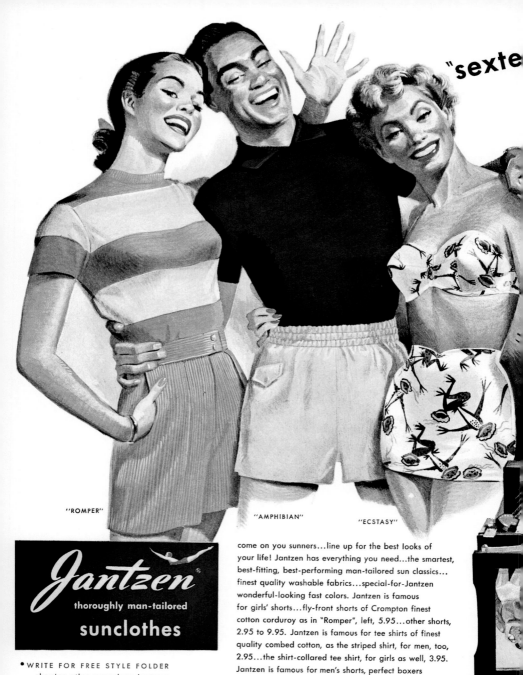

"sexte

"ROMPER" "AMPHIBIAN" "ECSTASY"

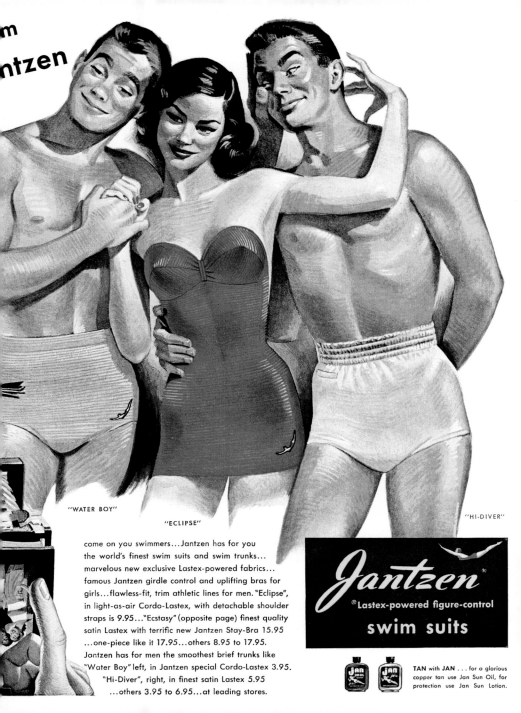

"WATER BOY"

"ECLIPSE"

"HI-DIVER"

come on you swimmers...Jantzen has for you
the world's finest swim suits and swim trunks...
marvelous new exclusive Lastex-powered fabrics...
famous Jantzen girdle control and uplifting bras for
girls...flawless-fit, trim athletic lines for men. "Eclipse",
in light-as-air Cordo-Lastex, with detachable shoulder
straps is 9.95..."Ecstasy" (opposite page) finest quality
satin Lastex with terrific new Jantzen Stay-Bra 15.95
...one-piece like it 17.95...others 8.95 to 17.95.
Jantzen has for men the smoothest brief trunks like
"Water Boy" left, in Jantzen special Cordo-Lastex 3.95.
"Hi-Diver", right, in finest satin Lastex 5.95
...others 3.95 to 6.95...at leading stores.

Jantzen

® Lastex-powered figure-control

swim suits

TAN with JAN . . . for a glorious
copper tan use Jan Sun Oil, for
protection use Jan Sun Lotion.

"CHIC IS WHERE YOU FIND IT."
– BONNIE CASHIN

„CHIC FINDEST DU ÜBERALL."
–BONNIE CASHIN

1950

« LE CHIC SE TROUVE LÀ
OÙ VOUS LE VOYEZ. »
– BONNIE CASHIN

1959

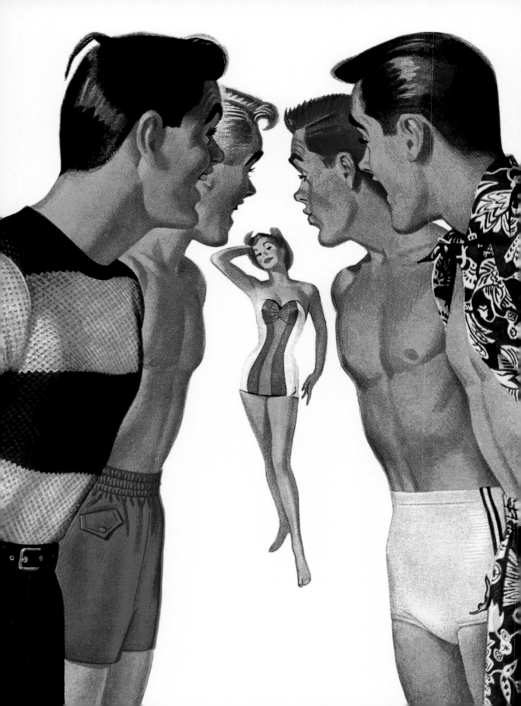

WILD ONES AND WOMANLY WILES

American veterans back from fighting in the Pacific had brought Hawaiian shirts and surf culture to the mainland, but it was teen surfer-girl Kathy "Gidget" Kohner's innocent exploits at Malibu beach that cemented California's reputation as a fountainhead of youth culture.

WITH STRIKING RED HAIR, HIGH CHEEKBONES, AND ARCHED EYEBROWS, MODEL SUZY PARKER WAS THE FACE OF THE 1950S, appearing on more than 60 magazine covers of the decade. She became Chanel's model of choice, and was photographed by Richard Avedon in Dior, whose "New Look" dominated women's fashions for a generation. The silhouette made its way to the big and small screens: Elizabeth Taylor's white, strapless, cinch-waist gown for the 1951 film *A Place in the Sun* became one of the most copied prom dresses of the era. Full skirts were key to Lucille Ball's wardrobe when *I Love Lucy* debuted on that new medium, television, in 1952.

By 1954, television sales had surpassed radio, as millions of families tuned in to watch situation comedies like *Father Knows Best* and *Leave It to Beaver*; game shows like *What's My Line?* and *Twenty One*; and variety shows like *Sid Caesar's Your Show of Shows*. Television proved to be a successful advertising vehicle, but for fashion, print remained the dominant medium. New magazines like *Playboy*, *Jet*, *Sports Illustrated*, *TV Guide*, and *Confidential* were launched, targeting new demographics.

Still, there were early examples of "as-seen-on TV" trends. Disney's Davy Crockett's popularity sent millions of children to the store to buy everything from coonskin caps to licensed Davy Crockett pajamas and lunchboxes. *American Bandstand* host Dick Clark showcased pop musicians and the latest dance trends, which helped define the "American teen."

American veterans back from fighting in the Pacific had brought Hawaiian shirts and su[n] culture to the mainland, but it was teen surfer-girl Kathy "Gidget" Kohner's innocent exploits at Mal[ibu] beach in *Gidget* that cemented California's reputation as a fountainhead of youth culture. Jame[s] Dean and Natalie Wood offered another example of American teen life in 1955's *Rebel without a Caus[e]* and, by 1956, Elvis Presley released *Heartbreak Hotel*, bringing rock 'n' roll to the fore. The rebel loo[k] worn by Dean and Presley—not to mention Marlon Brando, in 1953's *The Wild One*—was blue jean[s] a white T-shirt, and a leather jacket. All were a stark contrast to the professional look of the day: sli[m] and somber suits worn with a skinny tie and topped with a fedora.

In addition to Dior's full-skirt silhouette, 1950s womenswear included pencil skirts, tailored suit[s] and dresses with demure ballet necklines or sexy, off-the-shoulder or strapless styles for evenin[g]. In 1954, Coco Chanel reopened for business. Her line of suits with boxy jackets trimmed with gol[d] braid and accessorized with a pile of pearls became the hallmark of the design house.

While the decade's fashions were predominantly conservative, signs of change were alread[y] forming. In 1947, a French civil engineer, Louis Réard, introduced the bikini at a Paris fashio[n] show. The following year, Italian designer Emilio Pucci created his first American collection fo[r] Lord & Taylor stores. In 1951, Finnish designer Armi Ratia launched the company that eventual[ly] became print powerhouse Marimekko. Cristobal Balenciaga introduced balloon jackets, the cocoo[n] coat, the sack dress, and the chemise; and Pierre Cardin created the bubble dress. The 1960s wer[e] right around the corner.

◄◄ Jantzen Swimwear, 1950 ► L'Aiglon, 195[0]

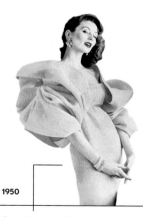

1950

1950

1950

Hawaiian shirt boom

Das Hawaii-Hemd boomt

La mode de la chemise hawaïenne déferle sur les États-Unis

Original supermodel Suzy Parker arrives in Paris

Mit Suzy Parker trifft ein echtes Supermodel in Paris ein

Suzy Parker, la première top-modèle, débarque à Paris

Pomade-slicked hairstyles popular with teen boys throughout decade

Glatte Pomadefrisuren sind das Jahrzehnt hindurch bei Teenager-Jungs beliebt

Les adolescents adoptent les coiffures lissées à la brillantine pendant toute la décennie

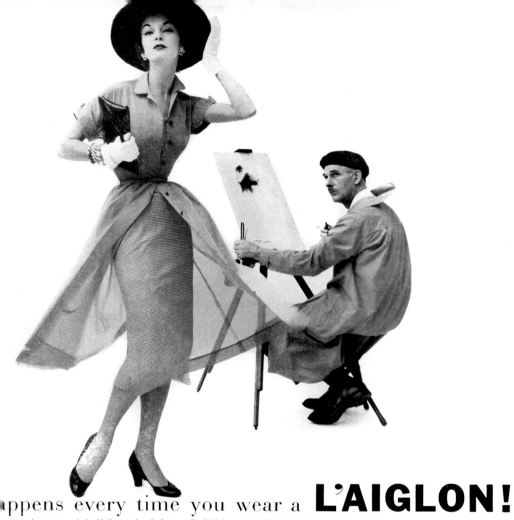

...ppens every time you wear a **L'AIGLON!**

...s cease when you pass by in this devastating, dual-personality L'Aiglon outfit with its checked gingham sundress, its tissue chambray redingote. Brown, black,
...Sizes 10 to 20. $19.95. For illustrated brochure and name of nearest L'Aiglon store, write Dept. H, L'Aiglon Apparel, Inc., 1350 Broadway, New York 18, N. Y.

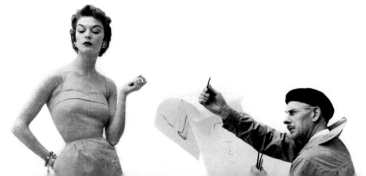

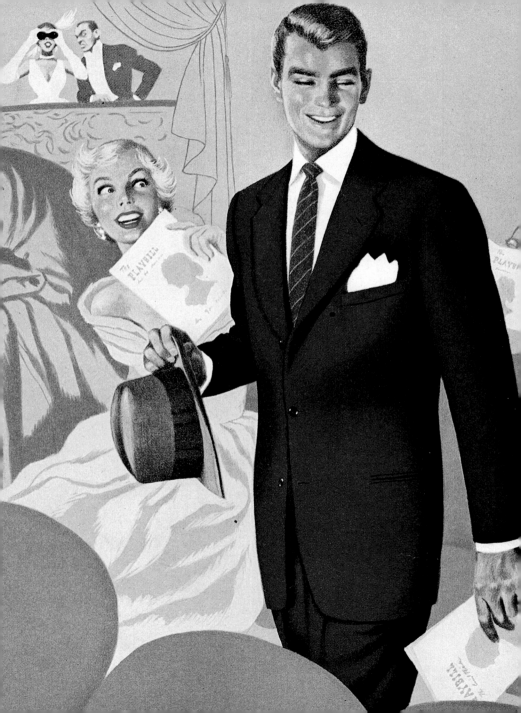

HALBSTARKE UND WEIBLICHE RAFFINESSE

*Amerikas Veteranen aus dem Pazifik hatten
Hawaiihemden und Surfer-Atmosphäre mit
ans Festland gebracht, aber eigentlich waren es
erst die unschuldigen Heldentaten des Teeny-
Surfer-Girls Kathy „Gidget" Kohner am Strand
von Malibu, die Kaliforniens Ruf als Urquell der
Jugendkultur untermauerten.*

MIT FLAMMEND ROTEM HAAR, HOHEN WANGENKNOCHEN UND GESCHWUNGENEN AU-
GENBRAUEN WAR DAS FOTOMODELL SUZY PARKER DAS GESICHT DER 50ER, das im Laufe
es Jahrzehnts mehr als sechzigmal die Titelseiten diverser Magazine schmückte. Sie avancierte zu
Chanels Lieblingsmodell und wurde von Richard Avedon in Dior fotografiert, dessen New Look die
Damenmode eine ganze Generation lang dominieren sollte. Die Silhouette beherrschte die große wie
ie kleine Leinwand: Elizabeth Taylors weißes, schulterfreies, tailliertes Abendkeid aus dem Film *Ein
Platz an der Sonne* von 1951 war eines der meistkopierten Ballkleider jener Ära. Weite Röcke waren
uch das Markenzeichen der Garderobe von Lucille Ball, als *I Love Lucy* 1952 im damals neuen Me-
ium Fernsehen startete.

1954 hatten die Verkaufszahlen für Fernseher jene für Radios überholt, und Millionen von Fami-
en verfolgten Sit-Coms wie *Vater ist der Beste* und *Erwachsen müßte man sein*, Spielshows wie *What's My
ine?* und *Twenty One* sowie Unterhaltungssendungen wie Sid Caesars *Your Show of Shows*. Das Fern-
ehen erwies sich als erfolgreiches Werbemedium, doch für die Modebranche blieb der Printbereich
m wichtigsten. Neue Magazine wie *Playboy*, *Mad*, *Jet*, *Sports Illustrated*, *TV Guide* und *Confidential* ka-
en auf den Markt und nahmen neue Zielgruppen ins Visier.

Es gab allerdings auch schon frühe Beispiele von „wie aus dem TV bekannt". So sorgte etwa die
eliebtheit von Disneys Davy Crockett dafür, dass Millionen amerikanischer Kinder die Geschäfte

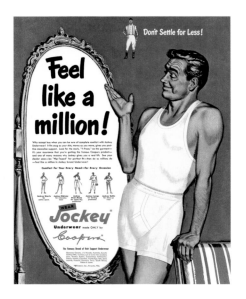

stürmten, um von Waschbärfellmützen bis hi
zu lizensierten Pyjamas und Brotdosen einfac
alles von Davy Crockett zu kaufen. Dick Clar
Gastgeber bei *American Bandstand*, präsentiert
Popmusiker und die neuesten Modetänze un
trug damit dazu bei, den typisch amerikanische
Teenager zu definieren.

Amerikas Veteranen aus dem Pazifik ha
ten Hawaiihemden und Surfer-Atmosphäre m
ans Festland gebracht, aber eigentlich waren e
erst die unschuldigen Heldentaten des Teeny
Surfer-Girls Kathy „Gidget" Kohner am Stran
von Malibu, die Kaliforniens Ruf als Urquell de
Jugendkultur untermauerten. James Dean un
Natalie Wood gaben in *Denn sie wissen nicht, wa
sie tun* von 1955 ein anderes Beispiel für ein ame
rikanisches Teenagerleben, und mit der Verö
fentlichung von Heartbreak Hotel 1956 bracht
Elvis Presley den Rock'n'Roll entscheidend nac
vorn. Der Rebellen-Look von Dean und Presley
gar nicht zu reden von Marlon Brando in *Der Wila
von 1953 – bestand aus Bluejeans, weißem T-Shi
und Lederjacke. Das war der denkbar größt

Kontrast zum damaligen Business-Outfit, bestehend aus einem eng geschnittenen Anzug in ge
deckter Farbe, schmaler Krawatte und Filzhut.

1952

Teen boys embrace Converse All Star
basketball shoe

Männliche Teenager favorisieren den Basket-
ballschuh Converse All Star

Les adolescents adoptent les baskets Converse
All Star

1952

Trendy teens dance on Dick Clark's
American Bandstand

Trendbewusste Teenies tanzen nach Dick Clar-
ks *American Bandstand*

Les ados branchés adoptent les danses présen-
tées dans *American Bandstand* de Dirck Clark

1953

Marilyn Monroe's cat's-eye glasses lampoone
in *How to Marry a Millionaire*

Marilyn Monroes Katzenaugen-Brille wird in
Wie angelt man sich einen Millionär veralbert

Les lunettes « œil de chat » de Marilyn Monro
font sensation dans *Comment épouser un
millionnaire*

Neben Diors weitschwingenden Röcken gab
s in der Damenmode der 50er auch Bleistiftrö-
ke, figurnahe Kostüme und Kleider mit sittsa-
em Rundhalsausschnitt sowie sexy schulterfreie
der trägerlose Teile für den Abend. 1954 kehrte
oco Chanel ins Geschäft zurück. Ihre Kollektion
us Kostümen mit kastenförmigen Jacken, die mit
oldborten verziert waren und mit haufenweise
erlen getragen wurden, avancierte zum Marken-
eichen ihres Modehauses.

Auch wenn die Trends des Jahrzehnts vor-
ehmlich konservativ waren, so konnte man doch
hon Anzeichen eines Wandels erkennen. 1947
eß der französische Maschinenbauingenieur
ouis Réard bei einer Pariser Modenschau erst-
als einen Bikini vorführen. Im Jahr darauf ent-
arf der italienische Designer Emilio Pucci seine
rste amerikanische Kollektion für die Kette
ord & Taylor.

1951 gründete die finnische Designerin Armi
atia die Firma, die schließlich zu Marimekko,
em Spezialisten für Stoffdruck, wurde. Cristo-
al Balenciaga führte Ballonjacken, den Kokon-

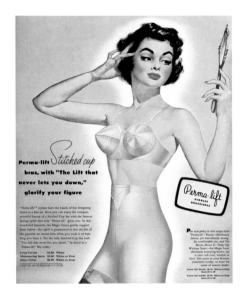

Perma-lift Bras, 1951

antel, das Sackkleid sowie das Hemdblusenkleid ein. Pierre Cardin erfand das Ballonkleid. Und
ie Sixties warteten schon um die Ecke.

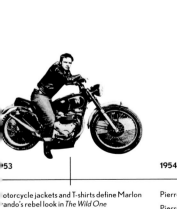

53	1954	1956
otorcycle jackets and T-shirts define Marlon ando's rebel look in *The Wild One*	Pierre Cardin introduces bubble dress	Pencil skirts offer narrow alternative to "New Look"
otorradjacken und T-Shirts bestimmen arlon Brandos Rebellen-Look in *Der Wilde*	Pierre Cardin präsentiert das Ballonkleid	Bleistiftröcke sind die schmale Alternative zum New Look
ans *L'Équipée Sauvage*, Marlon Brando donne e au look rebelle en T-shirt et blouson	Pierre Cardin lance la robe bulle	Les jupes droites offrent une alternative au New Look

273

NORTHWEST
AIRLINES
208

JEUNES REBELLES ET CHARMES FÉMININS

Après avoir combattu dans le Pacifique, les vétérans américains rapportent les chemises hawaïennes et la mode du surf sur le continent, mais c'était la jeune surfeuse Kathy «Gidget» Kohner sur la plage de Malibu… qui cimente la réputation de la Californie en tant que berceau de la culture jeune.

VEC SES CHEVEUX ROUGE FEU, SES POMMETTES SAILLANTES ET SES SOURCILS ARQUÉS, E MANNEQUIN SUZY PARKER EST LE VISAGE DES ANNÉES 50 qui fera plus de soixante couvertures de magazines au cours de la décennie. Elle devient le mannequin de prédilection de Chanel et se fait photographier par Richard Avedon habillée de Dior, dont le New Look domine la mode féminine pendant toute une génération. Cette silhouette fait son chemin jusqu'aux petit et au grand écrans : la robe bustier blanche cintrée à la taille portée par Elizabeth Taylor en 1951 dans le film *Une place au soleil* devient l'un des modèles les plus copiés dans l'histoire des robes de bal de promo. En 1952, les jupes amples s'imposent comme un basique de la garde-robe de Lucille Ball dès les débuts de la série *L'Extravagante Lucie* sur ce nouveau média qu'est la télévision.

En 1954, les ventes de téléviseurs surpassent celles des radios alors que des millions de familles s'équipent pour regarder des feuilletons humoristiques tels *Papa a raison* et *Leave It to Beaver*, des jeux télévisés comme *What's My Line?* et *Twenty One* et des émissions de variétés, notamment *Your Show of Shows* animée par Sid Caesar. La télévision s'avère un formidable support publicitaire, mais la presse reste le média dominant pour la mode. De nouveaux magazines comme *Playboy*, *Mad*, *Jet*, *Sports Illustrated*, *TV Guide* et *Confidential* sont lancés à l'attention de nouvelles tranches démographiques.

On voit cependant apparaître les premiers exemples de modes «vues à la télé». Face à la popularité du *Davy Crockett* de Disney, des millions d'enfants fréquentent les magasins pour acheter toutes

sortes de choses, des casquettes en raton laveur aux pyjamas et cantines sous licence Davy Crocket
Dick Clark, l'animateur d'*American Bandstand*, présente des groupes de pop et les dernières danses
la mode, contribuant ainsi à définir le « teenager américain ».

Après avoir combattu dans le Pacifique, les vétérans américains rapportent les chemise
hawaïennes et la mode du surf sur le continent, mais ce sont les exploits innocents de la jeune su
feuse Kathy « Gidget » Kohner sur la plage de Malibu dans le film *Un Amour de vacances* qui cimenter
la réputation de la Californie en tant que berceau de la culture jeune. James Dean et Natalie Woo
offrent un autre exemple de la vie des adolescents d'Amérique dans *La Fureur de vivre* en 1955, tandi
qu'en 1956, Elvis Presley popularise le rock'n'roll en sortant *Heartbreak Hotel*. Le look de rebelle arbor
par Dean et Presley – sans oublier Marlon Brando dans *L'Équipée sauvage* en 1953 – se compose d'u
blue jean, d'un T-shirt blanc et d'un blouson de cuir. Leur allure contraste radicalement avec le loo
professionnel de l'époque, la plupart des hommes portant des costumes de couleur sombre et prè
du corps avec une étroite cravate et un fedora.

Outre la silhouette à jupe ample de Dior, la mode féminine des années 50 inclut des jupe
droites, des tailleurs et des robes au modeste décolleté de danseuse, ou des modèles sexy, à bustie
ou bretelle asymétrique pour le soir. En 1954, Coco Chanel reprend du service. Sa collection de tail
leurs aux vestes carrées, gansés d'un galon doré et accessoirisés de plusieurs rangs de perles, devien
la signature de sa maison de haute couture.

Si les tendances de l'époque sont majoritairement conservatrices, des signes de changemer
apparaissent déjà. En 1947, l'ingénieur civil français Louis Réard présente le bikini lors d'un défilé d
mode parisien. L'année suivante, le couturier italien Emilio Pucci crée sa première collection améri
caine pour les magasins Lord & Taylor. En 1951, la créatrice finlandaise Armi Ratia fonde une entre
prise destinée à devenir le géant des imprimés textiles Marimekko. Cristobal Balenciaga invente le
vestes ballon, le manteau cocon, la robe sac et la robe-chemise, et Pierre Cardin, la robe bulle. Le
années 60 pointent leur nez à l'horizon.

◄◄ Sarong Girdles, 1956 ► Arrow Shirts and Ties, 1950 ►► Van Heusen Shirts, 195

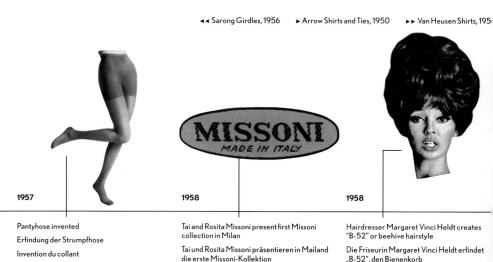

1957

Pantyhose invented
Erfindung der Strumpfhose
Invention du collant

1958

Tai and Rosita Missoni present first Missoni
collection in Milan

Tai und Rosita Missoni präsentieren in Mailand
die erste Missoni-Kollektion

Tai et Rosita Missoni présentent la première
collection Missoni à Milan

1958

Hairdresser Margaret Vinci Heldt creates
"B-52" or beehive hairstyle

Die Friseurin Margaret Vinci Heldt erfindet
„B-52", den Bienenkorb

La coiffeuse Margaret Vinci Heldt lance la
mode des coiffures « en choucroute »

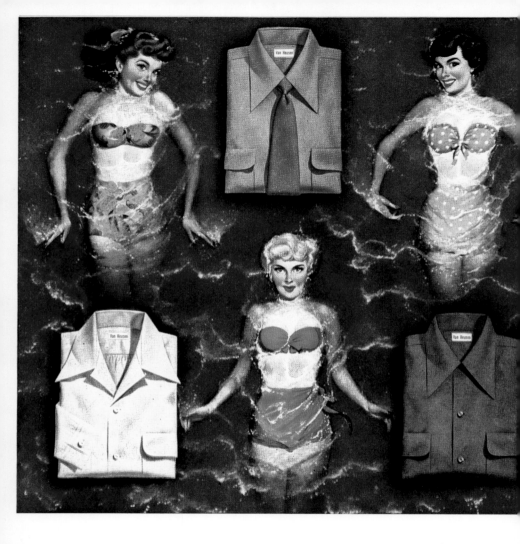

c'mon in ... the wearing's fine

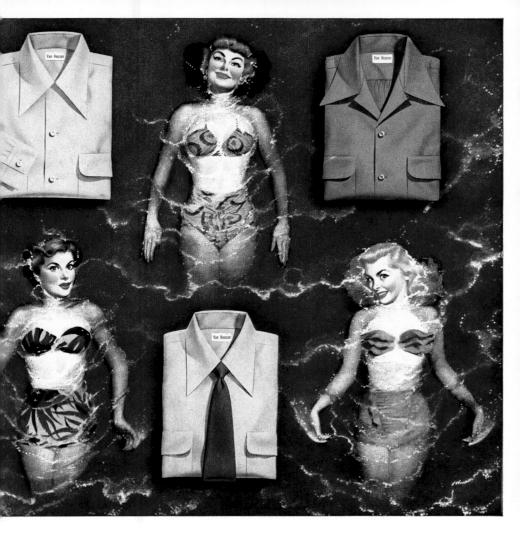

Van Heusen

new **Van Gab Sport** Shirts...

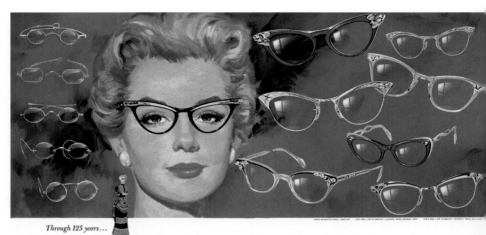

Through 125 years...

Grandma's "Specs" Have Become *Today's Fashion Showpieces*

When American Optical first started making silver-framed glasses in 1833, folks didn't think about how the *frames* looked. They were just downright glad to see better.

But how things have changed. Today,

glasses not only help you see better, but American Optical frames are smart fashion accessories . . . designed by stylists as carefully as a Paris original. Frames are scientifically sound and glow with fashion's warmest colors . . .

gleam with sparkling trim. Best of all, American Optical frames flatter your eyes . . . compliment your coloring . . . really *do* something for you.

You can obtain these new American Optical Showpieces anywhere in America through the Eye Care Professions.

RED DOT An AO exclusive.

Do your glasses loosen and slide around after a month's wear? Well, not if they are the new American Optical frames. These Red Dot frames have a unique "never loosen" construction which keeps them always in place, in comfort.

BETTER VISION FOR BETTER LIVING

American 🛡 Optical
COMPANY
SOUTHBRIDGE, MASSACHUSETTS

American Optical Company, 1959 ▶ Hathaway Shirts, 19!

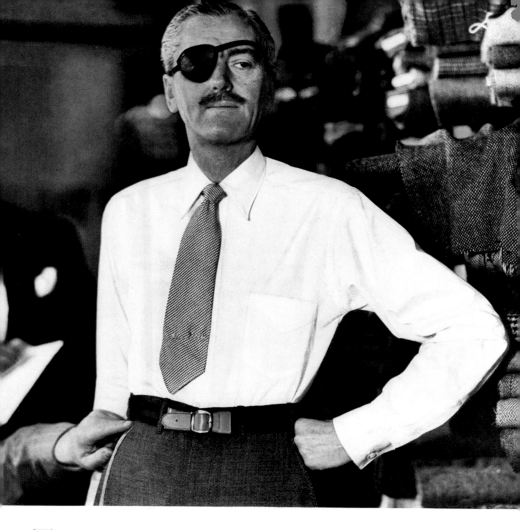

The man in the Hathaway shirt

AMERICAN MEN are beginning to realize that it is ridiculous to buy good and then spoil the effect by wearing ordinary, mass-produced shirt. Hence growing popularity of HATHAWAY, which are in a class by themselves. HATHAWAY shirts *wear* infinitely longer, matter of years. They make you younger and more distinguished, because of the subtle way HATHAWAY cut s. The whole shirt is tailored more ously, and is therefore more *comfort*-The tails are longer, and stay in your trousers. The buttons are mother-of-pearl. Even the stitching has an ante-bellum elegance about it.

Above all, HATHAWAY make their shirts of remarkable *fabrics*, collected from the four corners of the earth—Viyella and Aertex from England, woolen taffeta from Scotland, Sea Island cotton from the West Indies, hand-woven madras from India, broadcloth from Manchester, linen batiste from Paris, hand-blocked silks from England, exclusive cottons from the best weavers in America. You will get a great deal of quiet satisfaction out of wearing shirts which are in such impeccable taste.

HATHAWAY shirts are made by a small company of dedicated craftsmen in the little town of Waterville, Maine. They have been at it, man and boy, for one hundred and fifteen years.

At better stores everywhere, or write C. F. HATHAWAY, Waterville, Maine, for the name of your nearest store. In New York, telephone MU 9-4157. Prices from $5.50 to $25.00.

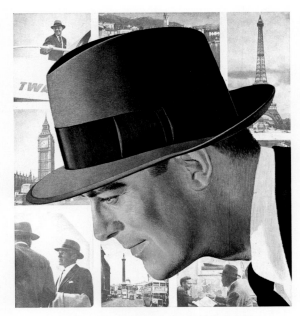

Cosmopolitan - the man who wears the Stetson with the Mode Edge

Wherever you are you're right in style wearing a Stetson with the famous Mode Edge. It's a sign of fine craftsmanship for those who demand the custom touch. Here you see the Stetson Sussex with the Mode Edge...a hat designed for the trend towards the slimmer, trimmer silhouette. New smart colors with contrasting bands. The Stetson Sussex—$15. Other Stetson styles with the Mode Edge—$15 and $20.

The STETSON is part of the man

The Stetson "Cushioned-To-Fit" leather has been the standard of hat comfort for over 70 years.
Stetson Hats are made only by John B. Stetson Company, and its affiliated companies throughout the world.

Stetson Hats, 1954

Perhaps hat manufacturers saw their products' future as novelty accessories for a small niche market. In 1952, hatmakers banded together to extol the virtues—both practical and sartorial—of hats.

Vielleicht betrachteten die Hutmacher eine kleine Marktnische für neueste Accesoires als Zukunft für ihre Produkte. 1952 taten sich die Hutfabriken jedenfalls zusammen, um die praktischen wie eleganten Vorzüge von Hüten zu rühmen.

Les fabricants de chapeaux pensaient peut-être que l'avenir de leurs produits se trouvait dans le petit segment de marché des acces-soires fantaisie. En 1952, ils s'unirent pour prôner les vertus tant pratiques que vestimen-taires des chapeaux.

▶ Hat Corporation of America, 1952

ATS—As healthy as they're handsome

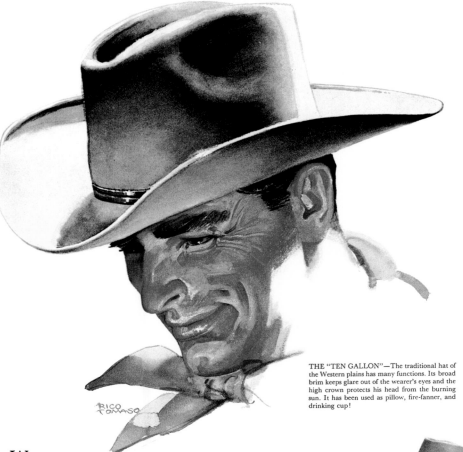

THE "TEN GALLON"—The traditional hat of the Western plains has many functions. Its broad brim keeps glare out of the wearer's eyes and the high crown protects his head from the burning sun. It has been used as pillow, fire-fanner, and drinking cup!

Whether you punch cows or punch a clock, never forget the primary purpose of a hat—to *protect* you. A hat shades your eyes from aching glare, keeps sun and city soot off your hair, and guards your head against icy blasts. That's why when you go bare-headed you're just asking for trouble. It's foolish—especially when there is a handsome, well-styled hat just waiting to improve your appearance. Look in your dealer's window—he has a hat designed *right* for any occasion, wherever you go, or play, or work.

"Wear a Hat—It's as Healthy as It's Handsome!"

HATS—As healthy as they're handsome

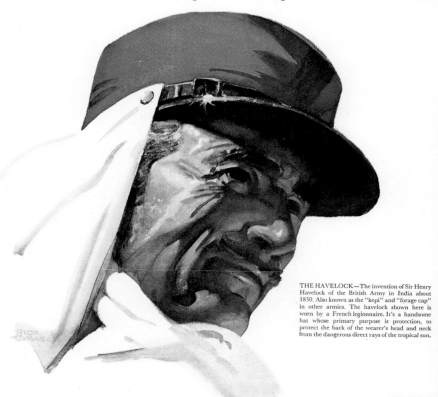

THE HAVELOCK—The invention of Sir Henry Havelock of the British Army in India about 1850. Also known as the "kepi" and "forage cap" in other armies. The havelock shown here is worn by a French legionnaire. It's a handsome hat whose primary purpose is protection, to protect the back of the wearer's head and neck from the dangerous direct rays of the tropical sun.

N̲o̲ ̲m̲a̲t̲t̲e̲r̲ ̲w̲h̲e̲r̲e̲ ̲y̲o̲u̲ ̲l̲i̲v̲e̲—in New York or New Caledonia—the purpose of your hat is to protect your eyes from glare, your hair from sun and soot, your head from icy blasts. That's the *primary* purpose of a hat. Don't go bareheaded—it simply isn't a very wise thing to do.

It's unkind to your sinuses, and definitely unkind to the hair on your head. There's a handsome hat waiting to improve your appearance—and to protect your head. Styled in shape and color to the moment, there's a *right* hat for the occasion wherever you go, or play, or work.

"Wear a Hat—It's as Healthy as It's Handsome!"

Hat Corporation of America, 195

HATS—As healthy as they're handsome

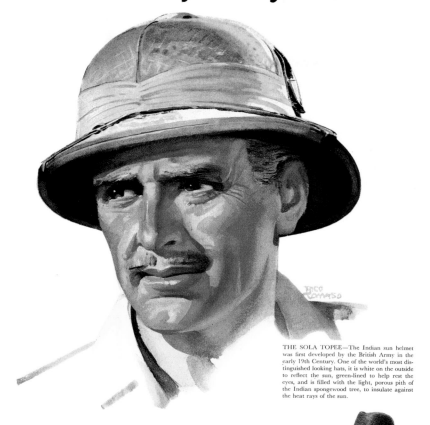

THE SOLA TOPEE—The Indian sun helmet was first developed by the British Army in the early 19th Century. One of the world's most distinguished looking hats, it is white on the outside to reflect the sun, green-lined to help rest the eyes, and is filled with the light, porous pith of the Indian spongewood tree, to insulate against the heat rays of the sun.

Your hat, too, is meant to protect you. It protects your hair from sun and soot, guards your eyes from painful glare, wards off the cold that can chill your head as well as your feet. Just as a practical matter—*it's wise to wear a hat*. It is rewarding, too. There's a healthy, appearance-improving hat waiting for you right now. In color and styling, it's *right* for the occasion—wherever you go, or play, or work.

"Wear a Hat—It's as Healthy as It's Handsome!"

These fine hat labels have published this advertisement in the interests of good grooming and good health of American men. } DOBBS CAVANAGH KNOX
BERG BYRON C&K DUNLAP

at Corporation of America, 1952

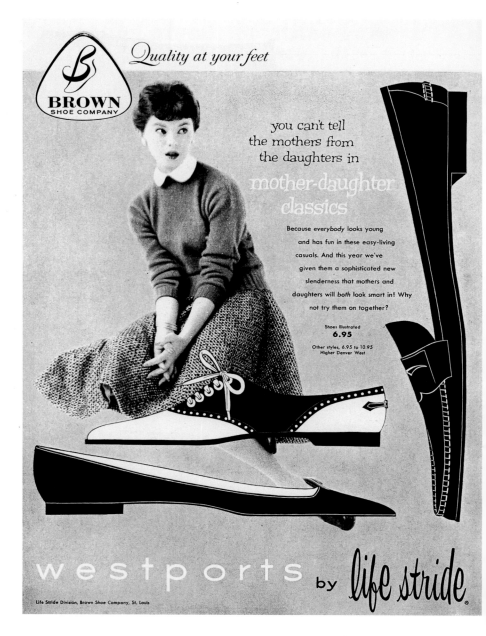

Quality at your feet

BROWN SHOE COMPANY

you can't tell
the mothers from
the daughters in

*mother-daughter
classics*

Because everybody looks young
and has fun in these easy-living
casuals. And this year we've
given them a sophisticated new
slenderness that mothers and
daughters will *both* look smart in! Why
not try them on together?

Shoes Illustrated
6.95

Other styles, 6.95 to 10.95
Higher Denver West

westports by *life stride*

Life Stride Division, Brown Shoe Company, St. Louis

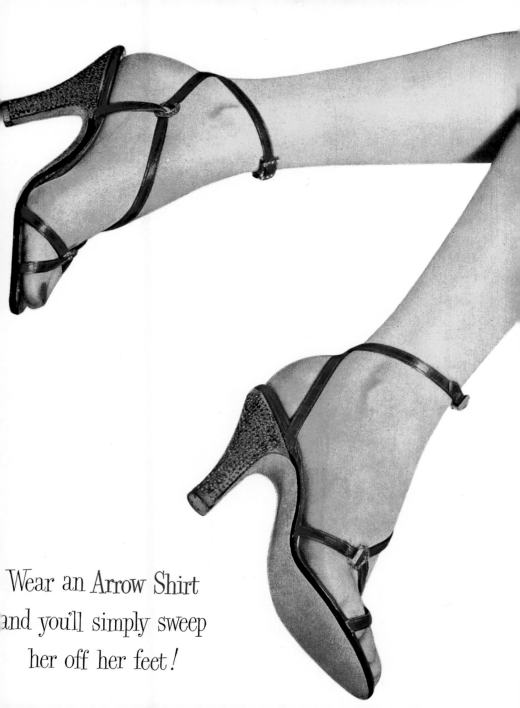

Wear an Arrow Shirt
and you'll simply sweep
her off her feet!

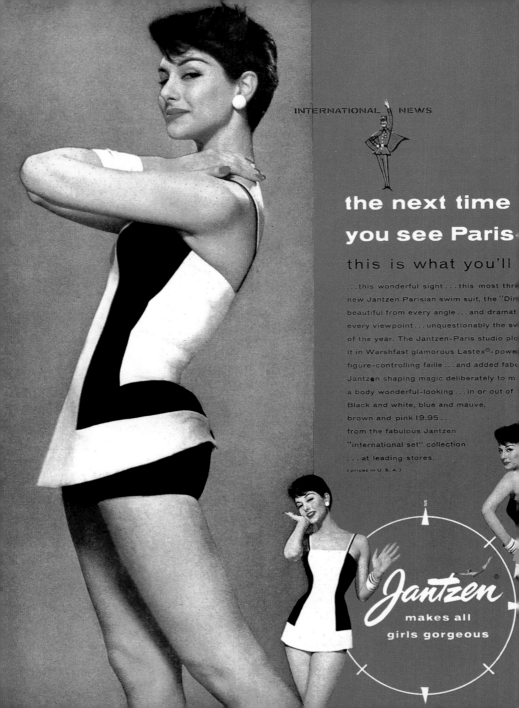

Jantzen Swimwear, 1956

In the late 1940s and early 1950s, postwar couturiers and designers opened for business in Paris, re-establishing the city as a center of fashion. In this ad, Jantzen, known for its pin-up- and sports-themed ads, took a different approach by emphasizing Parisian design and high-fashion sense.

In den späten 40ern und frühen 50ern eröffneten die Couturiers und Designer der Nachkriegsära Läden in Paris und machten die Stadt wieder zu einem Zentrum der Mode. In dieser Anzeige schlägt der für seine von Pin-ups und Sportthemen bekannte Hersteller Jantzen ungewohnte Töne an und betont das Pariser Design und hochmodische Eleganz.

À la fin des années 40 et au début des années 50, les couturiers et les créateurs de l'après-guerre s'installèrent à Paris, redorant le blason de la ville en tant que capitale de la mode. Dans cette publicité, la marque Jantzen, réputée pour ses visuels à pin-up ou thèmes sportifs, adopta une approche différente mettant en avant la création parisienne et le style haute couture.

Bur-Mil Cameo, 1956

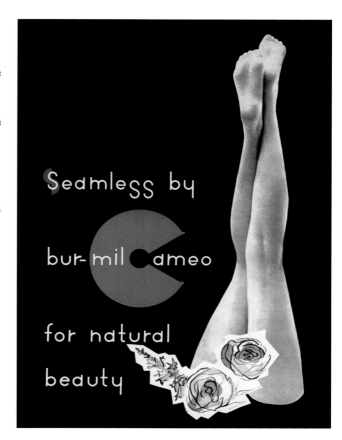

Seamless by bur-mil Cameo for natural beauty

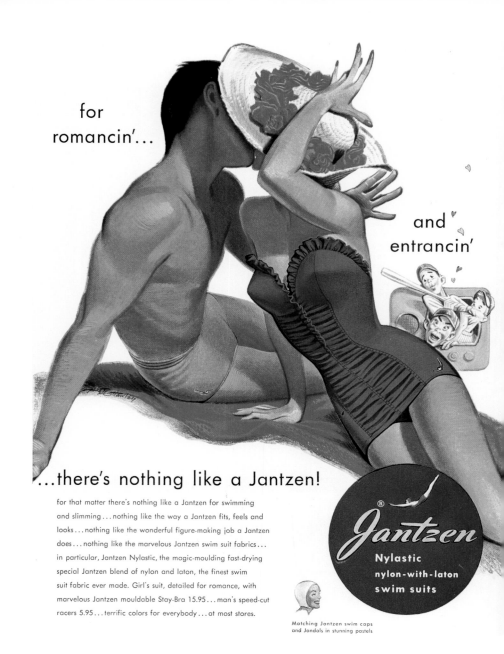

for
romancin'...

and
entrancin'

...there's nothing like a Jantzen!

for that matter there's nothing like a Jantzen for swimming
and slimming...nothing like the way a Jantzen fits, feels and
looks...nothing like the wonderful figure-making job a Jantzen
does...nothing like the marvelous Jantzen swim suit fabrics...
in particular, Jantzen Nylastic, the magic-moulding fast-drying
special Jantzen blend of nylon and laton, the finest swim
suit fabric ever made. Girl's suit, detailed for romance, with
marvelous Jantzen mouldable Stay-Bra 15.95...man's speed-cut
racers 5.95...terrific colors for everybody...at most stores.

Matching Jantzen swim caps
and Jandals in stunning pastels

®
Jantzen
Nylastic
nylon-with-laton
swim suits

Jantzen Swimwear, 19

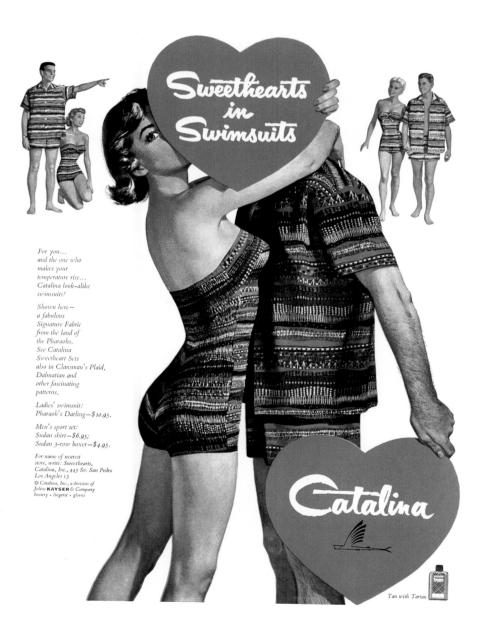

Sweethearts in Swimsuits

For you...
and the one who
makes your
temperature rise...
Catalina look-alike
swimsuits!

Shown here—
a fabulous
Signature Fabric
from the land of
the Pharaohs.
See Catalina
Sweetheart Sets
also in Clansman's Plaid,
Dalmatian and
other fascinating
patterns.

Ladies' swimsuit:
Pharaoh's Darling—$10.95.

Men's sport set:
Sudan shirt—$6.95;
Sudan 3-row boxer—$4.95.

For name of nearest
store, write: Sweethearts,
Catalina, Inc., 443 So. San Pedro
Los Angeles 13
© Catalina, Inc., a division of
Julius KAYSER & Company
hosiery • lingerie • gloves

Catalina

Tan with Tartan

Catalina Swimwear, 1955

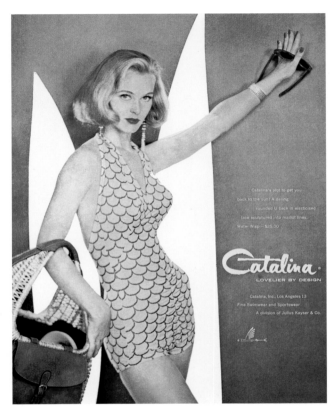

Catalina Swimwear, 1958

▶ Rose Marie Reid Swimwear, 1958

After the utilitarian ads of the war years, companies like Rose Marie Reid returned to presenting their products with an emphasis on the art of the ad and the beauty of the design.

Nach den nutzenorientierten Anzeigen der Kriegsjahre kehrten Firmen wie Rose Marie Reid dazu zurück, ihre Produkte wieder kunstvoll und mit Betonung auf das Design zu präsentieren.

Après les publicités utilitaires des années de guerre, des entreprises comme Rose Marie Reid revinrent au côté artistique et à la beauté graphique pour présenter leurs produits.

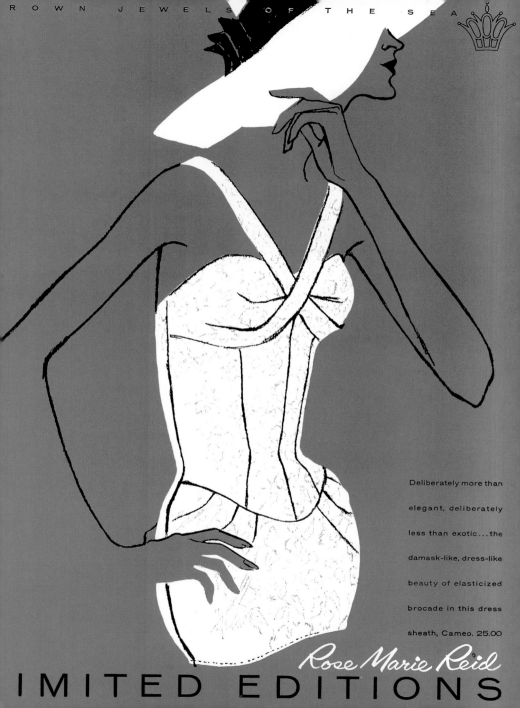

Warm & Sunny
When It's Icy Cold

Borgana Furs, 1951

Maidenform Bras, 1956

Maidenform first dreamed up its "I dreamed" campaign in 1949. This 1956 ad recalls the 1943 Howard Hughes film *The Outlaw*, famous as much for Jane Russell's breakout performance as for the bra Hughes had his engineers design for the actress. Russell never wore the bra and the film was repeatedly banned until 1947.

Maidenform hatte sich die „I dreamed"-Kampagne schon 1949 ausgedacht. Diese Anzeige von 1956 erinnert an Howard Hughes' Film *Geächtet* von 1943, der für Jane Russells Durchbruch ebenso verantwortlich war wie für den BH, den Hughes für die Schauspielerin hatte konstruieren lassen. Russell hat den BH niemals getragen und der Film wurde bis 1947 mehrmals verboten.

Maidenform inventa sa campagne « I dreamed » en 1949. Cette publicité de 1956 rappelle *Le Banni*, film d'Howard Hughes sorti en 1943, aussi célèbre pour avoir révélé Jane Russell que pour le fameux soutien-gorge conçu par les ingénieurs à la demande de Hughes. Jane Russell ne le porta jamais et le film subit plusieurs interdictions en salles avant sa sortie en 1947.

I dreamed I had Spring Fever in my maidenform bra

For the figure of your fondest day-dreams—Maidenform's lovely new Concerto* gives you curves that are more curvaceous, brings an exciting line to your outline! And it's all accomplished with row upon row of tiny, interlocked stitches! Each stitch catches up an inner cup-lining, pre-shapes this bra just enough to mould a fabulous form! In white stitched broadcloth, lace-margined. AA, A, B and C sizes...2.00

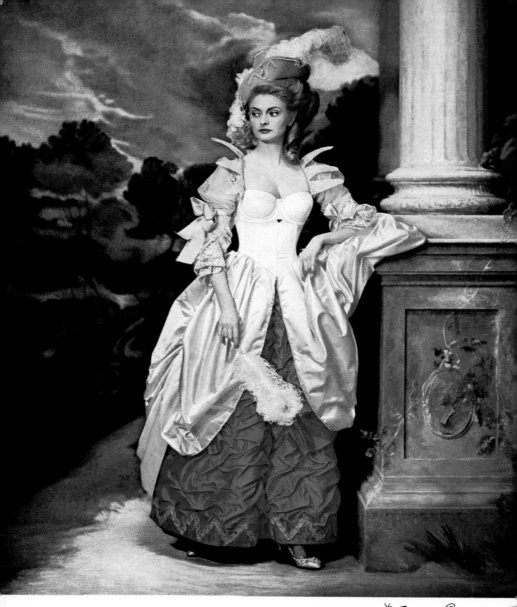

I dreamed I was a Work of Art in my *maidenform b*

PORTRAIT OF A LADY in a Maidenform masterpiece: the new Pre-Lude Once-Over Six
Lifts your curves, snugs in your waist, moulds a fabulous figure! With "quick-change"
six-way straps, to move or remove for every fashionable neckline. White cotton broadcloth,
A, B and C cups...8.95

JULIUS GARFINCKEL & CO.

IN THE NATION'S CAPITAL

JO COPELAND OF PATTULLO DRAMATIZES THE IRREGULAR-PEPLUM SHEATH WITH BAS-RELIEF OF JET EMBROIDERY. BRONZE GREEN SILK SATIN.

ALSO AT DE PINNA, N.Y.

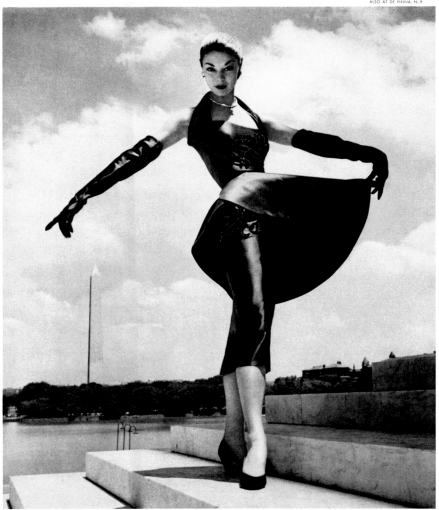

◄ Maidenform Bras, 1956 Julius Garfinckel & Co. Department Store/Pattullo-Jo Copeland, 1954

Flip yourself into a Jantzen Reversible!

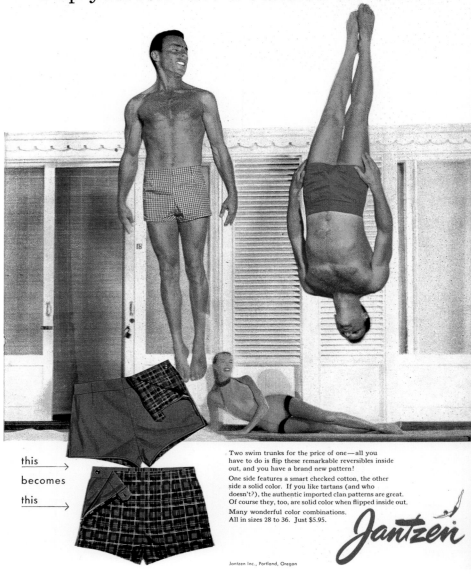

this →
becomes
this →

Two swim trunks for the price of one—all you have to do is flip these remarkable reversibles inside out, and you have a brand new pattern!

One side features a smart checked cotton, the other side a solid color. If you like tartans (and who doesn't?), the authentic imported clan patterns are great. Of course they, too, are solid color when flipped inside out.

Many wonderful color combinations. All in sizes 28 to 36. Just $5.95.

Jantzen

Jantzen Inc., Portland, Oregon

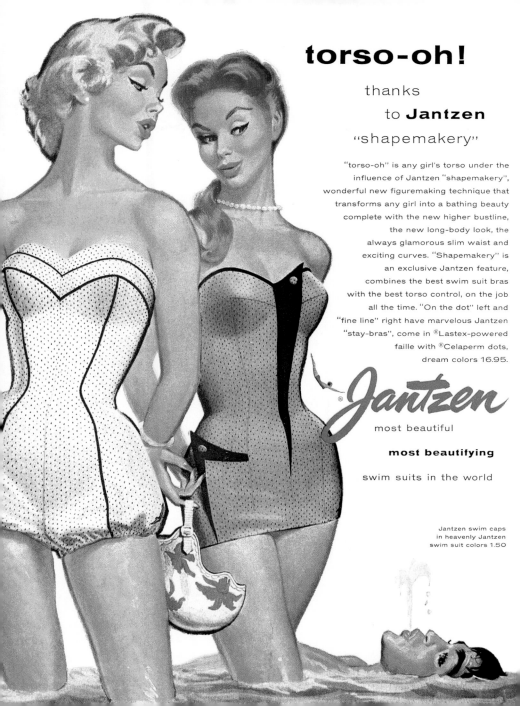

torso-oh!

thanks
to **Jantzen**
"shapemakery"

"torso-oh" is any girl's torso under the influence of Jantzen "shapemakery", wonderful new figuremaking technique that transforms any girl into a bathing beauty complete with the new higher bustline, the new long-body look, the always glamorous slim waist and exciting curves. "Shapemakery" is an exclusive Jantzen feature, combines the best swim suit bras with the best torso control, on the job all the time. "On the dot" left and "fine line" right have marvelous Jantzen "stay-bras", come in ®Lastex-powered faille with ®Celaperm dots, dream colors 16.95.

Jantzen

most beautiful

most beautifying

swim suits in the world

Jantzen swim caps
in heavenly Jantzen
swim suit colors 1.50

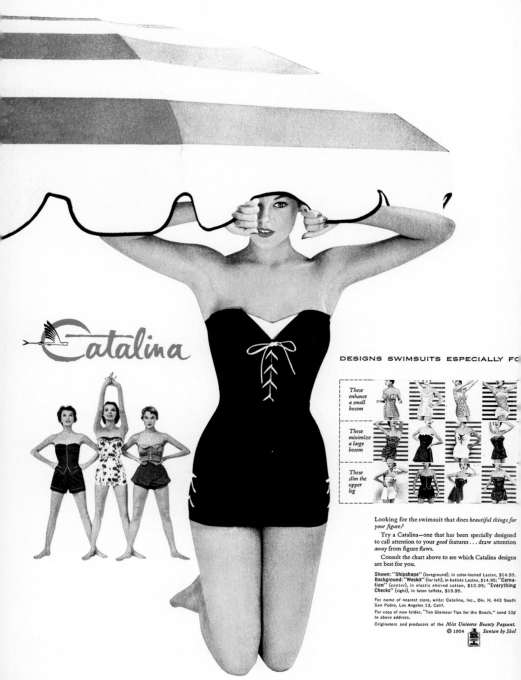

Catalina

the fiber is Courtaulds Coloray®...the color is forever!

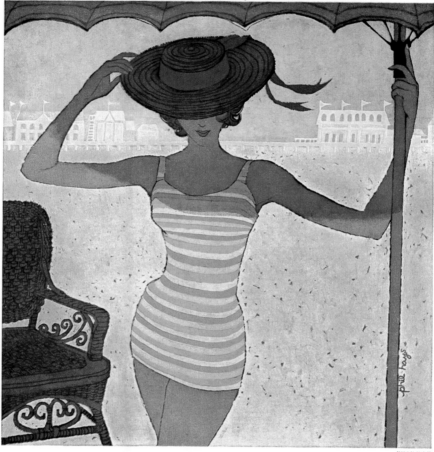

FABRIC BY MAYFLEX

swimsuit by Cole of California Beautiful, isn't it? A rainbow of Coloray pastels that live forever! No fading ever in sunlight or under water, including soap and water! Because all the color comes from Courtaulds Coloray, the fiber that's most colorfast to all color dangers. Swimsuit of elasticized Coloray-acetate-cotton in sizes 32 to 38. About $22.95. At B. Altman & Co., New York; Marshall Field, Chicago; Neiman-Marcus, Dallas and Houston; Woolf Bros., Kansas City; Frederick & Nelson, Seattle; Henry's, Wichita, or write Courtaulds (Alabama) Inc., 600 Fifth Ave., N. Y. 20.

Catalina, 1954 Coloray/Cole of California, 1958

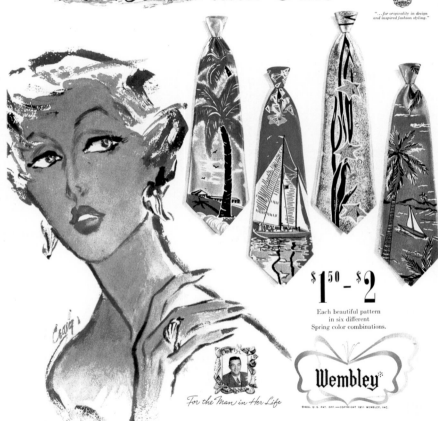

Wembley *fashions*

Sea, Sand and Sun

$1^{50} - ^\$2$

Each beautiful pattern
in six different
Spring color combinations.

For the Man in Her Life

Wembley

®REG. U. S. PAT. OFF.—COPYRIGHT 1951 WEMBLEY, INC.

Wembley Ties are approved for fashion by Men's Fashion Guild • For name of store nearest you, write Wembley, Inc., Empire State Building, New York

Wembley Ties, 1951 ► Manhattan Ties, 19⁵

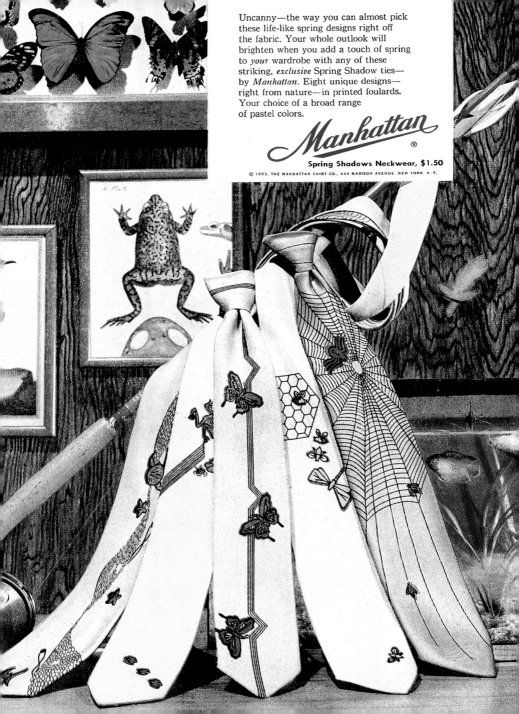

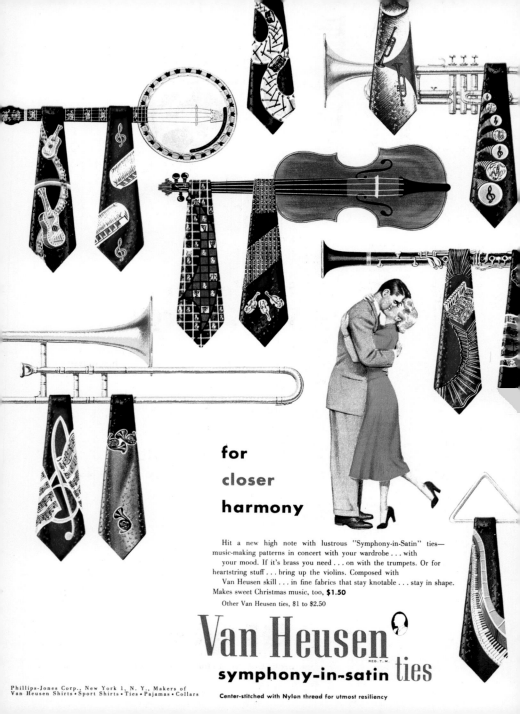

for closer harmony

Hit a new high note with lustrous "Symphony-in-Satin" ties—music-making patterns in concert with your wardrobe ... with your mood. If it's brass you need ... on with the trumpets. Or for heartstring stuff ... bring up the violins. Composed with Van Heusen skill ... in fine fabrics that stay knotable ... stay in shape. Makes sweet Christmas music, too, **$1.50**

Other Van Heusen ties, $1 to $2.50

Van Heusen *ties*
REG. T. M.
symphony-in-satin

Van Heusen Ties, 1950

Manhattan Ties, 1953

Postwar tie motifs ranged from the whimsical—western imagery, pinup girls, tropical beaches—to the art-inspired. Geometric patterns inspired by Art Déco became popular, as did ties featuring the work of famous artists such as Salvador Dalí.

Die Krawattenmotive der Nachkriegszeit reichten von skurril – Westernszenen, Pin-up-Girls und tropische Strände – bis hin zu künstlerisch. Geometrische Muster im Stil des Art Déco waren ebenso beliebt wie die Werke berühmter Künstler wie Salvador Dalí.

Après la guerre, les motifs de cravate allaient des plus fantaisistes – imagerie western, pin-up, plages tropicales – aux plus artistiques. La mode était aux motifs géométriques d'inspiration Art Déco, ainsi qu'aux cravates reproduisant les œuvres d'artistes célèbres comme Salvador Dalí.

new school of design in ties

"side glances"

Manhattan combines the conservative and the unusual in a refreshing new note in printed acetate foulard neckwear. These new "Side Glance" ties offer distinctive designs—with the focus of interest on one side of the tie! In a wide array of color combinations—from bright to subdued.

styled by

SIDE GLANCES NECKWEAR, $1.50
OTHERS TO $3.50

© 1953, THE MANHATTAN SHIRT CO., 444 MADISON AVENUE, NEW YORK, N. Y.

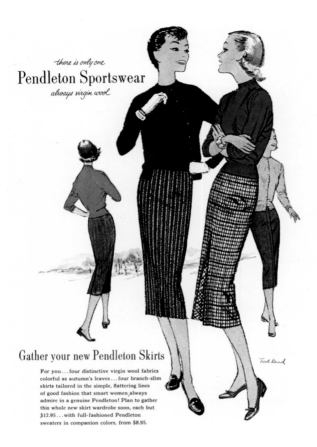

-there is only one-
Pendleton Sportswear
always virgin wool

Gather your new Pendleton Skirts

For you... four distinctive virgin wool fabrics
colorful as autumn's leaves... four branch-slim
skirts tailored in the simple, flattering lines
of good fashion that smart women always
admire in a genuine Pendleton! Plan to gather
this whole new skirt wardrobe soon, each but
$12.95... with full-fashioned Pendleton
sweaters in companion colors, from $8.95.

Ted Band

Pendleton Sportswear, 1956

Dior's "New Look" dominated women's silho
ettes in the 1950s, but it was not women's onl
fashion option. Pencil skirts and figure-huggi
sweaters were also in vogue. Pendleton got it
start in the 19th century as a wool mill based i
the United States' Pacific Northwest. The co
pany branched into women's apparel in 1949
and saw instant success with its "49er" jacke

Diors New Look dominierte die Silhouetten
der Damen in den 1950ern, aber er war nich
die einzige modische Option für die Frauen
damals. Bleistiftröcke und figurnahe Pullove
waren ebenso en vogue. Pendelton hatte im
19. Jahrhundert als Wollspinnerei mit Sitz
im Nordwesten der USA begonnen. Das
Unternehmen begann 1949 mit Damenbekl
dung und erzielte mit seiner Jacke „49er" au
sofort einen Erfolg.

Le New Look de Dior domina la mode fémini
dans les années 50, mais les femmes dispo-
saient aussi d'autres options. Les jupes droite
et les pulls moulants étaient également en
vogue. Après des débuts au 19ème siècle en ta
qu'usine de laine au nord de la côte ouest des
États-Unis, la société Pendleton se diversifia
dans la mode pour femme en 1949 et rempo
un succès immédiat avec sa veste « 49er ».

▶ Hart Schaffner & Marx Menswear, 1950

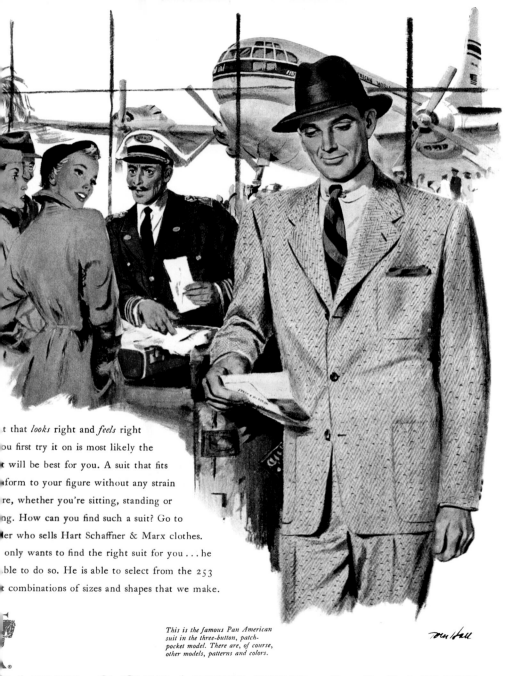

t that *looks* right and *feels* right

ou first try it on is most likely the

t will be best for you. A suit that fits

form to your figure without any strain

re, whether you're sitting, standing or

ng. How can you find such a suit? Go to

ler who sells Hart Schaffner & Marx clothes.

only wants to find the right suit for you . . . he

ble to do so. He is able to select from the 253

t combinations of sizes and shapes that we make.

This is the famous Pan American suit in the three-button, patch-pocket model. There are, of course, other models, patterns and colors.

ART SCHAFFNER & MARX

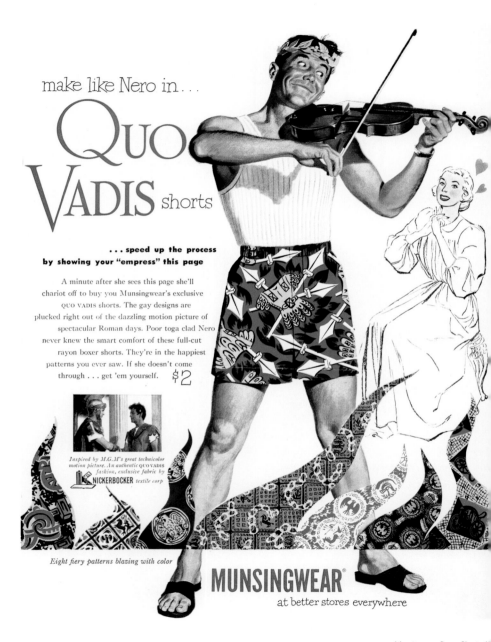

make like Nero in...

QUO VADIS shorts

**...speed up the process
by showing your "empress" this page**

A minute after she sees this page she'll
chariot off to buy you Munsingwear's exclusive
QUO VADIS shorts. The gay designs are
plucked right out of the dazzling motion picture of
spectacular Roman days. Poor toga clad Nero
never knew the smart comfort of these full-cut
rayon boxer shorts. They're in the happiest
patterns you ever saw. If she doesn't come
through ... get 'em yourself. $2

*Inspired by M.G.M's great technicolor
motion picture. An authentic QUO VADIS
fashion, exclusive fabric by*
NICKERBOCKER *textile corp*

Eight fiery patterns blazing with color

MUNSINGWEAR®

at better stores everywhere

Munsingwear Boxer Shorts, 1

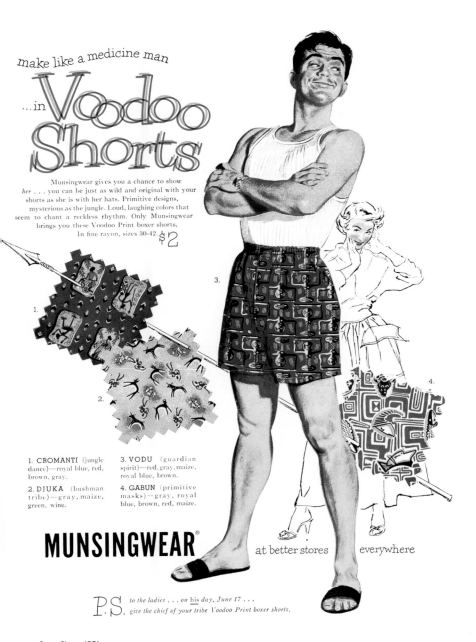

make like a medicine man

...in Voodoo Shorts

Munsingwear gives you a chance to show *her* . . . you can be just as wild and original with your shorts as she is with her hats. Primitive designs, mysterious as the jungle. Loud, laughing colors that seem to chant a reckless rhythm. Only Munsingwear brings you these Voodoo Print boxer shorts. In fine rayon, sizes 30-42. $2

1. **CROMANTI** (jungle dance)—royal blue, red, brown, gray.

2. **DJUKA** (bushman tribe)—gray, maize, green, wine.

3. **VODU** (guardian spirit)—red, gray, maize, royal blue, brown.

4. **GABUN** (primitive masks)—gray, royal blue, brown, red, maize.

MUNSINGWEAR® at better stores everywhere

P.S. *to the ladies . . . on his day, June 17 . . . give the chief of your tribe Voodoo Print boxer shorts.*

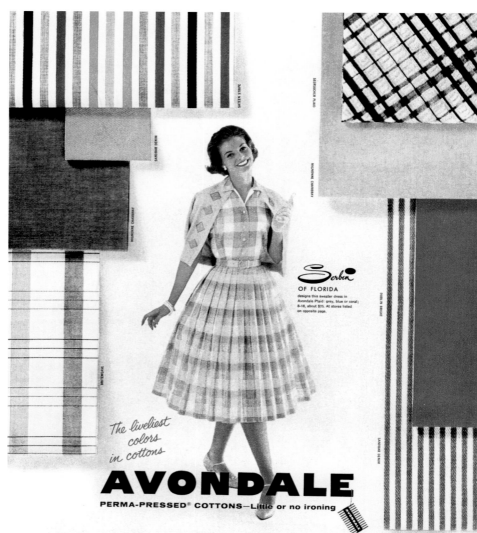

The liveliest
colors
in cottons

AVONDALE

PERMA-PRESSED® COTTONS—Little or no ironing

A joy to see, to wear . . . Avondale Cottons in Companion Colors to mix and match to your heart's content. And these lively colors stay fresh and bright through suds and sun. Upkeep is easy, Avondale Cottons are Perma-Pressed for wash and wear with little or no ironing. So look for the Avondale tag on the smartest clothes . . . like this **Serbin** fashion, for instance. By-the-yard, too, at popular prices. At fine stores. Sew your own with McCall Pattern No. 3299. Avondale Cottons are guaranteed to be as represented. If for any reason you are not satisfied, we will replace fabric or refund purchase price. Avondale Mills, Comer Building, Birmingham, Alabama.

Avondale Cottons/Serbin of Florida, 1959 ▸ Ship 'n Shore Blouses, 1953 ▸▸ Dan River Sunshade Cottons, 19⁵

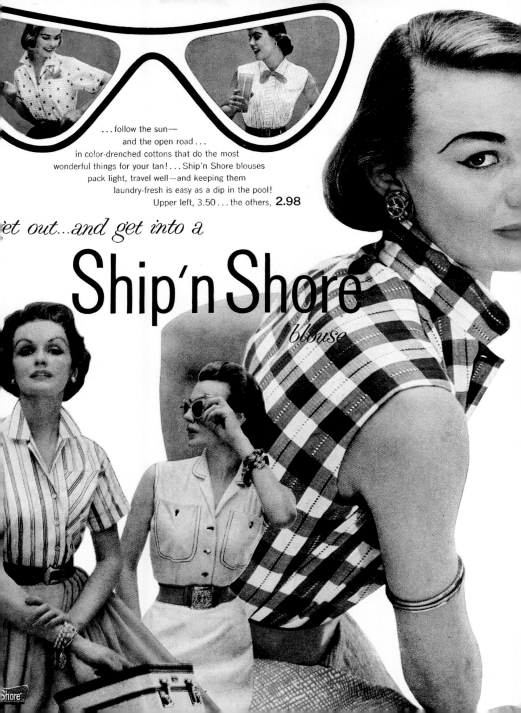

...follow the sun—
and the open road...
in color-drenched cottons that do the most
wonderful things for your tan!...Ship'n Shore blouses
pack light, travel well—and keeping them
laundry-fresh is easy as a dip in the pool!
Upper left, 3.50...the others, **2.98**

et out...and get into a

Ship'n Shore®

blouse

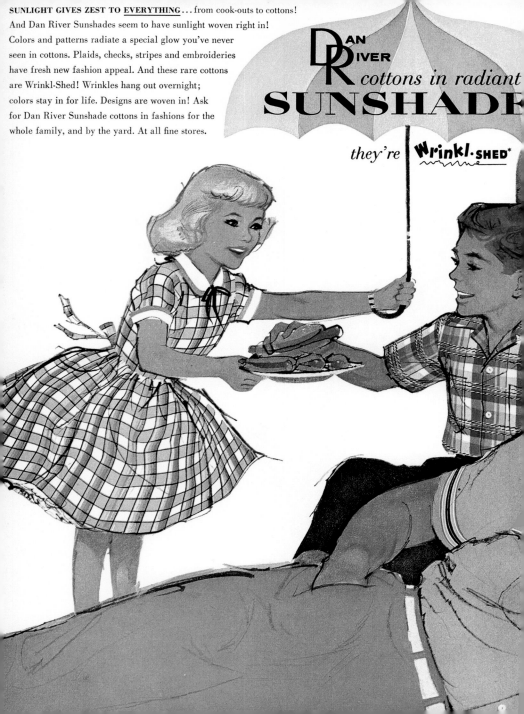

SUNLIGHT GIVES ZEST TO EVERYTHING...from cook-outs to cottons!
And Dan River Sunshades seem to have sunlight woven right in!
Colors and patterns radiate a special glow you've never
seen in cottons. Plaids, checks, stripes and embroideries
have fresh new fashion appeal. And these rare cottons
are Wrinkl-Shed! Wrinkles hang out overnight;
colors stay in for life. Designs are woven in! Ask
for Dan River Sunshade cottons in fashions for the
whole family, and by the yard. At all fine stores.

DAN RIVER cottons in radiant SUNSHADE

they're Wrinkl·SHED*

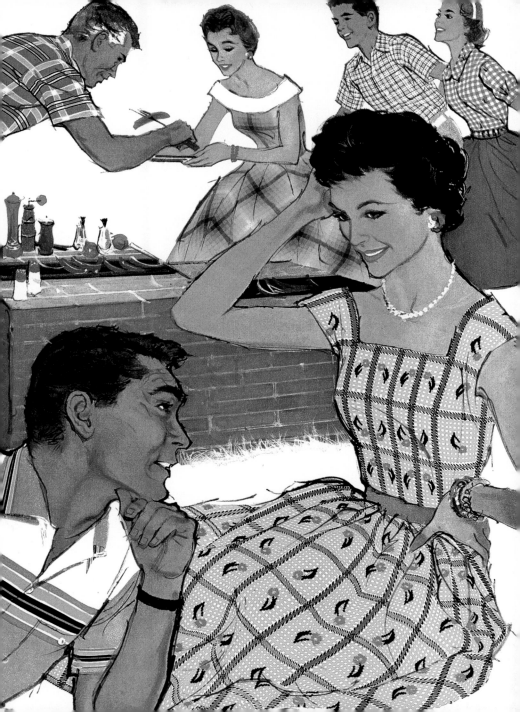

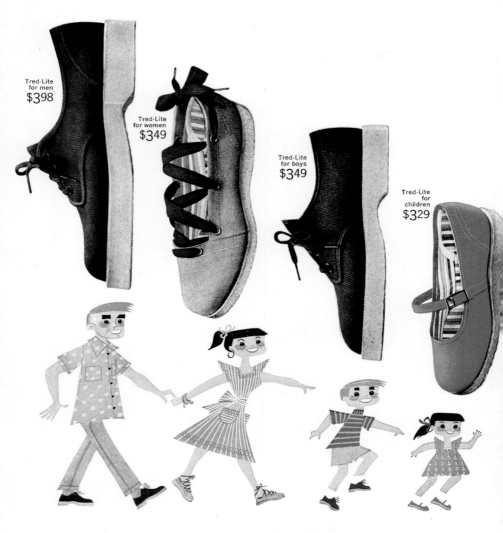

Tred-Lite
for men
$398

Tred-Lite
for women
$349

Tred-Lite
for boys
$349

Tred-Lite
for children
$329

SEE HOW LITTLE TRED-LITES COST FOR THE ENTIRE FAMILY

Surprisingly less than you'd expect! The whole family
can step out together and stay within the budget
. . . in these carefree casuals that put a soft,
deep-yielding cushion between your foot and the
ground. In many styles and many colors . . . for work
and play . . . shoes that wear a long,
long time and cost so very little.

Prices slightly higher Denver West

Tred·Lite®
by Cambridge

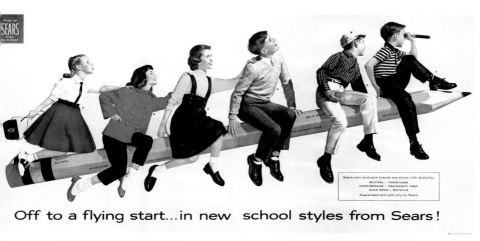

Tred-Lite Shoes, 1954

ars, Roebuck and Co. Department Store, 1951

the years following World War II, America
w a surge in births, known as the baby boom.
vvy retailers and manufacturers saw the
aring birthrate as a sign to start catering to
milies by adding more kid-focused products
their mix.

In den Jahren nach dem Zweiten Weltkrieg
erlebte Amerika eine steigende Geburten-
rate, den sogenannten Babyboom. Kluge
Einzelhändler und Produzenten nahmen den
Trend als Startsignal, um sich Familien anzudie-
nen, indem sie mehr kindgerechte Produkte in
ihr Sortiment aufnahmen.

Pendant l'après-guerre, les États-Unis
connurent une recrudescence des naissances,
le fameux baby-boom. Les détaillants et les
fabricants les plus avisés virent dans cette
explosion du taux de natalité un signe afin
d'élargir leur collection d'articles pour enfant.

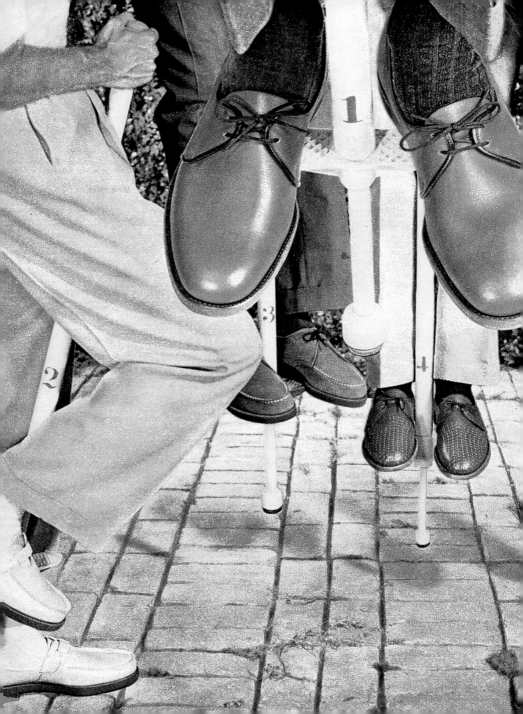

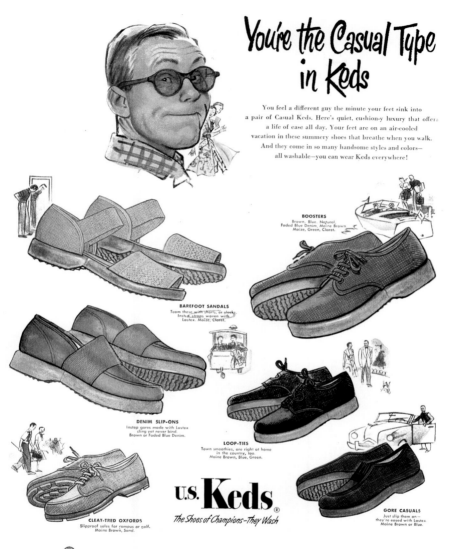

You're the Casual Type in Keds

You feel a different guy the minute your feet sink into a pair of Casual Keds. Here's quiet, cushion-y luxury that offers a life of ease all day. Your feet are on an air-cooled vacation in these summery shoes that breathe when you walk. And they come in so many handsome styles and colors— all washable—you can wear Keds everywhere!

BOOSTERS
Brown, Blue, Natural, Faded Blue Denim, Maine Brown, Maize, Green, Claret.

BAREFOOT SANDALS
Team these with shorts, or slacks. Instep straps woven with Lastex. Maize, Claret.

DENIM SLIP-ONS
Instep gores made with Lastex cling yet never bind. Brown or Faded Blue Denim.

LOOP-TIES
Town smoothies, are right at home in the country, too. Maine Brown, Blue, Green.

CLEAT-TRED OXFORDS
Slipproof soles for campus or golf. Maine Brown, Sand.

GORE CASUALS
Just slip them on— they're eased with Lastex. Maine Brown or Blue.

U.S. Keds ®
The Shoes of Champions—They Wash

UNITED STATES RUBBER COMPANY
Rockefeller Center, New York

◄ Mansfield Shoes, 1957 Keds Shoes, 1951

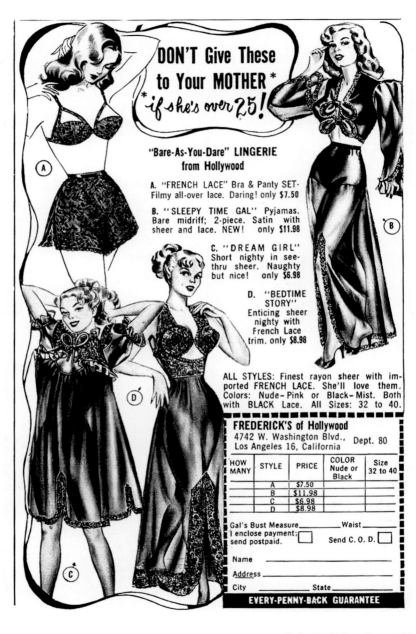

DON'T Give These to Your MOTHER *
*if she's over 25!

"Bare-As-You-Dare" LINGERIE from Hollywood

A. "FRENCH LACE" Bra & Panty SET. Filmy all-over lace. Daring! only $7.50

B. "SLEEPY TIME GAL" Pyjamas. Bare midriff; 2-piece. Satin with sheer and lace. NEW! only $11.98

C. "DREAM GIRL" Short nighty in see-thru sheer. Naughty but nice! only $6.98

D. "BEDTIME STORY" Enticing sheer nighty with French Lace trim. only $8.98

ALL STYLES: Finest rayon sheer with imported FRENCH LACE. She'll love them. Colors: Nude–Pink or Black–Mist. Both with BLACK Lace. All Sizes: 32 to 40.

FREDERICK'S of Hollywood
4742 W. Washington Blvd., Dept. 80
Los Angeles 16, California

HOW MANY	STYLE	PRICE	COLOR Nude or Black	Size 32 to 40
	A	$7.50		
	B	$11.98		
	C	$6.98		
	D	$8.98		

Gal's Bust Measure_____ Waist_____
I enclose payment; ☐
send postpaid. Send C. O. D. ☐

Name _____
Address _____
City _____ State _____

EVERY-PENNY-BACK GUARANTEE

Frederick's of Hollywood Lingerie, 1951

IT'S A BLOUSE...IT'S A SLIP...ALL IN ONE!

Blue Swan
Slipmates

SCHOOL • SPORTS

HOME • WORK

$2.98

SIZES 32 (dress 9/10) to 40 (dress 17/18)
Also TEEN SIZES for ages 10-12-14

- **ECONOMICAL** . . . Serves a Double Purpose!
- **FASHIONABLE** . . . Styled For Wear Almost Everywhere!
- **NEAT** . . . The Blouse Can't Slip Out!
- **SMOOTH-FITTING** . . . Cut From Exacting Slip Patterns!
- **PRACTICAL** . . . As Easy To Wash As a Regular Slip!

Just slip into Slipmates — step into a skirt and you're smartly
dressed! Wonderful for wear with a suit too! The blouse top is
styled with the popular "bat" sleeves in soft interlock combed
cotton jersey with a smart heather effect. Permanently attached
is a runproof tricot rayon half slip that beautifully molds to your
figure. A clever new idea — at an unbelievably low price.

Hurry to your favorite store for your Slipmates today!

Blouse tops in a choice of lovely heather tones.
GOLDEN ERA YELLOW • DRAMATIC RED • FLIGHT BLUE • GLAMOUR PINK
DYNAMIC GREEN • AUTUMN RUST • FROSTY WHITE

JUST ADD A SKIRT

CREATORS OF
Suspants and **minikins**

Available at Knit Lingerie Departments and Specialty Shops or write
BLUE SWAN MILLS, DIV. OF McKAY PRODUCTS CORP., 350 FIFTH AVE., N. Y., N. Y.

pmates, 1950

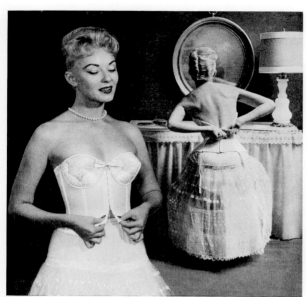

NO HELP NEEDED

Your New PERMA·LIFT BARE-BACK Bra
hooks in front—so quick—so easy

Lucky girl—you can forget all about those exasperating struggles with
elusive back fastenings, for darling, those days of twisting, turning,
reaching are all behind you. This chic new "Perma-lift"* Bare-Back
Bra hooks in front—quickly, easily,—without fuss or nonsense.
And the clever, little hooks will never show—even through your
clingiest, slinkiest dress. Be comfortably fitted today.

Style No. 88—Exclusive Criss-Cross** design keeps your Bare-Back Bra
comfortably in place always. And Magic Inserts in the cups support you from below
In Dacron, only $8.95. In "D" cup—$10.00.

*Reg. U. S. Pat. Off. · **Pat. Applied For · A product of A. Stein & Company · Chicago—New York—Los Angeles *Prices may be slightly higher west of the Rockies*

Perma-Lift Brassieries, 1957

Christian Dior, creator of the "New Look",
once said, "Without foundation, there can be
fashion." Although Dior's look was most often
associated with the wasp waist, most women
wore some sort of foundation garment, such
as long-leg panty girdles. At the time of this ad
two new developments were just a few years
pantyhose and Lycra, both introduced in 195

Christian Dior, der Erfinder des New Look,
sagte einmal: „Keine Mode ohne Mieder."
Obwohl man mit Diors Look am häufigsten d
Wespentaille assoziiert, trugen die meisten
Frauen eine Art Basiskleidung darunter,
ein Miederhöschen mit langem Bein. Zum
Zeitpunkt dieser Anzeige waren zwei Neue
wicklungen nur noch wenige Jahre entfernt:
die Strumpfhose und Lycra, die beide 1959 a
den Markt kamen.

« Sans sous-vêtements, il n'y a pas de mode »,
dit un jour Christian Dior, le créateur du New
Look. Bien que sa silhouette fût souvent
associée à la taille de guêpe, la plupart des
femmes portaient des sous-vêtements de
soutien sous une forme ou une autre, tels que
les gaines longues. Cette publicité précéda
quelques années deux nouvelles inventions :
collant et le Lycra, tous deux lancés en 1959.

▶ Peter Pan Brassieres, 1954

▶▶ Chemstrand, 1959

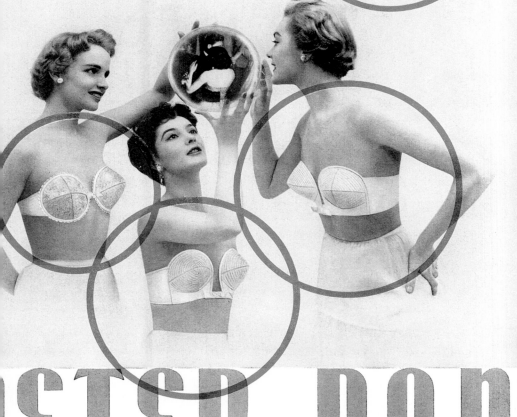

the genius of Peter Pan shapes a beautiful future!

WE'RE PUSHING LEOTARDS

Cold and getting colder: now's the time to push stretch tights. Here's how Chemstrand
helps you do it. With a full-page color supplement (theme: Tights for every use and
age) that Chemstrand Publicity just released to newspapers in 100 key markets. With
a special Promotion Kit containing two counter cards that are corkers, and a
host of selling tips. (Look for the kit around December 1.) Tie in your windows,
ads, interior displays. There's big business in leotards. Get your hands on some.

Chemstrand nylon

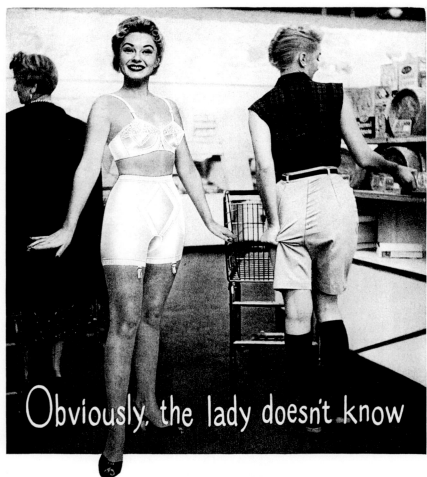

Obviously, the lady doesn't know

Perma·lift's Magic Oval Pantie

CAN'T RIDE UP—EVER!

Obviously the uncomfortable young shopper on your right doesn't know
that "Perma·lift's"* Magic Oval Pantie** Can't Ride Up—Ever! Tug-
ging at a girdle is so awfully necessary with ordinary garments. But this
can't happen to you when you wear a "Perma·lift" Magic Oval Pantie,
for it's actually guaranteed to remain in place always. Be fitted today.

Pantie 3844—Power Net with front and back control. Only $5.95.
Bra 132—Fine cotton with Magic Insets. $2.50.

Perma-lift Panties, 1957 ▶ Warner's Lingerie, 195

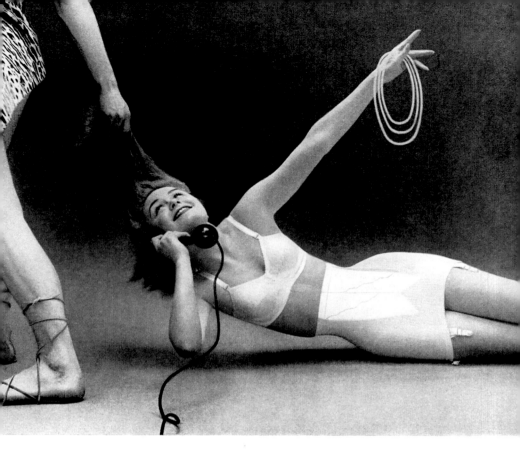

Come out of the bone age, darling...

Warner's exclusive new STA-FLAT replaces pokey bones with circular springlets

...takes the cave-man manners out ...oned girdles (poke, shove, groan), ...se long front bones that dug into ...ff. Now control's achieved with ...lets pocketed in the girdle's front ...'re light and flexible—modern ...y of life, sensible as vitamins.

...er control, too—STA-FLAT gives ...point support, like old-fashioned

bones, but firms a greater area with lively comfort. Bend, breathe, sit ... STA-FLAT™ moves through the day with you, responds to every movement of your body ... all with unbelievable lightness. And at the same time, it gives you extra support where you need it most (midriff, waist, tummy).

You don't need to wear armor to be a charmer. Warner's is happy to give the dino-

saur his due—but not on you. Come out beautifully, into the light, free whirl of today! At your nicest stores, here and in Canada.

WARNER'S®
Bras · Girdles · Corselettes

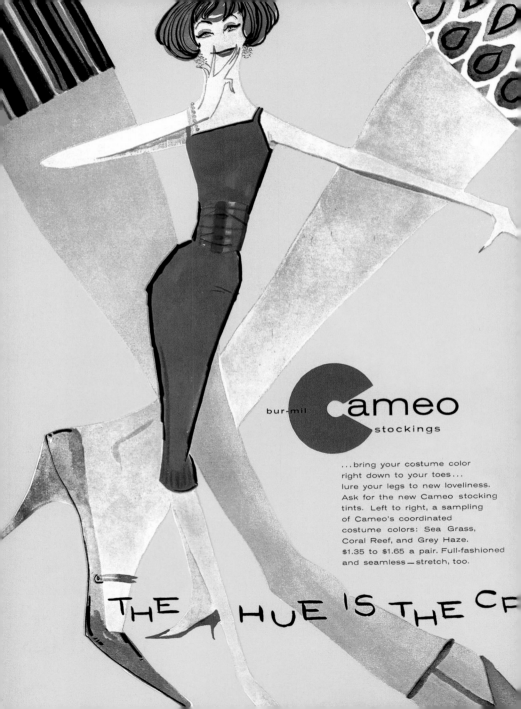

Cameo Stockings, 1958

Galey & Lord Cottons, 1958

The end of the 1950s saw the innovative creations of Cristobal Balenciaga (the baby-doll dress, the cocoon coat, the balloon skirt, and the sack dress), and Pierre Cardin (the bubble dress). Even textile company Galey & Lord, best known for its khaki and denim products, created an unexpected juxtaposition with its more fashion-forward looks.

Am Ende der 1950er standen innovative Kreationen von Pierre Cardin (das Ballonkleid) und Cristobal Balenciaga (das Babydoll-Kleid, der Kokonmantel, der Ballonrock und das Sackkleid). Selbst das Textilunternehmen Galey & Lord, das vor allem für seine Khaki- und Jeans-produkte bekannt war, schuf mit seinen stärker modeorientierten Looks ein überraschendes Nebeneinander.

La fin des années 50 fut le témoin des créations innovantes de Pierre Cardin (la robe bulle) et de Cristobal Balenciaga (la robe baby-doll, le manteau cocon, la jupe boule et la robe sac). Même le fabricant textile Galey & Lord, surtout connu pour ses produits en toile et en denim, créa la surprise en proposant des looks plus tendance.

blazing cottons

Galey & Lord

GALEY and LORD, A MEMBER OF BURLINGTON INDUSTRIES

Galey & Lord Cottons, 1956 ▸ Tussy Medicare, 1959

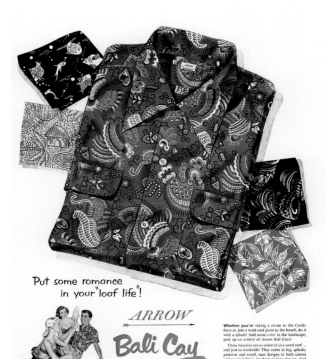

Put some romance in your "loaf life"!

ARROW

Bali Cay

Whether you're taking a cruise to the Caribbean or just a week-end jaunt to the beach, do it with a splash! Add some *color* to the landscape; pick up an armful of *Arrow Bali Cays!*

These beauties are as colorful as a coral reef ... and just as washable! They come in big, splashy patterns and small, neat designs in both cotton and rayon fabrics. In short or long sleeves. And all have the amazing Arafold Collar. Prices about $4.50 and up. (Subject to government regulation.) See *Bali Cay* at your Arrow dealer's now!

Cluett, Peabody & Co., Inc., Arrow Shirts • Sports Shirts • Ties • Handkerchiefs • Underwear

Arrow Shirts, 1952

Hawaiian shirts had a history dating back to the 1930s, but the 1950s interest in kitsch—plus the thousands of U.S. veterans' experiences while stationed in Polynesia—helped popularize the Aloha shirt back on the mainland.

Die Geschichte der Hawaiihemden reichte bis in die 1930er Jahre zurück, doch die Begeisterung der 50er für Kitsch – plus die Erinnerungen Tausender US-Veteranen, die in Polynesien stationiert gewesen waren – verhalfen dem Aloha-Shirt zu neuer Beliebtheit auf dem amerikanischen Festland.

L'histoire de la chemise hawaïenne remonte aux années 30, mais l'intérêt des années 50 pour le kitsch – et le retour de milliers de vétérans américains de Polynésie – contribua au renouveau de la chemise Aloha sur le continent.

▸ Van Heusen Shirts, 1951

▸▸ McGregor Sportswear, 1959

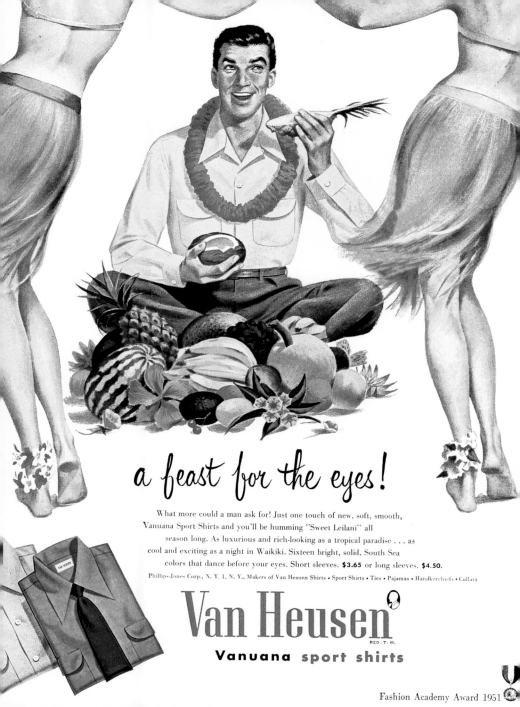

a feast for the eyes!

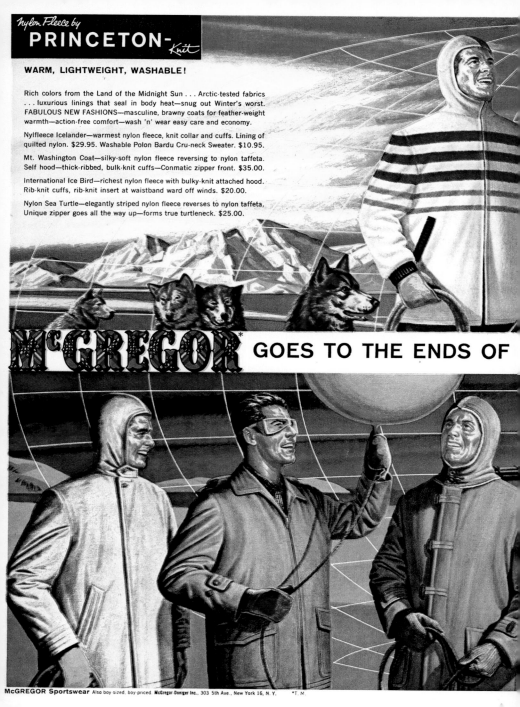

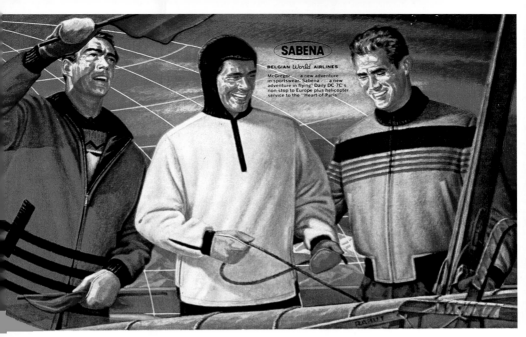

TH FOR NEW CLIMATE CONTROL OUTERCOATS...

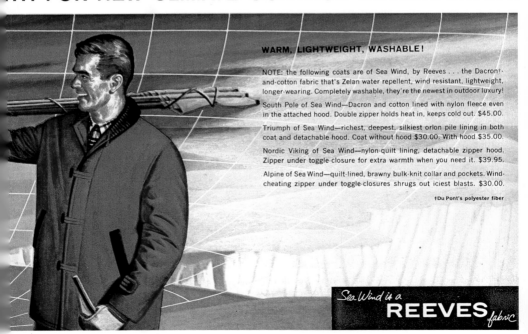

"FASHION IS NOT FRIVOLOUS.
IT IS PART OF BEING ALIVE TODAY."
– MARY QUANT

„MODE IST NICHT FRIVOL.
SIE GEHÖRT ZUM HEUTIGEN
LEBENSGEFÜHL."
–MARY QUANT

1960

«LA MODE N'EST PAS FRIVOLE.
ELLE FAIT PARTIE DE LA VIE
D'AUJOURD'HUI.»
– MARY QUANT

1969

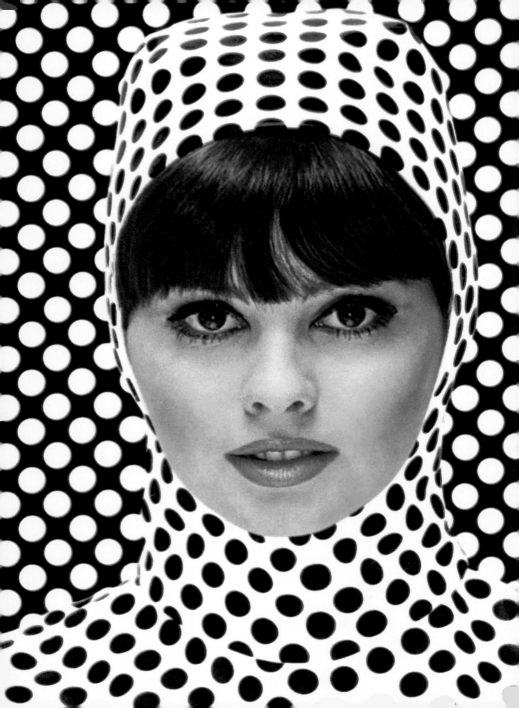

FROM CAMELOT TO THE SPACE AGE

*By the mid-1960s, new silhouettes pioneered by
Cardin and Balenciaga were modernizing
women's fashion. André Courrèges launched an
ultra-modern space-themed collection, and
Rudi Gernreich was soon defining Mod fashion…*

ACQUELINE KENNEDY WAS THE STYLISH IDEAL OF THE OPENING YEARS OF THE DECADE.
e worldly Jackie was a connoisseur of European couture, but, as America's first lady, she selected
American, Oleg Cassini, to design her wardrobe. Together they became known for simple suits,
eath dresses, pillbox hats, and understated but elegant evening gowns.

At the same time, Audrey Hepburn was both youthful and sophisticated wearing Hubert
Givenchy as Holly Golightly in *Breakfast at Tiffany's*. The "little black dress" had been introduced
Chanel in 1926, but Givenchy's glamorous version inspired the cocktail-party uniform for
nerations of women.

While the full-skirted look of the 1950s remained fashionable, by the mid-1960s new silhou-
tes pioneered by Cardin and Balenciaga were modernizing women's fashion. André Courrèges
unched an ultramodern space-themed collection, and Rudi Gernreich was soon defining Mod
shion—notably with his shocking topless swimsuit, the "monokini." Ursula Andress, wearing a
hite bikini, and Sean Connery, wearing slim suits, set the stylish tone for the first James Bond film,
: *No*, released in 1962.

In Europe, Barbara Hulanicki launched Biba's postal boutique catalog, precursor to the
onic London boutique; and Americans got a glimpse of the future of pop music when the Beatles
erformed on *The Ed Sullivan Show* in 1964.

The decade's fashions—and politics—dramatically changed course in 1965. Model Jea Shrimpton shocked crowds at the Victoria Derby in Melbourne, Australia, by wearing a short ski and no gloves. Venerable but struggling women's magazine *Cosmopolitan* dramatically and success fully changed its focus when it hired *Sex and the Single Girl* author Helen Gurley Brown as editor-i chief. And 3,500 U.S. marines arrived in Vietnam, signaling an official start to an ongoing conflict th would soon divide the nation.

Within the year, the National Organization for Women was founded, and counterculture music *Hair* opened on Broadway. Twiggy, with her slim frame and trademark androgynous haircut, bega her modeling career in London as the face of the "Swinging Look," and British designer Mary Quan inspired by Courrèges, introduced skirts cut six to seven inches above the knee in her Londo boutique, Bazaar.

The 1965 film *Dr. Zhivago* sparked a Russian fashion trend, as women donned mid-calf grea coats, fur hats, and military boots, which segued seamlessly into Renaissance and Gypsy trend Women's carefully molded bouffant and flip hairstyles gave way to longer, more natural looks. An younger men opted for longer hair and facial hair. African Americans began to embrace Africa culture, launching a trend for printed dashiki tunics and natural hairstyles.

And while the second half of the decade was dominated by the youth market and stree inspired fashions, high-end designers continued to redefine the luxury market. Roy Halston Fre wick, a former hatmaker, launched his first ready-to-wear collection under the label Halsto Geoffrey Beene, who had launched his women's collection in the early 1960s, added menswear t the mix. And, in 1966, Yves Saint Laurent—protégé and successor to Christian Dior—introduce "Le Smoking," his tuxedo cut for women, soon to be followed by his safari collection. His popula suits arrived with women's liberation—women were wearing the pants, and they liked it.

◄◄ Pond's Fresh-Start Cleanser, 1966 ► Plaza 8/Perma-lift Undergarments, 196

1960

1961

1961

Sales boom for DuPont's Orlon fiber

DuPonts Kunstfaser Orlon verkauft sich sensationell

Les ventes de la fibre Orlon de DuPont explosent

American women mimic iconic style of First Lady Jacqueline Kennedy

Amerikanerinnen kopieren den Stil von First Lady Jacqueline Kennedy

Les Américaines copient le style élégant de leur première dame, Jacqueline Kennedy

London's music and fashion scene dubbed "Youthquake" by Diana Vreeland

Diana Vreeland nennt die Londoner Musik-u Modeszene „Youthquake"

Diana Vreeland qualifie de « séisme jeune » le milieu londonien de la musique et de la mode

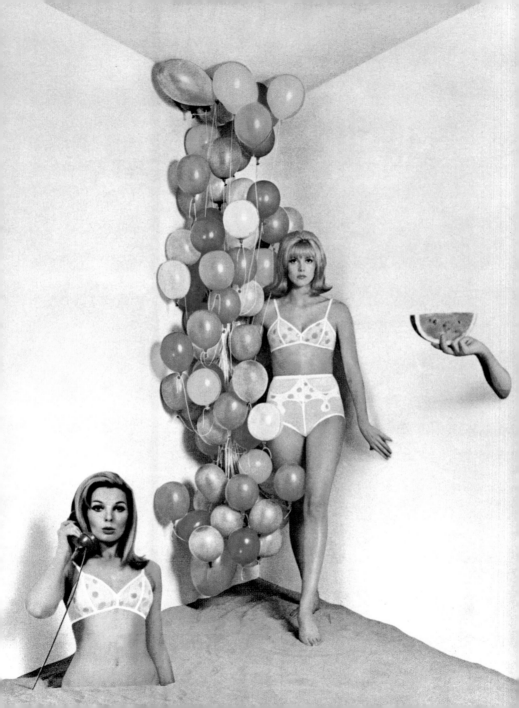

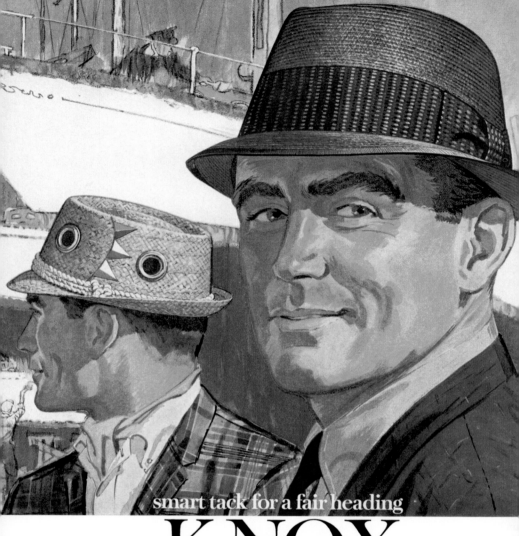

smart tack for a fair heading

KNOX
SUN WEAVES

Knox creates Sun Weaves...straw cool, straw light, straw comfortable. Young salt or landlubber...on deck or on business, there's a Knox Sun Weave for you. Casual or conservative, they're all cool, comfortable — and correct. Knox straws $5.95 to $20.00.
...**man to man it's KNOX SUN WEAVES**

VON CAMELOT INS
WELTRAUMZEITALTER

*Ab Mitte der Sechziger modernisierten jedoch
neue Silhouetten, wie Cardin und Balenciaga sie
eingeführt hatten, die Damenmode. André Courrèges
präsentierte eine ultramoderne Kollektion zum
Thema Weltraum, während Rudi Gernreich als-
bald den Mod-Look definierte ...*

ACQUELINE KENNEDY WAR DIE STILIKONE DER ERSTEN JAHRE DIESER DEKADE. Die weltge-
andte Jackie war eine Kennerin der europäischen Couture, doch als Amerikas First Lady erwählte
e den Amerikaner Oleg Cassini zum Designer ihrer Garderobe. Gemeinsam wurden sie berühmt
ır schlichte Kostüme, Etuikleider, Pillbox-Hüte und dezente, aber überaus elegante Abendkleider.

Gleichzeitig trug die jugendliche und zugleich anspruchsvolle Audrey Hepburn als Holly
olightly in *Frühstück bei Tiffany* Hubert de Givenchy. Das „kleine Schwarze" war 1926 von Chanel er-
ınden worden, doch erst Givenchys glamouröse Version machte es für Generationen von Frauen zur
inheitsgarderobe auf Cocktailpartys.

Der Look der 1950er mit seinen weiten Röcken blieb noch eine Weile in Mode, ab Mitte der
echziger modernisierten jedoch neue Silhouetten, wie Cardin und Balenciaga sie eingeführt hat-
ın, die Damenmode. André Courrèges präsentierte eine ultramoderne Kollektion zum Thema Welt-
ıum, während Rudi Gernreich alsbald den Mod-Look definierte – insbesondere mit seinem scho-
<ierenden Oben-ohne-Badeanzug, dem „Monokini". Ursula Andress im weißen Bikini und Sean
onnery in figurnahen Anzügen gaben modisch den Ton im ersten James-Bond-Film *Dr. No* an, der
)62 in die Kinos kam.

In Europa startete Barbara Hulanicki das Versandhaus Biba, Vorläufer der gleichnamigen legen-
ären Londoner Boutique. Gleichzeitig bekamen die Amerikaner eine Ahnung von der Zukunft der

Hi-fi fan Ernie Klack
finds Carter's knitted boxer shorts an indispensable component

For harmony in the Klack household, Ernie traditionally turns to the classic — knitted boxer shorts by Carter's. His good wife, Irma, is happy; she knows these cotton knits reject any discordant need for ironing. Ernie is happy:

he's shamelessly flattered by their trim styling, outrageously pampered by their soft comfort. Now the secret is out and you can be happy, too. Just keep in mind that the boxers are knit and the name is Carter's.

Ernie Klack is any guy who wears Carter's knitted boxer shorts and considers it unsolicited (and uncomfortable) to wear any other kind.

Carter's
MEANS COMFORT IN KNITTED BOXER SHORTS ... BRIEFS / T-SHIRTS ... ATHLETIC SHIRTS

FOULARD PRINT Knit Boxers, $1.75 ... at these and other fine stores: ATLANTA, Muirs • BOSTON, Jordan Marsh Co. • CHICAGO, Daube — All Stores CINCINNATI, John DeHaw Co. • DALLAS, Jos. K. Wilson • DAYTON, The Metropolitan Co. • DENVER, COLORADO SPRINGS, May D. & F. • FLINT, A. M. Davison Co. • HARRISBURG, Pomeroy's LOS ANGELES, Buford's • Greensboro, Westward, Pasadena, Santa Ana • LONG BEACH & SANTA ANA, Buffum's • MINNEAPOLIS, Dayton's • NEW YORK, B. Altman & Co., Wallachs, Yandles Circuit • NEWARK, Bamberger's • ORLANDO, Dickson's • PHOENIX, Diamond's • ST. LOUIS, Maff's • SALT LAKE CITY, Z.C.M.I. • SEATTLE-TACOMA, Stephenson's • WILMINGTON •

◄◄ Knox Hats, 1962 Carter's 1961

Popmusik, als die Beatles 1964 in der *Ed Sullivan Show* auftraten.

In modischer – und auch in politischer – Hinsicht änderte sich der Kurs dieses Jahrzehnts 1965 auf dramatische Weise. Das Fotomodell Jean Shrimpton schockierte das Publikum des Victoria Derby im australischen Melbourne, als sie in kurzen Rock und ohne Handschuhe erschien. Das ehrwürdige, aber um seine Existenz ringende Frauenmagazin *Cosmopolitan* änderte seine Ausrichtung auf ebenso dramatische wie erfolgreiche Weise, als es die Autorin von *Sex and the Single Girl* (dt. – und ledige Mädchen), Helen Gurley Brown, als Chefredakteurin engagierte. Zur selben Zeit trafen 3.500 U. S. Marines in Vietnam ein, was quasi den offiziellen Beginn eines anhaltenden Konflikts bedeutete, der bald die gesamte amerikanische Nation spalten sollte.

Im gleichen Jahr wurde auch die National Organization for Women gegründet, und das Protest-Musical *Hair* hatte am Broadway Premiere. Die superschlanke Twiggy mit ihrem unverwechselbaren androgynen Haarschnitt begann ihre Modelkarriere in London als das Gesicht des „Swinging Look". Die britische Designerin Mary Quant bot, inspiriert von Courrèges, in ihrer Londoner Boutique Bazaar erstmals Röcke an, die eine Handbreit über dem Knie endeten.

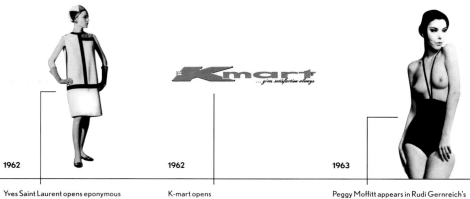

1962

Yves Saint Laurent opens eponymous fashion house

Yves Saint Laurent eröffnet das nach ihm benannte Modehaus

Yves Saint Laurent ouvre sa maison de haute couture éponyme

1962

K-mart opens

Eröffnung von K-mart

Ouverture de K-mart

1963

Peggy Moffitt appears in Rudi Gernreich's monokini

Peggy Moffitt präsentiert Rudi Gernreichs Monokini

Peggy Moffitt pose dans le monokini de Rudi Gernreich

Der Film *Dr. Schiwago* von 1965 löste einen
rend zu russischer Mode aus: Frauen kleideten
ch in wadenlange üppige Mäntel, trugen Pelz-
ützen und Militärstiefel. Der Übergang zu Re-
aissance- und Zigeunerstil war nahtlos.

Die sorgsam gestalteten Turmfrisuren
nd komplizierten Haarmoden machten län-
eren, natürlicheren Looks Platz. Auch jüngere
änner ließen sich die Haare länger und Bärte
achsen. Afroamerikaner besannen sich auf die
frikanische Kultur und lösten einen Trend zu
edruckten Dashiki-Tuniken und naturbelasse-
en Frisuren aus.

Und während die zweite Hälfte des Jahr-
*hnts von jugendlichen Käufern und modischen
lltagstrends bestimmt wurde, fuhren die Nobel-
esigner fort, den Luxusmarkt neu zu definieren.
er ehemalige Modist Roy Halston Frowick prä-
entierte seine erste Prêt-à-porter-Kollektion un-
*r dem Label Halston. Geoffrey Beene, der Anfang
er Sechziger seine erste Damenkollektion her-
usgebracht hatte, ergänzte seine Palette durch

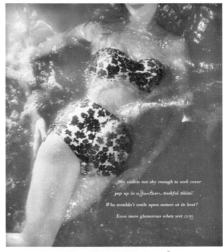

Jantzen Swimwear, 1960

errenmode. Und 1966 stellte Yves Saint Laurent Protégé and Nachfolger von Christian Dior – „Le Smoking" für Damen vor und bald darauf seine Sa-
rikollektion. Seine beliebten Hosenanzüge fielen zeitlich mit dem Erstarken der Frauenbewegung
usammen. Frauen hatten die Hosen an – und fanden Gefallen daran.

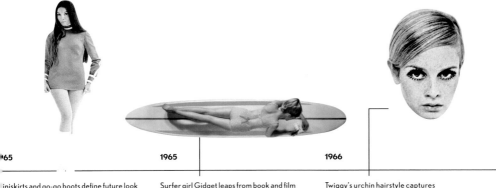

65	**1965**	**1966**
iniskirts and go-go boots define future look André Courrèges	Surfer girl Gidget leaps from book and film to small screen	Twiggy's urchin hairstyle captures Mary Quant's "Chelsea Look"
iniskirts und Go-go-Stiefel prägen den futu- stischen Look von André Courrèges	Das Surfergirl Gidget springt aus Buch und Kinofilm auf die Fernsehschirme	Twiggys jungenhafte Frisur entspricht Mary Quants „Chelsea Look"
minijupe et les cuissardes définissent le futur ok d'André Courrèges	Le personnage de la surfeuse Gidget passe du roman et du cinéma à la télévision	La coupe au bol effilée de Twiggy incarne le « Chelsea Look » de Mary Quant

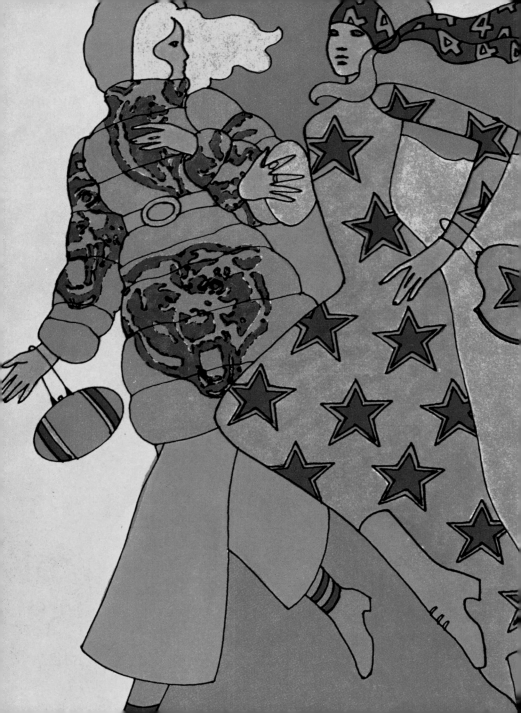

DE L'ÂGE D'OR AU SPACE AGE

Les nouvelles silhouettes inventées par Cardin et Balenciaga modernisent la mode féminine vers le milieu des années 60. André Courrèges lance une collection ultramoderne à thème spatial, et Rudi Gernreich jette les bases de la tendance Mod…

U DÉBUT DES ANNÉES 60, JACQUELINE KENNEDY INCARNE LA FIGURE DE MODE PAR XCELLENCE. La mondaine Jackie est une experte de la haute couture européenne, mais en tant que remière dame des États-Unis, c'est au créateur américain Oleg Cassini qu'elle commande sa garde-be. Tous deux se font une renommée grâce à leurs tailleurs simples, leurs robes fourreau, leurs etits chapeaux ronds sans bord et leurs robes du soir sobres mais élégantes.

Au même moment, Audrey Hepburn resplendit de jeunesse et de raffinement en Hubert e Givenchy dans son personnage d'Holly Golightly pour *Diamants sur canapé*. Givenchy revisite la petite robe noire » introduite par Chanel en 1926 sous une version glamour qui deviendra l'uniforme e cocktail de plusieurs générations de femmes.

Alors que les jupes amples des années 50 restent à la mode, les nouvelles silhouettes inventées ar Cardin et Balenciaga modernisent la mode féminine vers le milieu des années 60. André Cour-èges lance une collection ultramoderne à thème spatial, et Rudi Gernreich jette les bases de la ten-ance Mod, notamment avec son scandaleux maillot de bain « topless », le monokini. Ursula Andress n bikini blanc et Sean Connery dans ses costumes ajustés donnent le ton de la mode dans *James ond 007 contre Dr. No*, premier opus de la saga initiée en 1962.

En Europe, Barbara Hulanicki lance le catalogue de vente par correspondance de Biba, précur-eur de l'incontournable boutique de Londres ; en 1964, les Américains se font une idée de l'avenir de pop music lors du passage des Beatles au *Ed Sullivan Show*.

À l'instar de la politique, la mode de la décennie connaît un revirement spectaculaire en 1965. Au Derby Victoria de Melbourne en Australie, le mannequin Jean Shrimpton choque la foule en apparaissant sans gants et en jupe courte. En grande difficulté, le vénérable magazine féminin *Cosmopolitan* change radicalement de ton en embauchant Helen Gurley Brown, l'auteur d'*Une Vierge sur canapé* au poste de rédactrice en chef. 3 500 Marines américains débarquent au Vietnam, officialisant le début d'un interminable conflit qui n'allait pas tarder à diviser les États-Unis.

Cette année voit également la création de mouvements d'émancipation féminine et la première de la comédie musicale alternative *Hair* à Broadway. Avec sa silhouette menue et sa coupe de cheveux androgyne, Twiggy entame sa carrière de mannequin à Londres en tant que visage du « Swinging London », tandis que la créatrice britannique Mary Quant, inspirée par Courrèges, lance des jupes s'arrêtant quinze à dix-huit centimètres au-dessus du genou chez Bazaar, sa boutique londonienne.

En 1965, *Le Docteur Jivago* lance la tendance russe, les femmes arborant de sublimes manteaux tombant à mi-mollet, des chapeaux en fourrure et des brodequins militaires qui s'intègrent facilement aux tendances Renaissance et gitane. Les coiffures soigneusement crêpées et les brushings à la Nana Mouskouri cèdent la place à des coupes plus longues, plus naturelles. Quant aux jeunes, ils optent aussi pour les cheveux longs et se laissent pousser la barbe. Les Afro-américains se tournent vers la culture africaine et lancent la mode des tuniques Dashiki imprimées et des coupes afro.

Alors que la seconde partie des années 60 est dominée par le marché des jeunes et la mode inspirée de la rue, les couturiers haut de gamme continuent à redéfinir l'industrie du luxe. Roy Halston Frowick, un ancien chapelier, lance sa première collection de prêt-à-porter sous la griffe Halston. Geoffrey Beene, qui proposait une collection pour femme depuis le début des années 60, se diversifie dans la mode masculine. Et en 1966, Yves Saint Laurent – le protégé et successeur de Christian Dior – introduit « Le Smoking » pour femme, rapidement suivi par sa collection safari. Ses tailleurs-pantalons à succès coïncident avec l'émancipation féminine : les femmes portent des pantalons et elles aiment ça.

◄◄ NFL Sportswear, 1969 ► Dune Deck Tackle Tanky/Actionwear Clothing, 1968 ►► Oleg Cassini for Peter Pan Swimwear, 19

1967

1968

1969

Afro hairstyle symbolic of "Black Is Beautiful" movement in U.S.

Afrofrisuren symbolisieren die Bewegung „Black Is Beautiful" in den USA

Aux États-Unis, les coupes afro symbolisent le mouvement « Black Is Beautiful »

Dr. Scholl's exercise sandal introduced; one million pairs sold by end of 1972

Dr. Scholls Gymnastiksandale wird vorgestellt; bis Ende 1972 verkauft sie sich eine Million Mal

Lancement des sandales Exercise du Dr. Scholl ; un million de paires vendues fin 1972

The Gap founded

Gründung von The Gap

Fondation de The Gap

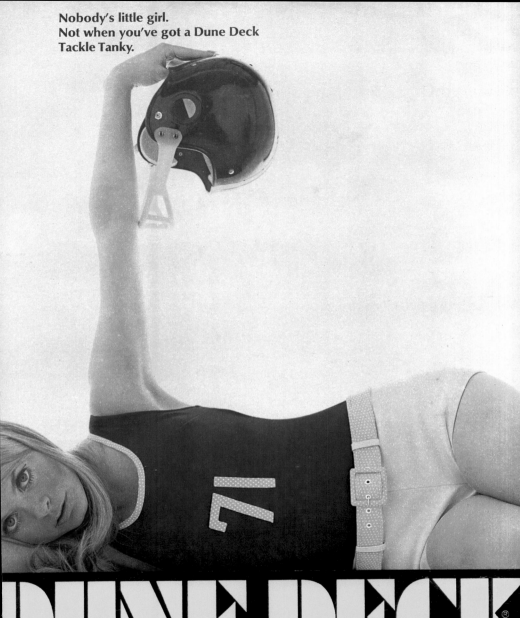

Nobody's little girl.
Not when you've got a Dune Deck
Tackle Tanky.

DUNE DECK

Actionwear

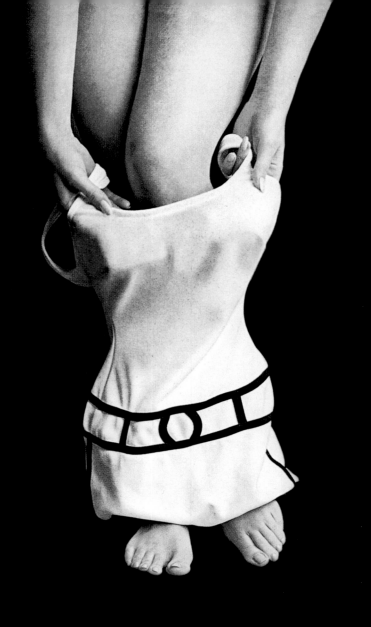

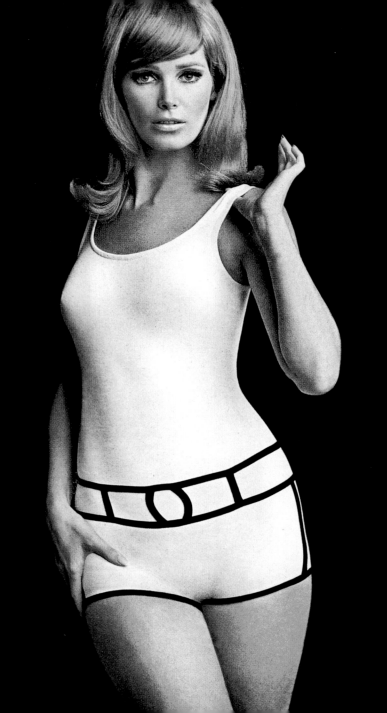

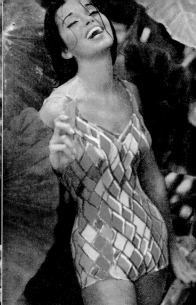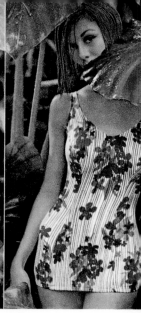

Part of the art of eve... *Catalina*

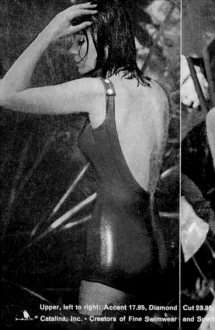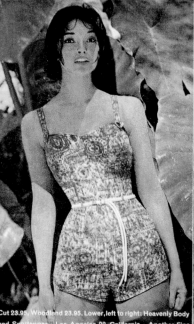

Upper, left to right: Accent 17.95, Diamond | Cut 23.95, Woodland 23.95. Lower, left to right: Heavenly Body | 19.95, East Wind 15.95, Enchantment 19.95.
Catalina, Inc. · Creators of Fine Swimwear | and Sportswear · Los Angeles 22, California · Another Fine | Kayser-Roth Product. Also Available in.

Let yourself show ❗

Maidenform's 'Sweet Nothing' bras

$4 'Sweet Nothing' brave nude net

'Sweet Nothing' shy nude lace $5

'Sweet Nothing' *Brave Nude Net in Nude, White, or Black. A-B-C cups, 4.00. 'Sweet Nothing' Shy Nude Lace with power net across the back. Also available with fiberfill contouring. Nude, White, Black. A-B-C cups, 5.00. *Reg. U.S. Pat. Off. ©1965 by Maidenform Inc., makers of bras, girdles, active sportswear.

This is the dream you can be—with

maidenform

Catalina Swimwear, 1961 Maidenform Bras, 1965

you're all wet...

but your hairdo isn't!

You're the belle of the beach! Sava-Wave inner rim in Kleinert's fashion swim caps "seals out" water, keeps your hair dry and beautiful. Ondine (shown) hugs head in a cascade of face-flattering petals. New ombré color effect in pink, green, blue, gold, black and orange.
Price $6. Other Sava-Wave caps from $1.25.
Who would have thought of it but Kleinert's.

Kleinert's
SWIM CAPS

485 FIFTH AVE., N.Y., N.Y. · TORONTO, CANADA · LONDON, ENGLAND

Kleinert's Swim Caps, 1962 ▸ Montag Post-A-Cards, 19

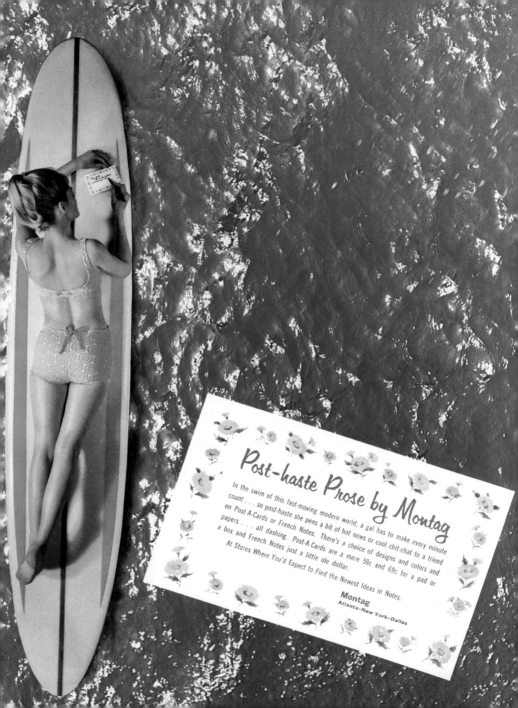

Post-haste Prose by Montag

In the swim of this fast-moving modern world, a gal has to make every minute count . . . so post-haste she pens a bit of hot news or cool chit-chat to a friend on Post-A-Cards or French Notes. There's a choice of designs and colors and papers all dashing. Post-A-Cards are a mere 59c and 69c for a pad or a box and French Notes just a little ole dollar.

At Stores Where You'd Expect to Find the Newest Ideas in Notes.

Montag
Atlanta–New York–Dallas

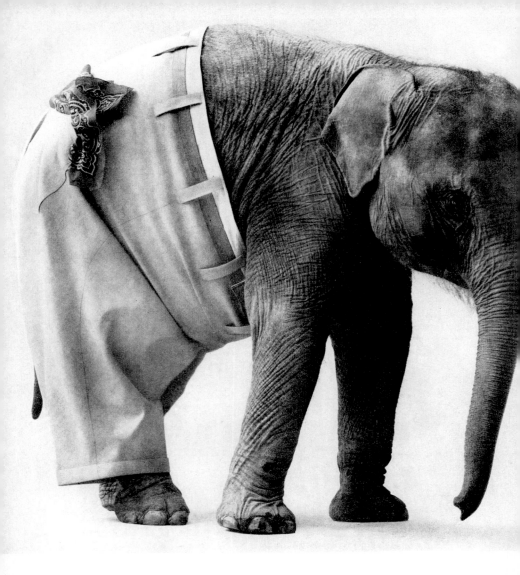

(*A little reminder*)

This is an elephant. Wearing a pair of pants.

The elephant is loxodonta africana. The pants are "Sanforized-Plus". The elephant is wrinkled. It's not his fault. He was made that way. The pants are never wrinkled. They were made that way, too.

They were made to be labeled, "Sanforized-Plus". Repeat. "Sanforized-Plus". The tag that lets you trust in wash-and-wear. Just as "Sanforized" protects you against shrinkage in cottons, so "Sanforized-Plus"

assures you of wash-and-wear that really works. There's no more "wash-and-wonder." If you see it is marked "Sanforized-Plus", you can be sure:

It won't wrinkle from washing. It'll stay smooth while worn. It'll survive wash after wash. It won't shrink out of fit.

In other words, "Sanforized-Plus" means wash-and-wear that really works. So always be sure to look for our label. Our model never forgets. Don't you!

·SANFORIZ TRADE ⊛ MARK
says it won't shrink ou

·SANFORIZED
TRADEMARK
says it's tested wash-an

CLUETT, PEABODY & CO., INC., PERMITS USE OF ITS TRADEMARK "SANFORIZED-PLUS" ONLY ON FABRICS WHICH MEET ITS ESTABLISHED TEST REQUIREMENTS FOR SHRINKAGE, SMOOTHNESS AFTER WASHING, CREASE RECOVERY, TENSILE STRENGTH AND TEAR STRENGTH. FABRICS BEARING THE TRADEMARKS "SANFORIZED" OR "SANFORIZED-PLUS" WILL NOT SHRINK MORE THAN 1% BY THE GOVERNMENT'S STANDARD TEST.

◄ Dan River Wash & Wear Cottons, 1962

Sanforized Menswear, 1963

nford L. Cluett, a nephew of the founders of
uett collars who joined his uncles' company
1919, invented the Sanforized process, which
ontrols shrinkage and wrinkling for cotton
d cotton-blend fabrics. These ads follow in
e tongue-in-cheek tradition of adman Bill
rnbach, whose company, Doyle Dane Bern-
ch, created the Volkswagen "Think Small"
mpaign.

nford L. Cluett, ein Neffe des Gründers
r Kragenfabrik Cluett, der 1919 in das
nternehmen seines Onkels eintrat, erfand
s Sanforized-Verfahren. Dies verhindert
s Einlaufen und Knittern von Baumwollstoff
d Baumwollmischgewebe. Diese Anzeigen
gen der ironischen Tradition des Werbema-
ers Bill Bernbach, dessen Agentur Doyle
ane Bernbach die Volkswagen-Kampagne
hink Small" kreierte.

nford L. Cluett, neveu des fondateurs des
ols Cluett, rejoignit l'entreprise de ses oncles
1919 et inventa le procédé de sanforisage
ti-rétrécissement et anti-plis pour le coton
les tissus en mélange de coton. Ces visuels
nscrivent dans la tradition d'humour décalé
u publicitaire Bill Bernbach, dont l'agence
oyle Dane Bernbach créa la campagne
Think Small » de Volkswagen.

ll Blass for Maurice Rentner Womenswear,
66

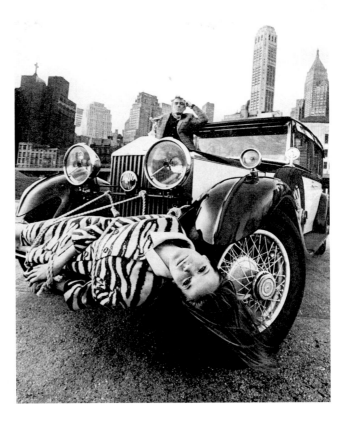

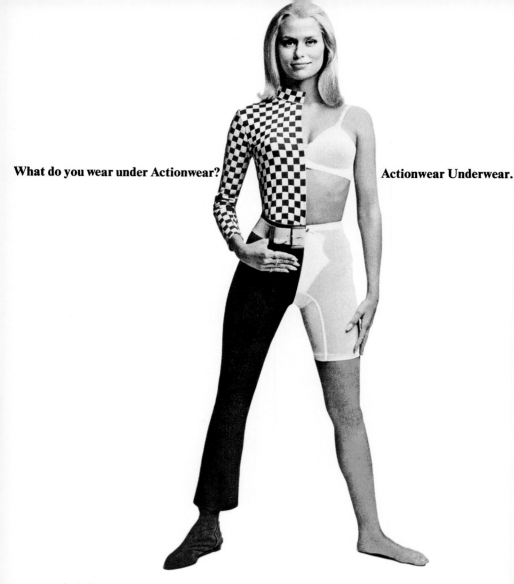

What do you wear under Actionwear?

Actionwear Underwear.

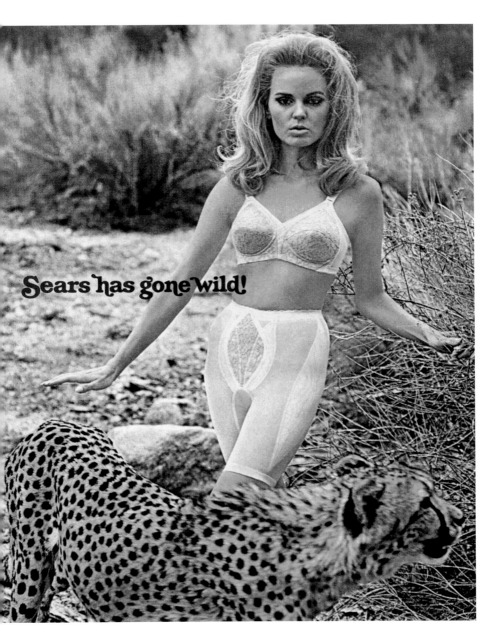

Actionwear Clothing/Sears, Roebuck and Co. Department Store, 1966 Sears Adventuress Undergarments, 1969

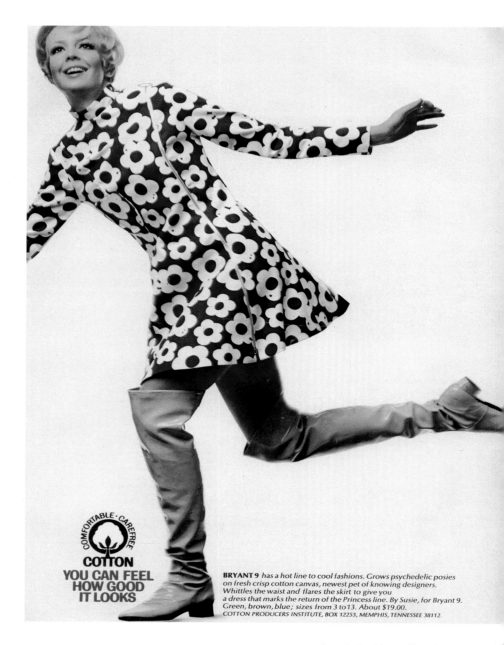

BRYANT 9 has a hot line to cool fashions. Grows psychedelic posies on fresh crisp cotton canvas, newest pet of knowing designers. Whittles the waist and flares the skirt to give you a dress that marks the return of the Princess line. By Susie, for Bryant 9. Green, brown, blue; sizes from 3 to 13. About $19.00.
COTTON PRODUCERS INSTITUTE, BOX 12253, MEMPHIS, TENNESSEE 38112.

Cotton Producer's Institute/Bryant 9 Womenswear, 1968

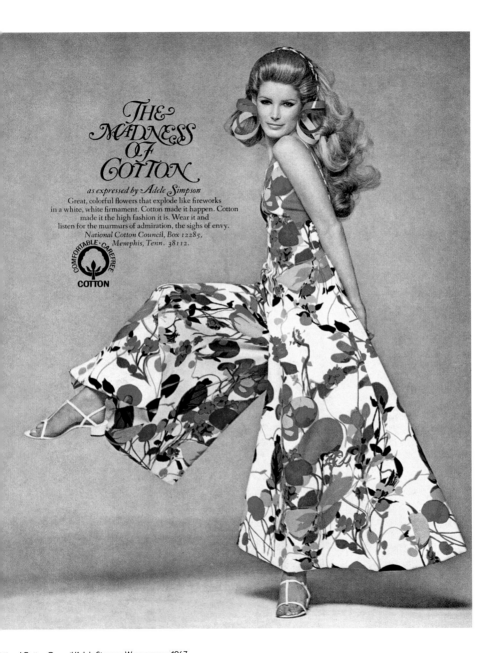

THE
MADNESS
OF
COTTON

as expressed by Adele Simpson

Great, colorful flowers that explode like fireworks
in a white, white firmament. Cotton made it happen. Cotton
made it the high fashion it is. Wear it and
listen for the murmurs of admiration, the sighs of envy.
*National Cotton Council, Box 12285,
Memphis, Tenn.* 38112.

COMFORTABLE·CAREFREE
COTTON

tional Cotton Council/Adele Simpson Womenswear, 1967

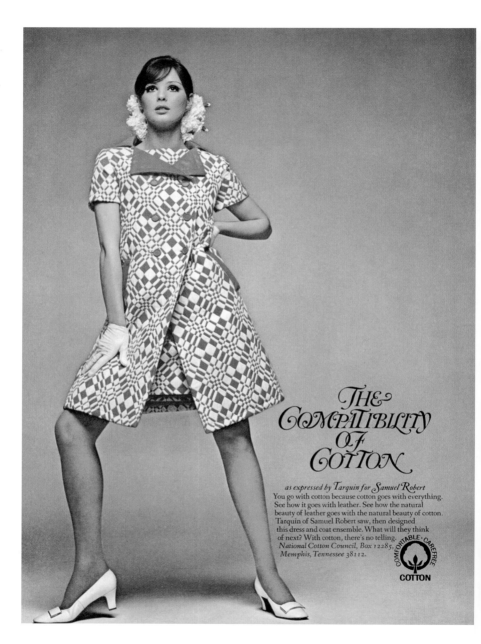

THE
COMPATIBILITY
OF
COTTON

as expressed by Tarquin for Samuel Robert
You go with cotton because cotton goes with everything.
See how it goes with leather. See how the natural
beauty of leather goes with the natural beauty of cotton.
Tarquin of Samuel Robert saw, then designed
this dress and coat ensemble. What will they think
of next? With cotton, there's no telling.
National Cotton Council, Box 12285,
Memphis, Tennessee 38112.

COMFORTABLE · CAREFREE

COTTON

National Cotton Council/Tarquin for Samuel Robert Womenswear, 1967

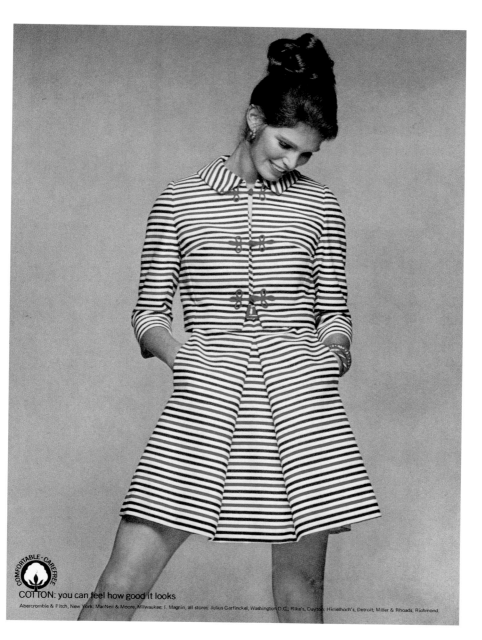

COMFORTABLE · CAREFREE

COTTON: you can feel how good it looks

Abercrombie & Fitch, New York; MacNeil & Moore, Milwaukee; I. Magnin, all stores; Julius Garfinckel, Washington D.C.; Rike's, Dayton; Himelhoch's, Detroit; Miller & Rhoads, Richmond.

Cotton Producer's Institute/Custom Casuals by Tom Mallo, 1969

Dacron®.
It ought to be
a law.

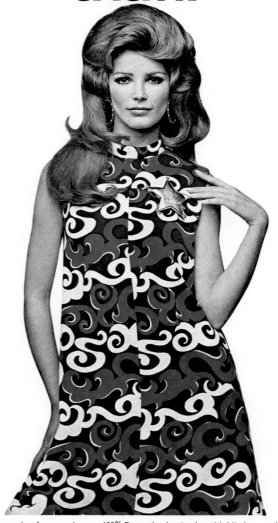

JUNIOR ACCENT thinks 'twould be a crime for pure pizzaz not to have the lasting shape of "Dacron". Thus, this sonic knit that has—a print so bold you can almost hear it. And a fresh so great it goes on forever. And why? Because it's

100% Dacron* polyester. In red/white/navy, yellow/white/ black. Sizes 6-16. About $46. Available at Franklin Simon, New York and branches; Town and Country, Des Moines; Joseph Horne Co., Pittsburgh; Frederick & Nelson, Seattle.

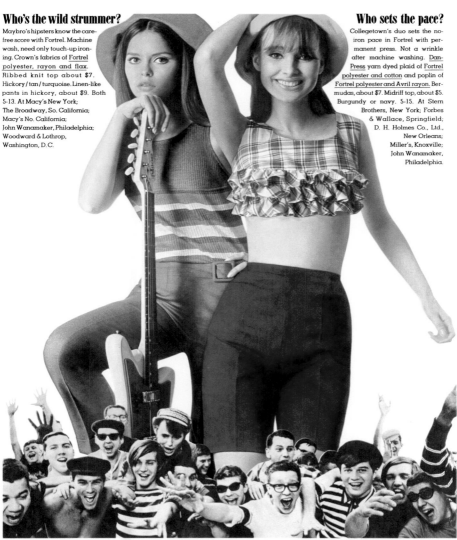

Who's the wild strummer?

Maybro's hipsters know the care-free score with Fortrel. Machine wash, need only touch-up ironing. Crown's fabrics of Fortrel polyester, rayon and flax. Ribbed knit top about $7. Hickory/tan/turquoise. Linen-like pants in hickory, about $9. Both 5-13. At Macy's New York; The Broadway, So. California; Macy's No. California; John Wanamaker, Philadelphia; Woodward & Lothrop, Washington, D.C.

Who sets the pace?

Collegetown's duo sets the no-iron pace in Fortrel with permanent press. Not a wrinkle after machine washing. Dan-Press yarn dyed plaid of Fortrel polyester and cotton and poplin of Fortrel polyester and Avril rayon. Bermudas, about $7. Midriff top, about $5. Burgundy or navy. 5-15. At Stern Brothers, New York; Forbes & Wallace, Springfield; D. H. Holmes Co., Ltd., New Orleans; Miller's, Knoxville; John Wanamaker, Philadelphia.

The Celanese Crowd-Pleasers...

◄ DuPont Dacron/Junior Accent Womenswear, 1961 Celanese, 1966

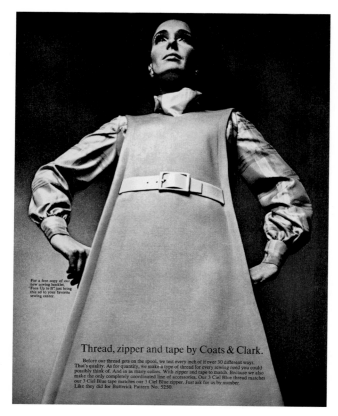

For a free copy of our new sewing booklet, "Face Up to It" just bring this ad to your favorite sewing center.

Thread, zipper and tape by Coats & Clark.

Before our thread gets on the spool, we test every inch of it over 30 different ways. That's quality. As for quantity, we make a type of thread for every sewing need you could possibly think of. And in as many colors. With zipper and tape to match. Because we also make the only completely coordinated line of accessories. Our 3 Ciel Blue thread matches our 3 Ciel Blue tape matches our 3 Ciel Blue zipper. Just ask for us by number. Like they did for Butterick Pattern No. 5250.

Coats & Clark Sewing Products/Butterick Patterns, 1969

▶ Groshire-Austin Leeds Suits, 1968

Menswear became more experimental in the 1960s, with designers searching for styles from around the globe that could be translated into cuts that would be recognizable to mainstream audiences. Groshire appealed to a sophisticated audience by featuring Rat Pack mainstay Sammy Davis Jr. as the spokesmodel for its edgy, handmade Nehru suits.

Herrenmode wurde in den 1960ern experimentierfreudiger, denn die Designer suchten rund um die Welt nach Trends, die sich in Schnitte umsetzen ließen und auch von Massenpublikum verstanden wurden. Groshire richtete sich mit Sammy Davis Jr., einer der tragenden Säulen des Rat Pack, als Fürsprecher für seine ausgefallenen, handgenähten Nehru-Anzüge an eine gehobene Klientel.

Dans les années 60, la mode pour homme devint plus expérimentale, avec des créateurs parcourant le monde entier en quête d'idées à traduire sous forme de coupes susceptibles de séduire le grand public. Groshire ciblait une clientèle sophistiquée en engageant Sammy Davis Jr., pilier du Rat Pack, comme mannequin pour ses costumes avant-gardistes à col Nehru faits main.

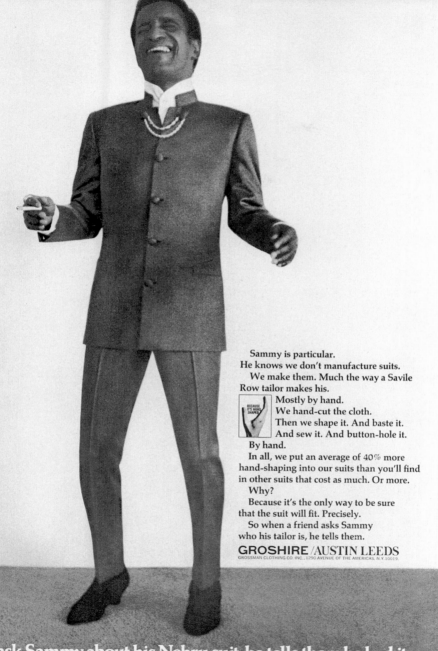

Sammy is particular.

He knows we don't manufacture suits.

We make them. Much the way a Savile Row tailor makes his.

Mostly by hand.
We hand-cut the cloth.
Then we shape it. And baste it.
And sew it. And button-hole it.
By hand.

In all, we put an average of 40% more hand-shaping into our suits than you'll find in other suits that cost as much. Or more.

Why?

Because it's the only way to be sure that the suit will fit. Precisely.

So when a friend asks Sammy who his tailor is, he tells them.

GROSHIRE/AUSTIN LEEDS
GROSSMAN CLOTHING CO. INC., 1290 AVENUE OF THE AMERICAS, N.Y. 10019.

n they ask Sammy about his Nehru suit, he tells them he had it made.
And he's not putting them on.

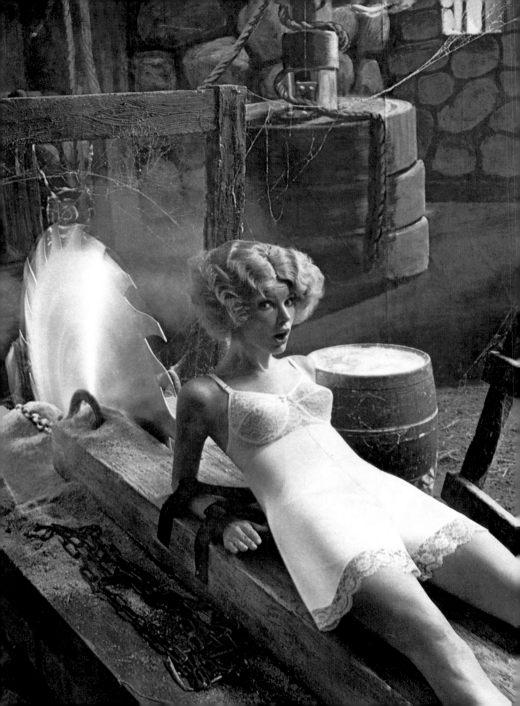

Movie Star Lingerie, 1969

Jonathan Logan Dresses, 1969

1966, London designer Mary Quant helped
propel the miniskirt into the mainstream, a
style that soon earned the moniker the
"Chelsea Look." Quant drew inspiration from
such predecessors as André Courrèges and
Rudi Gernreich, who did much to launch the
mod, miniskirted look.

1966 trug die Londoner Designerin Mary
Quant dazu bei, den Minirock zu einem Mas-
senphänomen zu machen; der Trend sollte bald
den Spitznamen „Chelsea Look" bekommen.
Quant holte sich ihre Inspiration bei Vorgän-
gern wie André Courrèges und Rudi Gern-
reich, die ebenfalls viel für die Verbreitung des
mod Look mit Minirock taten.

1966, la créatrice londonienne Mary Quant
contribua à la démocratisation de la minijupe,
un style rapidement surnommé le « Chelsea
Look ». Mary Quant puisa son inspiration
auprès de ses prédécesseurs comme André
Courrèges et Rudi Gernreich, qui firent beau-
coup pour lancer le look court moderne.

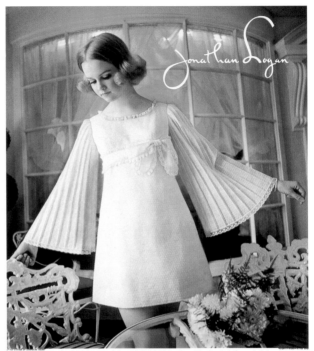

Graduation up your sleeve? And then a round of parties? Here's a fabulous dress with a sleeve for both . . . and a look so deceptively fragile you'll want to wear it on every VIP date all summer long! Voile of Dacron polyester-cotton with—yes—permanently pleated sleeves. White, as shown only. Junior sizes 5 to 15. About $26. For the store nearest you write Jonathan Logan, 1407 Broadway, New York City, 10018 . . . or call or visit one of the fine stores listed below.*

LORD & TAYLOR, New York; STIX, BAER & FULLER, St. Louis; JORDAN MARSH, Boston; MAISON BLANCHE, New Orleans; NORDSTROM BEST, Seattle & Portland; JACOBSON'S of Michigan; J. W. ROBINSON, Los Angeles; CARSON, PIRIE SCOTT, Chicago; STRAWBRIDGE & CLOTHIER, Philadelphia.

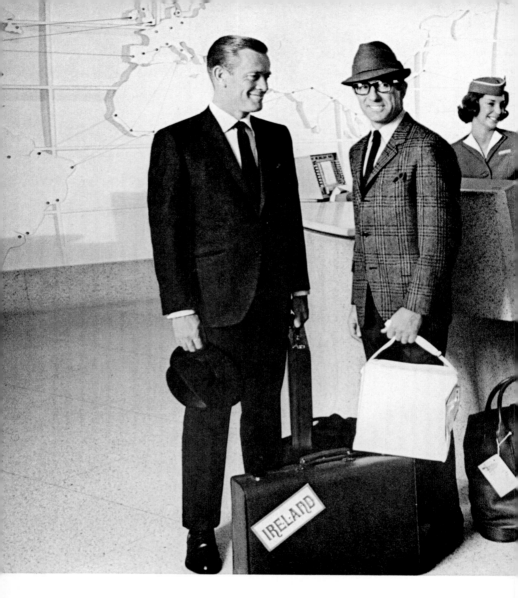

HART SCHAFFNER & MARX travels far to bring

FLY! fly! Spare nothing! Go the world over to discover new inspiration. Our experts make the *grand tour* and return to tailor the taste, touch and ideas for a new world of Fall clothing.

Behold: the happy travellers above. From the Far East, the mysterious luster of the Black Jade worsted.

From Ireland, a tweed with a brogue distin-

guishes this Irish County Coat.

From England, a suit of firm Saxo With extra colour-blended sport trou comes a versatile trio for weekend w

From America, a revolutionary idea— Suit. This fine-weave hopsack can be v classic sport coat it is, with slacks. Or the matching trousers as a business-lik

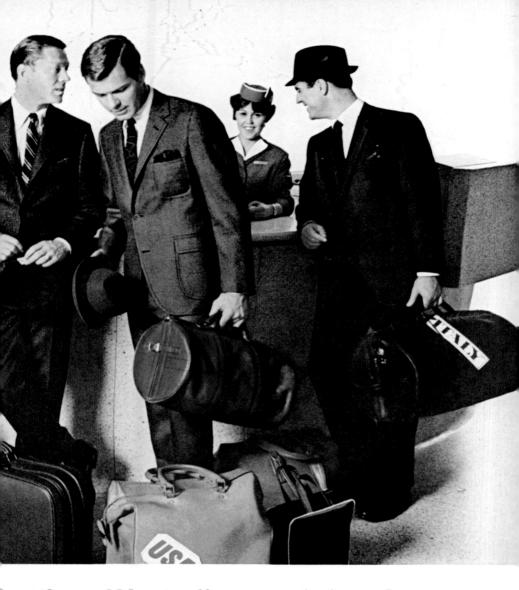

best the world has to offer...pure virgin wool.

THE CATALINA® MAN *discovers* Creslan

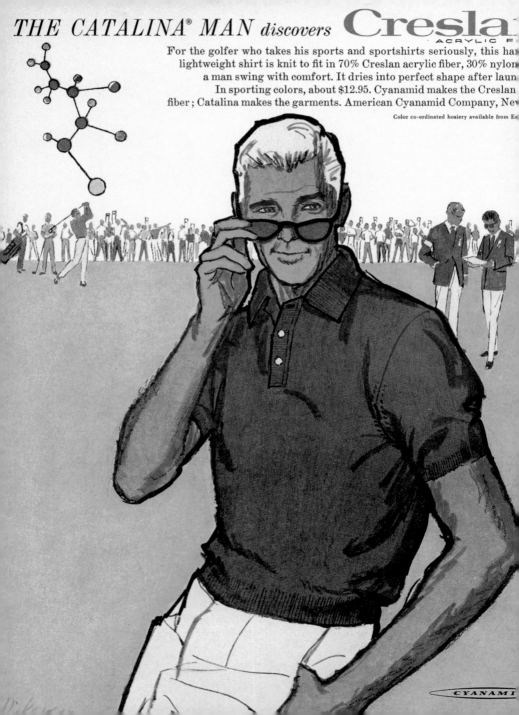

"Mr. Thomson....*please!*"

◄ Hart Schaffner & Marx, 1966 ◄ Creslan Acrylic Fiber/Catalina Sportswear, 1960 Mr. Thomson, 1963

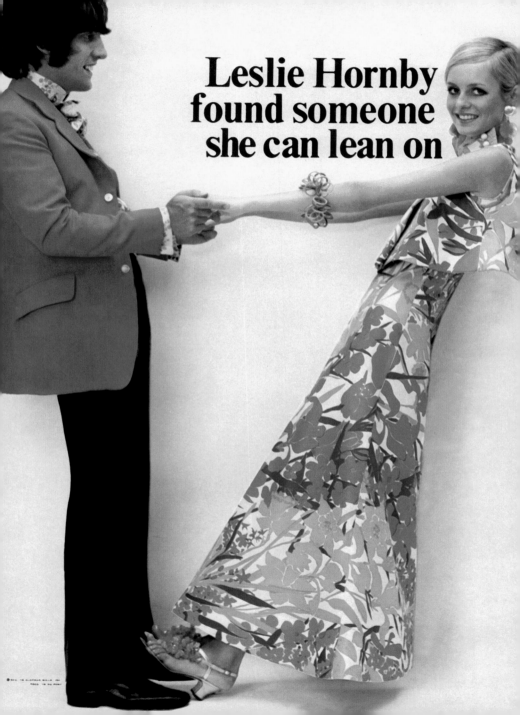

Leslie Hornby
found someone
she can lean on

Klopman Mills, 1968

British model Twiggy (née Leslie Hornby) had
a look that was distinctively different from
the glamorous models of the 1950s and early
1960s. Her slight frame and gamine looks
were a perfect match with the mod styles of
the decade.

Das britische Model Twiggy (geb. Leslie
Hornby) hatte einen Look, der sich unverwech-
selbar von den glamourösen Models der 50er
und frühen 60er unterschied. Ihre schmäch-
tige Gestalt und knabenhafte Erscheinung
passten perfekt zur Mod-Mode der Dekade.

Le mannequin britannique Twiggy (née Leslie
Hornby) avait un physique très différent
des modèles glamour des années 50 et du
début des années 60. Sa frêle ossature et son
physique de garçon manqué correspondaient
parfaitement aux vêtements modernes de la
décennie.

Galey & Lord Cottons, 1960

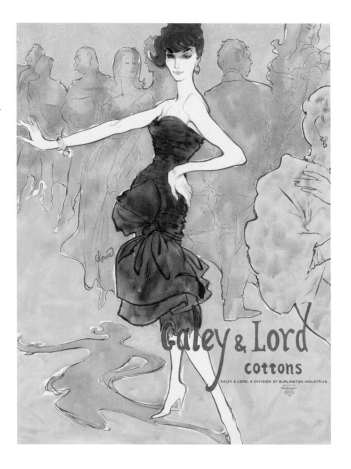

Mavest Menswear, 1968

▶ Hathaway Shirts, 1968

An update of David Ogilvy's famous "Man in the Hathaway Shirt" campaign featured a debonair man in an eye patch. Running from 1951 into the late 1980s, the ads showed the Hathaway man engaging in activities from the ordinary to the exotic—but always in a crisp Hathaway shirt and a mysterious eye patch.

Eine Neuauflage der berühmten Kampagne „Man in the Hathaway Shirt" von David Ogilvy stellt einen charmanten Mann mit Augenklappe dar. Die von 1951 bis in die späten 80er geschalteten Anzeigen zeigten den Hathaway-Mann bei den unterschiedlichsten Aktivitäten – von konventionell bis exotisch, aber stets in einem gestärkten Hathaway-Hemd und mit der geheimnisvollen Augenklappe.

Une version moderne de la célèbre campagne « Man in the Hathaway Shirt » de David Ogilvy présentait un homme jovial doté d'un couvre-œil. De 1951 à la fin des années 80, ces publicités montrèrent l'homme Hathaway engagé dans des activités ordinaires ou originales, mais toujours vêtu d'une impeccable chemise Hathaway et de son mystérieux couvre-œil.

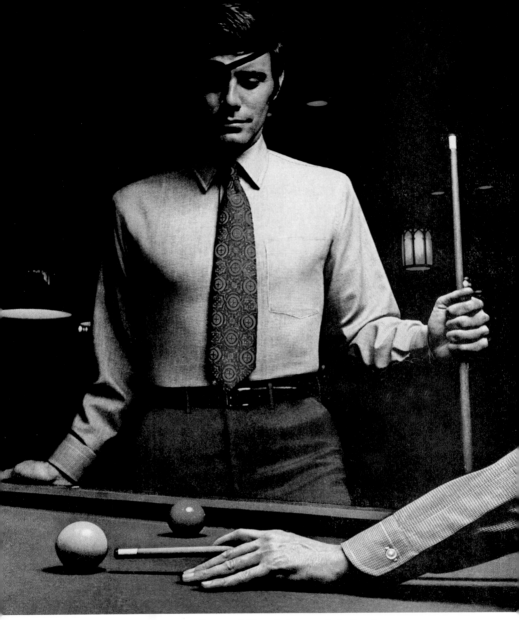

Hathaway presents the world's mini-est mini-checks

(Version #4 — made of Dacron* and cotton — with a Durable Press finish)

...ay introduced mini-check shirts for men
...rs ago. We seem to have started a cross-
...rage. Here is our *fourth* version of the mini-
...and the smallest yet.

...you see it close up in red. And in blue you
...t looks at a distance. Like a solid color but

more interesting. It takes threads of four different
colors to get this effect.

The wrinkle-resistant Dacron and cotton fabric
means that your shirt ought to look morning-fresh
all through the day and evening. The Durable
Press finish means it positively *will*. The collar is

Hathaway's Chelsea, just in from London.

This shirt, like every Hathaway shirt, is hand-
tailored. So it costs about $11.
For store names, write C. F.
Hathaway, Waterville, Me.

Hathaway®
THE WARNACO GROUP

*DuPont's trademark for its polyester fiber

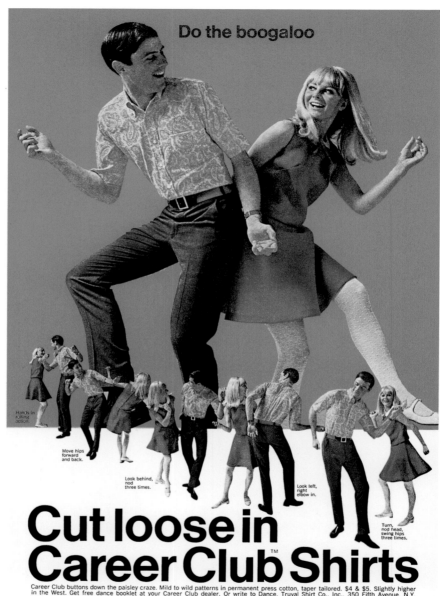

Do the boogaloo

Cut loose in
Career Club™ Shirts

Career Club buttons down the paisley craze. Mild to wild patterns in permanent press cotton, taper tailored. $4 & $5. Slightly higher in the West. Get free dance booklet at your Career Club dealer. Or write to Dance, Truval Shirt Co., Inc., 350 Fifth Avenue, N.Y.

Career Club Shirts, 1967

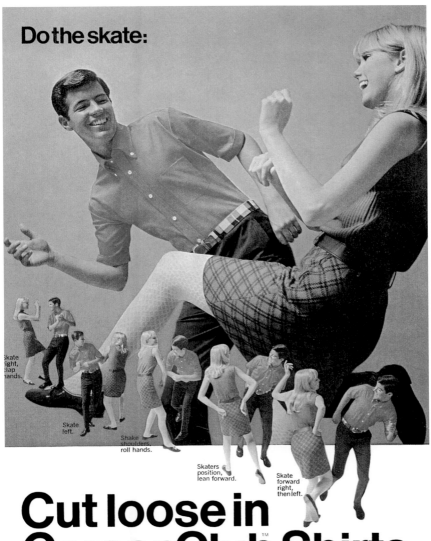

Do the skate:

Skate
right,
clap
hands.

Skate
left.

Shake
shoulders,
roll hands.

Skaters
position,
lean forward.

Skate
forward
right,
then left.

Cut loose in Career Club Shirts™

Career Club tapered shirts in cotton broadcloth with new hi-boy roll collar. 15 hot and sweet colors. $4. Slightly higher in the West. Get free dance booklet at your Career Club dealer. Or write to Dance, Truval Shirt Co. Inc., 350 Fifth Ave., N.Y.

Career Club Shirts, 1967

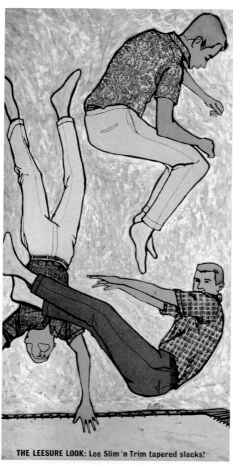

THE LEESURE LOOK: Lee Slim 'n Trim tapered slacks!

These tapered slacks can take all the bounce a Trampoline® can dish out — or show up for a party! Lee tailors all the things you like into these slacks ...makes 'em sharp enough for practically any occasion. Here's classic styling—in high-sheen, Narrow Wale Cord (Loden Green) and Super Polished Cotton (Sand). Also featured above are new "Lee Trims," slim beltless slacks in new Textured Weave Polished Cotton (Cactus Green). "Sanforized-Plus" for easy care. Priced from only $4.95! And look at those great Lee sport shirts. Unlimited selection from just $3.98!

Leesures® by Lee

© 1961, H. D. Lee Company, Kansas City, Mo.

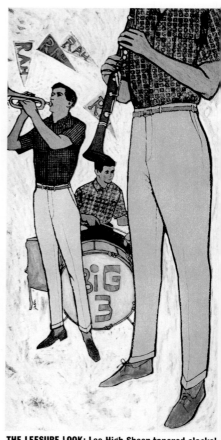

THE LEESURE LOOK: Lee High-Sheen tapered slacks!

Once you pull on these tapered slacks you'll practically <u>live</u> in them. They're that sharp. They're that comfortable. Made of exclusive "Lee Lustre" smooth polished cotton and twill, they're the latest thing for casual wear. And these slacks <u>keep</u> their sheen. It's <u>woven in</u> to last the life of the fabric. "Sanforized-Plus" for easy care, permanent fit. Classic tailoring with latest style details—in Tawn, Sand and shades of green. Only $5.95. Team 'em up with smart Lee sport shirts and you're <u>really</u> swinging!

Leesures® by Lee

© 1961, H. D. Lee Company, Kansas City, Mo.

Lee Leesures Slacks, 19◀

Love him with
Puritan Ban-Lon® Brookviews
of Du Pont Nylon

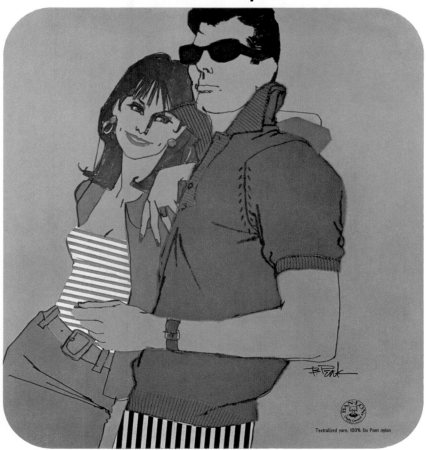

Give him America's favorite knit shirts. Full-Fashioned.
Automatic wash and dry. In 25 amorous colors. $8.95 each.

Textralized yarn, 100% Du Pont nylon

Puritan Sportswear, 1965

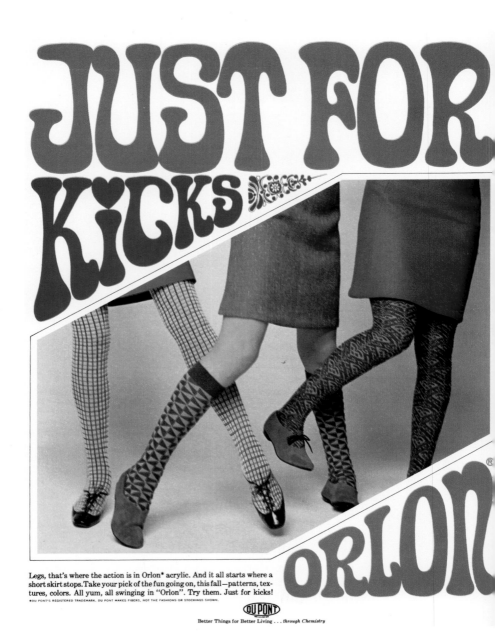

JUST FOR KICKS

ORLON®

Legs, that's where the action is in Orlon* acrylic. And it all starts where a short skirt stops. Take your pick of the fun going on, this fall—patterns, textures, colors. All yum, all swinging in "Orlon". Try them. Just for kicks!

*DU PONT'S REGISTERED TRADEMARK. DU PONT MAKES FIBERS, NOT THE FASHIONS OR STOCKINGS SHOWN.

DUPONT

Better Things for Better Living . . . *through Chemistry*

DuPont Orlon, 1966 ▸ Alamac Knitting Mills/Bobbie Brooks Sportswear, 19

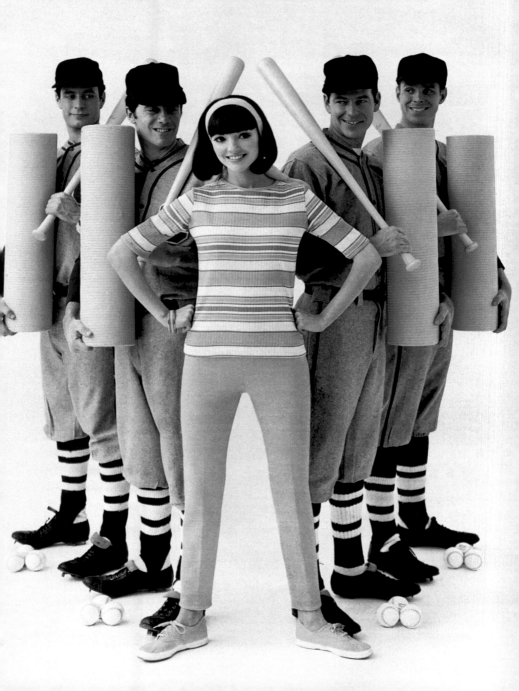

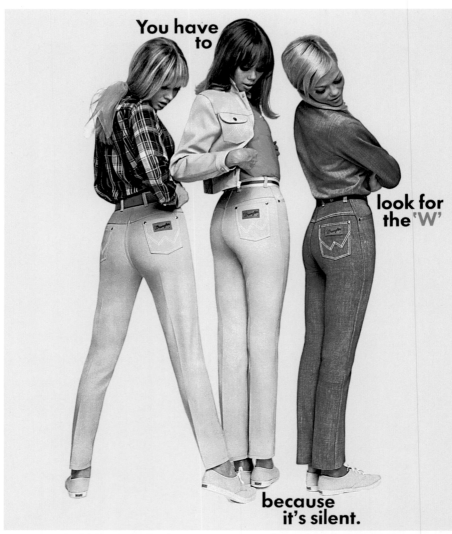

You have to

look for the 'W'

because it's silent.

Once you've found the "W"—wrelax. You've got the wreal jeans. Wremarkable Wrangler with the fit that's wright! So wround-up a collection of Wrangler cotton denims. Sanforized® so the snug fit stays, never strays out of shape. Wrugged too...hard to wrip...but in all the wreal girl colors. About $3.98 to $5.

Wrangler's got tops too. Created to go with your Wrangler jeans. Everything from man-tailored blouses and leather-laced Ponderosa shirts to western jackets with wreal Wrangler verve. About $4 to $6.

And now Wrangler's got cotton denim sneakers too. Color coordinated perfectly because they're in wreal jean-tones. About $3.95.

But wremember, the "W" is silent. It's up to you to wreach for Wrangler.

Wrangler Jeans, 1407 Broadway, New York 10018.

Wrangler® the wreal jeans!

PRICES SLIGHTLY HIGHER IN THE WEST

Wrangler Jeans, 1966 ▶ Wrangler Jeans, 19

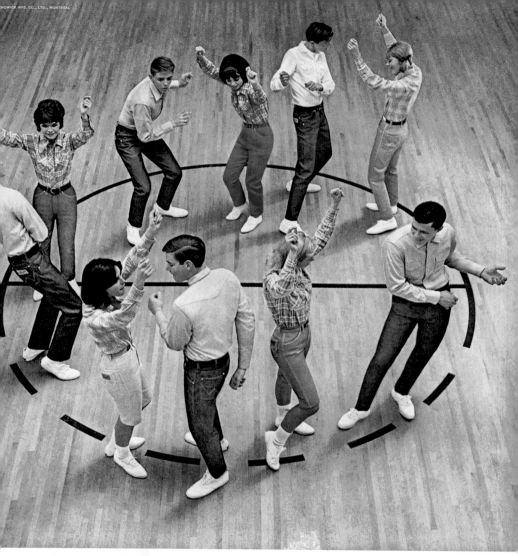

HOWICK MFG. CO., LTD., MONTREAL

the Wrangler Stretch is the dance to do

Say goodbye to the Monkey, Chicken, Hully Gully and Watusi, too.
s new dance really moves. You'll recognize the beat and love it. The
iration for the whole craze—believe it or not—is a pair of jeans!

The jeans—we should say the jeans—are Wrangler jeans, of course.
only part of the Old West today's generation thinks is worth keeping.
'/re tough as tumbleweed, trim as a rawhide thong and pre-shrunk
oot. What makes Wrangler jeans absolutely irreplaceable though, is
they fit so well they move like part of you. That's how they made the
о so easily from the saddle to the dance floor.

Okay now, if you're ready to do the Wrangler Stretch, get on your
horse and head for the nearest Wrangler dealer. He'll give you free copies
of the words and music and instructions on what steps to take. You
might also ask him how to get a 45 rpm record of the whole bash.
Get a pair of Wrangler jeans while you're there.

This is your night to Stretch!

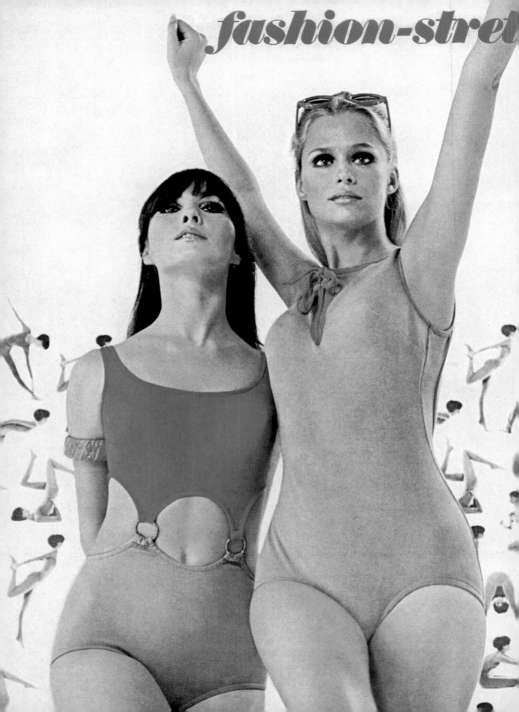

fashion-stret

Celanese Nylon/Sea B, Inc. Swimwear, 1967 Revlon, 1964 ►► Exquisite Form Lingerie/Rudi Gernreich Young Happenings, 1966

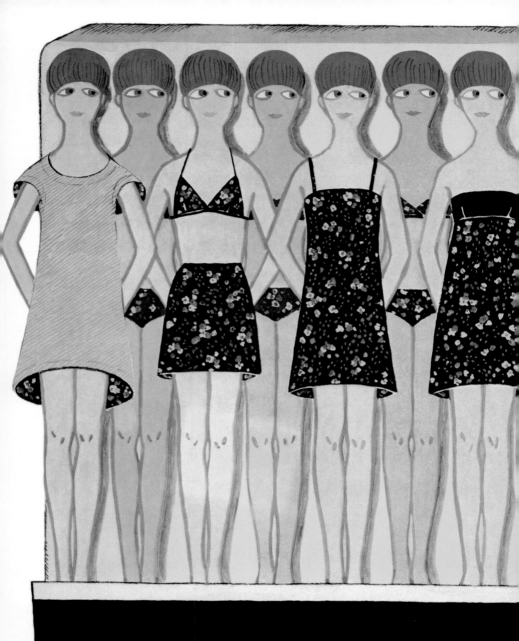

Rudi even does dresses to match **Halter Bra.** Wear it as a bare back halter **Camise.** A camisole slip with **Bikini.** Tiny bikini pantie **Strapless Band Sli**
 or convert it to a regular bra. $4. the look of a little chemise. $7. to wear under everything. won't need a bra w
 Petticoat. Short for today's short skirts. $4. $2.50. stretch top band sl

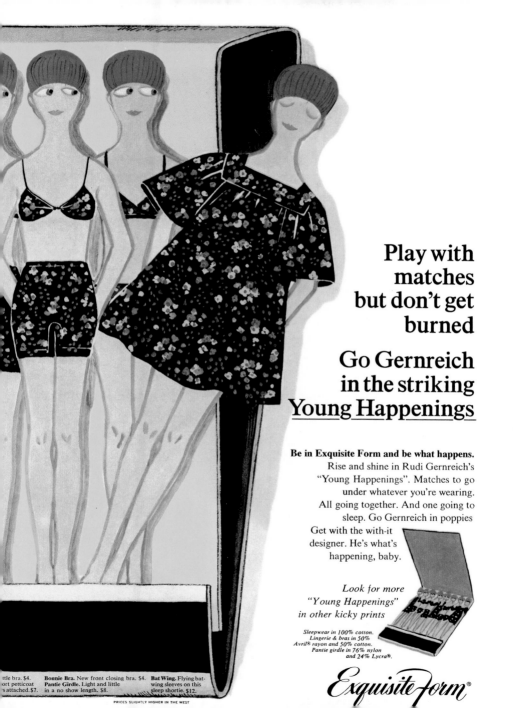

Play with matches but don't get burned

Go Gernreich in the striking <u>Young Happenings</u>

Be in Exquisite Form and be what happens.
Rise and shine in Rudi Gernreich's "Young Happenings". Matches to go under whatever you're wearing. All going together. And one going to sleep. Go Gernreich in poppies Get with the with-it designer. He's what's happening, baby.

Look for more "Young Happenings" in other kicky prints

Sleepwear in 100% cotton.
Lingerie & bras in 50%
Avril® rayon and 50% cotton.
Pantie girdle in 76% nylon
and 24% Lycra®.

ttle bra. $4. **Bonnie Bra.** New front closing bra. $4. **Bat Wing.** Flying bat-
ort petticoat **Pantie Girdle.** Light and little wing sleeves on this
s attached. $7. in a no show length. $8. sleep shortie. $12.

PRICES SLIGHTLY HIGHER IN THE WEST

Exquisite form ®

the lass
with the
Pendleton®
air

She's a girl on the
Packs 28 hours into
Depends on Pendleton and
classic 49'ers® (which
collects like coins, they're nea
that immortal) to take her *everywhe*
Fall's fresh crop is bright and brac
plaids, tartans, checks, the handso
herringbone squares pictured. In sof
loveliest Pendleton virgin wool that sir
refuses to wear out. *Wear y
49'er belted, with a color-cued Pendl
skirt, and you're wearing a suit.* 1

The skirt: 6 panels, half-lining,
knee-pleats fore and aft. 1
The sweater: classic short-sleeved slip
fine-gauge virgin wool.
And now, all sweaters mothproof

Country clothes by Pendlet

The Frug The Popeye The Hitchhiker

The Dress...definitely discothèque

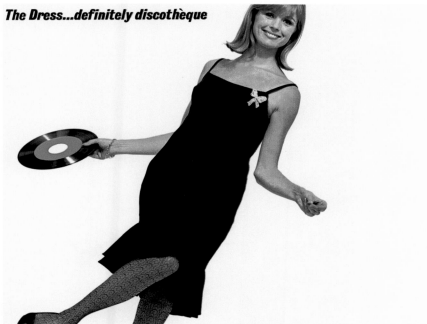

Learn a step (the Frug). Go to an "in" place. Wear a crepe with a flounce (McCall's Pattern 7565). And you have the latest word in nightlife: Discothèque. Discothèque is a club or hideaway where the accent is on hully-gullying and the beat comes from records, or discs (as in French). Of course, the dress is very important. It must be little and black and very expensive looking. Psst! You can make one for yourself. McCall's has created the Dress. In the deepest black crepe, it's slim like a chemise with thin spaghetti straps for glamour and a short, flounced skirt for dancing. The Dress is perfect for any little evening you're out with the "ins." Sew McCall's 7565 and go disco-thèque. But definitely! **McCall's Patterns**

Seventeen—November, 1964

219

WOOL

All aglow in natural wool that drinks up color . . . a luxurious mohair and wool cardigan with an air of lightness that brightens the day and a rich softness that lightens the night. The wool flannel skirt is color matched and tailored to perfection. Ragtime Orange, Flapper Blue, White or pastels. Sweater, about $14. Longer version, about $16. Sizes 34 to 40. Skirt, about $10. Sizes 8 to 16, 7 to 15. At fine stores everywhere.

IRWILL KNITWEAR CORP., 1407 BROADWAY, NEW YORK

DESIGNED TO BE LIVED IN
JANE IRWILL

JANE IRWILL RECOMMENDS CKC COLD WATER WASH

SPONSORED JOINTLY WITH AMERICAN WOOL COUNCIL

Jane Irwill Knitwear/American Wool Council, 1961 ▶ Cameo Stockings, 196

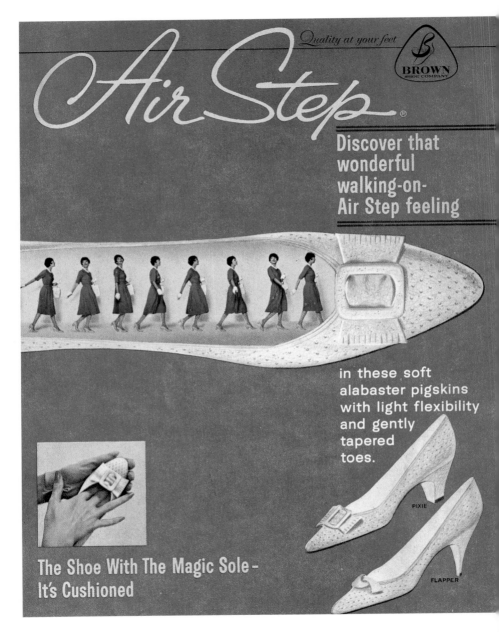

Quality at your feet

Air Step ®

BROWN
SHOE COMPANY

Discover that wonderful walking-on-Air Step feeling

in these soft
alabaster pigskins
with light flexibility
and gently
tapered
toes.

PIXIE

FLAPPER

The Shoe With The Magic Sole – It's Cushioned

Air Step Shoes, 19●

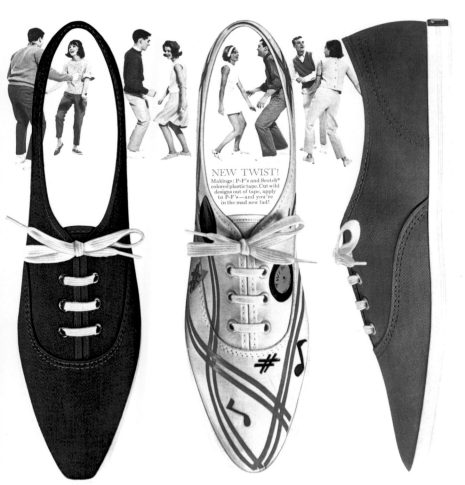

NEW TWIST!
Makings: P-F's and Scotch® colored plastic tape. Cut wild designs out of tape, apply to P-F's—and you're in the mad new fad!

THE FANCY FOOTWORK YOU MADE FAMOUS—

Who made the sneaker *the* shoe? You! And who made it beautifully better? B.F.Goodrich and Hood. Look: square toes and taper toes, adding tomorrow's touch of fashion to the classic look of the sneaker. And, of course, P-F's® have the exclusive Posture Foundation wedge built right into the heel. Does great things for foot and leg muscles, whether you're dancing dervishly or simply rushing into a morning class. P-F's—the real things—the McCoys—the sneakers that *started* it all!

See your favorite BFG or Hood Footwear dealer or write: President's Office, The B.F.Goodrich Company, Akron 18, Ohio.

Flyer Sneakers/B. F. Goodrich Company, 1962

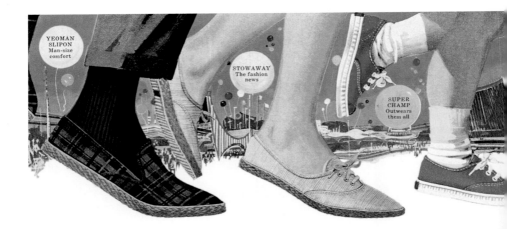

come to the Fair in KED

Light as balloons. Cool as grass. Keds are wonderful to wear any-where, and the *only* pair to wear to the Fair. Keds feel so great no matter how long or far you walk in them. What's their secret?

Only Keds have an exclusive shockproofed arch cushion, heel cushion and a full cushion innersole, all molded toge one lasting, inseparable comfort cushion. What a marvelou

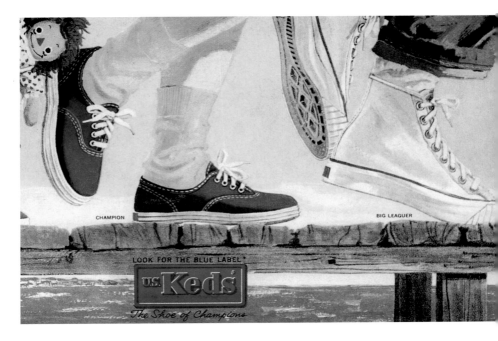

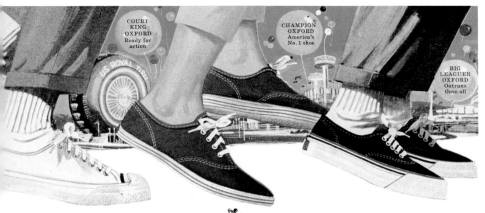

COURT
KING
OXFORD
Ready for
action

CHAMPION
OXFORD
America's
No. 1 shoe

BIG
LEAGUER
OXFORD
Outruns
them all

See Kolonel Keds fly *in 'Leonidoff's Wonder World' at the N.Y. World's Fair Amphitheatre!*

y're fair to your feet

LOOK FOR THE BLUE LABEL*

U.S. Keds

not only feel better, they fit better, and take the most wash and wear
you toss them in a machine. So why not be fair to all the feet in your
utfit them all in the great new '64 Keds. They're the fairest of all.

*Both U. S. Keds and the blue label ▬ are registered trademarks of

United States Rubber

Rockefeller Center, New York 20, New York ■ In Canada: Dominion Rubber Company, Ltd.

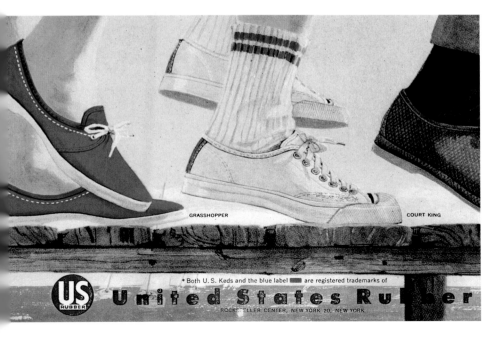

GRASSHOPPER

COURT KING

* Both U. S. Keds and the blue label ▬ are registered trademarks of

US RUBBER

United States Rubber

ROCKEFELLER CENTER, NEW YORK 20, NEW YORK

SHARK!

ETONIC ®

Styles for Men and Ladies
$19.95 to $65.00
IN LEADING PRO SHOPS

The ultimate in golf styling.
For players who eat up the course.

CHARLES A. EATON CO. · BROCKTON, MASS. 02403

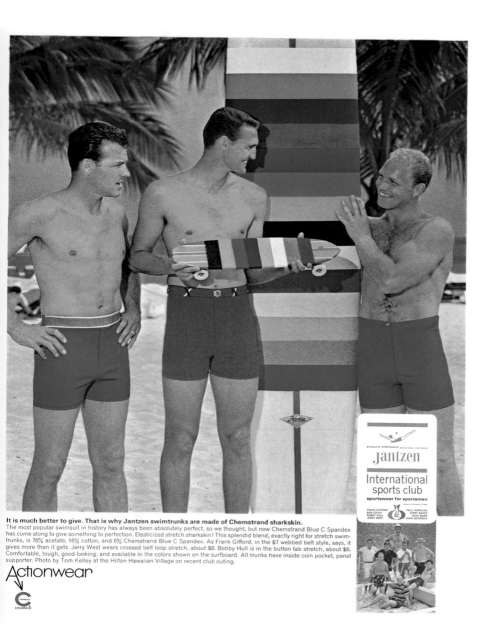

It is much better to give. That is why Jantzen swimtrunks are made of Chemstrand sharkskin.

The most popular swimsuit in history has always been absolutely perfect, so we thought, but now Chemstrand Blue C Spandex has come along to give something to perfection. Elasticized stretch sharkskin! This splendid blend, exactly right for stretch swim-trunks, is 78% acetate, 16% cotton, and 6% Chemstrand Blue C Spandex. As Frank Gifford, in the $7 webbed belt style, says, it gives more than it gets. Jerry West wears crossed belt loop stretch, about $8. Bobby Hull is in the button tab stretch, about $6. Comfortable, tough, good-looking, and available in the colors shown on the surfboard. All trunks have inside coin pocket, panel supporter. Photo by Tom Kelley at the Hilton Hawaiian Village on recent club outing.

Actionwear

just wear a smile

Smile, Canada, you can buy Jantzen there too. Jantzen Inc., Portland 8,

nd a jantzen

This is no shape for a girl.

That's why Warner's makes the Concentrate girdle and the Little Fibber bra.

Girls with too much bottom and too little top: Warner's® can reshape you.

We reshape you on the bottom with the Concentrate girdle: Its all-around panels do more for you than a little girdle (they're lined up to help you where you need help most), yet Concentrate doesn't squash you like a heavy girdle.

We reshape your top with the Little Fibber bra. super-soft fiberfill lining doesn't make a big produ out of you. It rounds out your bosom just enough with your trimmed-down hips.

All of a sudden, you've got a proportioned body, and clothes fit better. Warner's calls t Body-Do.™ You can get fitte one in any good s

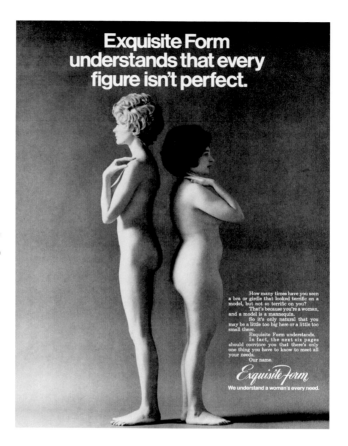

◄ Jantzen Swimwear, 1961

Warner's, 1967

quisite Form Lingerie, 1969

the mid-1960s, designer Rudi Gernreich
eated the No-Bra Bra, a sheer bra with little
pport. The designer went on to work with
gerie label Exquisite Form to create a similar
oduct. The introduction of sheer, no-support
as marked an end to the heavily engineered
dergarments of the 1950s. The hourglass
ape of the previous decade had given way to
more natural silhouette.

itte der Sechziger erfand der Designer Rudi
ernreich den No-Bra Bra, einen hauchdün-
n BH mit wenig Verstärkung. Zusammen
t dem Dessous-Label Exquisite Form
beitete der Modeschöpfer an der Idee für
ähnliches Produkt. Die Einführung zarter,
verstärkter Büstenhalter bedeutete das
de der technisch aufwändigen Unterwäsche
r Fünfziger. Das Sanduhr-Ideal des vorange-
ngenen Jahrzehnts hatte einer natürlicheren
houette Platz gemacht.

u milieu des années 60, le créateur Rudi
ernreich inventa le No-Bra Bra, un soutien-
rge transparent offrant peu de support.
ravailla ensuite avec la marque de lingerie
quisite Form pour créer un produit similaire.
ntroduction des soutiens-gorge transparents
ns armatures marqua la fin des sous-vête-
ents extrêmement complexes des années
). Les formes en sablier de la décennie pré-
dente furent supplantées par une silhouette
us naturelle.

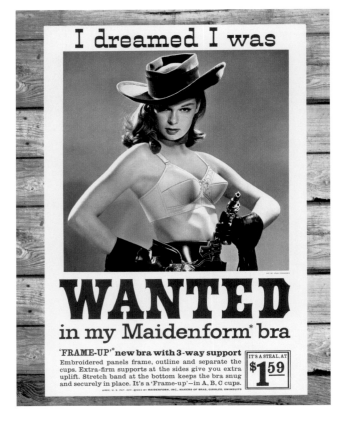

I dreamed I was

WANTED
in my Maidenform* bra

'FRAME-UP'* new bra with 3-way support
Embroidered panels frame, outline and separate the
cups. Extra-firm supports at the sides give you extra
uplift. Stretch band at the bottom keeps the bra snug
and securely in place. It's a 'Frame-up'—in A, B, C cups.
®REG. U. S. PAT. OFF. ©2003 BY MAIDENFORM, INC., MAKERS OF BRAS, GIRDLES, SWIMSUITS

IT'S A STEAL AT
$1⁵⁹

Maidenform Bras, 1963

By 1962, the Maidenform "I dreamed"
campaign was so well known, *Mad* magazine
spoofed it in an ad that read, "I dreamed I
was arrested for indecent exposure in my
Maidenform bra." The company went on to
create its equally well-known campaign, "The
Maidenform woman, you never know where
she'll turn up."

1962 war die Maidenform-Kampagne
„I dreamed" schon so bekannt, dass die
Zeitschrift *Mad* sie in einer Anzeige aufs
Korn nahm, in der es hieß „Mir träumte, ich
sei wegen unzüchtigen Auftretens in meinem
Maidenform-BH verhaftet worden". Das
Unternehmen setzte seine Aktivitäten mit
einer bald ebenso bekannten Kampagne fort:
„The Maidenform woman, you never know
where she'll turn up."

En 1962, la campagne « I dreamed » de
Maidenform était si célèbre que le magazine
Mad la parodia dans une publicité qui disait :
« J'ai rêvé qu'on m'arrêtait pour attentat à
la pudeur dans mon soutien-gorge Maiden-
form. » L'entreprise poursuivit en lançant une
autre campagne tout aussi célèbre : « Avec la
femme Maidenform, on ne sait jamais à quoi
s'attendre. »

▶ Maidenform Bras, 1961

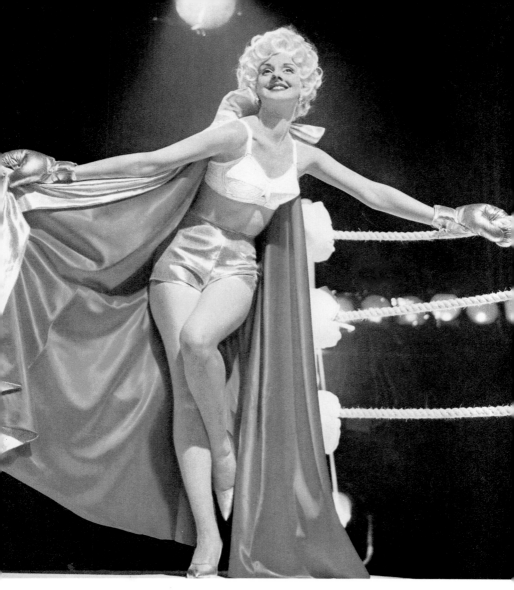

I dreamed I was a knockout
in my *maidenform* bra

Arabesque... new Maidenform bra...* has bias-cut center-of-attraction for *superb*
separation...insert of elastic for *comfort*...floral circular stitching for the most *beautiful* contours!
White in A, B, C cups, just 2.50. Also pre-shaped (light foam lining) 3.50.

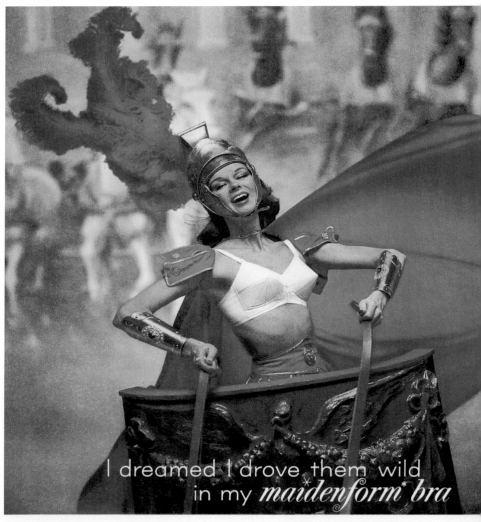

I dreamed I drove them wild
in my *maidenform* bra

COUNTERPOINT*...new Maidenform bra made with super-strong Spandex—new, non-rubber elastic that weighs almost nothing at all yet lasts (and <u>controls</u> you) far longer than ordinary elastic. Exclusive "butterfly insert" adjusts size and fit of each cup as it uplifts and separates! Cotton or Spandex back. White. From 2.00.

Maidenform Bras, 196

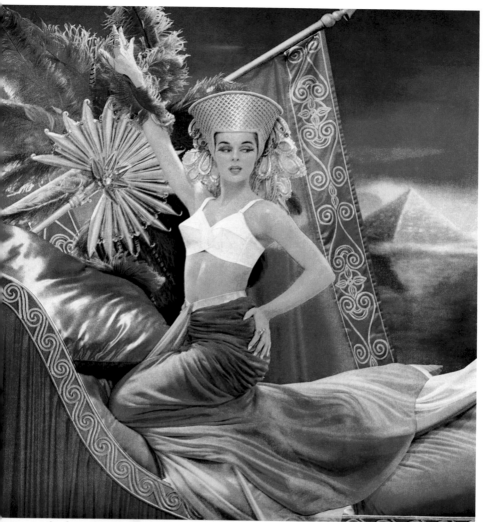

I dreamed
I barged down the Nile in my *maidenform* bra*

Sweet Music®...Maidenform dream bra...features spoke-stitched cups for Cleopatra curves! All-elastic band for freedom of fit; reinforced undercups for everlasting uplift. White in A, B, C cups. This and seven other enchanting Sweet Music styles, from 2.50.

*REG. U. S. PAT. OFF. ©1962 BY MAIDENFORM, INC., MAKERS OF BRAS, GIRDLES AND SWIMSUITS

aidenform Bras, 1961

Pick a flower. Power.
Do a daisy. Crazy.
Plant your stems in panty
hose. Stretch nylon crepe
fresh from the Hanes
hothouse in shocked and
whispered tones. For a
bloomin' pow wow,
buy dozens.

flower pow

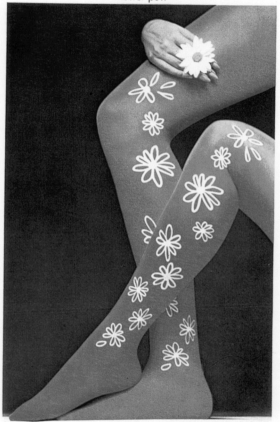

Hanes Hosiery, 1969 ► Berkshire Hosiery, 196█

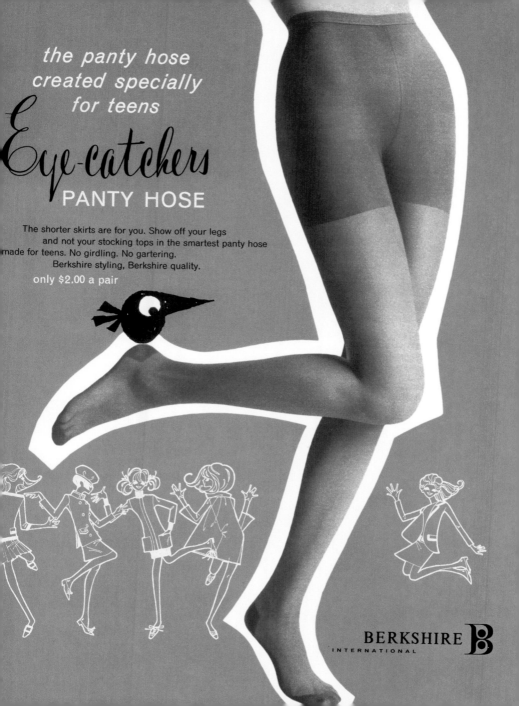

the panty hose
created specially
for teens

Eye-catchers
PANTY HOSE

The shorter skirts are for you. Show off your legs
and not your stocking tops in the smartest panty hose
made for teens. No girdling. No gartering.
Berkshire styling, Berkshire quality.

only $2.00 a pair

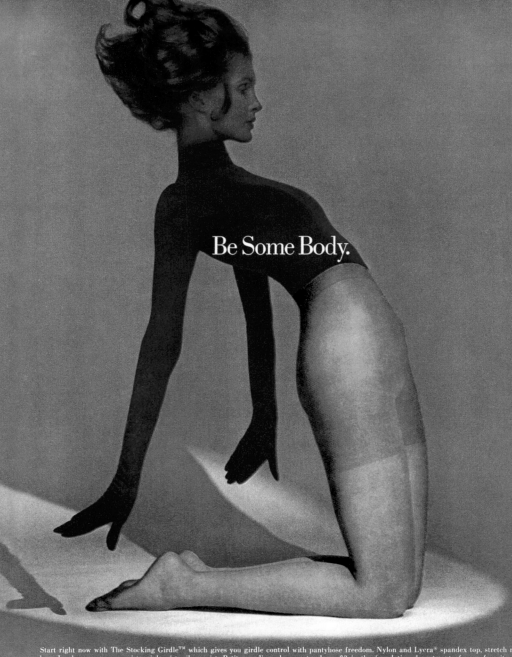

Be Some Body.

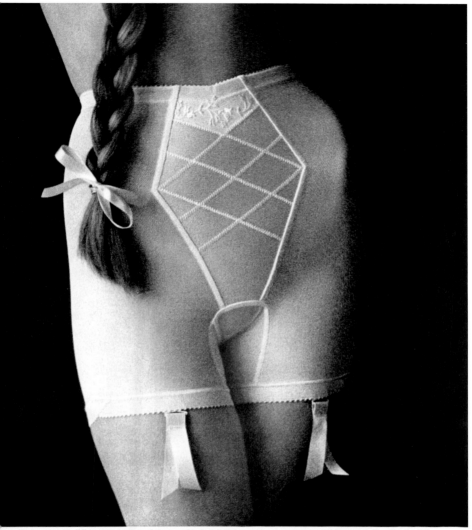

Waistline pantie or girdle, $7.50. In white, black, beige, blue. (In Canada, too.) Other Double Play™ slimwear briefs, panties, corselettes from $5.95. Better washed in Warner Wash, 10 oz. $1.50.

Now there's a girdle with crisscross bands that gives you back the flat tummy of your teens! The Double Play girdle by Warner's

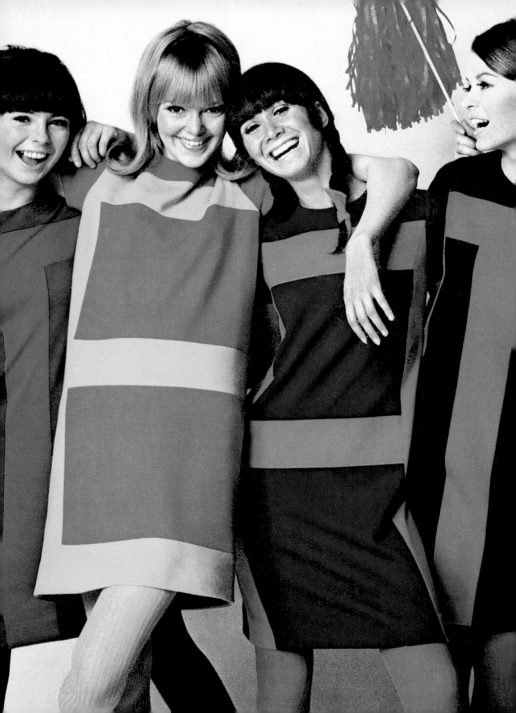

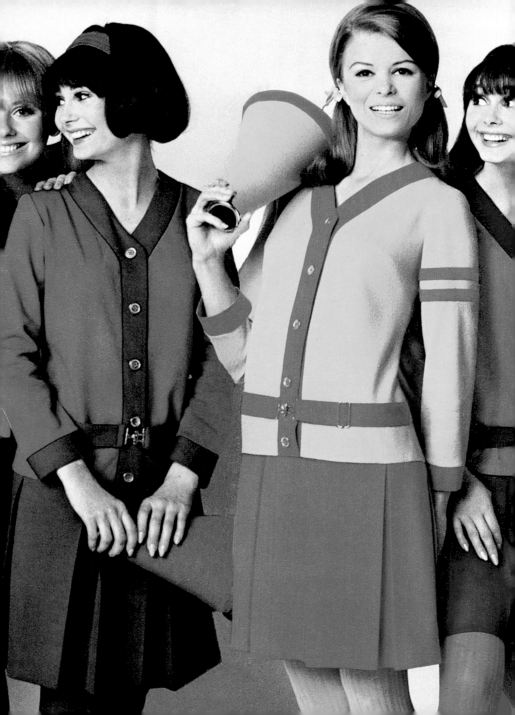

"ELEGANCE IS NO LONGER
SIGNIFICANT; CLOTHES
HAVE TO BE FUN."
– YVES SAINT LAURENT

„ELEGANZ HAT KEINE
BEDEUTUNG MEHR;
KLEIDER MÜSSEN
SPASS MACHEN."
–YVES SAINT LAURENT

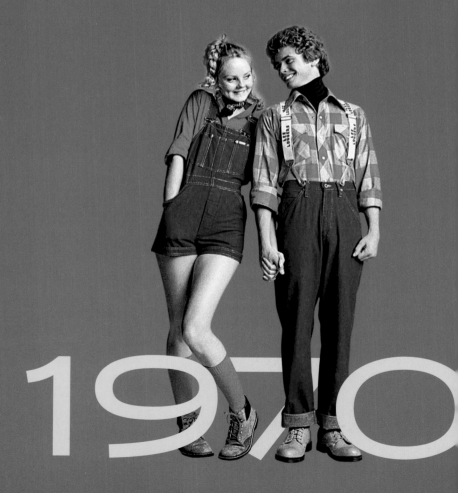

1970

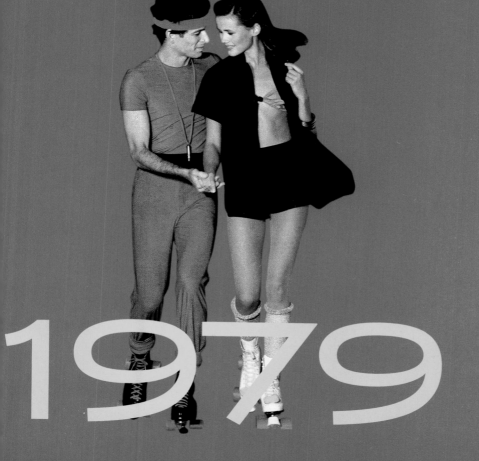

1979

Riviera Brings Fashion to Sunsensor™

Hurry up sunshine! Fashion glasses…they turn darker as the sun turns brighter

Provocative! Intriguing! And superbly practical!
"Sunsensor"™ lenses adjust to all light
conditions…quickly, smoothly.
Styled to match the life you lead.
Fashion drama…available at
fine stores everywhere…
and exclusive styling
from Riviera.

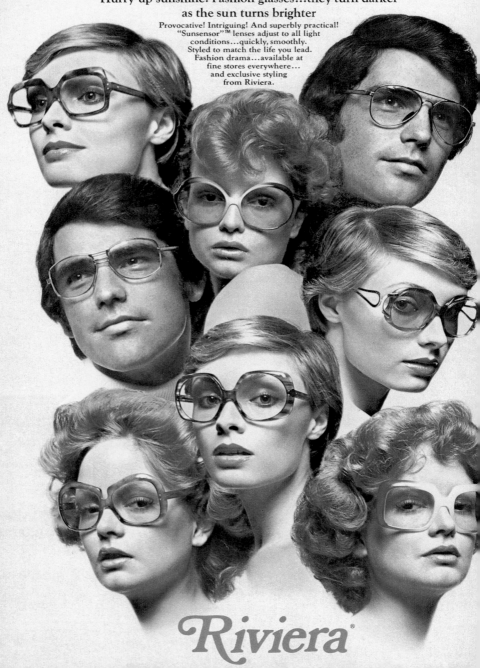

Riviera®

HIPPIES TO HALSTON

The designer most identified with the disco years — and its cultural epicenter, Studio 54 in New York — was Halston… [who] pioneered a clean, tailored look that was a dramatic departure from the bohemian styles of the day.

HE COUNTERCULTURE WENT MAINSTREAM IN THE EARLY 1970S, AS THE RADICAL ASHIONS OF THE 1960S — miniskirts, bell-bottoms, and bright graphic prints — were opted by the masses. The carefully manufactured "natural" look was pervasive in advertising. he culture wars made their way into advertising as products targeting women were pitched with an npowerment message, while those pitched to men took advantage of relaxed standards about sex capture attention.

In 1971, James Brown recorded "Hot Pants," his ode to short-shorts. That year, Vivienne Westwood ened a store in London called Let It Rock with her boyfriend, music promoter Malcolm McLaren. he two later renamed the store Sex, and, in 1976, Westwood began dressing McLaren's punk band, e Sex Pistols. Surfboard manufacturer Ocean Pacific launched its California-inspired apparel e in 1972, and, the same year, the new athletic footwear company Nike launched. Burt Reyn- ds's urban cowboy film *Smokey and the Bandit* exceeded box office figures and helped sustain inter- t in modern Western wear. Diane Keaton pioneered an androgynous look — garbed in men's ties, sts, and trousers — as the title character of Woody Allen's 1977 film, *Annie Hall*.

The most iconic look of the 1970s is the white pantsuit. It was memorably worn by John Travolta the 1977 film *Saturday Night Fever*. But its roots date back to 1971 and the wedding of Rolling Stones ntman Mick Jagger to Bianca Perez Morena De Macias in Saint-Tropez. The bride and groom both

wore white Yves Saint Laurent suits — his was a three-piece pantsuit, hers had a long skirt, which sh
soon abandoned for pants. The white pantsuit became Bianca Jagger's signature look.

The designer most identified with the disco years — and its cultural epicenter, Studio 54
New York — was Halston. Born Roy Halston Frowick, the designer got his start in the 1950s as
hatmaker. Jacqueline Kennedy wore one of Halston's pillbox hats at her husband's inauguratio
By the 1960s, Frowick would make the switch to womenswear, launching his own label in 196
He pioneered a clean, tailored look that was a dramatic departure from the bohemian styles of the da
His later attempt to take the label to the mass market, however, became his undoing. After he stru
a deal to produce a lower-priced line for moderate department store J.C. Penney in 1982, upsca
retailer Bergdorf Goodman dropped his collection.

The decade's other pioneering designers include Norma Kamali, who introduced her "sleepi
bag" coat in 1975; and Perry Ellis, who launched his Portfolio line that same year. Working women ha
a new champion in Liz Claiborne, who debuted her first collection in 1976 and soon positioned th
brand as affordable clothing for career women.

The end of the decade saw the launch of a new class of designers, including Betsey Johnso
Gianni Versace, and Claude Montana. In 1978, Italian label Diesel opened its doors, and the gran
daughter of Mario Prada's venerable but declining leather-goods company took control of Frate
Prada. Miuccia Prada had her sights on the global market, and she would start with simple, stylis
nylon backpacks that suited the needs of modern women.

◄◄ Riviera Eyewear, 1974 ► Montgomery Ward Department Store, 19

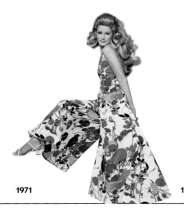

1971

Women don halterneck catsuits—often in
bright, exotic prints

Frauen tragen schulterfreie Catsuits—oft mit
grellen, exotischen Mustern

Les femmes adoptent le catsuit à dos nu, sou-
vent orné d'imprimés exotiques

1971

James Brown records "Hot Pants";
fashion follows

James Brown nimmt den Song „Hot Pants" auf;
die Mode folgt ihm

James Brown enregistre son ode aux mini-shorts,
« Hot Pants »; la mode suit

1972

Ralph Lauren debuts mesh shirt with polo-po
logo in 24 colors

Ralph Lauren präsentiert erstmals ein Mesh
Shirt mit Polo-Pony-Logo in 24 Farben

Ralph Lauren lance ses polos avec logo de
poney en 24 couleurs

Velour: some like it hot.

And soft. And cool. That's how you'll feel about Wards HotPants jumpsuit. Touchable velour of Celanese Arnel® triacetate-and-nylon. Braided down the front.

In plum, berry or copper. Pour yourself into one of the most feminine outfits around. But don't take our word for it. Ask a man.

Jr. Petites 3-11. $18.

Open a Wards "Charg-All" account. It makes shopping simpler in our stores and catalogs.

VOM HIPPIE-LOOK ZU HALSTON

Der Designer, den man am ehesten mit den Discojahren assoziiert – wie auch mit deren kulturellem Epizentrum, dem New Yorker Studio 54 – war Halston ... Er propagierte als erster einen klaren, perfekt geschneiderten Look, der sich geradezu dramatisch vom damals aktuellen Bohème-Chic unterschied.

IE PROTESTKULTUR WURDE ANFANG DER 1970ER ZUM MAINSTREAM, ALS AUCH DIE REITE MASSE DIE RADIKALEN TRENDS DER SECHZIGER – Miniröcke, Schlaghosen und leuchnd bunte grafische Muster – übernahm. Der sorgsam erzeugte „natürliche" Look dominierte die Verbung. Der Geschlechterkampf fand auch in der Werbebranche statt, wo Produkte mit weiblicher ielgruppe mit emanzipatorischer Message versehen wurden, während solche für Männer durch inen lockeren Umgang mit dem Thema Sex um Aufmerksamkeit buhlten.

1971 nahm James Brown „Hot Pants" auf, seine Hymne an die Ultra-Shorts. Im selben Jahr eröffnete ivienne Westwood in London gemeinsam mit ihrem Freund, dem Musik-Promoter Malcolm McLaen, einen Laden namens Let It Rock. Später benannten die beiden ihn in Sex um, und 1976 begann Vestwood, McLarens Punkband Sex Pistols auszustatten. Der Surfbretthersteller Ocean Pacific kam nit seiner kalifornisch geprägten Funktionskleidung 1972 auf den Markt; im selben Jahr trat auch las Sportschuh-Unternehmen Nike auf den Plan. Burt Reynolds Asphalt-Cowboy-Film *Smokey and the andit* übertraf alle Erwartungen an die Kinokassen und hielt das Interesse an modernen Westernlamotten wach. Diane Keaton fungierte dagegen als Pionierin eines androgynen Looks – mit Kravatte, Weste und Anzughose – und zwar als Titelfigur in Woody Allens *Annie Hall* von 1977.

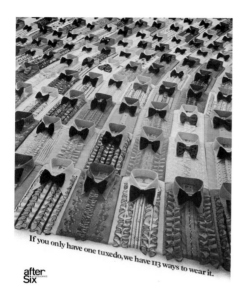

If you only have one tuxedo, we have 113 ways to wear it.

after Six

◄◄ Puritan Sportswear, 1971 After Six Accessories, 1972

Das ikonografischste Outfit der 1970 war allerdings der weiße Hosenanzug. Unvergessen bleibt John Travolta darin in *Saturde Night Fever* 1977. Seine Anfänge reichen jedoc zurück ins Jahr 1971 und zur Hochzeit von Roling-Stones-Frontman Mick Jagger mit Bianc Perez Morena De Macias in Saint-Tropez. Bra und Bräutigam trugen beide weiße Ensemb les von Yves Saint Laurent – er einen dreitei ligen Anzug, sie ein Kostüm mit langem Roc den sie jedoch bald gegen eine Hose tauscht Denn der weiße Hosenanzug avancierte zu B anca Jaggers Markenzeichen.

Der Designer, den man am ehesten m den Discojahren assoziiert – wie auch mit de ren kulturellem Epizentrum, dem New Yo ker Studio 54 – war Halston. Geboren als Ro Halston Frowick begann er seine Karriere i den 1950ern als Hutmacher. So trug etwa Jac queline Kennedy bei der Amtseinführung ih res Mannes eine Pillbox von Halston. Ab de Sechzigern verlegte sich Frowick auf Damer mode und startete 1968 sein eigenes Label. E

propagierte als erster einen klaren, perfekt geschneiderten Look, der sich geradezu dramatisch vom damals aktuellen Bohème-Chic unterschied. Der spätere Versuch, sein Label mas

1975

Vivienne Westwood and Malcolm McLaren dress Sex Pistols; dawn of punk era

Vivienne Westwood u. Malcolm McLaren statten die Sex Pistols aus; Ausbruch der Punk-Ära

Vivienne Westwood et Malcolm McLaren habillent les Sex Pistols aux tout débuts du punk

1975

Both hippies and disco divas don wide bellbottoms

Markenzeichen in der Hippie- und der Disco-Szene erreichen Schlaghosen neue Weiten

Emblème des cultures hippie et disco, les pantalons à pattes d'éléphant s'élargissent

1977

Roy Halston Frowick defines disco era as designer for Studio 54 crowd

Roy Halston Frowick prägt als Designer für da Studio-54-Publikum die Disco-Ära

Le tailleur Roy Halston Frowick incarne l'ère du disco auprès des habitués du Studio 54

ntauglich zu machen, wurde ihm jedoch zum
erhängnis. Nachdem er 1982 den Zuschlag für
ne preiswerte Linie im Auftrag der Kette J.C.
enney erhalten hatte, nahm das Nobelkauf-
aus Bergdorf Goodman seine Kollektion aus
em Verkauf.

Zu den übrigen Designpionieren der De-
ade gehörte Norma Kamali, die 1975 ihren
Schlafsack"-Mantel präsentierte, wie auch
erry Ellis, der im selben Jahr seine Portfo-
o-Linie herausbrachte. Berufstätige Frauen
nden in Liz Claiborne eine neue Favoritin,
ie ihre erste Kollektion 1976 vorstellte und
ire Marke bald als bezahlbares Label für
arrierefrauen positionierte.

Am Ende des Jahrzehnts erlebte man den
uftritt einer neuen Klasse von Designern wie
etsey Johnson, Gianni Versace und Claude
lontana. 1978 öffnete die italienische Marke
iesel ihre Läden, und die Enkelin von Mario
rada übernahm die Verantwortung für die eh-
enwerte, aber im Niedergang begriffene Le-
erwarenfabrik Fratelli Prada. Miuccia Prada

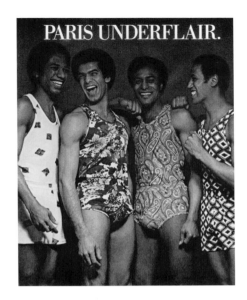

Paris Underflair Underwear, 1973

atte den Weltmarkt im Blick und startete mit schlichten, eleganten Nylonrucksäcken, die den
edürfnissen moderner Frauen entsprachen.

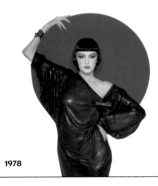

77 **1977** **1978**

iane Keaton's menswear-influenced
ardrobe in *Annie Hall* spawns imitators

iane Keatons maskuline Garderobe in *Annie
all* findet Nachahmerinnen

a garde-robe masculine de Diane Keaton
ans *Annie Hall* inspire de nombreuses femmes

Bob Rush founds Le Tigre as American answer
to French polo shirt

Bob Rush gründet Le Tigre als amerikanische
Antwort auf das französische Poloshirt

Bob Rush commercialise Le Tigre, réponse de
l'Amérique au polo français

Gianni Versace launches in Milan

Gianni Versace gibt in Mailand sein Debüt

Gianni Versace fait ses débuts à Milan

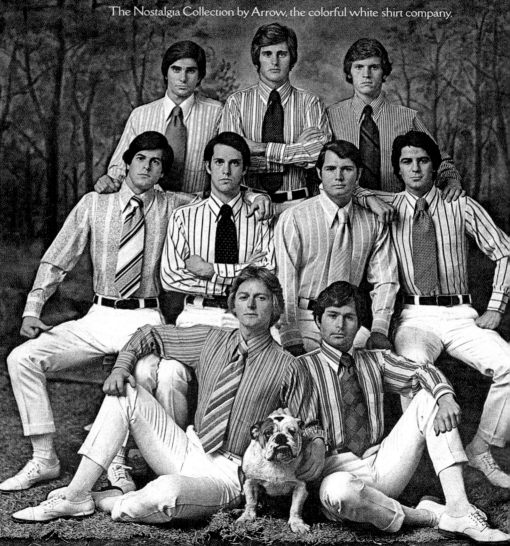

The advertisement text in the upper portion reads:

There's a shirt you can wear today that men wore sixty years ago. It won't make you look old. Or corny. Or out of style.

To the contrary, you'll look quite dashing in it. Just like the man who made it famous. The handsome young Arrow Collar Man.

He was the model for this shirt back in 1905. And he captured the heart of America. All the men wanted to look like him. All the young ladies just pla[...] him. Such was the magic of his boldly striped [...]

And that magic is alive today. For we've recr[...] shirts the Arrow Collar Man wore to glory. In polyester and cotton. And Sanforized-Plus-2. colorful now as they were sixty years ago.

But that's no surprise. Once you're a classic, you're always a classic.

-Arr[...]
A division of Clue[...]

The Nostalgia Collection by Arrow, the colorful white shirt company.

DES HIPPIES À HALSTON

Halston est le couturier le plus typique des années disco et de leur épicentre culturel, le Studio 54 à New York ... Il invente des tailleurs aux lignes épurées qui tranchent nettement avec les tenues bohème de l'époque.

AU DÉBUT DES ANNÉES 70, LA CONTRE-CULTURE SE DÉMOCRATISE QUAND LA RUE ADOPTE LES TENUES RADICALES DE LA DÉCENNIE PRÉCÉDENTE: MINIJUPES, PANTALONS À PATTES D'ÉLÉPHANT ET IMPRIMÉS GRAPHIQUES AUX COULEURS VIVES. Ce look « nature » pourtant soigneusement étudié est omniprésent dans la publicité. Les combats sociaux transparaissent dans la publicité qui vend les produits destinés aux femmes avec un message d'émancipation, tandis que ceux qui s'adressent aux hommes tirent parti de références à la libération sexuelle pour attirer leur attention.

En 1971, James Brown enregistre « Hot Pants », son ode aux mini-shorts. La même année, Vivienne Westwood ouvre à Londres une boutique appelée Let It Rock avec son petit ami, le producteur de musique Malcolm McLaren. Ils rebaptisent ensuite leur boutique Sex et, en 1976, Vivienne Westwood commence à habiller le groupe punk de McLaren, les Sex Pistols. Le fabricant de planches de surf Ocean Pacific lance sa ligne de vêtements d'inspiration californienne en 1972, et la même année assiste à la création de la nouvelle entreprise de chaussures de sport Nike. *Cours après moi Shérif,* le film de cow-boy urbain avec Burt Reynolds, explose au box-office et contribue à susciter de l'intérêt pour les tenues western modernes. Diane Keaton arbore un nouveau look androgyne – avec cravates, gilets et pantalons d'homme – dans le rôle-titre du film *Annie Hall* de Woody Allen en 1977.

Le look le plus emblématique des années 70 reste le costume blanc, mémorable de John Tra
volta dans le film *Saturday Night Fever* en 1977. Ses racines remontent pourtant à 1971 et au mariag
tropézien de Mick Jagger, leader des Rolling Stones, avec Bianca Perez Morena De Macias. Les marié
étaient tous deux habillés en blanc par Yves Saint Laurent : lui dans un costume trois pièces, elle dan
une jupe longue qu'elle abandonnera rapidement au profit d'un pantalon. Le tailleur-pantalon blar
devient l'image de marque de Bianca Jagger.

Halston est le couturier le plus typique des années disco et de leur épicentre culturel, le Studi
54 à New York. Né Roy Halston Frowick, il avait débuté sa carrière en tant que chapelier dans le
années 50. Lors de l'investiture de son mari, Jacqueline Kennedy portait l'un des petits chapeau
sans bord de Halston. Dans les années 60, Frowick s'était lancé dans la mode pour femme, créar
sa propre griffe en 1968. Il invente des tailleurs aux lignes épurées qui tranchent nettement ave
les tenues bohème de l'époque. Sa dernière tentative pour commercialiser sa collection sur le ma
ché de masse cause toutefois sa perte. Après avoir signé un contrat pour produire une ligne moin
chère avec le grand magasin J. C. Penney en 1982, le détaillant haut de gamme Bergdorf Goodma
renonce à sa collection.

Parmi les autres couturiers innovants de la décennie, Norma Kamali lance son manteau « sa
de couchage » en 1975 et Perry Ellis présent, la même année, sa ligne Portfolio. Les femmes qu
travaillent trouvent un nouveau soutien en la personne de Liz Claiborne, qui commercialise s
première collection en 1976 et positionne rapidement sa marque comme celle des vêtements abo
dables pour femmes actives.

La fin de la décennie voit l'arrivée d'une nouvelle génération de créateurs de mode, dont Be
sey Johnson, Gianni Versace et Claude Montana. La marque italienne Diesel est fondée en 197
et la petite-fille de Mario Prada, propriétaire d'une entreprise de maroquinerie respectable ma
sur le déclin, reprend la direction de Fratelli Prada. Miuccia Prada vise le marché mondial et con
mence par proposer des sacs à dos en nylon simples et élégants qui répondent aux besoins d
femmes modernes.

◄◄ Arrow Shirts, 1971　　► YSL Jeans, 19

BETSEY
JOHNSON.

1978	1978	1978

Velcro introduced

Der Klettverschluss Velcro kommt auf den
Markt

Commercialisation du Velcro

Betsey Johnson launches and opens first retail
store in Soho

Betsey Johnson promotet und eröffnet ihren
ersten Laden in Soho

Betsey Johnson ouvre sa première boutique
à Soho

Continental briefs become popular for men

Slips von Continental sind bei Männern gefra

Le slip Continental devient à la mode chez les
hommes

The big difference between us and them is the pocket. And the price.

The jeans with the fancy
stitching on the back
pocket are the world's
best-selling jeans.
They cost about $15.00.
The jeans on the right are
JCPenney Plain Pockets.
They cost $10.00.
Which would you rather
have? A half-cent's
worth of stitching on
your pocket, or $5.00
in your pocket.

Plain Pocket Jeans
only at
JCPenney

JC Penney, 1977 Adam Briefs, 1976

How to get a second glance.
Wear Career Club Shirts.

New exclusive dobby pattern from our BELGRAVE SQUARE collection. Long point collar with just the right angle of spread. Permanent press blend of 65% Fortrel® polyester, 35% cotton. Career Club priced at $8.50.

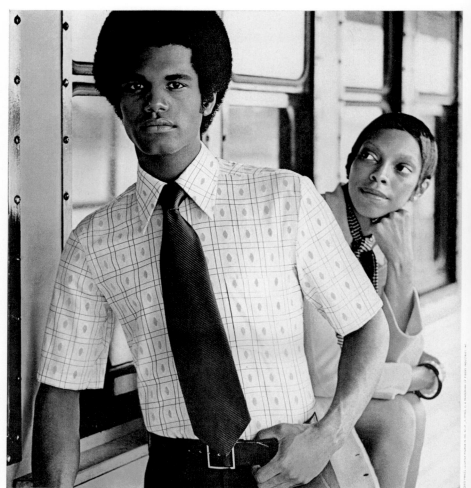

Career Club Shirt Co., Inc., 350 Fifth Avenue, New York 10001

Career Club, 197

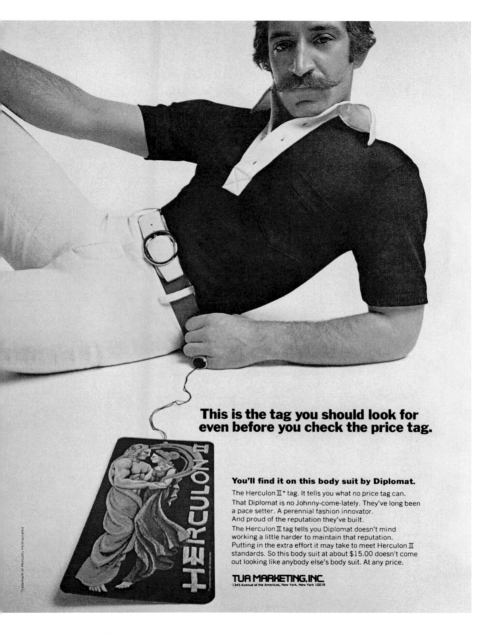

This is the tag you should look for even before you check the price tag.

You'll find it on this body suit by Diplomat.

The Herculon II* tag. It tells you what no price tag can.

That Diplomat is no Johnny-come-lately. They've long been a pace setter. A perennial fashion innovator. And proud of the reputation they've built.

The Herculon II tag tells you Diplomat doesn't mind working a little harder to maintain that reputation. Putting in the extra effort it may take to meet Herculon II standards. So this body suit at about $15.00 doesn't come out looking like anybody else's body suit. At any price.

TUA MARKETING, INC.
1345 Avenue of the Americas, New York, New York 10019

*Trademark of Hercules Incorporated

rculon II/Diplomat Menswear, 1973

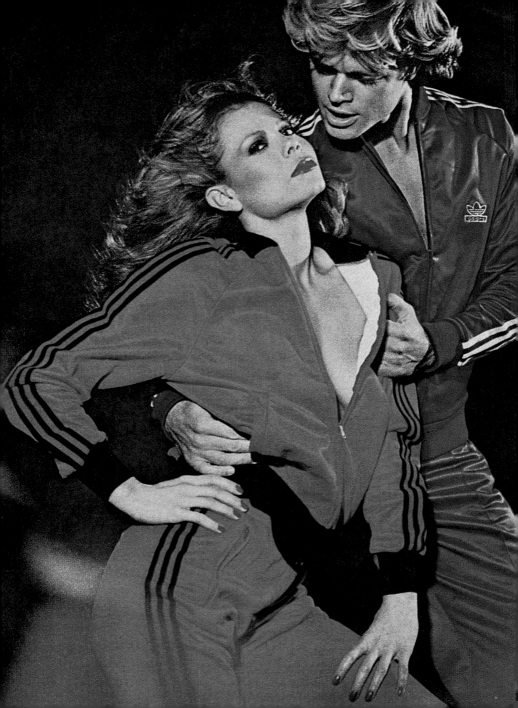

Introducing Oleg Cassini's tennis whites. In smashing colors.

Oleg Cassini, avid tennis player. Oleg Cassini, top fashion designer. Who else could have created a smashing collection like the Oleg Cassini Tennis Club?

The *designer* in Cassini created the smashing colors and a sporting harmony in men's and women's outfits never before seen on the court.

But the *tennis player* in Cassini

created the *fit*. It's pure tennis and ready for action. Every warm-up suit, sweater, jacket, dress, skirt, shirt and pair of shorts designed to *give* luxuriously. And cut to flatter too, like a Cassini original.

It doesn't look like ordinary

tenniswear because it isn't. It's the Oleg Cassini Tennis Club.

And you're invited to join this season at a fine store near you.

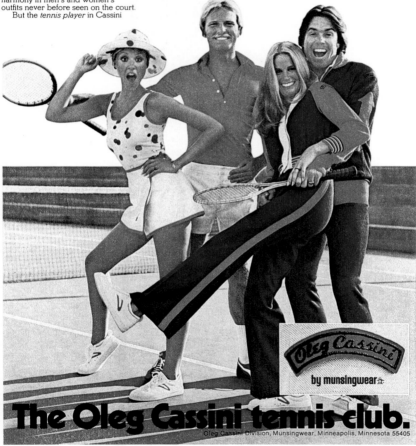

Oleg Cassini by munsingwear

The Oleg Cassini tennis club.

Oleg Cassini Division, Munsingwear, Minneapolis, Minnesota 55405

◄ Adidas Warm Ups/Keyrolan Fabrics, 1977 Oleg Cassini, 1974

A direct hit from the **Christian Dior** sunglass collection.

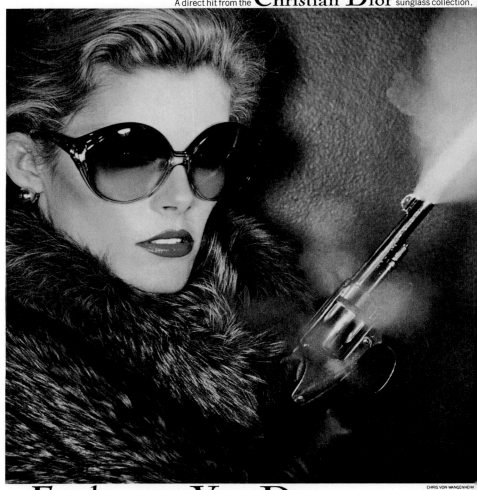

CHRIS VON WANGENHEIM

Explosive is Your Dior.

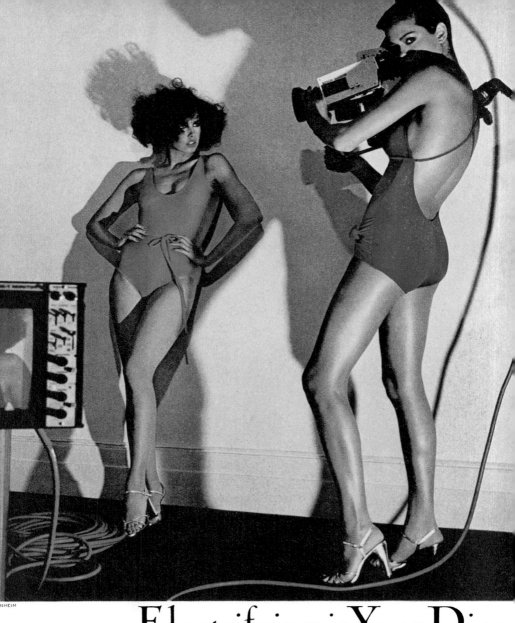

NHEIM

Electrifying is Your Dior.

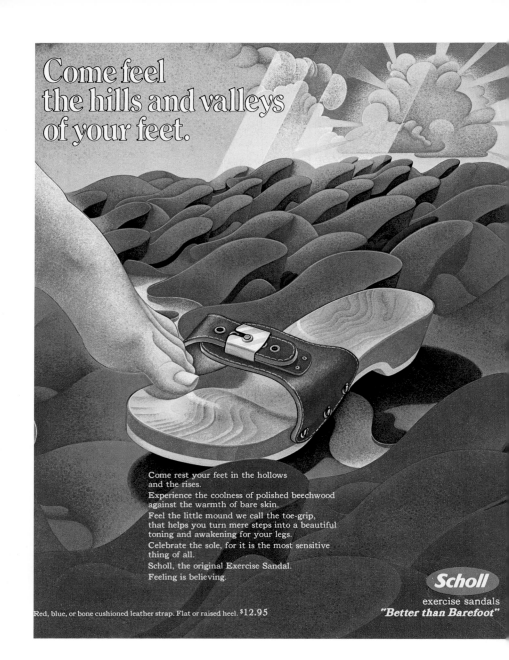

Come feel
the hills and valleys
of your feet.

Come rest your feet in the hollows
and the rises.

Experience the coolness of polished beechwood
against the warmth of bare skin.

Feel the little mound we call the toe-grip,
that helps you turn mere steps into a beautiful
toning and awakening for your legs.

Celebrate the sole, for it is the most sensitive
thing of all.

Scholl, the original Exercise Sandal.

Feeling is believing.

Scholl

exercise sandals
"Better than Barefoot"

Red, blue, or bone cushioned leather strap. Flat or raised heel. $12.95

Scholl Excercise Sandal, 19.

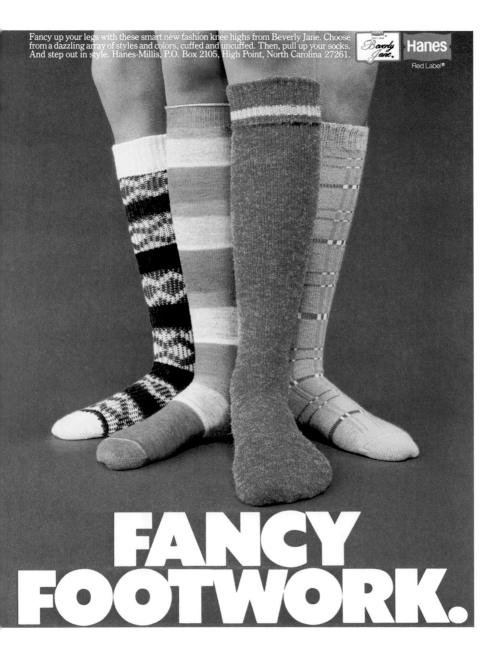

FANCY FOOTWORK.

Beverly Jane/Hanes Socks, 1977

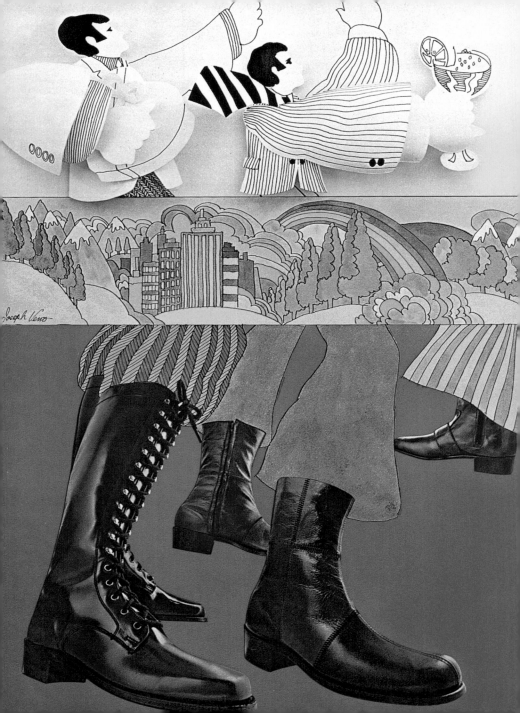

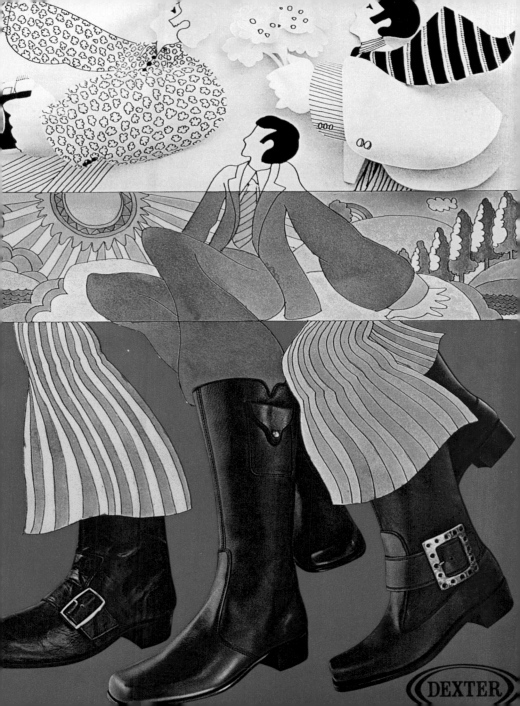

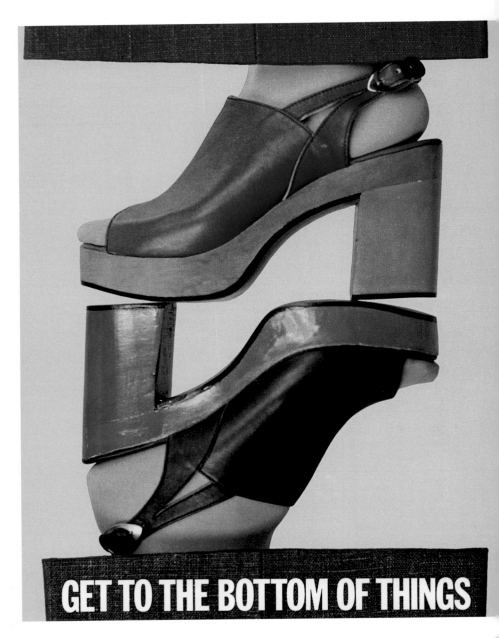

GET TO THE BOTTOM OF THINGS

◄◄ Dexter Boots, 1971 Tempos Shoes, 1973 ► Sears, Roebuck and Co. Department Store, 197

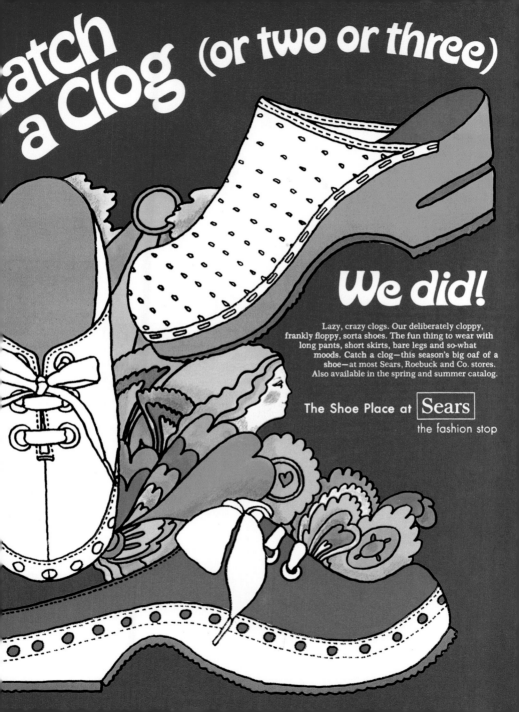

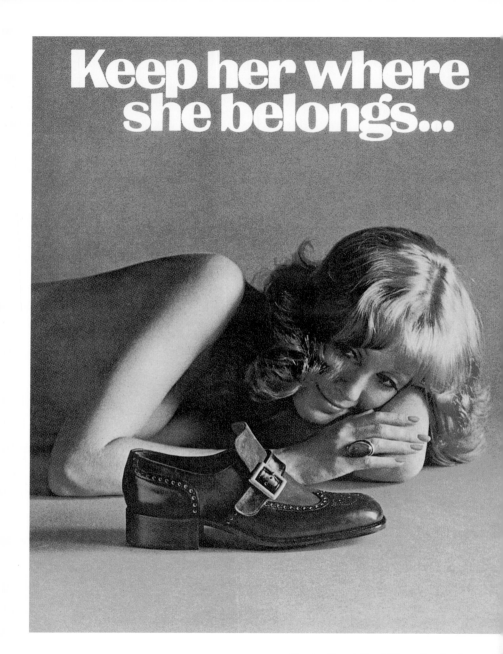

Keep her where she belongs...

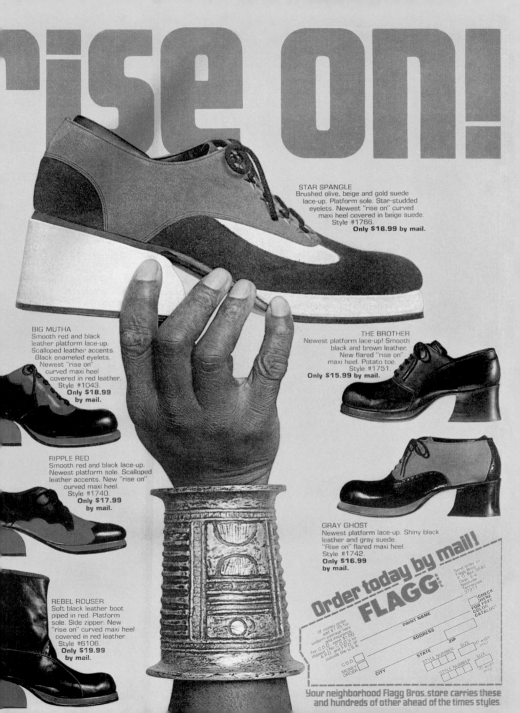

You'll get a boot out of this.
$5.88 a pair.

Where can you possibly find hook and eyelet lace-up boots, with side zippers, stretch shiny vinyl uppers, 1½ inch man-made heel, man-made soles, 16 inches high for $5.88 a pair?

At Wards. If you're ready for a boot, we're ready for you. In brown, black and white.

Open a Wards "Charg-All" account. It makes shopping simpler in our stores and catalogs.

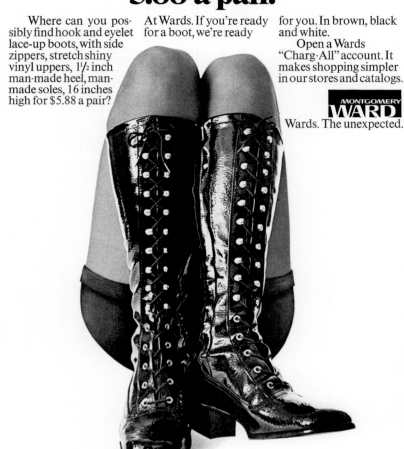

MONTGOMERY WARD

Wards. The unexpected.

Montgomery Ward Department Store, 19▮

444 1970–1979

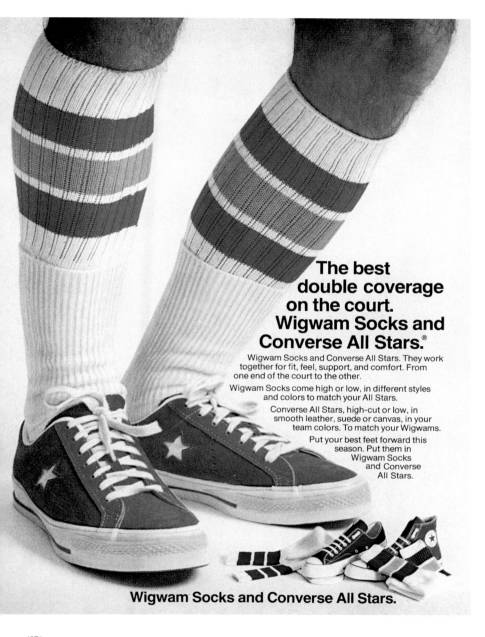

**The best
double coverage
on the court.
Wigwam Socks and
Converse All Stars.®**

Wigwam Socks and Converse All Stars. They work together for fit, feel, support, and comfort. From one end of the court to the other.

Wigwam Socks come high or low, in different styles and colors to match your All Stars.

Converse All Stars, high-cut or low, in smooth leather, suede or canvas, in your team colors. To match your Wigwams.

Put your best feet forward this season. Put them in Wigwam Socks and Converse All Stars.

Wigwam Socks and Converse All Stars.

nverse, 1974

What becomes a Legend most

Blackglama

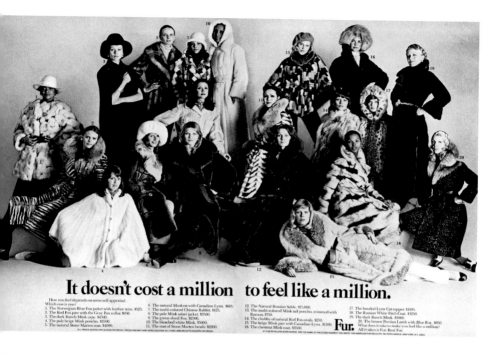

It doesn't cost a million to feel like a million.

How you feel depends on some self-appraisal.
Which one is you?
1. The Norwegian Blue Fox jacket with leather trim. $325.
2. The Red Fox paw with the Gray Fox collar. $950.
3. The dark Ranch Mink cape. $4500.
4. The pale beige Mink poncho. $3500.
5. The natural Stone Marten cape. $4400.

6. The natural Muskrat with Canadian Lynx. $665.
7. The multi-colored Chinese Rabbit. $125.
8. The pale Mink safari jacket. $3500.
9. The green-dyed Fox. $500.
10. The bleached white Mink. $5000.
11. The coat of Stone Marten heads. $2200.

12. The Natural Russian Sable. $25,000.
13. The multi-colored Mink tail poncho, trimmed with Raccoon. $350.
14. The chubby of natural Red Fox ovals. $250.
15. The beige Mink paw with Canadian Lynx. $1100.
16. The chestnut Mink coat. $3500.

17. The hooded Lynx Cat topper. $1095.
18. The Russian White Fitch Coat. $7250.
19. The dark Ranch Mink. $5000.
20. The brown Persian Lamb with Blue Fox. $950.

Fur. What does it take to make you feel like a million?
All it takes is Fur. Real Fur.

ALL PRICES QUOTED ARE SUGGESTED RETAIL. PRICES AND MAY VARY WITH LOCATION. ALL FURS LABELED AS TO COUNTRY OF ORIGIN.

AT FINE RETAILERS EVERYWHERE. FOR THE NAME OF THE STORE NEAREST YOU WRITE: THE AMERICAN FUR INDUSTRY, 350 FIFTH AVENUE, NEW YORK, N.Y. 10001

Blackglama Furs, 1973

Pearl Bailey was one of several famous faces—including Judy Garland and Ray Charles—featured in the long-standing Blackglama Furs "Legends" campaign, which debuted in 1968.

Pearl Bailey war eines von mehreren berühmten Gesichtern – darunter auch Judy Garland und Ray Charles – in der langlebigen Kampagne „Legends" für Blackglama-Pelze, die 1968 startete.

Outre Judy Garland et Ray Charles, Pearl Bailey compta parmi les nombreux visages célèbres qui prêtèrent leur image à la longue campagne « Legends » des fourrures Blackglama, lancée en 1968.

American Fur Industries, 1972

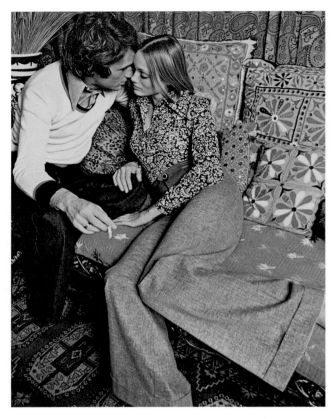

Happy Legs Sportswear, 1973

Happy Legs used the risqué slogan, "What to
wear on Sunday when you won't be home until
Monday," throughout the 1970s, exploiting the
relaxed sexual mores of the era.

Happy Legs benutzte den gewagten Slogan
„Was Sie am Sonntag tragen sollten, wenn Sie
nicht vor Montag nach Hause kommen" die
1970er Jahre hindurch und spielte damit auf
die gelockerten sexuellen Gewohnheiten
jener Ära an.

Happy Legs utilisa l'audacieux slogan « Que
porter le dimanche quand on ne rentrera
pas avant lundi » tout au long des années 70,
reflétant le libéralisme sexuel de l'époque.

▶ Thom McAn Boots, 1971

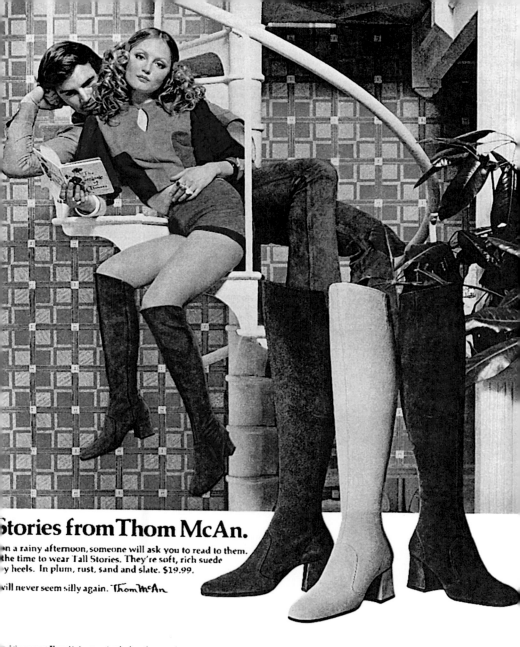

Stories from Thom McAn.

n a rainy afternoon, someone will ask you to read to them.
the time to wear Tall Stories. They're soft, rich suede
y heels. In plum, rust, sand and slate. $19.99.

will never seem silly again. *Thom McAn*

d the nearest Thom McAn store, just look on the opposite page

The velour sportshirt that stays soft without getting flabby.

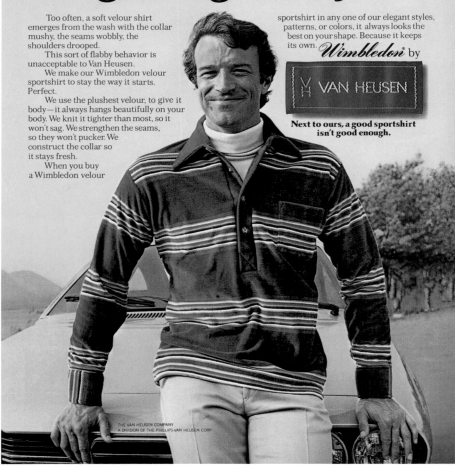

Too often, a soft velour shirt emerges from the wash with the collar mushy, the seams wobbly, the shoulders drooped.

This sort of flabby behavior is unacceptable to Van Heusen.

We make our Wimbledon velour sportshirt to stay the way it starts. Perfect.

We use the plushest velour, to give it body—it always hangs beautifully on your body. We knit it tighter than most, so it won't sag. We strengthen the seams, so they won't pucker. We construct the collar so it stays fresh.

When you buy a Wimbledon velour

sportshirt in any one of our elegant styles, patterns, or colors, it always looks the best on your shape. Because it keeps its own. *Wimbledon* by

VAN HEUSEN

Next to ours, a good sportshirt isn't good enough.

THE VAN HEUSEN COMPANY
A DIVISION OF THE PHILLIPS-VAN HEUSEN CORP.

Van Heusen Sportswear, 1977 ▶ Levi's, 1979

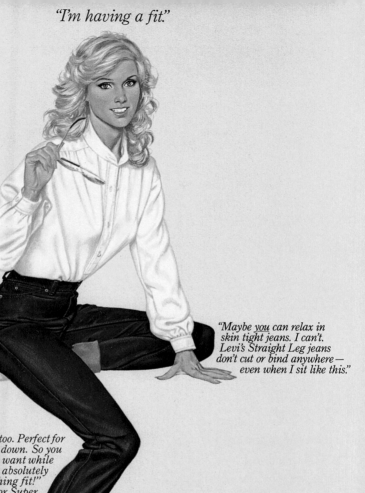

"I'm having a fit."

"These Straight Leg jeans from Levi's®Womenswear ___ my kind of fit. Not tight. Never uncomfortable. Just soft, smooth, and very flattering—almost like they were custom tailored!"

"Maybe you can relax in skin tight jeans. I can't. Levi's Straight Leg jeans don't cut or bind anywhere— even when I sit like this."

"The length is right, too. Perfect for rolling up or leaving down. So you can have the look you want while you're enjoying an absolutely smashing fit!" (Ask for Straight or Super Straight Leg Jeans, 26048-02 or 26068-02.)

Tanenbaum

LEVI'S
WOMENSWEAR

QUALITY NEVER GOES OUT OF STYLE.

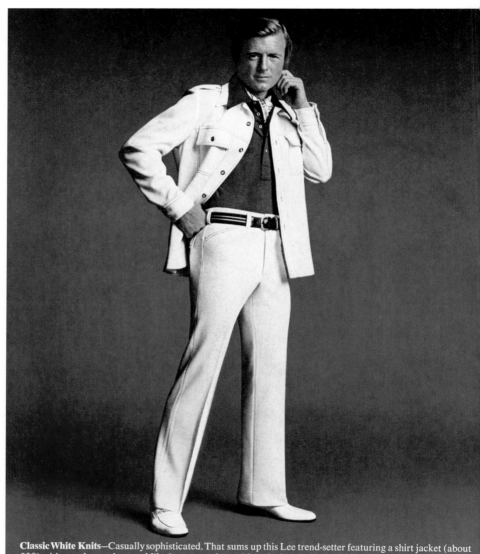

Classic White Knits—Casually sophisticated. That sums up this Lee trend-setter featuring a shirt jacket (about $30) with epaulets and enamel-like buttons and matching slacks (about $20). Both are defined twill double-knits of non-glitter 100% Dacron® polyester. The sports shirt (about $17) tops off another great "Tops & Bottoms" idea from The Lee Company, 640 Fifth Ave., N.Y., N.Y. 10019. **Lee**™ A company of V͡C corporation

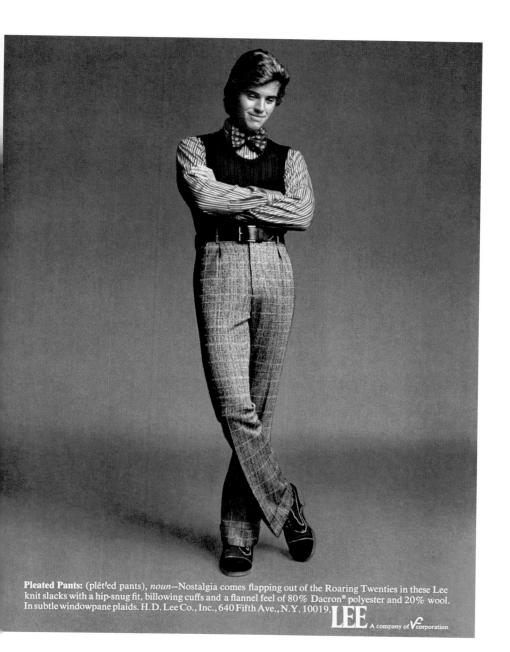

Pleated Pants: (plēt'ed pants), *noun*—Nostalgia comes flapping out of the Roaring Twenties in these Lee knit slacks with a hip-snug fit, billowing cuffs and a flannel feel of 80% Dacron® polyester and 20% wool. In subtle windowpane plaids. H. D. Lee Co., Inc., 640 Fifth Ave., N.Y. 10019. **LEE** A company of **V**Fcorporation

e Slacks, 1972

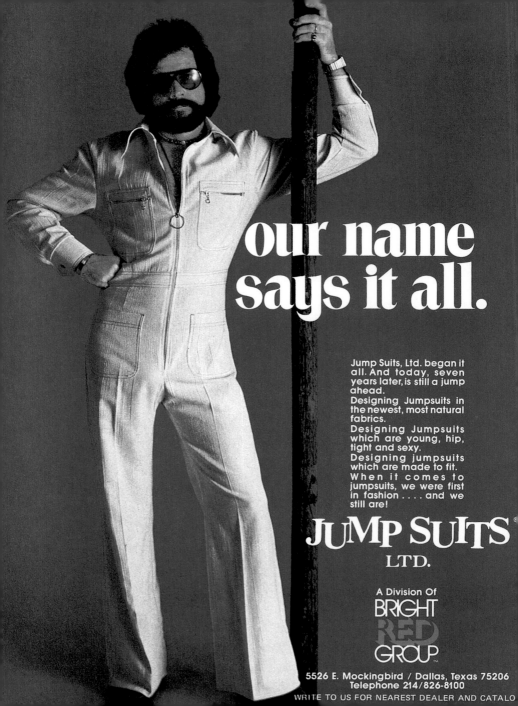

ımp Suits, Ltd., 1976

ne 1970s, jumpsuits made the jump from
kwear staple to men's fashion item. It was
ort-lived trend for men, but the style soon
de its way into women's fashion, where it
remained off and on ever since. The white
ure suit, on the other hand, was a mainstay of
era, reaching its pinnacle with *Saturday Night*
er star John Travolta. Even classic American
im brand Lee got into the trend with its own
sion in white double knit.

en 1970ern gelang dem Overall der
ung von der Arbeitskleidung zum Modear-
el für Herren. Es war zwar nur ein kurzlebi-
Trend, aber er schaffte es rasch auch in die
enmode, wo er seither immer mal wieder
agt ist. Als weißer Freizeitanzug erreichte
len Gipfel der Popularität mit John Travolta
Star in *Saturday Night Fever*. Selbst die klas-
he amerikanische Jeansmarke Lee sprang
einem eigenen Modell aus weißem Double
t auf den Zug auf.

ns les années 70, salopettes et combinai-
s, à l'origine vêtements d'ouvrier, firent
e incursion dans la mode masculine. Ce fut
e tendance éphémère chez les hommes,
is on la retrouva rapidement dans la mode
ur femme, où la combinaison n'a jamais
sé d'apparaître et de disparaître depuis.
opposé, le costume blanc marqua cette
oque, sa popularité culminant grâce à John
volta dans *Saturday Night Fever*. Même Lee,
rque de jean américain classique, surfa sur
te tendance en proposant sa propre version
maille blanche doublée.

ger Sewing Machine, 1970

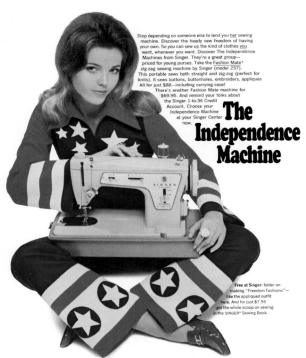

Stop depending on someone else to lend you her sewing
machine. Discover the heady new freedom of having
your own. So you can sew up the kind of clothes you
want, whenever you want. Discover The Independence
Machines from Singer. They're a great group—
priced for young purses. Take the Fashion Mate*
zig-zag sewing machine by Singer (model 237).
This portable sews both straight and zig-zag (perfect for
knits). It sews buttons, buttonholes, embroiders, appliques
All for just $88—including carrying case!
There's another Fashion Mate machine for
$69.95. And remind your folks about
the Singer 1-to-36 Credit
Account. Choose your
Independence Machine
at your Singer Center
now.

The Independence Machine

Free at Singer: folder on
making "Freedom Fashions"—
like the appliqued outfit
here. And for just $7.95
get the whole scoop on sewing
in the SINGER* Sewing Book.

What's new for tomorrow is at SINGER *today!**

* A Trademark of THE SINGER COMPANY

The tie for the shirt by Hathaway.

The sound of Jazz: Hathaway's Cabaret Plaid.

It's bold and beautiful! Like the vibrant tones from an Armstrong or Beiderbecke.
Syncopated checks over checks create real added dimension in this stunning
Cabaret Plaid, and the sheik, Rutland collar is a perfect set-up for a
contemporary bow tie. The shirt is a weave of Durable
Press polyester and cotton, priced at $16.00. For the store nearest you, write
C. F. Hathaway Company, Waterville, Maine 04901, a division of Warnaco, Inc.

Introducing Joe Namath Clothes

The name says it all.
Joe Namath Clothes.

Reflecting the sure,
confident style of a winner.
Tasteful. Understated.
Unerringly correct.

Yet for all their classic
elegance, they offer a very
special kind of casual
comfort and wearability.

For the man who would
indulge his own star
qualities, the introduction
of this heralded new
collection of Joe Namath
Suits and Sport Coats
is truly a signal event.

See them now at fine
stores everywhere.

Suits from $125.
Jackets from $80.

Joe Namath
CLOTHES
New York, N.Y.

Hathaway Shirts, 1973　　Joe Namath Clothes, 1977　　►► Jockey Underwear, 1976

TAKE AWA
THEIR
UNIFORMS
AND WHO
ARE THEY.

JOCKEY
BRAND ®

…arvey/Los Angeles Dodgers

Brad Park/Boston Bruins

Lou Brock/St. Louis Cardinals

…adfield/Pittsburgh Penguins

Fred Dryer/Los Angeles Rams

Craig Morton/New York Giants

…y Metcalf/St. Louis Cardinals

Ed Marinaro/Minnesota Vikings

Jim McMillian/Buffalo Braves

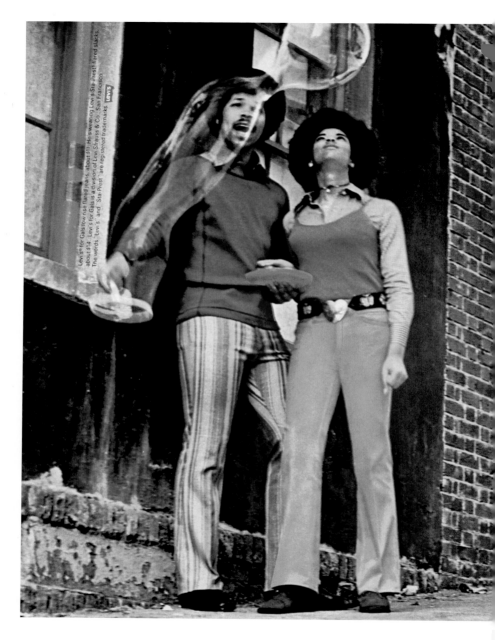

Levi's for Gals low-rise flared jeans, about $11. He's wearing Levi's Sta-Prest® flared slacks, about $14. Levi's for Gals is a division of Levi Strauss & Co., San Francisco. The words "Levi's" and "Sta-Prest" are registered trademarks. Levi's

Levi's Sportswear, 19

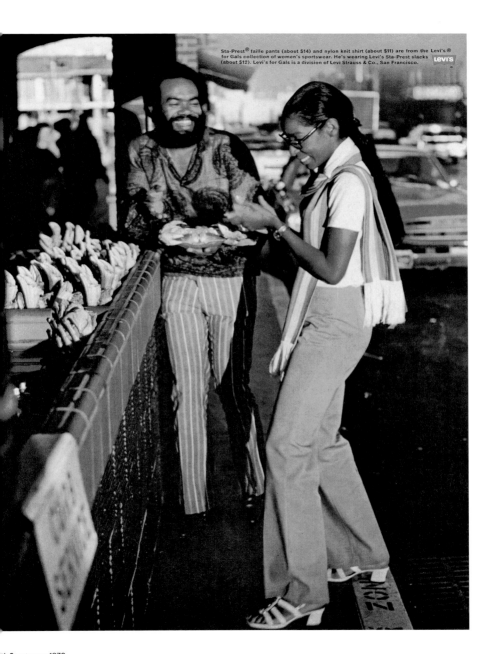

Sta-Prest® faille pants (about $14) and nylon knit shirt (about $11) are from the Levi's® for Gals collection of women's sportswear. He's wearing Levi's Sta-Prest slacks (about $12). Levi's for Gals is a division of Levi Strauss & Co., San Francisco.

i's Sportswear, 1970

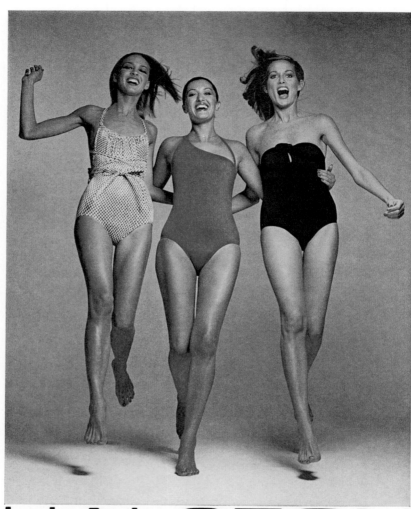

HALSTON
LIMITED EDITION BEACHWEAR
A DIVISION OF JONATHAN LOGAN, 1407 BROADWAY, NEW YORK 10018.

Halston Beachwear, 1971

COTTON

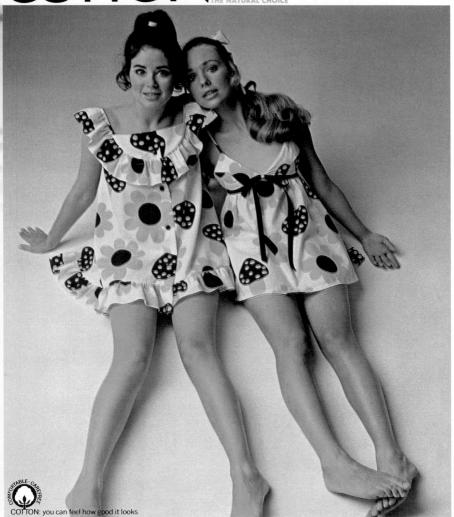

COMFORTABLE · CARE·FREE

COTTON: you can feel how good it looks

Tapping their way to stard

What every kid knows is that where
is where it was. Like twirly skirts. And ce
shirts. And ingenue dresses. And plaids
paisley and patchwork prints. All the gr
looks of the past that are the great looks
today.

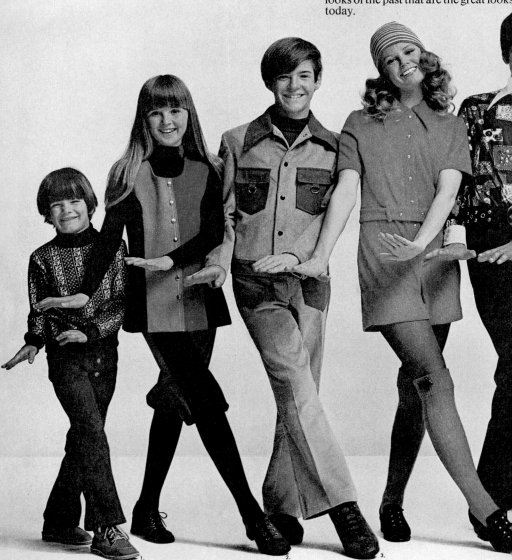

rds clothes for today's kids.

Wards has made a change. All those
ear-looking clothes are made in right
asy to care for fabrics. When we give
ds the clothes they want
you the clothes you
hem to have. Open a Wards **MONTGOMERY WARD** Wards. The unexpected.
"Charg-All" account. It makes
shopping simpler in our stores and catalog.

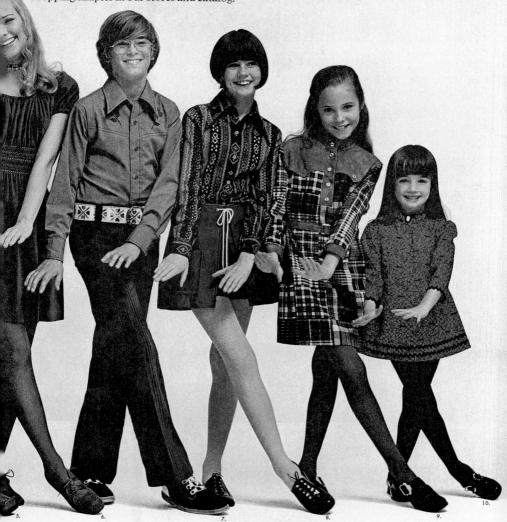

Look for Turtle Bax. You'll find easy-living clothes that say spring is in the air. Cool crop tops for all the freedom under the sun. denim with playful lace...and super skirts just for the fun of it all. Yet Turtle Bax are still priced like ordinary clothes.

Left, Petticoat Junction. Jeans about $13, top about $8. Mood Indigo. Skirt about $12, top about $8.
You'll find these and all the other exciting Turtle Bax looks at stores everywhere that sell fun fashions.

Turtle Bax
Priced like ordinary clothes.

turtle ba
A product of Washington Manufacturi
Nashville, Tennessee

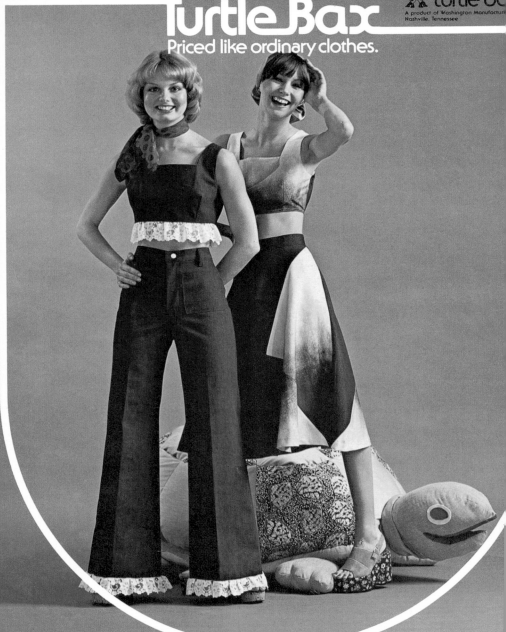

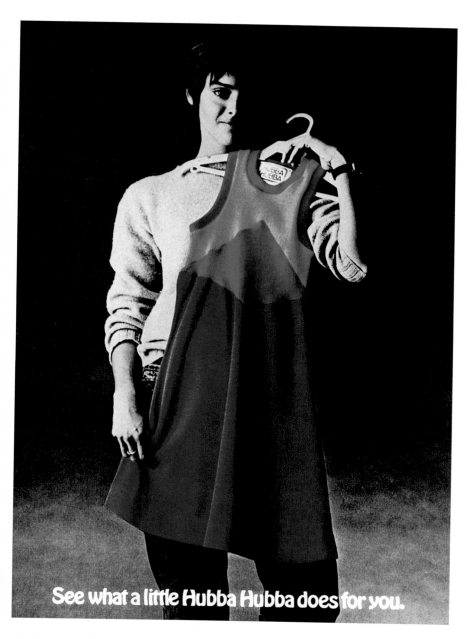

See what a little Hubba Hubba does for you.

◄ Turtle Bax Clothing, 1975 Hubba Hubba Apparel, 1972

THE GREAT DENIM SUIT

Denim's got the inside track this spring but there's only one Great Denim Suit. This one. It's denim with a difference: Dacron® polyester and Avril® rayon that bypass wrinkles. Great Denim styling with a hot line of Bandana Red stitching that telegraphs the fashion details. M. Wile tailors the one and only Great Denim Suit and you can catch it at great stores across the U.S.

For the name of the store nearest you, write: M. Wile & Company, 2020 Elmwood Avenue, Buffalo, New York 14240

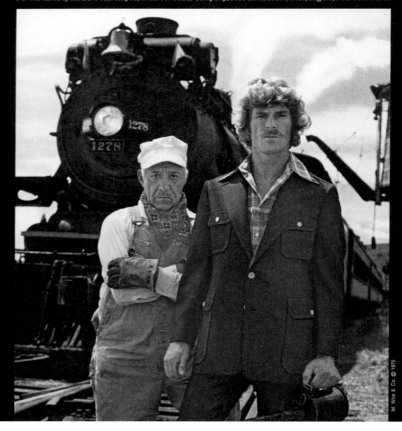

M. Wile and Co., ca. 1974 ▶ Wrangler Jeans & Sportswear, 197?

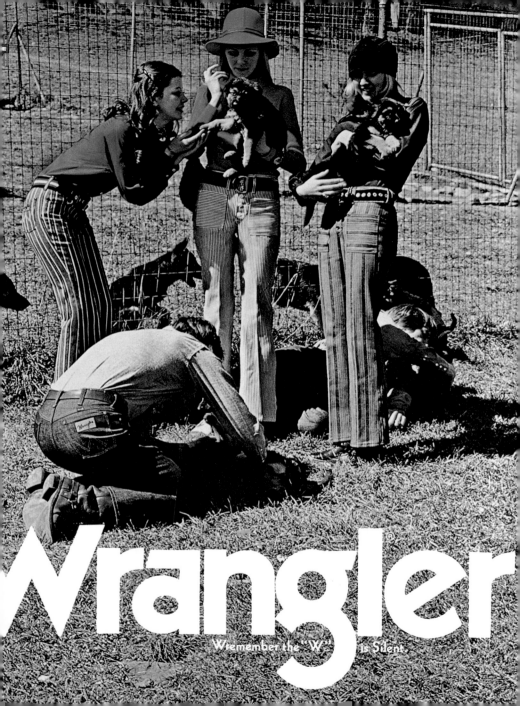

Wrangler

Wremember the "W" is Silent.

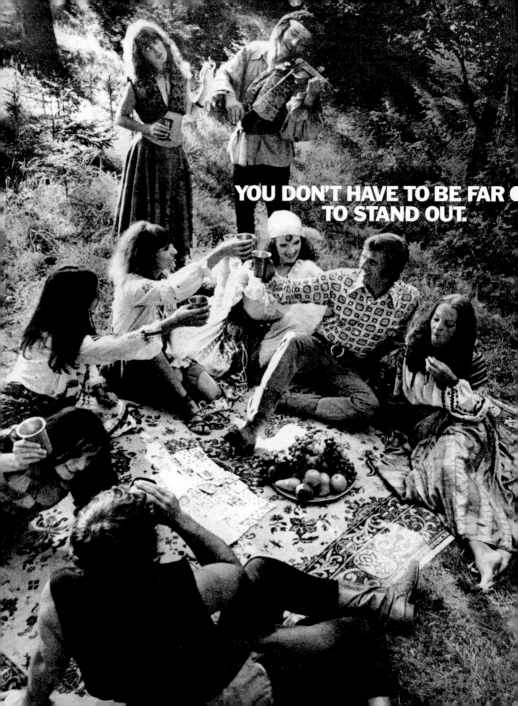

YOU DON'T HAVE TO BE FAR OUT
TO STAND OUT.

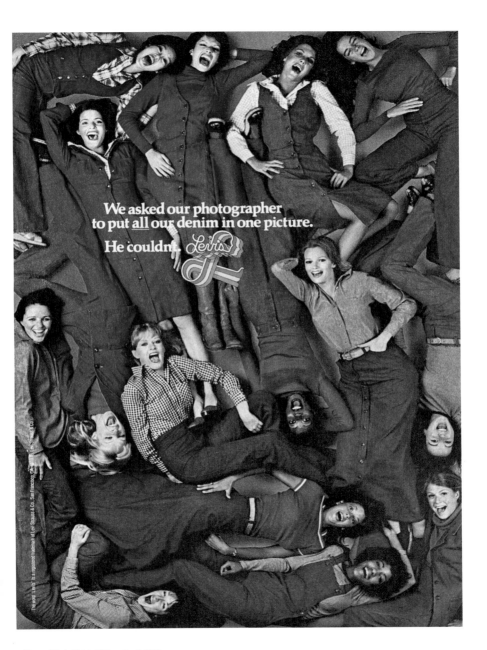

We asked our photographer
to put <u>all</u> our denim in one picture.

He couldn't. Levi's

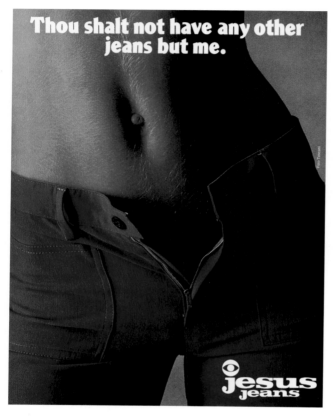

Thou shalt not have any other jeans but me.

jesus jeans

Jesus Jeans, 1976

▶ Sasson Jeans, 1979

Paul Guez, the man who went on to launch
Antik Denim, was behind Sasson Jeans, one of
the pioneers of designer denim. The company
"Oo la la!" campaign reached the height of its
popularity with a TV commercial that featured
members of the New York Rangers hockey
team, wearing the jeans in an ice rink,
tunelessly singing the jingle.

Paul Guez, der später Antik Denim starten
sollte, war auch der Drahtzieher bei Sasson
Jeans, einem der Pioniere im Bereich Design-
nerjeans. Die „Oo la la!"-Kampagne der Firma
erreichte den Gipfel ihrer Popularität mit
einem TV-Spot, der Mitglieder des Hockey-
teams der New York Rangers zeigt, die die
Jeans auf einem Eislaufplatz tragen, während
sie völlig schief den Jingle singen.

Pionnier du jean de créateur, Paul Guez créa
aussi Sasson Jeans avant de lancer Antik
Denim. La campagne « Oo la la! » atteignit des
sommets de popularité grâce à un spot TV
présentant des joueurs de l'équipe de hockey
des New York Rangers qui portaient les jeans
sur une patinoire et reprenaient la rengaine en
chantant faux.

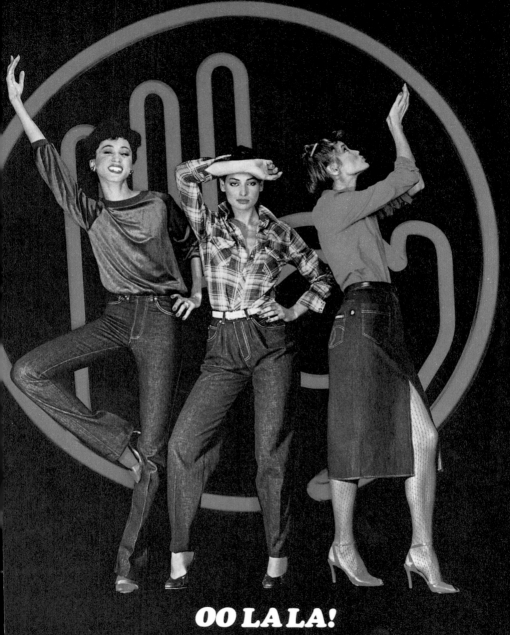

OO LA LA!

SASSON

jeans, inc.

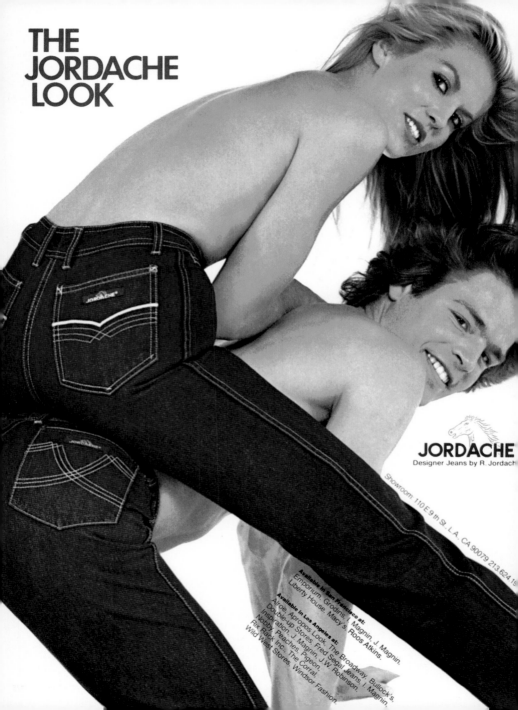

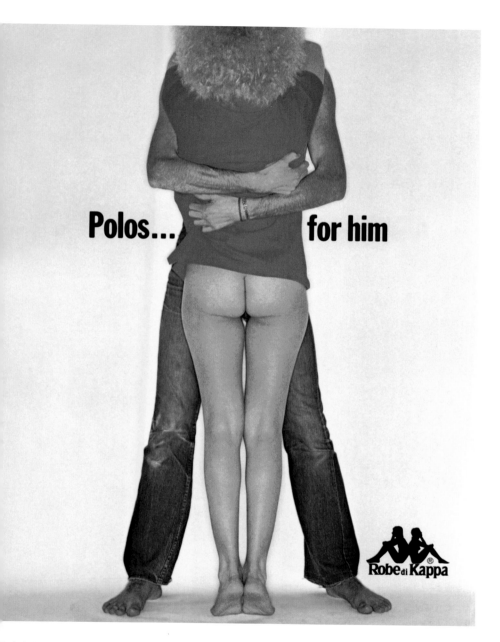

Polos.... for him

Jordache Jeans, 1979 Robe di Kappa Menswear, 1976

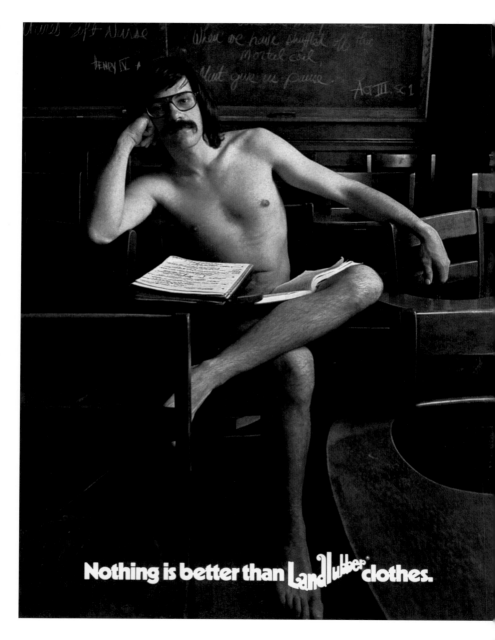

Nothing is better than Landlubber clothes.

Landlubber Menswear, 1971 ▸ Interwoven Socks, 197

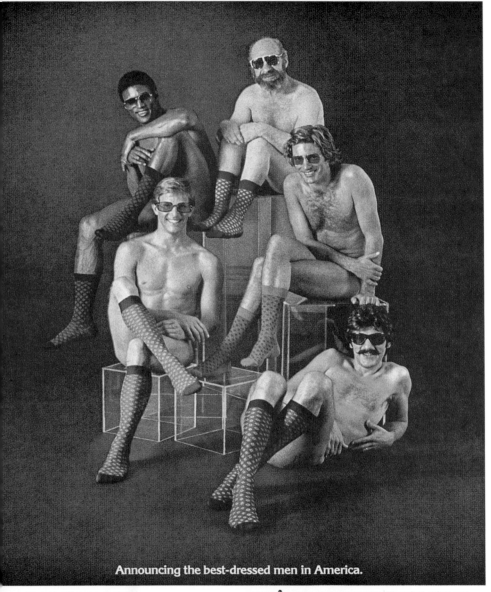

Announcing the best-dressed men in America.

You're looking at a revolution.

The most influential men in America are breaking out of their socks—out of their old, blah, boring, one-color, no-style socks.

At Interwoven/Esquire Socks, we saw it coming all the way. That's why we make the great fashion socks that are making it happen.

In lots of great colors and lengths. All in the first

Ban-Lon® pattern socks ever made. They feel softer and fit better than any sock you've ever worn.

That's why we dress the best-dressed men in America. Or anywhere.

ESQUIRE SOCKS®

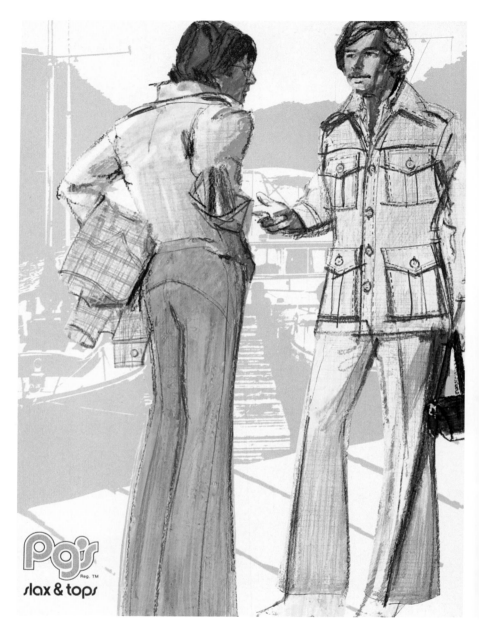

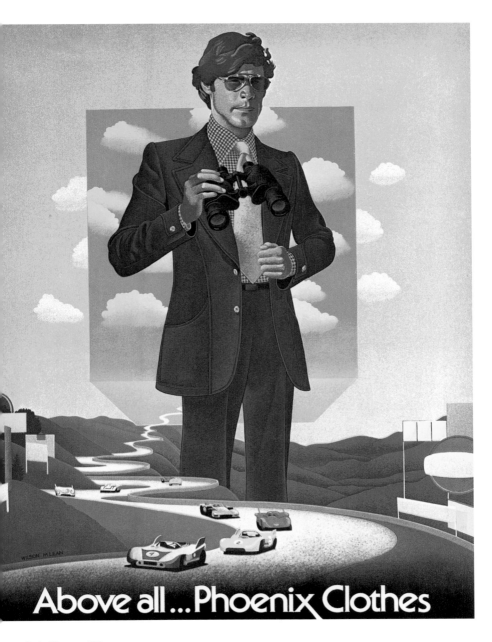

Above all ... Phoenix Clothes

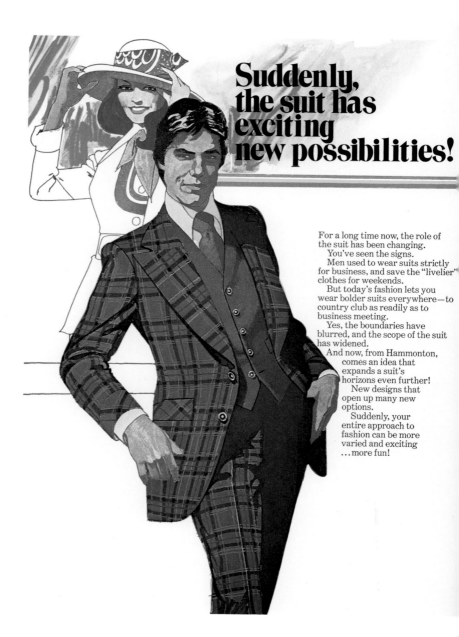

Suddenly, the suit has exciting new possibilities!

For a long time now, the role of the suit has been changing.

You've seen the signs.

Men used to wear suits strictly for business, and save the "livelier" clothes for weekends.

But today's fashion lets you wear bolder suits everywhere—to country club as readily as to business meeting.

Yes, the boundaries have blurred, and the scope of the suit has widened.

And now, from Hammonton, comes an idea that expands a suit's horizons even further!

New designs that open up many new options.

Suddenly, your entire approach to fashion can be more varied and exciting ...more fun!

Hammonton Suits, 197

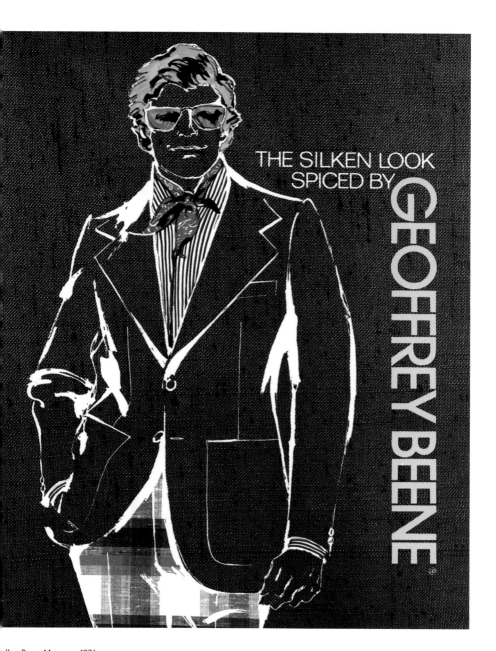

THE SILKEN LOOK
SPICED BY
GEOFFREY BEENE

Geoffrey Beene Menswear, 1974

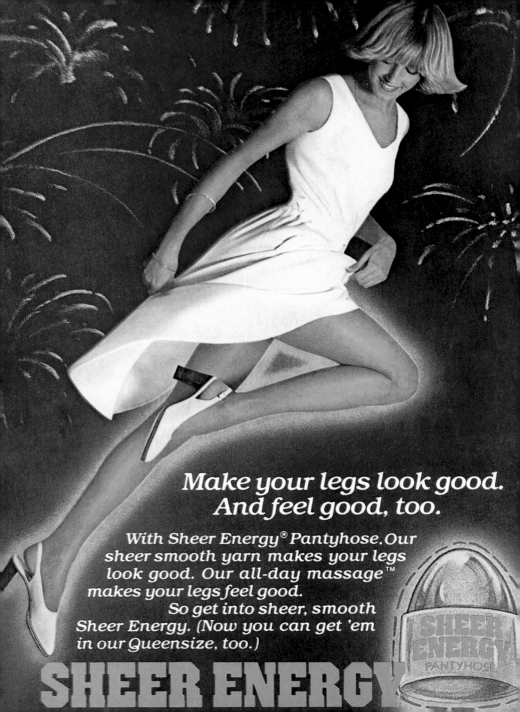

'eggs Sheer Energy Hosiery, 1977

hirt and underwear manufacturer Hanes
oduced its L'eggs brand pantyhose in
70, selling the product in distinctive plastic
g-shaped containers in grocery stores and
armacies. The company launched its Sheer
ergy brand three years later, with the claim
t the style would give the wearer added
ergy to get her through her busy day.

r T-Shirt- und Wäschehersteller Hanes
llte 1970 seine Strumpfhose der Marke
ggs vor, wobei das Produkt im unverwech-
baren eiförmigen Plastikbehälter in Lebens-
telläden und Apotheken verkauft wurde.
ine Marke Sheer Energy brachte das Unter-
hmen drei Jahre später heraus, und zwar
t der Behauptung, sie würde ihrer Trägerin
sätzliche Energie für ihren anstrengenden
tag schenken.

fabricant de T-shirts et de sous-vêtements
nes lança sa marque de collants L'eggs en
70. Les produits étaient vendus dans des
îtes en plastique originales en forme d'œuf
ns les épiceries et les pharmacies. L'entre-
se introduisit sa marque Sheer Energy trois
s plus tard, proclamant que ses collants
nnaient aux femmes plus d'énergie pour
sumer leurs journées surchargées.

uit of the Loom Hosiery, 1978

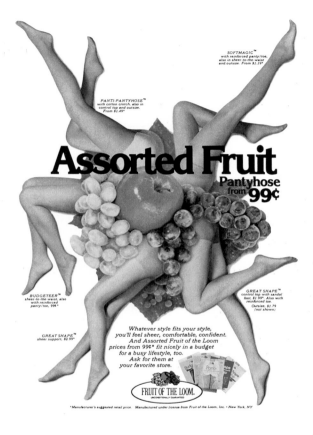

Peter Max paints panty hose for Burlington-Cameo.

they come in three proportioned-to-fit sizes, $6.00 each. body stockings, too. one size only, in 2 peter max original designs (not shown). cost $10.00 each. buy the panty hose or body stockings and you get a coupon for a peter max poster. (it's a copy of this page blown up to poster size 24''x36'.) send us the coupon you'll find in the package and one dollar to cover handling and postage. we'll send you the poster. who knows, your room might even look as good as your legs.

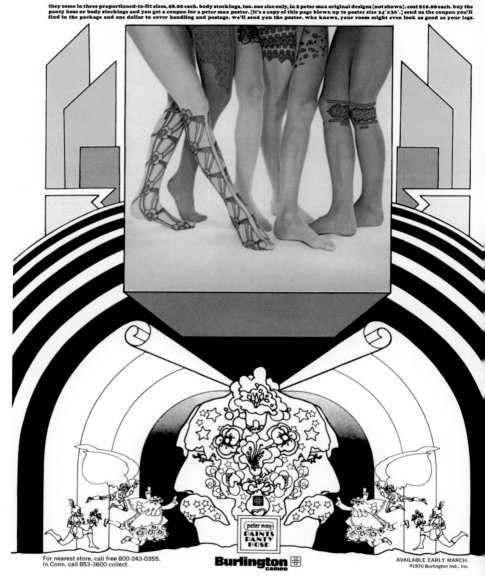

For nearest store, call free 800-243-0355.
In Conn. call 853-3600 collect.

Burlington cameo

AVAILABLE EARLY MARCH.
®1970 Burlington Ind., Inc.

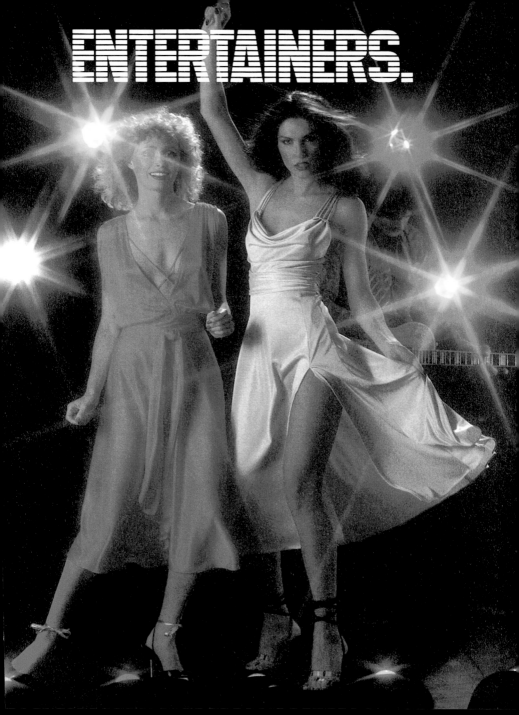

ENTERTAINERS.

Modern Art

Jantzen sets the new direction for swimwear in these *soft*, stylish knits. An action brief of DuPont ANTRON® nylon and LYCRA® spandex, a shirt of ANTRON. They're pure "Body Art"™— from just one of the collections that makes Jantzen #1 in swimwear.

Jantzen®

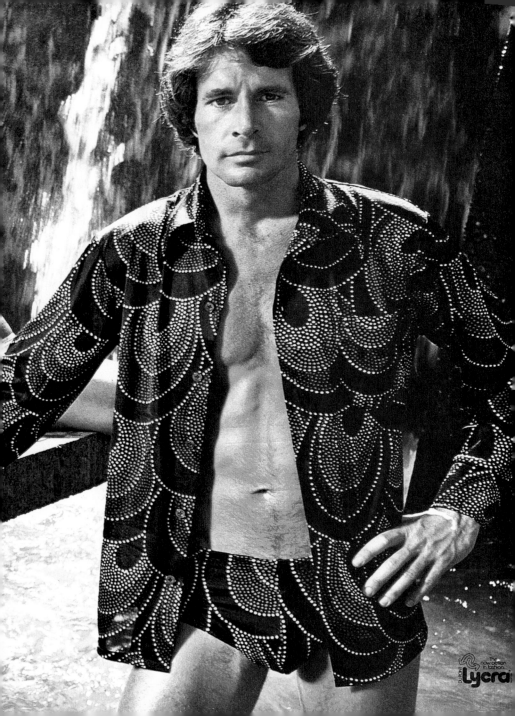

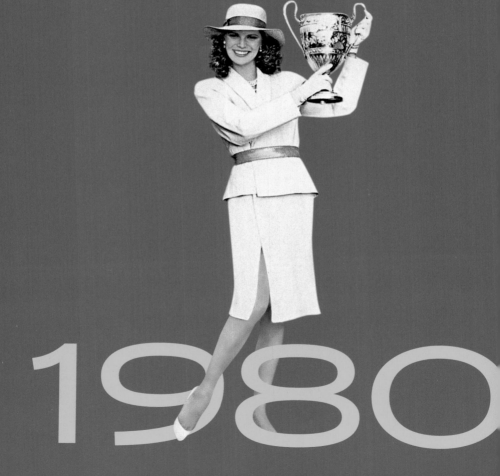

"IT'S ALWAYS THE BADLY
 DRESSED PEOPLE WHO ARE
 THE MOST INTERESTING."
–JEAN PAUL GAULTIER

„DIE SCHLECHT
 ANGEZOGENEN LEUTE
 SIND IMMER AM
 INTERESSANTESTEN."
–JEAN PAUL GAULTIER

1980

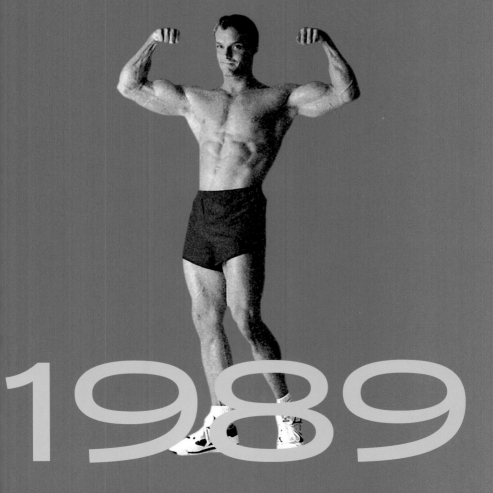

«LES GENS LES PLUS MAL HABILLÉS SONT TOUJOURS LES PLUS INTÉRESSANTS.»
–JEAN PAUL GAULTIER

1989

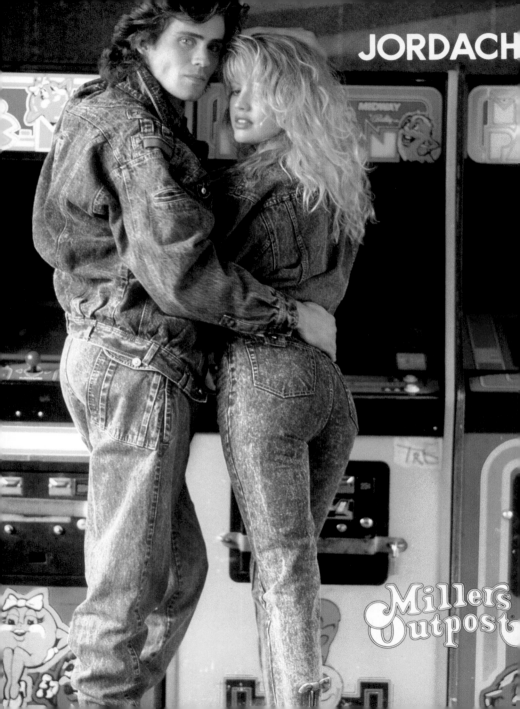

PUNK, POP, AND POWER SUITS

Venerable denim labels like Levi's found themselves faced with a new wave of competition when Brooke Shields put herself and Calvin Klein very definitively on the map by declaring that nothing came between her and her Calvins.

MTV LAUNCHED ITS ALL-MUSIC VIDEO CABLE NETWORK IN 1981, BRINGING ROCK-STAR STYLE INTO THE LIVING ROOM. Overnight, rock stars had to look the part—projecting an image that reflected their music and resonated with their fans. No one did that better than Madonna, a little-known up-and-comer until the first MTV Video Music Awards in 1984, when many music fans got their first glimpse of the future material girl. Dressed in a lingerie-inspired wedding dress, Madonna stunned the crowd as she writhed across the stage while performing her hit, "Like a Virgin." The following year, the film *Desperately Seeking Susan* put the spotlight on Madonna's vintage-chic style.

The music industry exploded with new genres and new style-setters, from Michael Jackson's leather jackets to Pat Benatar's leotards and legwarmers. Meanwhile, rap music was just beginning to break, and with it came new street-inspired fashions. But it wasn't all rock 'n' roll in the 1980s.

Early on, disco gave way to the chaste preppy looks of Ralph Lauren's lifestyle empire. The 1980s saw Liz Claiborne go public and quickly grow into a mega brand; former Anne Klein designer Donna Karan took up where Claiborne left off, carving out a new niche for professional women: minimalist and professional. This became the decade of the "power suit," as more women entered the workforce and strong U.S. and Japanese economies put the spotlight on the business class. Giorgio Armani's impeccably tailored suits came to the fore, thanks in no small

part to the 1980 film *American Gigolo*, in which Richard Gere memorably contemplates his vast Armani wardrobe in the opening scene.

It was also the decade of the avant-garde designer, including Jean Paul Gaultier and Martin Margiela. Japanese designers Yohji Yamamoto and Comme des Garçons' Rei Kawakubo began showing their collections in Paris, and a new avant-garde design movement was born in Brussels. The Antwerp Six included Ann Demeulemeester and Dries Van Noten. Miuccia Prada launched her first ready-to-wear collection for Prada, and Karl Lagerfeld became the designer for Chanel.

For the masses, sportswear put the emphasis on "sports." A fitness craze led by actress Jane Fonda led to aerobics-inspired fashions filtering into daily dress. Norma Kamali took the look to a stylish new level with her sweatshirt collection. Nike set a new standard for celebrity endorsements by brokering a deal with Chicago Bulls rookie Michael Jordan to introduce the Air Jordan shoe.

Venerable denim labels like Levi's found themselves faced with a new wave of competition when Brooke Shields put herself and Calvin Klein very definitively on the map by declaring that nothing came between her and her Calvins. Los Angeles became a center for youth fashions from soon-to-be giant Guess and rival denim brands Z. Cavaricci and Bugle Boy. L.A. Gear joined the sneaker movement with an emphasis on Valley Girl style; and new brand Cross Colours took advantage of the burgeoning rap movement, taking urban streetwear to the mainstream.

◄◄ Jordache Jeans, 1988 ► Converse, 198

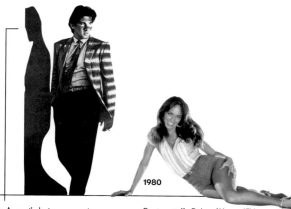

1980

Giorgio Armani's designs appear in *American Gigolo*

Giorgio Armanis Kreationen sind in *American Gigolo* zu sehen

Le film *American Gigolo* met à l'honneur les créations de Giorgio Armani

1980

Denim cutoffs, *Dukes of Hazzard* TV star sparks "Daisy Duke" trend

Mit abgeschnittenen Jeans setzt TV-Star von *Dukes of Hazzard* den „Daisy Duke"-Trend

Dans ses mini-shorts en jean, la star de *Shérif, fais-moi peur* lance la tendance « Daisy Duke »

1980

PETA begins to give furs bad name

PETA beginnt mit Anti-Pelz-Aktionen

Le PETA commence à ternir l'image de la fourrure

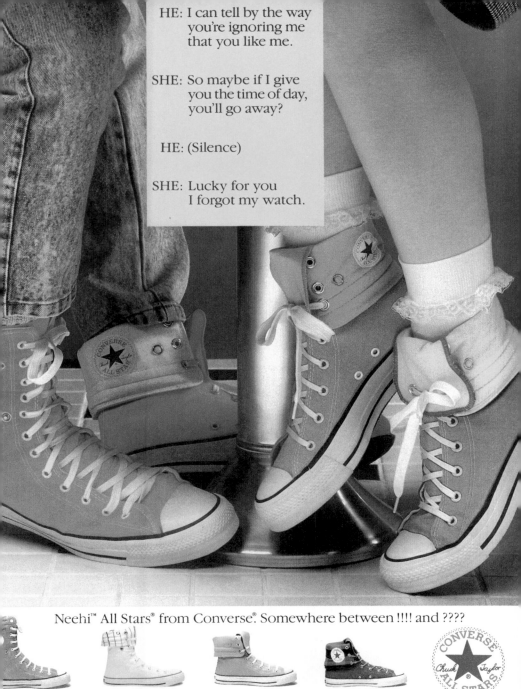

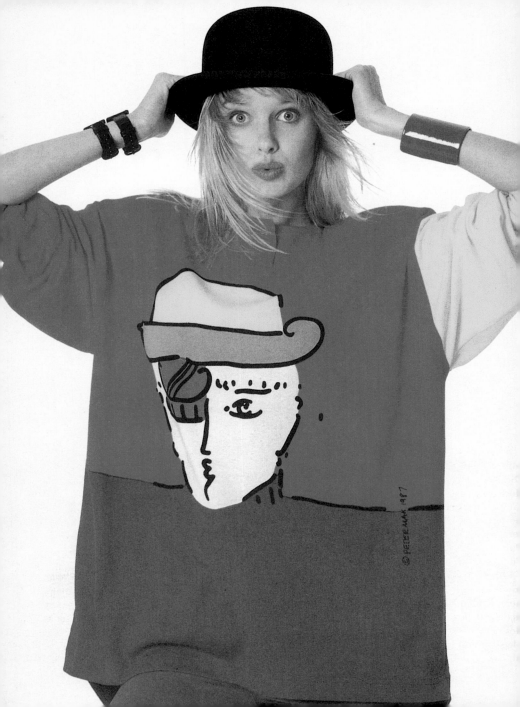

PUNK, POP UND POWER SUITS

Ehrwürdige Jeanslabels wie Levi's wurden mit einer Welle neuer Konkurrenten konfrontiert, als Brooke Shields ein Zeichen für sich und Calvin Klein setzte, indem sie erklärte, ihr käme schlichtweg nichts zwischen sie und ihre Calvins.

TV STARTETE 1981 SEINEN MUSIKVIDEO-SENDER UND BRACHTE SO DAS ROCKSTAR-STYLING DIREKT INS WOHNZIMMER. Quasi über Nacht waren die Rockstars plötzlich gefordert – hatten sie doch ein Image zu vermitteln, das ihrer Musik entsprach und zugleich bei ihren Fans ankam. Das gelang niemandem besser als Madonna, einer bis zu den ersten MTV Video Music Awards 1984 kaum bekannten Newcomerin; damals bekamen viele Musikfans einen ersten Eindruck vom künftigen Material Girl. In einem an Spitzenunterwäsche erinnernden Hochzeitskleid überwältigte Madonna das Publikum, als sie sich zu ihrem Hit „Like a Virgin" auf der Bühne wand. Im Jahr darauf brachte der Film *Susan verzweifelt gesucht* Madonnas Vintage-Chic noch stärker ins Rampenlicht.

Die Musikindustrie überschlug sich mit neuen Genres und Trendsettern, von Michael Jackson und seinen Lederjacken bis hin zu Pat Benatar in Trikot und Beinwärmern. Rap war gerade im Entstehen begriffen und damit auch eine neue, von der Kultur der Straße inspirierte Mode. Allerdings war in den 80ern nicht alles Rock'n'Roll. Schon früh machte die Discomode den keuschen, braven Looks des Lifestyle-Imperiums von Ralph Lauren Platz. Liz Claiborne wurde massentauglich und zu einer Megamarke; die bis dato für Anne Klein tätige Designerin Donna Karan füllte die Lücke, die Claiborne hinterließ, und schuf sich eine neue Nische für Karrierefrauen: minimalistisch und professionell. Es

war das Jahrzehnt der sogenannten Power Suits, als zunehmend Frauen ins Berufsleben traten u
die florierende amerikanische und japanische Wirtschaft die Aufmerksamkeit auf die Business Cla
lenkten. Giorgio Armanis tadellos sitzende Anzüge rückten ins Blickfeld, was zu keinem gering
Anteil dem Film *American Gigolo* von 1980 zu verdanken ist: In der ersten unvergesslichen Szene sie
man Richard Gere versunken vor seiner riesigen Armani-Garderobe.

Es war aber auch das Jahrzehnt der Avantgarde-Designer, u. a. Jean-Paul Gaultier und Mart
Margiela. Die japanischen Modeschöpfer Yohji Yamamoto und Rei Kawakubo von Comme des Ga
çons begannen, ihre Kollektionen in Paris zu zeigen, und in Brüssel entstand eine neue avantgardi
tische Designbewegung. Zu den Antwerp Six zählten u.a. Ann Demeulemeester und Dries Van Note
Miuccia Prada präsentierte ihre erste Prêt-à-porter-Kollektion für Prada, und Karl Lagerfeld wur
Designer bei Chanel.

Die breite Masse nahm den Begriff Sportswear ernst. Angeführt von der Schauspielerin Ja
Fonda setzte ein Fitness-Wahn ein, der Modetrends aus dem Aerobic in die Alltagsmode einfließ
ließ. Norma Kamali brachte den Look mit ihrer Sweatshirt-Kollektion auf ein neues elegantes Nivea
Nike setzte Maßstäbe in der Verpflichtung Prominenter, als man einen Deal mit Michael Jordan, d
mals Neuling bei den Chicago Bulls, abschloss, um den Schuh Air Jordan vorzustellen.

Ehrwürdige Jeanslabels wie Levi's wurden mit einer Welle neuer Konkurrenten konfrontiert, a
Brooke Shields ein Zeichen für sich und Calvin Klein setzte, indem sie erklärte, ihr käme schlichtwe
nichts zwischen sie und ihre Calvins. Los Angeles wurde ein Zentrum der jugendlichen Mode des si
rasch zu einem Branchenriesen entwickelnden Labels Guess und konkurrierender Jeansmarken w
Z. Cavaricci und Bugle Boy. L.A. Gear schloss sich dem Turnschuhtrend mit dem Schwerpunkt a
Valley-Girl-Mode an; und das neue Label Cross Colours nutzte die aufblühende Rap-Bewegung, u
urbane Streetwear massentauglich zu machen.

◄◄ Neo Max Sportswear, 1987 ► Used Jeans, 198

1982

1982

1983

Jane Fonda's workout video sparks
exercise craze

Jane Fondas Workout-Video löst einen Fitness-
Wahn aus

La vidéo d'aérobic de Jane Fonda déclenche la
folie du fitness

Oliviero Toscani launches controversial
"United Colors" campaign for Benetton

Oliviero Toscani präsentiert die umstrittene
Kampagne „United Colors" für Benetton

Oliviero Toscani crée « United Colors », la
campagne controversée de Benetton

Designer power suits sport XL shoulder pads

Designer bringen Schulterpolster im XL-
Format in Mode

Les power suits des grands couturiers affichen
des épaulettes extra larges

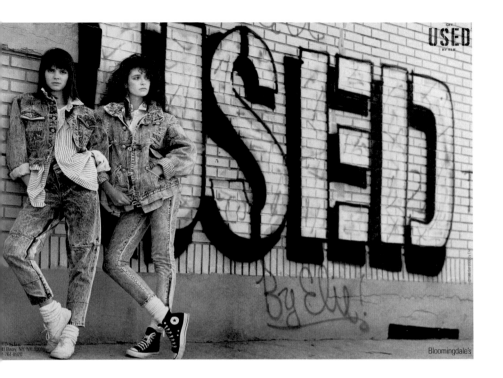

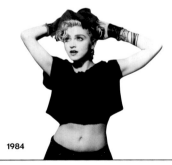

1983

1983

1984

en girls don leg warmers after seeing films
me and *Flashdance*

enies tragen Beinwärmer, nachdem sie die
me Fame und *Flashdance* gesehen haben

s adolescentes adoptent les jambières repé-
es dans les films *Fame* et *Flashdance*

Swatch releases cheap and chic watches

Swatch bringt preiswerte, schicke Uhren auf
den Markt

Swatch lance ses montres chics et bon marché

Madonna performs at first MTV Video Music
Awards in vintage garb

Madonna tritt bei den ersten MTV Video Mu-
sic Awards in Vintage-Kleidern auf

Madonna se produit aux premiers MTV Video
Music Awards en costume vintage

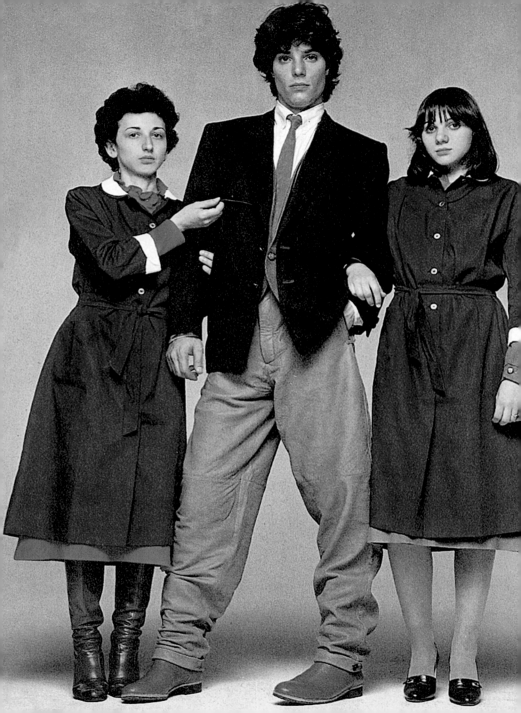

PUNK, POP ET POWER SUITS

*Les marques de jeans établies de longue date
comme Levi's sont confrontées à une nouvelle
forme de concurrence quand Brooke Shields fait
sa gloire et celle de Calvin Klein en déclarant ne
rien porter sous son jean Calvin.*

**N 1981, MTV LANCE SA CHAÎNE CÂBLÉE ENTIÈREMENT CONSACRÉE AUX VIDÉOCLIPS ET
E STYLE DES ROCK- STARS ENTRE DANS LES FOYERS AMÉRICAINS.** Du jour au lendemain,
es stars du rock se doivent de projeter une image fidèle à leur musique et qui résonne auprès de
eurs fans. Personne n'y excelle mieux que Madonna, chanteuse alors méconnue mais prometteuse.
Quand elle vient recevoir son premier MTV Video Music Awards en 1984, elle offre à de nombreux
mateurs de musique pop un aperçu de la future « material girl ». Vêtue d'une robe de mariée très
ngerie, Madonna stupéfait le public lorsqu'elle se contorsionne sur scène en chantant son tube
Like a Virgin ». L'année suivante, le film *Recherche Susan Désespérément* attire l'attention sur son
tyle vintage chic.

L'industrie de la musique explose grâce à de nouveaux genres et de nouvelles figures de mode,
ntre Michael Jackson et ses blousons en cuir, et Pat Benatar en collants de danse et jambières. Paral-
èlement, le rap qui commence à peine à percer lance les nouvelles tendances repérées dans la rue.
ourtant, tout n'est pas que rock'n'roll dans les années 80. Très tôt, le disco fait place aux chastes
ooks BCBG de l'empire Ralph Lauren. Désormais cotée en bourse, la marque de Liz Claiborne
evient une énorme entreprise ; Donna Karan, anciennement styliste chez Anne Klein, reprend le ter-
ain cédé par Liz Claiborne, se forgeant une nouvelle niche avec des vêtements minimalistes au look
rofessionnel pour femmes actives. Alors qu'un nombre croissant de femmes accède au monde du

travail et que les économies fortes des États-Unis et du Japon mettent en avant hommes et femme d'affaires, c'est la décennie du «power suit», ce fameux tailleur aux épaules structurées. Les coupe impeccables de Giorgio Armani occupent le devant de la scène, un succès en grande partie dû au film *American Gigolo* de 1980, avec cette mémorable scène d'ouverture où Richard Gere contemple sa vast garde-robe Armani.

C'est aussi la décennie des couturiers d'avant-garde, dont Jean Paul Gaultier et Martin Mar giela. Les créateurs japonais Yohji Yamamoto et Rei Kawakubo de Comme des Garçons com mencent à présenter leurs collections à Paris tandis qu'un mouvement de création très point émerge à Bruxelles. Les «six d'Anvers» font connaître Ann Demeulemeester et Dries Van Note Miuccia Prada lance sa première collection de prêt-à-porter pour Prada, et Karl Lagerfeld devie directeur de la création chez Chanel.

Pour le grand public, le sportswear semble s'adapter enfin au sport. La folie du fitness et de l'ae robic déclenchée par l'actrice Jane Fonda voit naître des créations qui s'infiltrent dans les tenues d quotidien. Norma Kamali hisse ce look vers de nouveaux sommets d'élégance grâce à sa collectio de sweat-shirts. Nike établit une référence publicitaire sans précédent en signant un contrat ave Michael Jordan, le petit nouveau des Chicago Bulls, pour lancer ses baskets Air Jordan.

Les marques de jeans établies de longue date comme Levi's sont confrontées à une nouvell forme de concurrence quand Brooke Shields fait sa gloire et celle de Calvin Klein en déclarant ne rie porter sous son jean Calvin. Los Angeles devient la plaque tournante de la mode jeune, du futur géa Guess aux marques rivales Z. Cavaricci et Bugle Boy. L.A. Gear surfe sur la tendance des tennis pou femme en optant pour le style «Valley Girl»; et la nouvelle griffe Cross Colours mise sur le mouve ment rap émergent en démocratisant le streetwear.

◄◄ Gianni Versace Ready-to-Wear, 1981 ► Esprit Sport, 1985 ►► Benetton Sportswear, 198

1985

1986

1989

Nike introduces Air Jordan model

Nike stellt sein Modell Air Jordan vor

Nike lance son modèle Air Jordan

Run-D.M.C. immortalize their love for their sneakers in hit song "My Adidas"

Run-D.M.C. machen ihr Faible für Turnschuhe in dem Hit „My Adidas" unsterblich

Run-D.M.C. immortalise sa passion des baskets dans le tube « My Adidas »

Claudia Schiffer among first top models to appear in Guess ads

Claudia Schiffer ist eines der ersten Topmode in den Guess-Anzeigen

Claudia Schiffer figure parmi les premières top-modèles à poser pour les publicités Gues

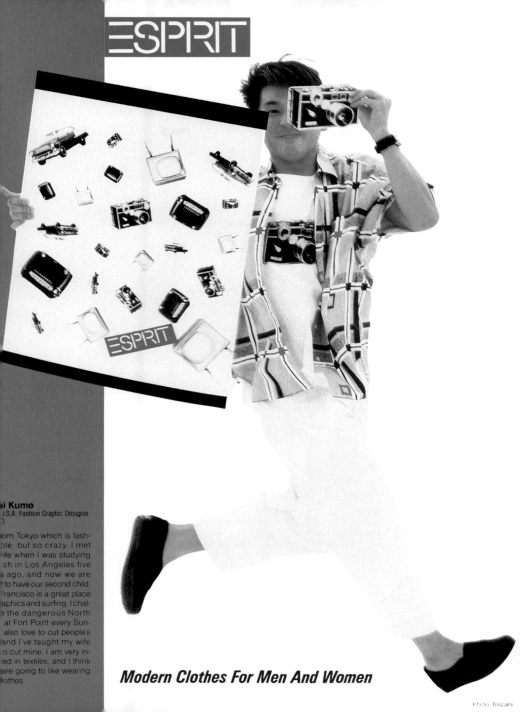

ESPRIT

ESPRIT

i Kume
U.S.A. Fashion Graphic Designer

om Tokyo which is fash-
ble, but so crazy. I met
ife when I was studying
sh in Los Angeles five
s ago, and now we are
to have our second child.
rancisco is a great place
aphics and surfing. I chal-
the dangerous North
at Fort Point every Sun-
also love to cut people's
and I've taught my wife
o cut mine. I am very in-
ed in textiles, and I think
are going to like wearing
othes.

Modern Clothes For Men And Women

Photo Toscani

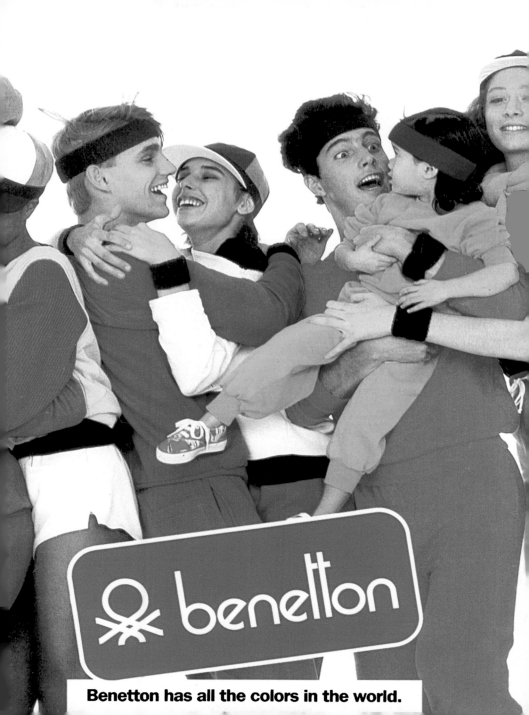

Benetton has all the colors in the world.

MISSONI
836 Madison Avenue New York, N.Y.

Missoni Menswear, 1983 ▶ Valentino Menswear, 198

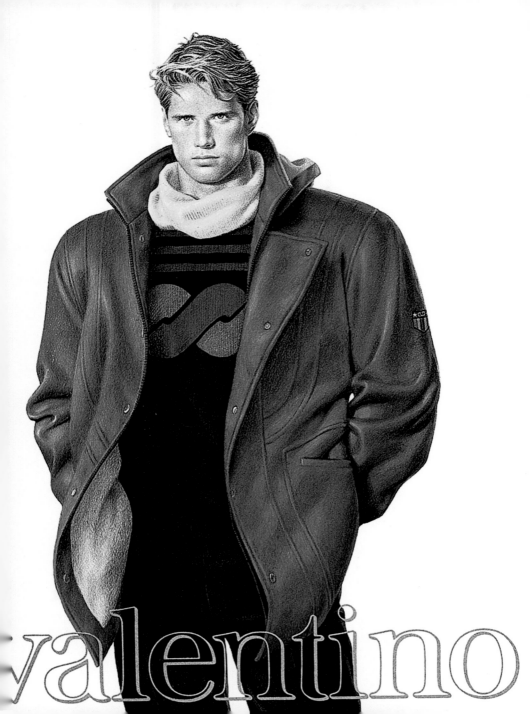
valentino

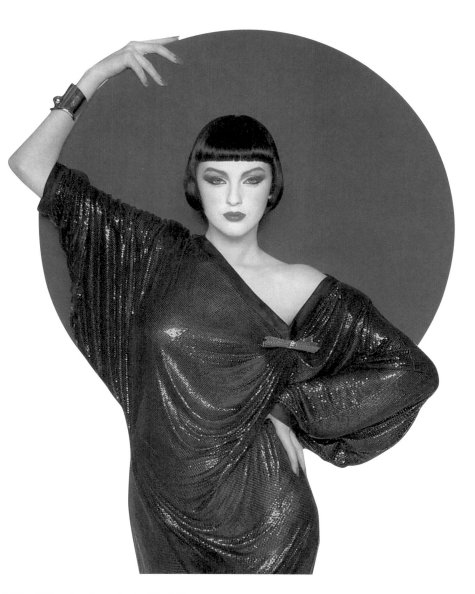

Bill Blass, 1985 Gianni Versace Ready-to-Wear, 1985

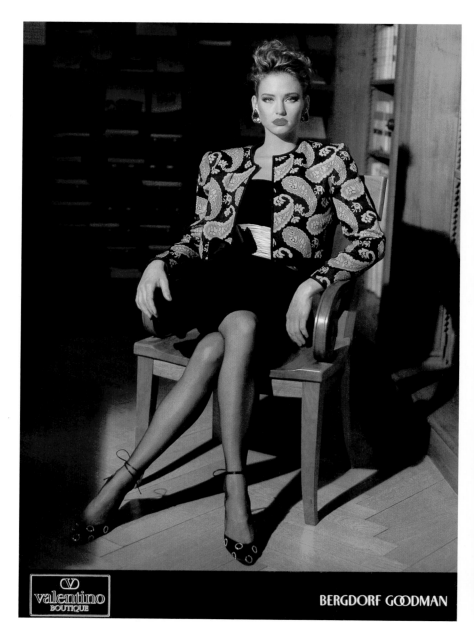

Valentino, Ready-to-Wear, 1985

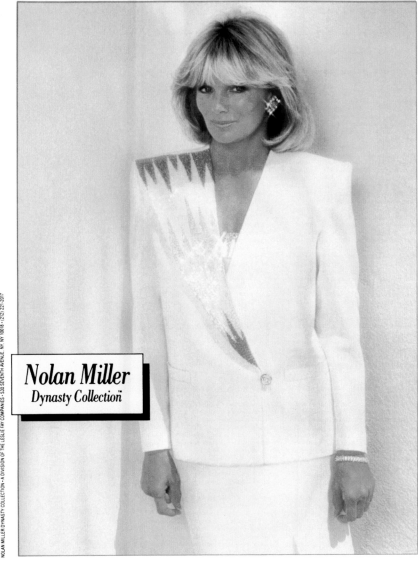

Nolan Miller
Dynasty Collection

Nolan Miller Womenswear, 1985

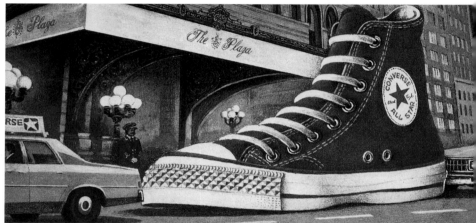

LIMOUSINES FOR YOUR FEET.

Converse All Stars.® The original canvas high tops and
oxfords in eighteen fun and flashy colors and
prints for people who want to go places in style.

CONVERS

Reach for the s

Converse, 1985 ▸ Levi's Jeans, 19

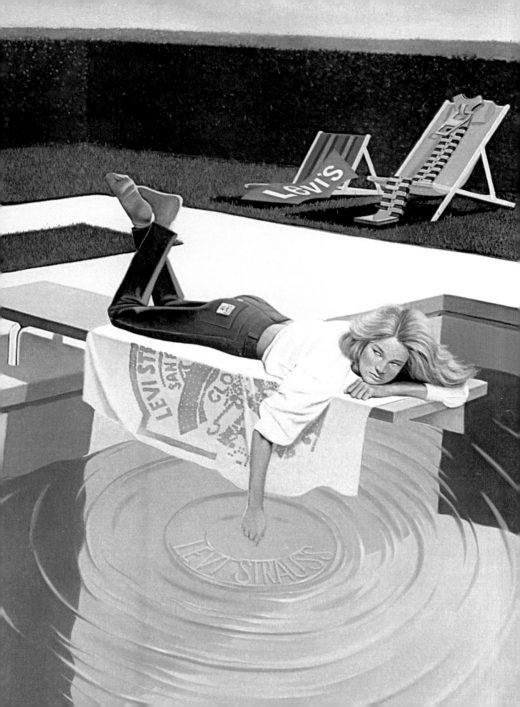

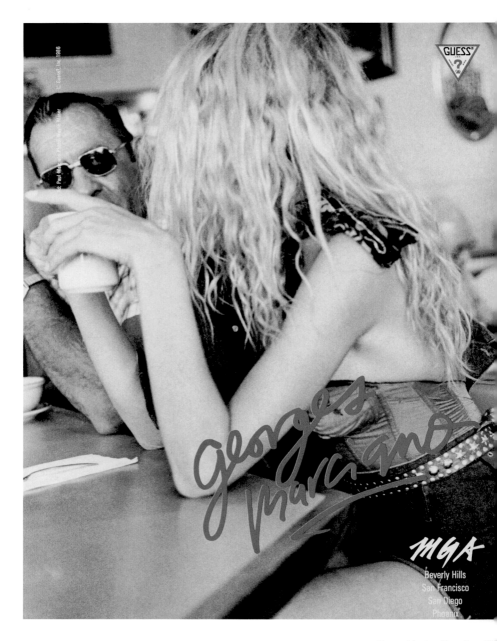

Georges Marciano/Guess Jeans, 19█

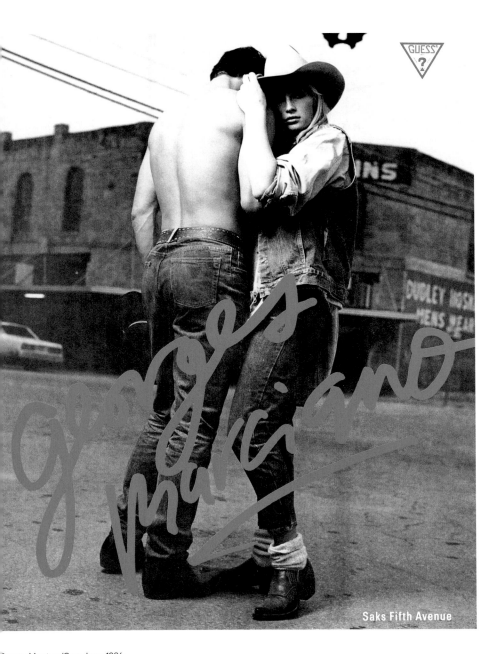

Georges Marciano/Guess Jeans, 1986

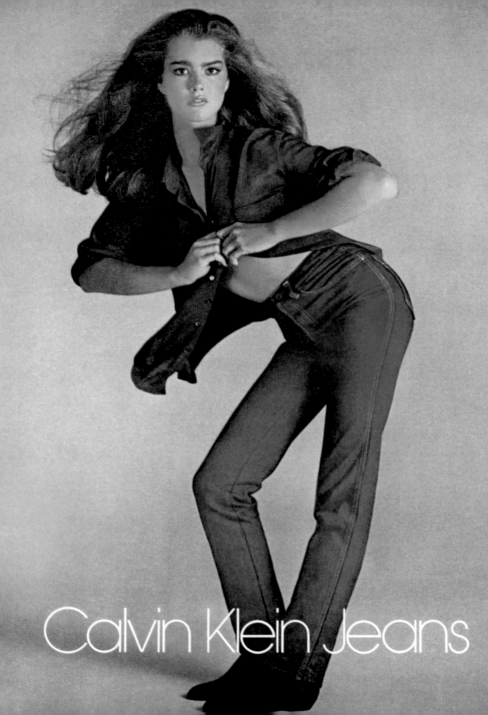

Calvin Klein Jeans

Calvin Klein Jeans, 1980

Georges Marciano/Guess Jeans, 1985

Frederique van der Wal was one of the first models for Guess ad campaigns. Over the next 20 years, Guess ads would go on to feature such models as Claudia Schiffer, Carré Otis, Eva Herzigova, Laetitia Casta, Carla Bruni, Naomi Campbell, and Anna Nicole Smith; and such photographers as Wayne Maser, Ellen von Unwerth, Neil Kirk, and others.

Frederique van der Wal war eines der ersten Models der Werbekampagne für Guess. Im Verlauf der nächsten 20 Jahre folgen Guess-Anzeigen mit Models wie Claudia Schiffer, Carré Otis, Eva Herzigova, Laetitia Casta, Carla Bruni, Naomi Campbell und Anna Nicole Smith; die Fotografen waren u. a. Wayne Maser, Ellen von Unwerth und Neil Kirk.

Frederique van der Wal compta parmi les premiers mannequins à poser pour les campagnes publicitaires de Guess. Au cours des 20 années suivantes, les publicités Guess allaient engager des top-modèles telles que Claudia Schiffer, Carré Otis, Eva Herzigova, Laetitia Casta, Carla Bruni, Naomi Campbell et Anna Nicole Smith, photographiées par Wayne Maser, Ellen von Unwerth, Neil Kirk, entre autres.

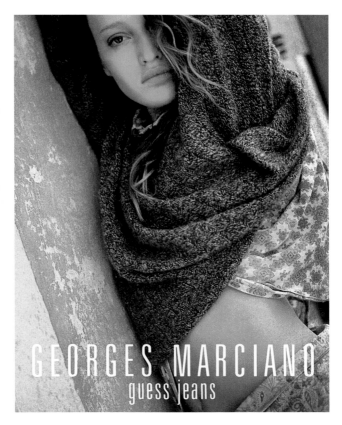

GEORGES MARCIANO
guess jeans

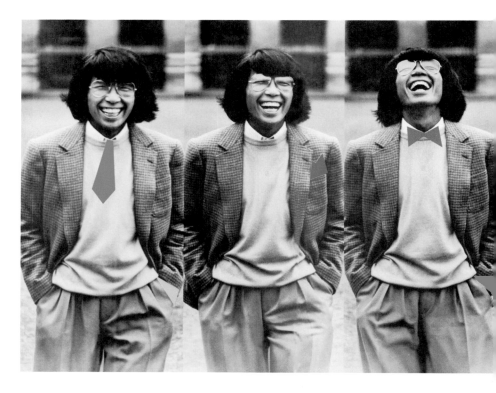

Kenzo Menswear, 1985

▶ L.A. Eyeworks, 1984

L.A. Eyeworks began running its "Great Faces" campaign in 1981. With a memorable tagline, "A face is like a work of art. It deserves a great frame," the ads have featured many familiar faces, including Paul Reubens, Andy Warhol, Stephen Sprouse, and Iman.

L.A. Eyeworks begann 1981 mit der Kampagne „Great Faces". Dazu gehörte der bemerkenswerte Slogan: Ein Gesicht ist wie ein Kunstwerk. Es vedient einen großartigen Rahmen. In den Anzeigen wurden viele bekannte Gesichter präsentiert, u. a. Paul Reubens, Andy Warhol, Stephen Sprouse und Iman.

L.A. Eyeworks lança sa campagne « Great Faces » en 1981. Avec l'inoubliable slogan « Ur visage est comme une œuvre d'art, il mérite un beau cadre », ses publicités utilisèrent de nombreux visages célèbres, dont ceux de Paul Reubens, Andy Warhol, Stephen Sprouse et Iman.

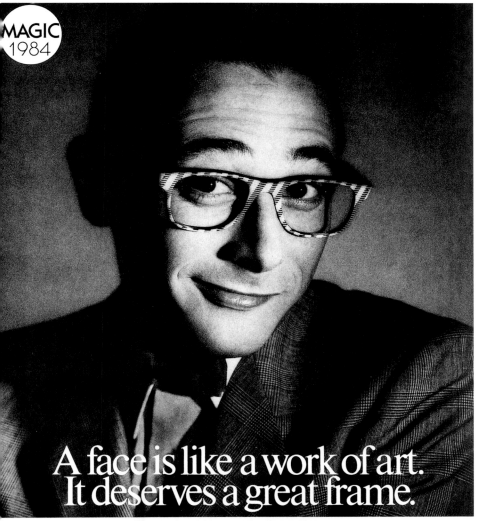

A face is like a work of art.
It deserves a great frame.

There has never been a frame quite like "The Beat." It was designed by l.a. Eyeworks, made in France and comes in dozens of textures, patterns and colors. Everything from matte crystal to buffalo horn to pink and black rayure (shown above). "The Beat" is available with many colored lenses and all prescriptions are filled in our own laboratory. Send $1 for a color catalog featuring "The Beat" and other designs by l.a. Eyeworks.

l.a. Eyeworks
7407 MELROSE, LOS ANGELES, CA 90046

Glasses shown: The Beat. Designed by l.a. Eyeworks. Face: Pee Wee Herman. Photographer: Greg Gorman. © 1984, l.a. Eyeworks, Los Angeles, CA 90046. Available at Barneys New York; Bendel's; Bergdorf-Goodman; Bullock's; Carson, Pirie Scott; Charavari; Foley's; I. Magnin; Jerry Magnin; McInerny; Neiman Marcus; Robinson's; Sointu; Theodore; Ultimo; Wilkes Bashford. For wholesale inquiries contact Three, 7407 Melrose Avenue, Los Angeles, CA 90046. 213/653-8176.

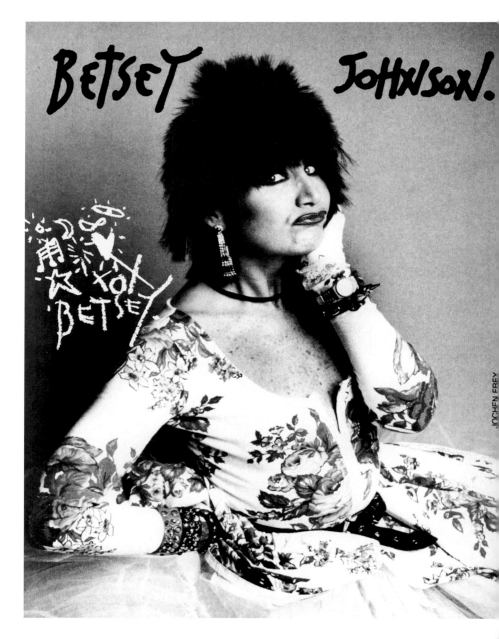

Betsey Johnson Womenswear, 1985 ▶ Brittania Jeans, 198

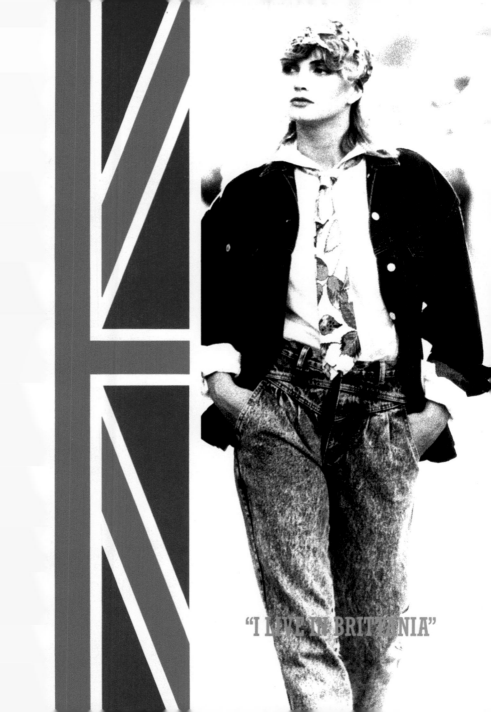

"I LIVE IN BRITTANIA"

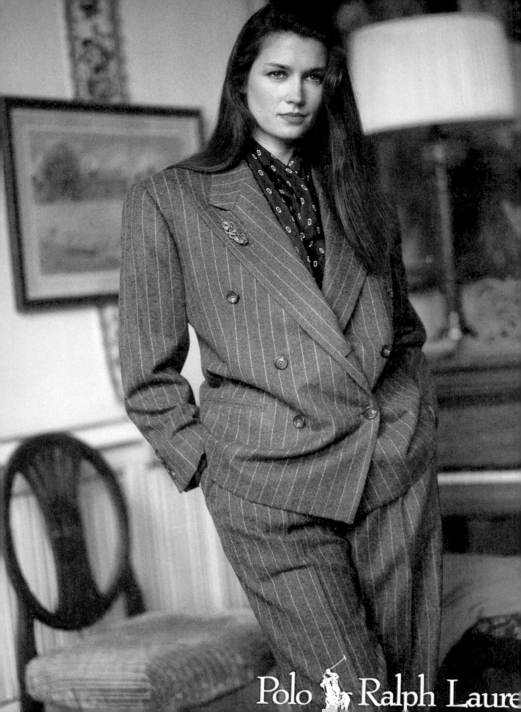

Polo Ralph Laure

Polo Ralph Lauren, 1984

Polo Ralph Lauren, 1986

Ralph Lauren started in the late 1960s as a menswear retailer. By the 1980s, his company had grown to include women's and children's apparel, and would soon expand further into many licensed categories. The company's ads underscored the brand's position as an upscale lifestyle brand.

Ralph Lauren begann in den späten 1960ern als Einzelhändler für Herrenmode. In den 80ern war sein Unternehmen deutlich gewachsen und umfasste nun auch Damen- und Kinderbekleidung. Bald sollte sich sein Geschäft noch in viele lizensierte Kategorien ausdehnen. Die Anzeigen unterstrichen die Stellung der Marke als Label für den gehobenen Lebensstil.

Ralph Lauren débuta sa carrière à la fin des années 60 en tant que vendeur de vêtements pour homme. Au début des années 80, son entreprise s'était diversifiée dans la mode pour femme et pour enfant, avant de développer de nombreuses catégories sous licence. Les publicités de la marque soulignaient son positionnement haut de gamme.

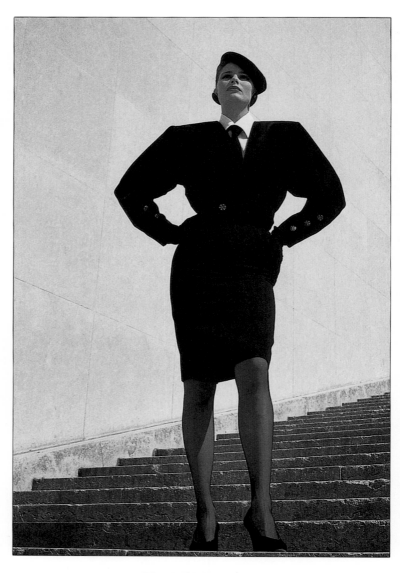

SAINT LAURENT
rive gauche

Yves Saint Laurent Rive Gauche, 1985

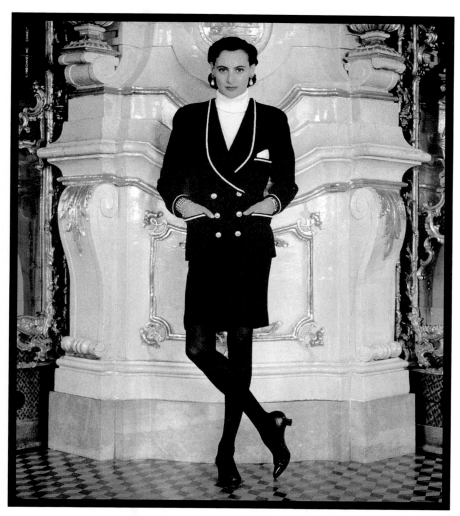

CHANEL

Chanel Ready-to-Wear, 1988

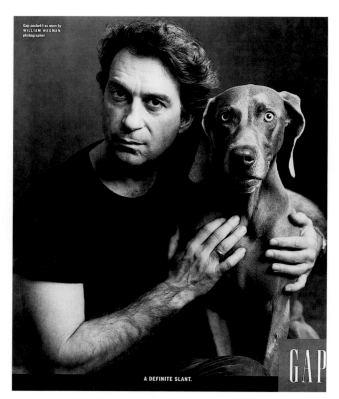

Gap pocket-t as worn by
WILLIAM WEGMAN,
photographer

A DEFINITE SLANT.

GAP

The Gap Sportswear, 1989

Formerly a small clothing shop in San Francisco, The Gap began its "Fall into the Gap" a campaign in 1974 and eventually became the number one retailer in America. It upgraded its look in 1988 with what would become a long-running "Individuals of Style" campaign, which featured celebrities from actress Kim Basinger to beat novelist William S. Burrough photographed by top photographers from Annie Leibovitz to Herb Ritts.

Der ehemals kleine Klamottenladen in San Francisco namens The Gap begann seine Kampagne „Fall into the Gap" 1974 und wurd schließlich zur Nummer 1 unter den Textil-Ein zelhändlern Amerikas. 1988 polierte man se Image mit der sich als langlebig erweisenden Kampagne „Individuals of Style" auf. In deren Rahmen präsentierte man Promis, angefangen bei der Schauspielerin Kim Basinger bis hin zum Beatpoeten William S. Burroughs, fotografiert von Spitzenfotografen wie Annie Leibovitz oder Herb Ritts.

The Gap, une petite boutique de vêtements d San Francisco, lança sa campagne « Fall into t Gap » en 1974 et finit par devenir le détaillant numéro un des États-Unis. La marque réactu lisa son look en 1988 avec ce qui allait deveni la longue campagne « Individuals of Style ». Celle-ci présentait des célébrités, de l'actrice Kim Basinger au romancier de la beat genera tion William S. Burroughs, immortalisées par des photographes de renom, d'Annie Leibovi à Herb Ritts.

▶ The Gap Sportswear, 1989

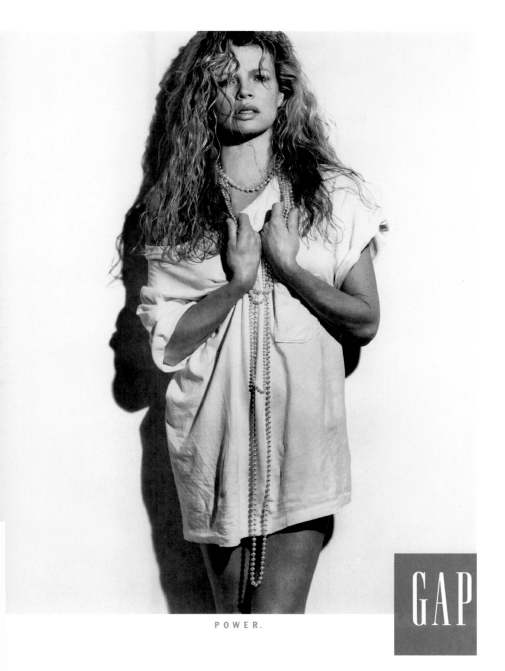

POWER.

GAP

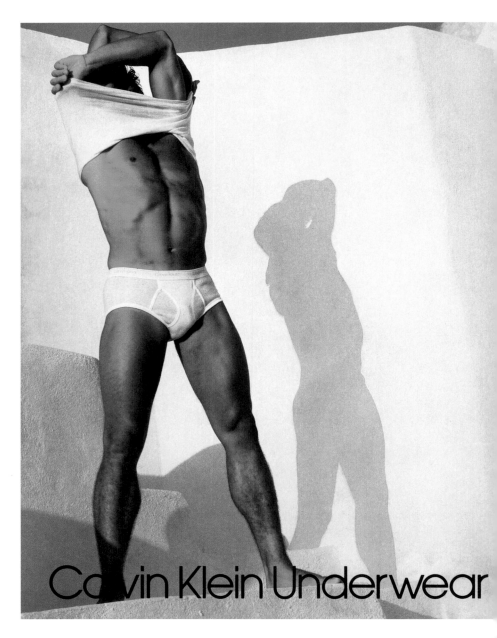

Calvin Klein Underwear, 198

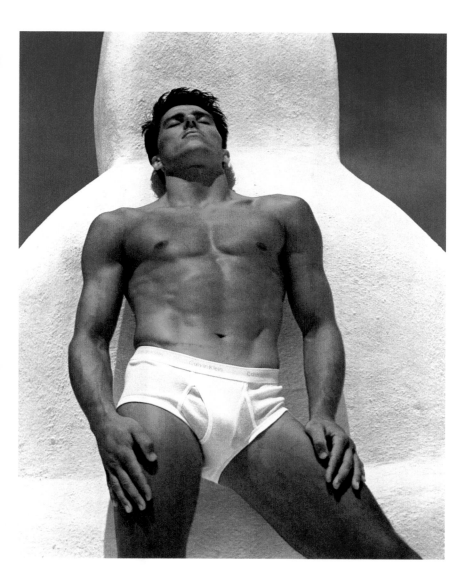

Calvin Klein Underwear

vin Klein Underwear, 1983

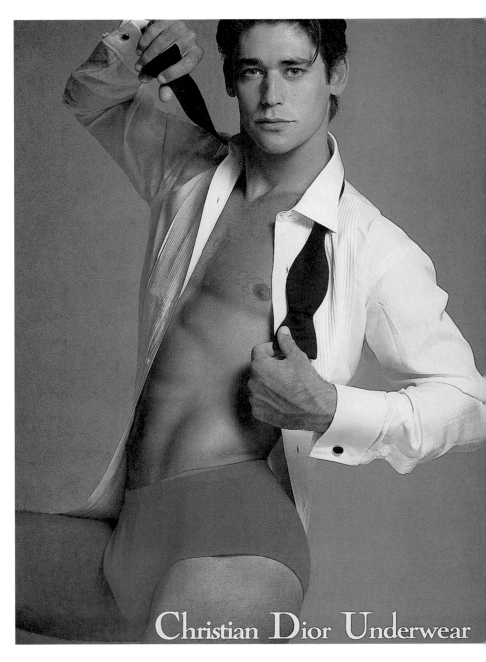

Christian Dior Underwear

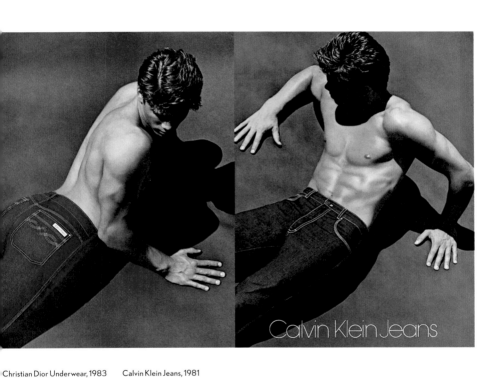

Christian Dior Underwear, 1983 Calvin Klein Jeans, 1981

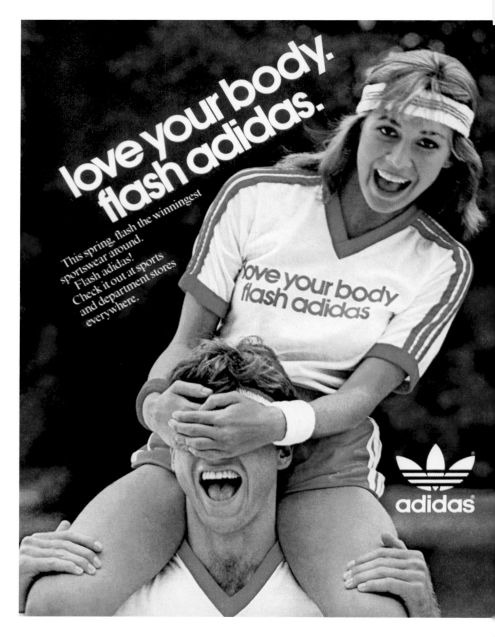

Adidas Sportswear, 198

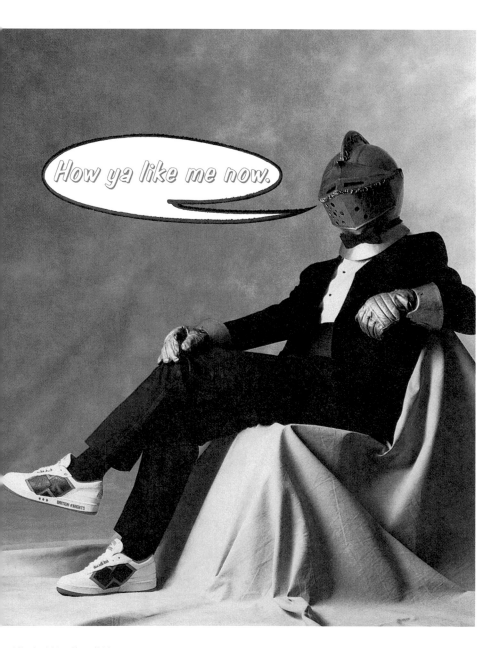

British Knights Athletic Shoes, 1988

THE ONLY WAY TO GE
HIGHER IS ILLEGA

◀ Jump Athletic Shoes, 1988 Bass Shoes, 1984

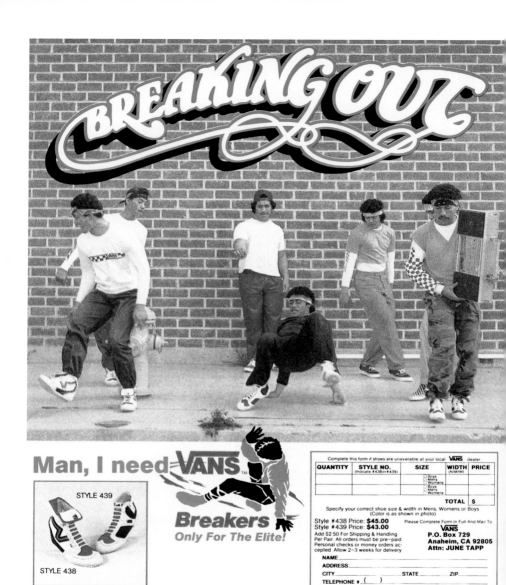

Man, I need VANS™

Breakers
Only For The Elite!

STYLE 439

STYLE 438

Vans Breakers, 1984 ► Reebok Athletic Shoes, 1989

MILLIONS OF GIRLS WANT TO BE IN HER SHOES.

BUT SHE WANTS TO BE IN OURS.

Paula Abdul is wearing shoes from the Dance Reebok® Collection. Available at department and fine specialty stores. Call 1-800-843-4444 for locations nearest you.

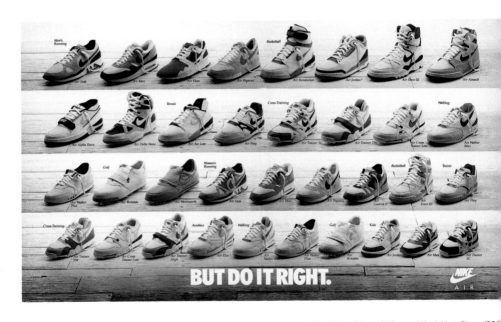

BUT DO IT RIGHT.

Nike Athletic Shoes, 1988 ▶ Nike Athletic Shoes, 1988

JUST DO IT.

"IT'S A NEW ERA IN FASHION—
THERE ARE NO RULES."
– ALEXANDER MCQUEEN

„ES IST EINE NEUE ÄR
IN DER MODE – ES
GIBT KEINE REGELN.
– ALEXANDER MCQUEEN

1990

«LA MODE EST ENTRÉE
DANS UNE NOUVELLE ÈRE
OÙ TOUTES LES RÈGLES
SONT ABOLIES.»
– ALEXANDER MCQUEEN

1999

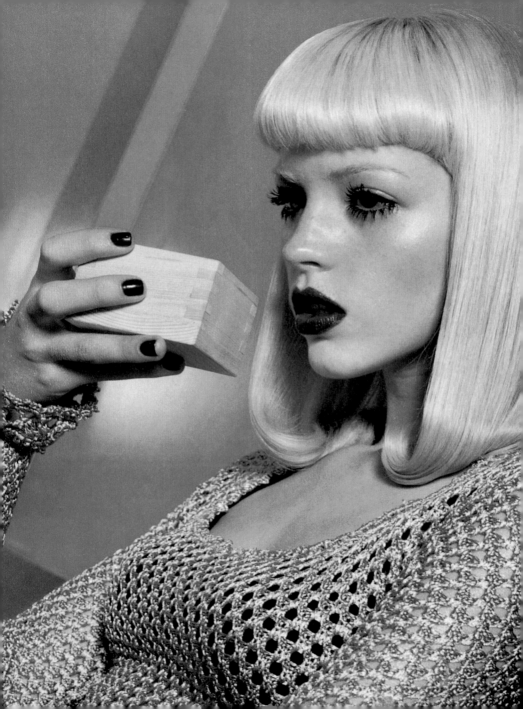

HIP-HOP MEETS HAUTE COUTURE

Trends would no longer trickle down from designer collections to the masses, and with a wide world hungry for brand names, savvy designers began launching lower-priced secondary lines, denim collections, and accessories to attract wider audiences.

THE 1990S OPENED WITH AN ANTI-FASHION BACKLASH—ALBEIT SHORT-LIVED—FUELED BY THE GRUNGE MUSIC SCENE growing in America's Pacific Northwest. Classic Levi's, Doc Martens boots, and battered plaid flannel shirts became the youth uniform. But the movement did not last long, and, by 1993, a new medium emerged that would accelerate the speed of information around the world.

Even in its infancy, the Internet promised to deliver instantaneous access to news. Fashion magazines were slow to adapt to the new medium, and advertisers were unsure how to capitalize on its potential, but it was clear that the Web would soon deliver a virtual front-row seat to the latest fashion collections. Trends would no longer trickle down from designer collections to the masses, and with a wide world hungry for brand names, savvy designers began launching lower-priced secondary lines, denim collections, and accessories to attract wider audiences.

At the center of the fashion shift were Tom Ford, who had been promoted to Gucci creative director in 1994, to revive the Italian luxury label's image, and Miuccia Prada. With her minimalist fashions, Prada gave women — and eventually men — a reason to get dressed up again. The designer also helped kick off the "it" bag craze with its leather-trimmed nylon backpack. (The bag was first released in the early 1980s, but when the backpack was featured on the runway with the 1989 launch of Prada's ready-to-wear collection, the style took off and became a ubiquitous accessory of the 1990s.)

Ford, meanwhile, took a moribund luxury brand and gave it a luxury makeover, updating pieces from Gucci's archives and showcasing the luxe look in ads photographed by Mario Testino. In addition to overtly sexy imagery, Gucci ads excelled at highlighting one well-branded "must-have" item: the must-have bag, or the must-have sunglasses.

Fashion was having a pop-culture close-up, as well. In 1992, British TV viewers tuned in to *Absolutely Fabulous* to watch the antics of fashion publicist Edina and her sidekick Patsy. An attempt to translate the hit show for the American audience failed, as did Robert Altman's fictitious sendup of Paris Fashion Week, *Prêt-à-Porter*. But *Unzipped*, the 1995 documentary following the months leading up to the release of Isaac Mizrahi's fall 1994 runway show, was a modest hit that turned Mizrahi into an overnight star.

The counterculture flourished in the rave music scene and with music festivals like Perry Farrell's Lollapalooza, which drew crowds of tattooed and pierced teens. The graphic T-shirt has its roots in this era, with companies like Freshjive taking a swipe at America's consumer culture with its Tide-logo T. Denim makers were touting relaxed-fit styles, while the hip-hop scene was super-sizing everything from jeans to T-shirts. Within the rave scene and deejay culture, the look for denim was the elephant-bell jean—the most extreme styles had leg openings up to 50 inches around. But as the decade came to a close, denim prepared for another major shift. In 1999, Los Angeles designer Daniella Clarke launched her Frankie B. label, creating the ultra-low-rise jean, a look that would take denim into the next century.

◀◀ D&G Dolce&Gabbana, 1997 ▶ Versus Ready-to-Wear, 199

1990

International celebrity models dubbed "supermodels"

International berühmte Fotomodels heißen fortan „Topmodels"

Les mannequins mondialement célèbres sont surnommés les « top-modèles »

1991

Gucci's creative director Tom Ford revives label's double-G logo

Guccis Creative Director Tom Ford belebt das Logo mit dem Doppel-G neu

Tom Ford, le directeur de la création Gucci, ressuscite le logo en double G de la griffe

1991

Doc Martens and plaid flannel shirts hallmark of grunge fashion

Doc Martens und karierte Flanellhemden sind die Markenzeichen der Grunge-Mode

Les Doc Martens et la chemise à carreaux en flanelle symbolisent la mode grunge

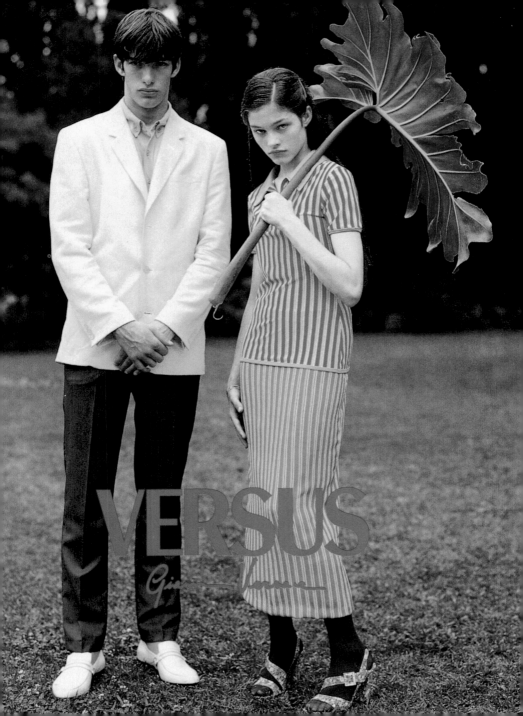

VERSUS

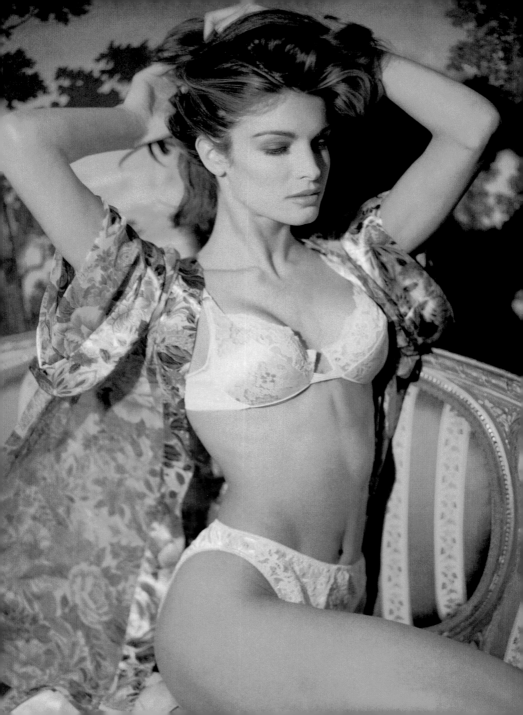

HIP-HOP TRIFFT HAUTE COUTURE

Trends würden nicht länger langsam aus Designerkollektionen in die Massenproduktion durchsickern, und angesichts der weltweiten Gier nach Markennamen begannen schlaue Designer mit günstigeren Zweitlinien, Jeans-kollektionen und Accessoires für ein breiteres Publikum auf den Markt zu drängen.

[D]IE 1990ER BEGANNEN MIT EINER KURZLEBIGEN ANTI-MODE-BEWEGUNG, AUSGELÖST [V]ON DER GRUNGE-MUSIKSZENE, DIE IN AMERIKAS NORDWESTEN ENTSTANDEN WAR. [K]lassische Levi's, Stiefel von Doc Martens und schäbige karierte Flanellhemden wurden zur Uni-[fo]rm der Jugendlichen. Der Trend hielt allerdings nicht lange an, und ab 1993 machte ein neues [M]edium Furore, das die Informationsgeschwindigkeit rund um die Welt enorm beschleunigen [so]llte. Selbst in seinen Kindertagen versprach das Internet bereits unverzüglichen Nachrichten-[zu]gang. Modemagazine adaptierten das neue Medium nur zögerlich, und auch die Werbebran-[c]he war sich nicht sicher, wie sie dieses Potenzial für sich nutzen sollte; klar war jedoch, dass das [W]eb im Hinblick auf die neuesten Kollektionen bald für einen virtuellen Platz in der ersten Reihe [g]ut sein würde. Trends sollten nicht länger langsam aus Designerkollektionen in die Massen-[p]roduktion durchsickern, daher begannen schlaue Designer angesichts der weltweiten Gier nach [M]arkennamen mit günstigeren Zweitlinien, Jeanskollektionen und Accessoires für ein breiteres [P]ublikum auf den Markt zu drängen.

Im Zentrum dieser Veränderungen im Modebereich standen Tom Ford, den man 1994 als Crea-[ti]ve Director zu Gucci geholt hatte, um das Image des italienischen Luxuslabels neu zu beleben, und [M]iuccia Prada. Mit ihren minimalistischen Kreationen gab Prada Frauen – und schließlich auch Män-[n]ern – wieder einen Grund, sich aufzustylen. Die Designerin trug auch zum Beginn des Hypes um die

sogenannte „It"-Bag bei, und zwar in Gestalt des mit Leder gesäumten Nylonrucksacks. (Die Tasch
kam Anfang der 1980er erstmals auf den Markt, doch setzte sie sich erst durch, als sie 1989 zusamme
mit Pradas Prêt-à-porter-Kollektion auf dem Laufsteg präsentiert wurde, von da aus avancierte si
schließlich zum allgegenwärtigen Accessoire der 1990er.)

Ford nahm sich inzwischen des todgeweihten Luxuslabels Gucci an und verpasste ihm ein Lu
xus-Lifting, indem er Stücke aus den Gucci-Archiven modernisierte und den Luxus-Look mit vo
Mario Testino fotografierten Anzeigen groß herausstellte. Neben der eindeutig sexuellen Bildspr
che waren die Gucci-Anzeigen auch perfekt darin, ein die Marke unverkennbar repräsentierende
Must-have zu betonen: die Tasche oder die Sonnenbrille, die man einfach haben muss.

Auch die Popkultur unterzog die Mode einer näheren Betrachtung. 1992 schalteten britisch
Fernsehzuschauer *Absolutely Fabulous* ein, um sich die Possen der Modejournalistin Edina und il
res Handlangers Patsy zu Gemüte zu führen. Der Versuch, die Erfolgs-Show für das amerikanisch
Publikum zu adaptieren, scheiterte ebenso wie *Prêt-à-Porter*, Robert Altmans fiktive Doku über di
Pariser Modewoche. Dagegen war *Unzipped*, eine Dokumentation von 1995 über die Monate vor de
Präsentation von Isaac Mizrahis Laufstegpremiere seiner Herbstkollektion 1994, ein regelrecht
Hit, der Mizrahi über Nacht zum Star machte.

Die Gegenkultur blühte in Gestalt der Rave-Szene und im Rahmen von Musikfestivals wi
Perry Farrells Lollapalooza, das massenhaft tätowierte und gepiercte Teenies anlockte. Das grafisc
gestaltete T-Shirt hat seine Wurzeln in dieser Zeit, als Firmen wie Freshjive mit seinem Tide-Log
Shirt Amerikas Konsumkultur aufs Korn nahmen. Jeanshersteller propagierten bequeme Schnitt
während die Hip-Hop-Szene von der Jeans bis zum T-Shirt alles in Übergrößen einführte. Inne
halb der Raver- und Deejay-Szene waren Elephant-Bell-Jeans gefragt – die extremsten Schnitt
hatten knapp 1,30 m Beinumfang. Doch gegen Ende des Jahrzehnts bereitete sich der Jeansmar
auf eine weitere große Neuerung vor: 1999 startete die Designerin Daniella Clarke aus Los Angele
ihr Label Frankie B. mit einer ultratiefen Hüftjeans – ein Look, der die Denimmode gleich bis ir
nächste Jahrhundert prägen sollte.

1992

Calvin Klein begins creating provocative ads
with Bruce Weber and Herb Ritts

Calvin Klein beginnt provokative Anzeigen-
kampagne mit Bruce Weber und Herb Ritts

Calvin Klein conçoit des campagnes provocantes
avec Bruce Weber et Herb Ritts

1992

Urban streetwear brand FUBU (For Us By Us)
launches in New York

Die Streetwear-Marke FUBU (For Us By Us)
wird in New York eingeführt

Lancement de la marque de streetwear urbain
FUBU (For Us By Us) à New York

1992

Prada launches Miu Miu

Prada präsentiert erstmals Miu Miu

Prada lance la collection Miu Miu

◀◀ Victoria's Secret Lingerie, 1992 Fendi Bags, 1999

994	1994	1994

Donatella Versace runs Versace after murder of brother Gianni

Donatella Versace übernimmt nach dem Mord an ihrem Bruder Gianni die Leitung von Versace

Donatella Versace reprend les rênes de Versace après l'assassinat de son frère Gianni

Touting its engineered fit, Wonderbra launches in U.S.

Wonderbra propagiert in einer US-Kampagne seine ausgereifte Passform

Revendiquant une coupe ampliforme, le Wonderbra est commercialisé aux États-Unis

Uma Thurman's crisp white shirt in *Pulp Fiction* revives the minimalist staple

Uma Thurmans gestärktes weißes Hemd in *Pulp Fiction* bringt minimalistische Basics wieder in Mode

Le chemisier blanc d'Uma Thurman dans *Pulp Fiction* remet le minimalisme au goût du jour

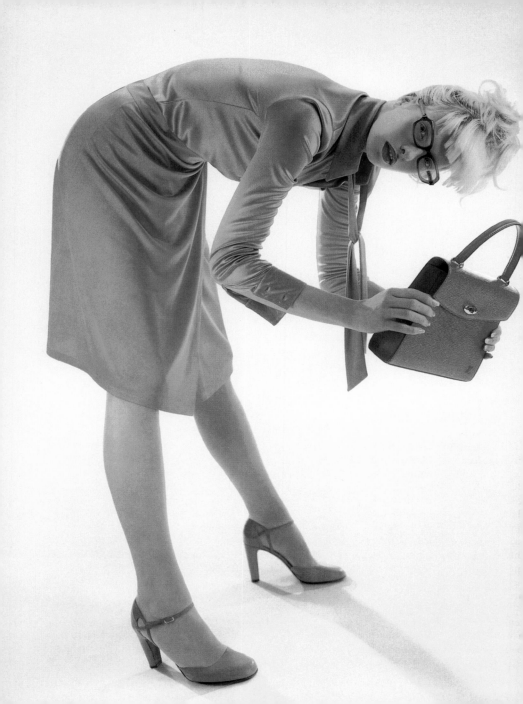

LE HIP-HOP RENCONTRE LA HAUTE COUTURE

Les tendances des collections ne se traduisent plus dans la mode grand public. Alors que le monde entier semble obsédé par les marques, certains créateurs ont le flair de lancer des lignes secondaires, des collections en denim et des gammes d'accessoires moins onéreuses pour attirer une plus large clientèle.

LES ANNÉES 90 S'OUVRENT SUR UN MOUVEMENT ANTI-MODE DE COURTE DURÉE ALIMENTÉ PAR LA SCÈNE GRUNGE QUI SE DÉVELOPPE AU NORD DE LA CÔTE OUEST AMÉRICAINE. Le jean Levi's classique, les bottes Doc Martens et les chemises à carreaux en flanelle élimée deviennent l'uniforme des ados, bien que cette tendance s'essouffle rapidement. En 1993, l'émergence d'un nouveau média accélère la vitesse de l'information dans le monde entier. Même à ses débuts, Internet promet déjà un accès instantané à l'actualité. Les magazines de mode tardent à se mettre en ligne et les publicitaires ne savent pas vraiment comment exploiter le potentiel du Web, mais il est évident qu'il permettra bientôt de découvrir les tout derniers défilés de mode aux premières loges. Les tendances des collections ne se traduisent plus dans la mode grand public. Alors que le monde entier semble obsédé par les marques, certains créateurs ont le flair de lancer des lignes secondaires, des collections en denim et des gammes d'accessoires moins onéreuses pour attirer une plus large clientèle.

Cette transformation de la mode est principalement due à Tom Ford, promu au poste de directeur de la création de Gucci en 1994 pour réactualiser l'image de la griffe italienne de luxe, mais aussi à Miuccia Prada : avec ses vêtements minimalistes, elle donne aux femmes – puis aux hommes – une bonne raison de redevenir élégantes. La créatrice contribue également à lancer la folie des sacs à main grâce à son sac à dos en nylon passepoilé de cuir (d'abord introduit au début des années 80, ce

modèle décolle vraiment en 1989 lors de son apparition sur le podium du défilé de la première collec
tion de prêt-à-porter Prada, devenant un accessoire omniprésent dans les années 90).

De son côté, Tom Ford ressuscite une marque de luxe moribonde en modernisant les pièces de
archives Gucci, soutenu par les visuels publicitaires du photographe Mario Testino comme vitrine d
son look luxueux. Outre une imagerie ouvertement sexy, les publicités Gucci excellent quand il s'agi
de vendre un *must* siglé, qu'il s'agisse d'un sac à main ou de lunettes de soleil.

La mode, elle aussi, se détourne de la culture pop. En 1992, les téléspectateurs angla
regardent *Absolutely Fabulous* pour suivre les aventures déjantées de l'attachée de presse en mod
Edina et de son acolyte Patsy. L'adaptation américaine de la série ne touche pas son public, tou
comme la parodie de la semaine de la mode parisienne réalisée par Robert Altman, *Prêt-à-Porter*
Mais en 1995, le documentaire *Dégrafées, déboutonnées, dézippées* qui retrace les mois de travail pré
cédant le défilé automne 1994 d'Isaac Mizrahi remporte un joli succès qui fait de ce créateur un
star du jour au lendemain.

La scène alternative prospère grâce à la musique électro et aux festivals tels que le Lollapalooz
de Perry Farrell qui attire des foules de jeunes tatoués et piercés. Cette période voit naître le T-shir
graphique, des entreprises comme Freshjive s'appropriant la société de consommation avec u
T-shirt qui revisite le logo de Tide, une grande marque de lessive américaine. Les fabricants de jean
imposent les coupes décontractées, tandis que la mouvance hip-hop surdimensionne tous les vête
ments, des jeans aux T-shirts. Au sein de la culture rave et du milieu des DJ, le jean se porte à patte
d'éléphant, les modèles les plus extrêmes arborant des ourlets de 130 centimètres de circonférence
À l'approche du nouveau millénaire, le denim s'apprête à connaître une autre révolution. En 1999, l
créatrice de Los Angeles Daniella Clarke lance sa griffe Frankie B. et innove avec le jean à taille ultra
basse, le look qui fera entrer le jean dans le 21ème siècle.

◄◄ Louis Vuitton Bags, 1997 ► Esprit Sport, 1993 ►► Guess Hosiery, 199

1996

1997

1999

Swingers film reflects mid-decade vintage
fashion trends

Der Film *Swingers* spiegelt die Vintage-Mode-
Trends um die Mitte des Jahrzehnts wider

Le film *Swingers* reflète la folie du vintage qui
s'empare de la mode

Bruce Weber creates notorious imagery for
new Abercrombie & Fitch catalog

Bruce Weber entwirft die berühmten Bilder für
den neuen Katalog von Abercrombie & Fitch

Bruce Weber devient le photographe exclusif
du nouveau catalogue Abercrombie & Fitch

Daniella Clarke introduces Frankie B. and henc
launches premium low-rise denim market

Daniella Clarke führt Frankie B. ein und öffnet d
mit den Markt für tief geschnittene Nobeljeans

En lançant sa griffe Frankie B., Daniella Clarke
invente le marché du jean taille basse en denim

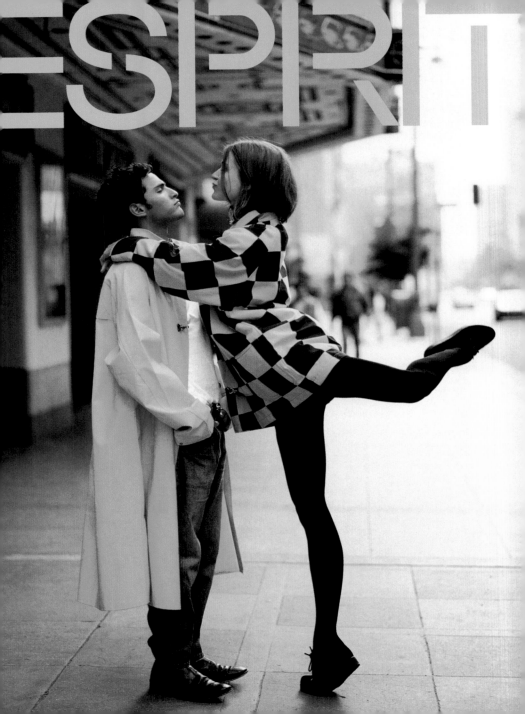

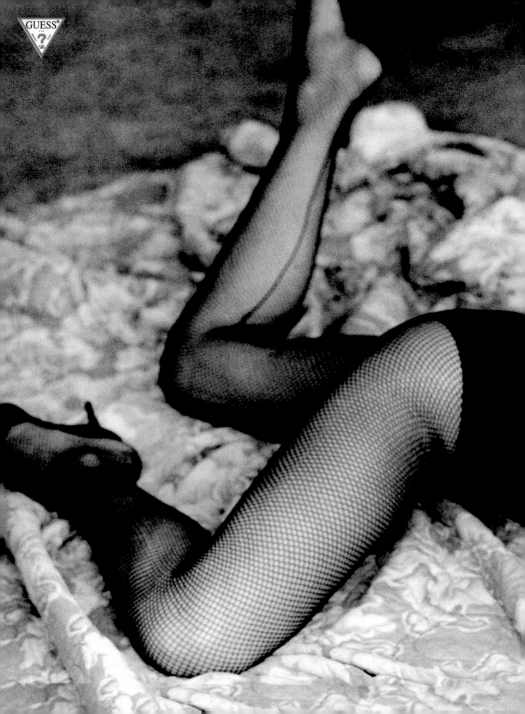

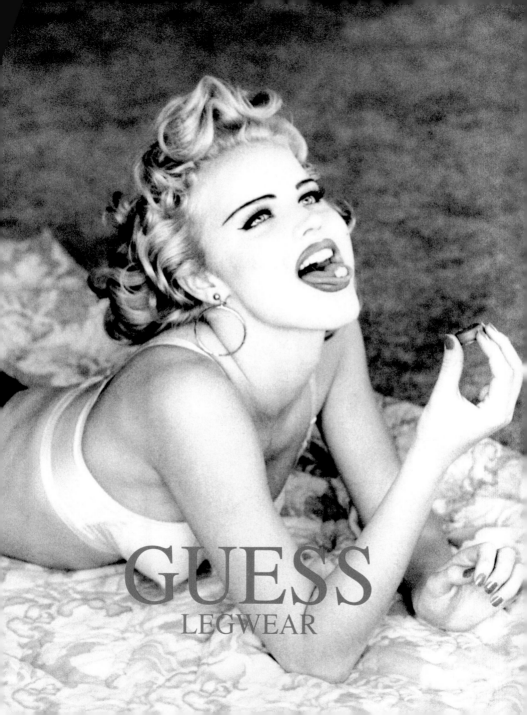

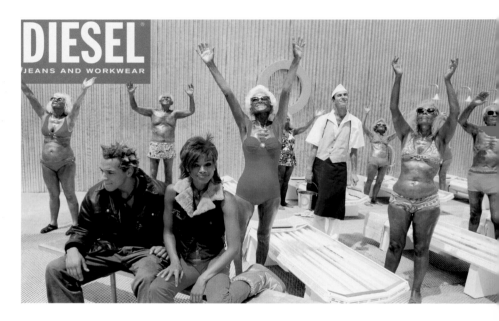

Diesel Jeans and Workwear, 1994

Italian brand Diesel began working with Swedish ad agency DDB Paradiset, a division of DDB Needham Worldwide, in 1991, together launching an international campaign that blended humor with social issues. The DDB campaigns twice won the grand prix in the Cannes Press & Poster competition.

Das italienische Label Diesel begann 1991 mit der schwedischen Werbeagentur DDB Paradiset, einer Sparte von DDB Needham Worldwide, zusammenzuarbeiten; gemeinsam präsentierte man schließlich eine internationale Kampagne, die Humor mit sozialpolitischen Themen verband. Die DDB-Kampagnen gewannen zweimal den Grand Prix in Cannes im Wettbewerb Press & Poster.

En 1991, la marque italienne Diesel commença à travailler avec l'agence de publicité suédoise DDB Paradiset, une division de DDB Needham Worldwide, sur une campagne internationale mêlant humour et questions de société. Les campagnes DDB ont remporté deux fois le Grand Prix du concours Cannes Press & Poster.

► Charles David Shoes by Nathalie M., 1997

charles david
by Nathalie M

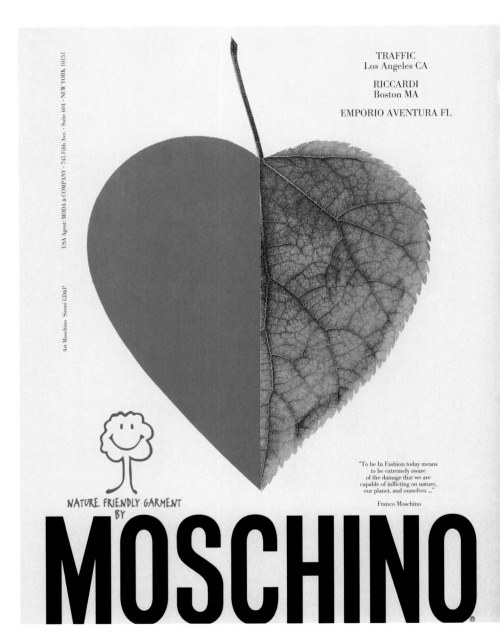

Moschino Jeans, 1990

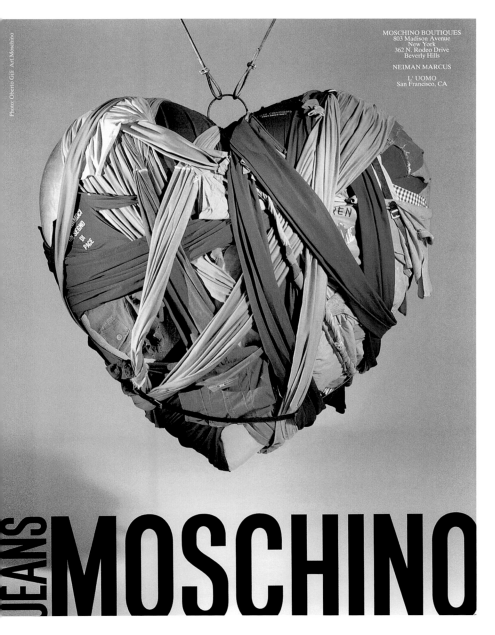

MOSCHINO BOUTIQUES
803 Madison Avenue
New York
362 N. Rodeo Drive
Beverly Hills

NEIMAN MARCUS

L' UOMO
San Francisco, CA

JEANS MOSCHINO

Moschino Jeans, 1994

◄ Lucky Jeans, 1997

Cross Colours Sportswear, 1993

The urban streetwear market was a largely untapped niche in the 1980s, addressed primarily by established athletic-apparel brands. Los Angeles–based Cross Colours launched in the late 1980s with much fanfare and soon landed in large U.S. department stores. The company fell victim to its own success, failing to keep up with the demands of rapid expansion, but it paved the way for other brands like FUBU and Phat Farm.

Der Markt für urbane Streetwear war in den 1980ern noch eine weitgehend unbeachtete Nische, um die sich vornehmlich etablierte Sportmodenhersteller kümmerten. Die Firma Cross Colours mit Sitz in Los Angeles trat in den späten 80ern mit großem Tamtam auf den Plan und etablierte sich bald in den großen amerikanischen Kaufhäusern. Letztlich fiel das Unternehmen allerdings seinem eigenen Erfolg zum Opfer, weil es ihm nicht gelang, den Anforderungen der raschen Expansion zu genügen, dafür ebnete es zumindest anderen Marken wie FUBU und Phat Farm den Weg.

Dans les années 80, le marché du streetwear était encore une niche largement inexploitée et principalement occupée par des marques de sportswear bien établies. La griffe Cross Colours de Los Angeles fut lancée en fanfare à a fin des années 80 et rapidement distribuée dans les grands magasins américains. Victime de son succès, l'entreprise ne réussit pas à suivre les exigences d'une expansion aussi rapide, mais essuya les plâtres pour d'autres marques telles que FUBU et Phat Farm.

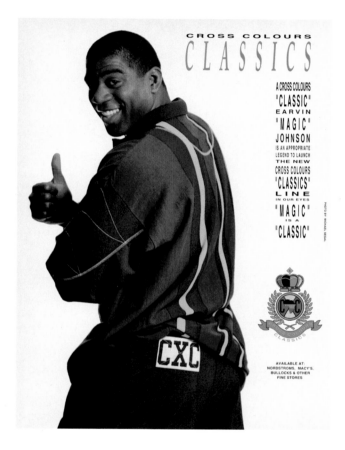

CROSS COLOURS
CLASSICS

A CROSS COLOURS "CLASSIC" EARVIN "MAGIC" JOHNSON IS AN APPROPRIATE LEGEND TO LAUNCH THE NEW CROSS COLOURS "CLASSICS" LINE IN OUR EYES "MAGIC" IS A "CLASSIC"

AVAILABLE AT: NORDSTROMS, MACY'S, BULLOCKS & OTHER FINE STORES

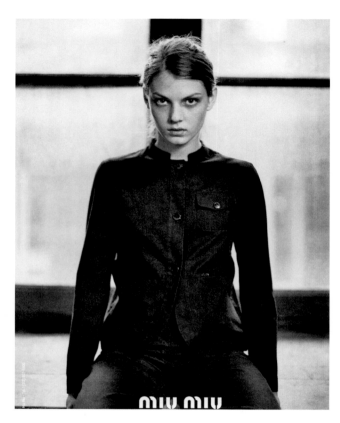

Miu Miu Ready-to-Wear, 1997

Miuccia Prada took over her grandfather's leather-goods company in 1978, launching a ready-to-wear line in 1989. In 1992, the company launched its diffusion line, Miu Miu—the designer's nickname. In the mid-1990s, the brand shifted from the anti-fashion of grunge to an intellectual and minimalist look that exuded sophisticated luxury.

Miuccia Prada übernahm 1978 die Lederwarenfabrik ihres Großvaters und startete 1989 eine Prêt-à-porter-Linie. 1992 führte man die Nebenlinie Miu Miu ein – benannt nach dem Spitznamen der Designerin. Mitte der 90er wechselte die Marke von der Anti-Mode im Stil von Grunge zu einem intellektuellen und minimalistischen Look, der raffinierten Luxus ausstrahlte.

Miuccia Prada reprit l'entreprise de maroquinerie de son grand-père en 1978 et lança une ligne de prêt-à-porter en 1989. En 1992, la société commercialisa une ligne secondaire baptisée Miu Miu, le surnom de la créatrice. Au milieu des années 90, la marque délaissa l'anti-mode du grunge au profit d'un look intello minimaliste emprunt de luxe et de sophistication.

▶ Versace Signature, 1994

▶▶ Levi's Sportswear, 1998

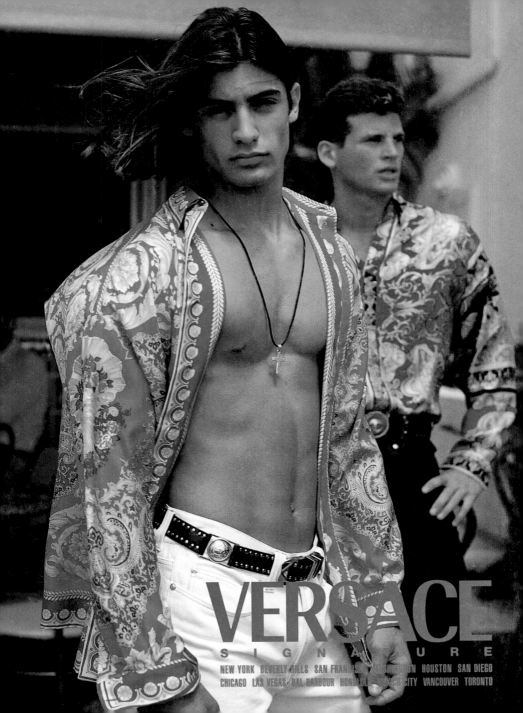

VERSACE
SIGNATURE

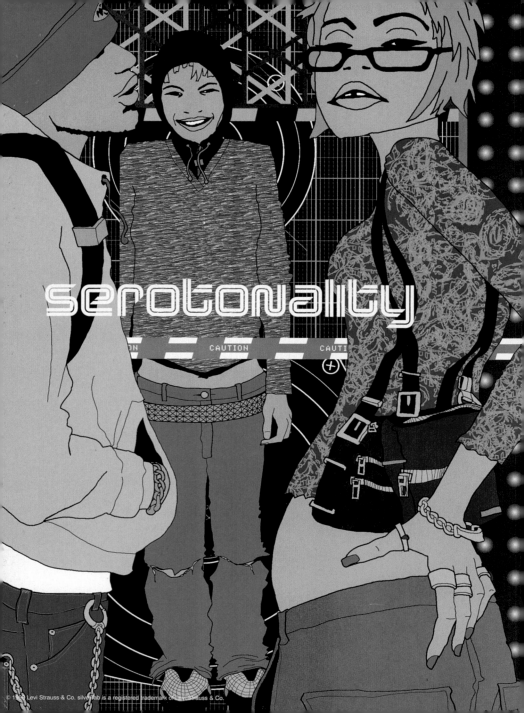

serotonality

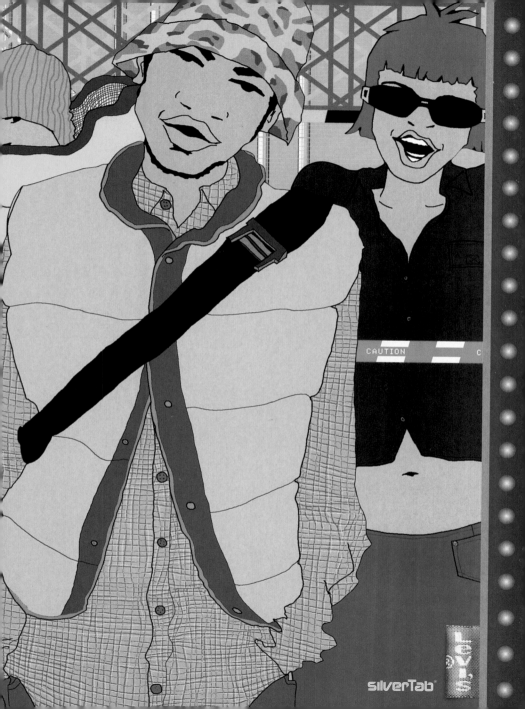

CAUTION

silverTab®

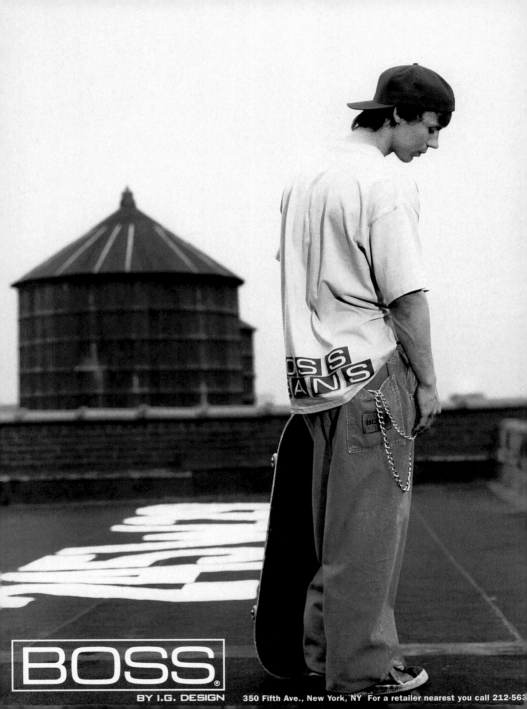

◀ Boss Jeans, 1994

FUBU Jeans, 1999

Following Cross Colours' short-lived success,
urban streetwear remained a largely untapped
market. Two New York companies stepped in
to fill the void. FUBU ("For Us By Us") launched
in 1992 as a hat line and soon expanded to
include an expansive, logo-driven collection.
Music executive Russell Simmons launched his
Phat Farm men's line that same year, followed
by a women's line, Baby Phat, in 1999.

Nach Cross Colours kurzlebigem Erfolg blieb
der Markt für urbane Streetwear zunächst
weitgehend unerschlossen. Dann traten zwei
New Yorker Firmen auf den Plan, um die
Lücke zu füllen. FUBU ("for us by us") startete
1992 als Hutmarke und expandierte bald
mit einer breiten, Logo-lastigen Kollektion.
Der Musikmanager Russell Simmons kam im
selben Jahr mit seiner Herrenlinie Phat Farm
auf den Markt, der 1999 die Damenlinie Baby
Phat folgte.

Après le succès éphémère de Cross Colours,
le marché du streetwear resta largement
inexploité. Deux entreprises de New York
comblèrent ce vide. Fondée en 1992, la
marque FUBU (« for us by us ») proposa d'abord
des chapeaux avant de développer toute une
collection tournant autour de son logo. La
même année, le producteur de hip-hop Russell
Simmons lança sa marque pour homme Phat
Farm, suivie d'une collection pour femme, Baby
Phat, en 1999.

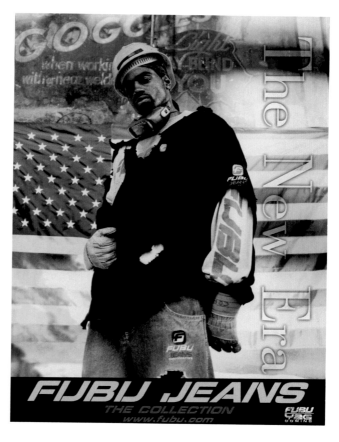

Gucci Bags, 199[9]

Gucci Boots, 1996

A&

QUARTE

ON SPRING BREAK
LOOKING FOR LOVE

◄ Abercrombie & Fitch Catalog, 1998 Pepe Jeans, 1993

JOOP!
MENSWEAR

Joop! Menswear, 1994 ▶ Guess Jeans, 1990

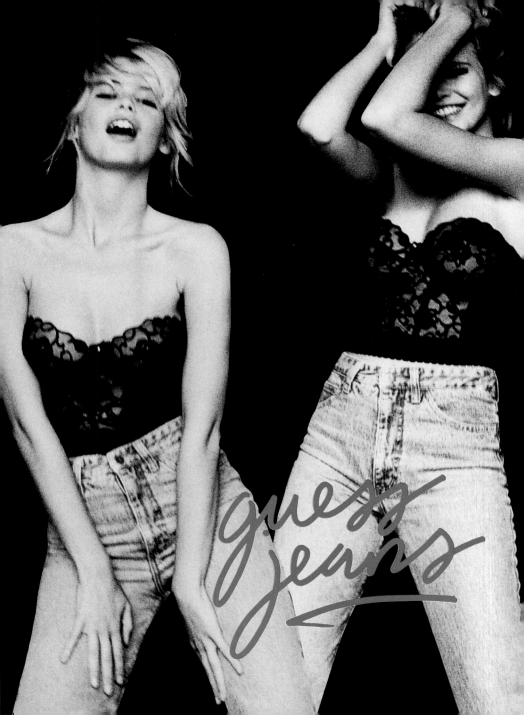

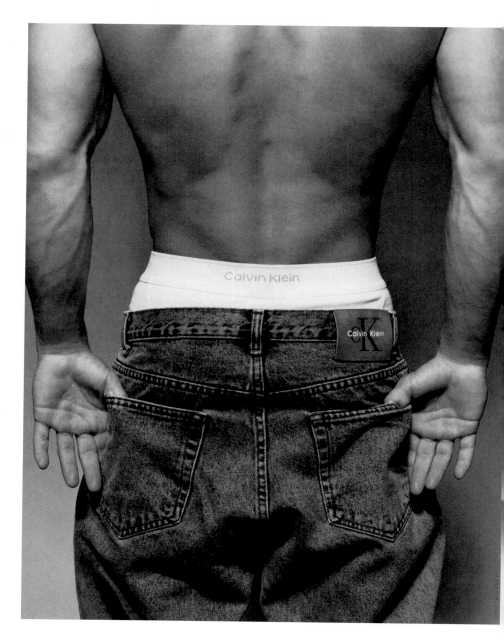

Calvin Klein Underwear and Jeans, 1993

Versace Jeans and Underwear, 1998

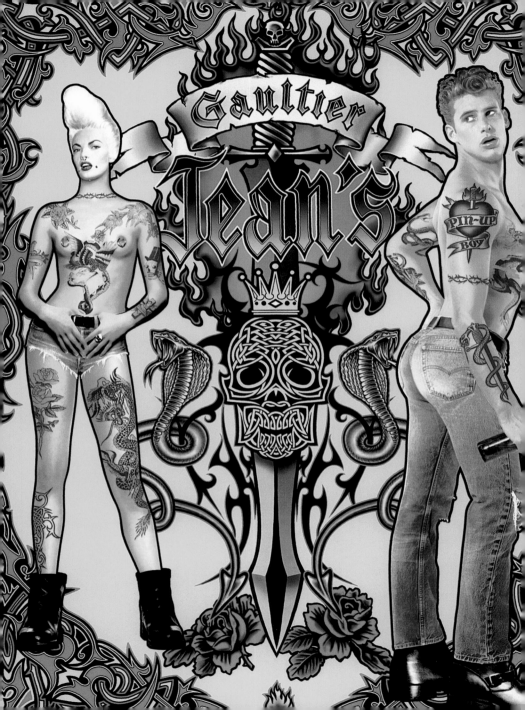

◄ Gaultier Jeans, 1997

Calvin Klein Jeans, 1995
Calvin Klein, no stranger to controversial
advertising, found itself faced with a flood of
negative press about its 1995 ad campaign,
which featured youthful-looking models shot
against a wood-paneled wall. Critics likened
the ads' look to amateur child pornography,
and the campaign was quickly abandoned.

Calvin Klein, dem kontroverse Werbung nicht
fremd war, wurde angesichts seiner Anzeigen-
kampagne von 1995 mit einer Flut von negati-
ven Pressemeldungen konfrontiert. Es ging um
sehr jung aussehende Models, die vor einer mit
Holzpaneelen verkleideten Wand fotografiert
waren. Kritiker verglichen die Anzeigen mit
amateurhafter Kinderpornografie, und die
Kampagne wurde rasch eingestellt.

Habitué à la controverse, Calvin Klein eut
très mauvaise presse en lançant sa campagne
publicitaire de 1995 qui mettait en scène de
jeunes mannequins photographiés devant
un mur en lambris de bois. Les critiques asso-
cièrent ce look à celui de la pédophilie amateur
et le créateur dut rapidement mettre fin à cette
campagne.

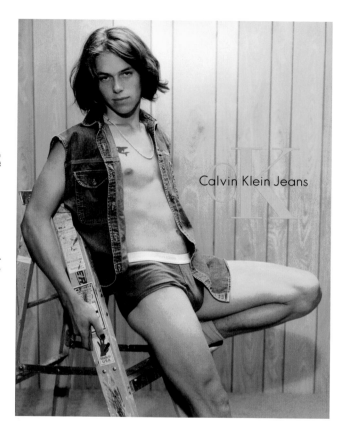

Calvin Klein Jeans

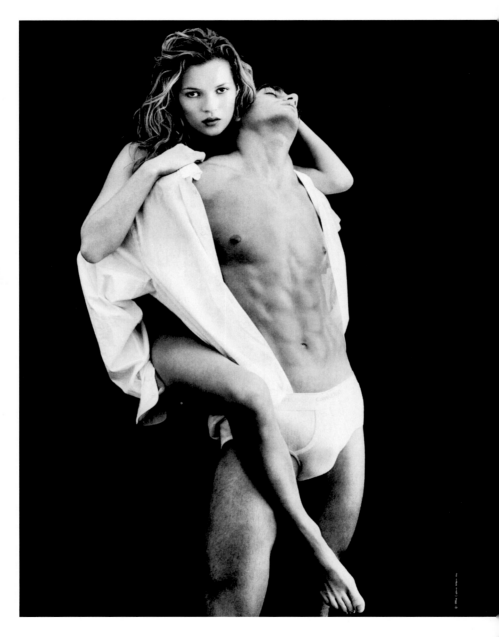

Calvin Klein Underwear, 1994 ▶ Wilke-Rodriguez Sportswear, 1992

EVOLUTION IS A PROCESS OF CHANGING UNDERWEAR.

JOE BOXER®

AMERICA, CHANGE DAILY!

JOE BOXER

UNDERWEAR, SLEEPWEAR AND HOME FURNISHINGS

AVAILABLE AT BETTER DEPARTMENT STORES AND SPECIALTY SHOPS NATIONWIDE
CONTACT JOE BOXER IN UNDERWEAR CYBERSPACE! INTERNET joeboxer@jboxer.com

JOE BOXER TV IS COMING TO Q3?
TUNE IN THIS FALL FOR THE PREMIERE OF AMERICA'S WACKIEST UNDERWEAR HOUR!

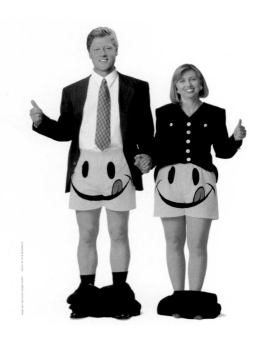

◄ Joe Boxer Underwear, 1993 Joe Boxer Underwear, 1994

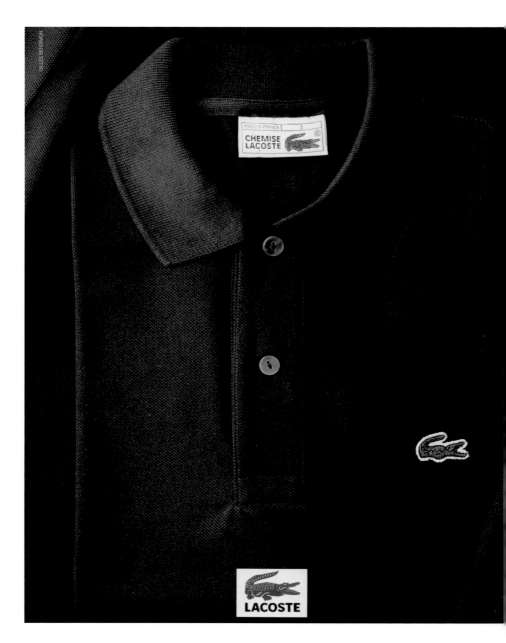

Lacoste Shirts, 1997 ▶ Lacoste Shirts, 1995

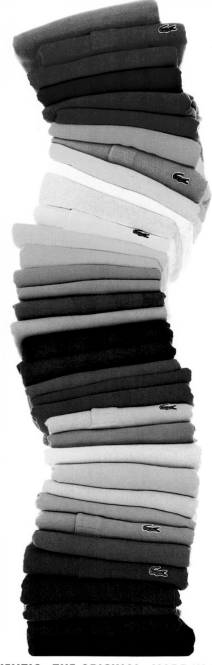

THE AUTHENTIC. THE ORIGINAL. MADE IN FRANCE.

LACOSTE

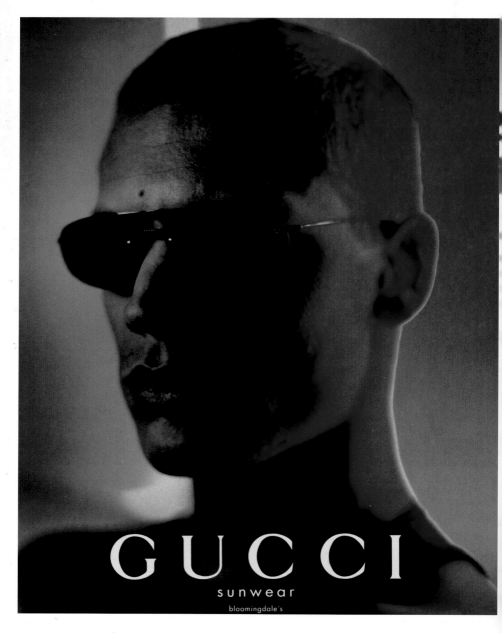

Gucci Eyewear, 1998 ▸ Yves Saint Laurent Furs, 1996 ▸▸ Ermenegildo Zegna Suits, 1996

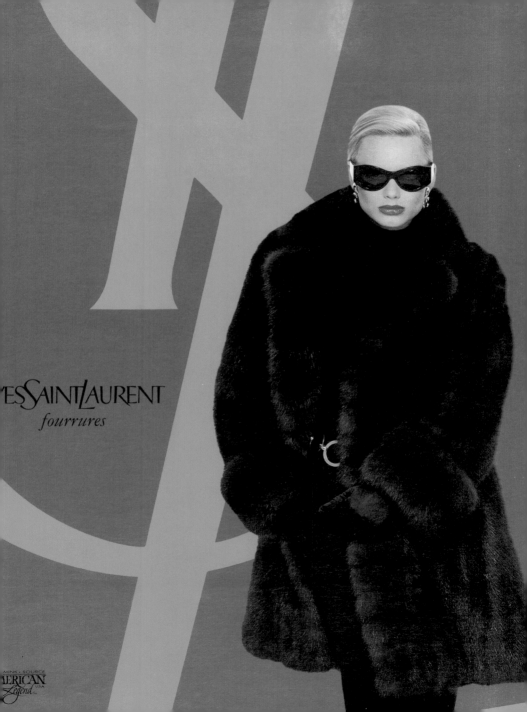

YVESSAINTLAURENT
fourrures

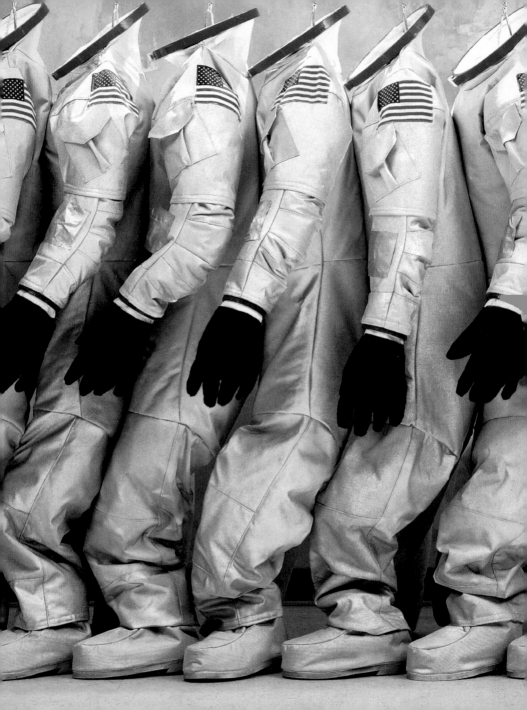

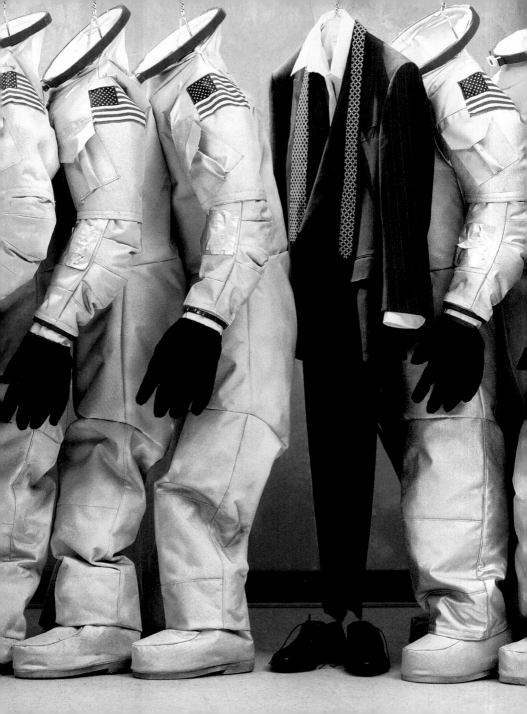

INDEX

Frontispiece Maidenform Bras, 1954
► Hillbilly Jeans, 1973

All images are from the Jim Heimann collection unless otherwise noted.
Any omissions of copy or credit are unintentional and appropriate
credit will be given in future editions if such copyright holders contact
the publisher.

Text © 2009 Alison A. Nieder

Timeline image credits: Anne Marie Borle: Lacoste (1933), Polo (1972),
Swatch (1983). Blake Roberts: Prada (1978). Burton Holmes Historical
Archive, www.burtonholmes.org: Eiffel Tower (1900), Josephine Baker
(1926), Charlie Chaplin (1931). Marco Zivny: Nike (1985). Nina Wiener:
Missoni (1958), Gucci (1991). Tyler Flatt: Le Tigre (1977).

The publisher thanks Mark Haddawy of Resurrection Vintage, Los Ange-
les and New York, for his fact-checking expertise; and Jennifer Patrick,
Tyler Flatt, Maurene Goo, Marco Zivny, Doug Adrianson, Cara Walsh,
Christopher Kosek, Thomas Chung, Joey Heller, and Jonathan Newhall
for their invaluable assistance in getting this book produced.

EACH AND EVERY TASCHEN BOOK PLANTS A SEED!
TASCHEN is a carbon neutral publisher. Each year, we offset our annual
carbon emissions with carbon credits at the Instituto Terra, a reforesta-
tion program in Minas Gerais, Brazil, founded by Lélia and Sebastião
Salgado. To find out more about this ecological partnership, please check:
www.taschen.com/zerocarbon
Inspiration: unlimited. Carbon footprint: zero.

To stay informed about TASCHEN and our upcoming titles, please
subscribe to our free magazine at www.taschen.com/magazine, follow
us on Twitter, Instagram, and Facebook, or e-mail your questions to
contact@taschen.com.

© 2016 TASCHEN GmbH
Hohenzollernring 53, D–50672 Köln
www.taschen.com

Original edition: © 2009 TASCHEN GmbH

Art direction: Josh Baker, Los Angeles
English-language editor & project management: Nina Wiener, New York
Design: Jessica Trujillo, Los Angeles
Cover lettering: Michael Doret, Los Angeles
Production: Thomas Grell, Cologne
German translation: Henriette Zeltner, Munich
French translation: Claire Le Breton, Paris

Printed in China
ISBN 978-3-8365-2279-3

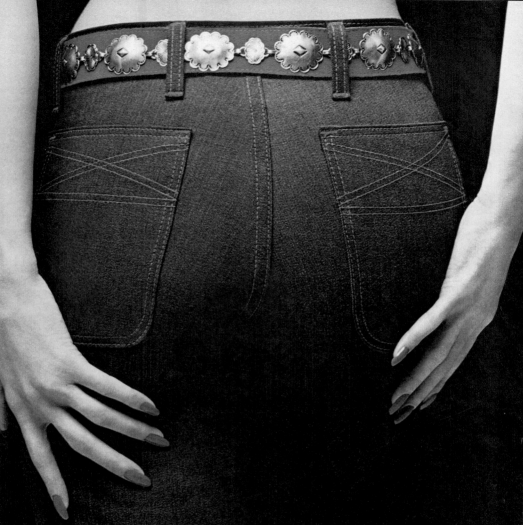

Be kind to your behind.

100 Contemporary Architects

100 Contemporary Houses

100 Interiors Around the World

1000 Chairs

1000 Lights

Industrial Design A-Z

Decorative Art 50s

Decorative Art 60s

Decorative Art 70s

Design of the 20th Century

Modern Architecture A-Z

Bookworm's delight: never bore, always excite!

TASCHEN
Bibliotheca Universalis

Scandinavian Design

Small Architecture

domus 1930s

domus 1940s

domus 1950s

domus 1960s

The Grand Tour

Architectural Theory

Braun/Hogenberg. Cities of the World

Byrne. Six Books of Euclid

Piranesi. Complete Etchings

The World
of Ornament

Racinet.
The Costume History

Fashion. A History from
18th–20th Century

100 Contemporary
Fashion Designers

20th Century Fashion

20th Century
Photography

A History of
Photography

Photographers A–Z

André de Dienes.
Marilyn Monroe

Bodoni. Manual of
Typography

Logo Design

Funk & Soul Covers

Jazz Covers

1000 Record Covers

Steinweiss

100 Illustrators

Illustration Now!
Portraits

Modern Art

Chinese Propaganda
Posters

Film Posters of the
Russian Avant-Garde

1000 Tattoos

1000 Pin-Up Girls

Mid-Century Ads

20th Century
Classic Cars

20th Century
Travel